This book is dedicated to EDITH GREGOR HALPERT (1900-1970) and to all the dealers of the time who believed in the American artist.

"Behold the great rondure, the cohesion of all, how perfect!"

— Walt Whitman

# THE LANE COLLECTION

## 20th-Century Paintings in the American Tradition

by Theodore E. Stebbins, Jr., and Carol Troyen

Distributed by
Northeastern University Press, Boston

Museum of Fine Arts
Boston

Copyright© 1983
by the Museum of Fine Arts, Boston,
Massachusetts
Library of Congress catalogue
card no. 83-60284
ISBN 0-87846-232-5 (paper)
0-87846-233-5 (cloth)
Printed in U.S.A. by Acme Printing Co.,
Medford, Massachusetts
Designed by Carl Zahn

Exhibition Itinerary

**Museum of Fine Arts, Boston**
April 13, 1983 – August 7, 1983

**San Francisco Museum of Modern Art**
October 1 – December 1, 1983

**Amon Carter Museum,
Fort Worth, Texas**
January 7, 1984 – March 5, 1984

Cover illustration:
**Charles Demuth**
**56.** *Longhi on Broadway,* 1927

# CONTENTS

# ACKNOWLEDGMENTS

Many people have contributed to making this book and this exhibition a reality. At the Museum of Fine Arts, we are especially indebted to: Carl Zahn and his staff in the Publications Department; to Judy Spear, who edited the manuscript; Linda Thomas, Registrar, and Lynn Herrmann, Assistant Registrar; and to Tom Wong and Judith Downes of the Design Department. In Paintings Conservation, Alain Goldrach, Frank Zuccari, Brigitte Smith, Jean Woodward, Emily Nord McClintock, and Irene Konefal have prepared the paintings for exhibition. In the Paintings Department, we particularly thank James Barter, Trevor Fairbrother, Galina Gorokhoff, Mary-Denise O'Connor-Kidney, who typed the manuscript, and Harriet Rome Pemstein, who has coordinated the project. The exhibition histories and other back matter were ably prepared by Mary-Charlotte Domandi and T. Samuel Stebbins. Finally, special thanks go to John Walsh, Curator of Paintings, for his encouragement and guidance of this project.

In addition, we are most grateful to William Dove, John P. Driscoll, Lloyd Goodrich, Bartlett H. Hayes, Juan Hamilton, Richard G. Leahy, and Georgia O'Keeffe. Indispensable to our research was the cooperation of Robert Brown and the staff of the Archives of American Art in Boston, and the Fine Arts Library at Harvard University.

Nearly all the superb color photography in the catalogue was done by Herbert P. Vose; the remaining six photographs were made by Don Stott at the Museum of Fine Arts. We acknowledge also the help of Herbert W. Chapman and Louise Baker of the William H. Lane Foundation, as well as that of Leon Brathwaite of the Huntington Frame Company, Boston.

T.E.S., Jr.
C.T.

# FOREWORD

It is a great privilege for the Museum of Fine Arts to present to our audience in New England, and the nation, this exhibition of twentieth-century paintings from the Lane Collection.

This first of several planned collaborative projects of the Museum of Fine Arts with the William H. Lane Foundation marks the thirtieth anniversary of the first exhibition sponsored by the Foundation. On that occasion in 1953 Bartlett H. Hayes, Jr., the longtime director of the Addison Gallery at Phillips Academy in Andover, exhibited forty paintings from the Lane Collection, many of which are included in the present exhibition. Following this precedent, the William H. Lane Foundation has carried on an active educational program in the arts for which I simply know no parallel. The Foundation has been truly a "museum without walls," in Malraux's terms, generously sending out over this thirty-year period some forty-three full-scale exhibitions of American art (drawn wholly from its collections) to the museums and particularly the college galleries of New England and New York. Paintings from the Lane Collection have also traveled far and wide across the nation and the world — including Canada, England, Germany, France, Italy, Sweden, Greece, Israel, and Japan — as the Foundation made loans to important retrospectives, to group shows, and to great expositions such as the Moscow World's Fair. All in all, some 360 museums and galleries have benefited from this lending program. Surely thousands upon thousands of people in New England and around the world have received their introduction to modern American painting through the Lane Foundation's superbly generous programs.

The Lane Collection presents a highly concentrated personal view of the work of the founders of modern painting in this country. Here we enjoy in depth the fruits of Mr. Lane's extraordinary eye, as seen in the important groups of work by Sheeler and Dove, O'Keeffe, Hartley, Stuart Davis, and their contemporaries. Though the Museum of Fine Arts over the years purchased selected masterpieces by these painters, including Sheeler's *View of New York* (1931) and the two Hartleys, *Carnival of Autumn* (1908) and *Black Duck* (1940-1941), among others, and though we had the great good fortune in 1972 to receive a gift of paintings from the Stephen and Sybil Stone Foundation, which includes several of the same masters — still, it is fair to say that until this time our audience has simply never been able to enjoy and study the best American art of its time in depth.

Through this exhibition, we at the Museum of Fine Arts reaffirm our commitment to the modern American painter — a commitment evidenced by last season's major exhibition of contemporary art from the Graham Gund Collection, as well as by recent retrospectives of such diverse talents as Fairfield Porter, Larry Poons, and Richard Estes.

This exhibition has been organized by Theodore E. Stebbins, Jr., John Moors Cabot Curator of American Paintings, and I am grateful to him, to Carol Troyen, Assistant Curator of Paintings, to Carl Zahn, who designed the catalogue, and to those members of many museum departments who have worked together to produce

this beautiful exhibition and this book. Our greatest gratitude, of course, goes to the Lane Foundation and especially to our Trustee, William H. Lane, and to his wife, Saundra, for their superb cooperation and great kindness in making this exhibition possible.

JAN FONTEIN
Director

Portrait of Bill and Saundra Lane       9
*Photograph by B.A. King*

"Stieglitz was a very exciting person. His battle was principally for the American artist — photographer, sculptor, or painter. He thought the artist should be appreciated and well paid. In his time the French were of much more interest than the Americans, but he thought that something of interest and importance must come out of America. And one by one he chose a group that he thought of interest and did his best to make it possible for them to work."

— Georgia O'Keeffe

"You will discover that if the artist could explain in words what he has made, he would not have had to create it."

— Alfred Stieglitz

# THE MEMORY AND THE PRESENT: ROMANTIC AMERICAN PAINTING IN THE LANE COLLECTION

by Theodore E. Stebbins, Jr.

The Lane Collection reflects the spirit of Alfred Stieglitz. The collection was made in the Stieglitz style, in an exploratory, adventurous way, without preconceptions or cynicism. Its paintings, for the most part, are *Stieglitz* paintings — some of the artists are ones Stieglitz loved and supported all his life, and others he knew and admired — and their pictures are strong, unsentimental, modern, yet they are also brilliantly colored, subtle, and often difficult. Most lack human subjects: they are landscapes and still lifes in the American tradition, and they speak as directly to American style, to the uneasy place of the artist in this land, as they do to international artistic currents. They resist typing and "isms." And they have been used in a way that Stieglitz and Edith Halpert and the other pioneers would have applauded: they have been exhibited again and again around this country and the world with the hope that their spark would strike some people, and that a few would learn their lessons of quality and integrity. This collection, formed with the same sense of mission, the same passion for beauty that guided Stieglitz, recalls Paul Rosenfeld's summation of the man: "Faith and love, love for art, faith in its divine powers to reveal life, to spur action, to excite the creative enterprise, those are the dominant characteristics of Alfred Stieglitz." [1]

Alfred Stieglitz played no single role; neither was he simply dealer, collector, editor, photographer, patron, or proselytizer, though he was all these things and more. His famous succession of New York galleries — first "291," named for its location at 291 Fifth Avenue, which he operated from 1905 to 1917; then the Intimate Gallery (1925-1929); and finally An American Place (1929 to his death in 1946) — introduced the American public to much of the best art of his time. At the beginning, "291" was a lonely outpost of the avant-garde, where the first U.S. shows of Picasso, Cézanne, and Matisse were held, and where the most advanced Americans gathered, found support, and were exhibited. William Homer writes that although Stieglitz presented exhibitions at "291," "he always insisted that it was a noncommercial enterprise, that he was not a dealer and not in business." And Homer quotes Marie Rapp: " '291 was not a gallery for selling things; it was to show the world what was being done by Americans. Stieglitz was dedicated to the idea of giving deserving artists a chance to be seen, and it gave him the greatest joy when he sold something, an absolute joy in getting people interested.' " [2] In later years, Stieglitz concentrated on the work of "Seven Americans" in whom he believed most passionately: the painters John Marin, Arthur G. Dove, Georgia O'Keeffe, Charles Demuth, and Marsden Hartley, as well as two photographers, Paul Strand and himself. Each of these five painters is well represented in the Lane Collection, though not in equal strength: thus, Marin — in his lifetime the most successful by far — is seen here in only two examples, a watercolor of the 'twenties and a late oil, and Demuth also by a pair of works, including a major painting, while Hartley and O'Keeffe are richly represented with a group of works that surveys their careers. The paintings by Dove reach yet another level: in number they rival the holdings of the Phillips Collection, and in terms of Dove's late work, they are unique. Only through the Lane pictures can one truly come to know this extraordinary painter.

Many of the others in the Lane Collection are also "Stieglitz painters" in some sense — not that there was a simple "Stieglitz style," but there was a governing spirit to his

taste, which demanded toughness, independence, clarity of vision, and a grounding in American fact. So Charles Sheeler, for example — who, like Dove, is superbly represented here — surely worked in the Stieglitz spirit, and in fact the two men were friends who corresponded and who expressed their admiration for each other's work.[3] Max Weber — seen here through three late paintings — had been close to Stieglitz, and had shown at "291" in 1910 and 1911. Stuart Davis presents a somewhat different case, for he matured too late to join Stieglitz's inner circle; as it was, beginning in 1927, he was handled by Edith Halpert — herself very much a Stieglitz disciple, as Carol Troyen points out in her essay in this catalogue. Stieglitz would have appreciated other younger painters such as Spencer and Crawford, for their abstracting vision was close to his. Also well represented in the Lane Collection are Hofmann, Gorky, and Kline. Though all were members of a succeeding artistic generation and masters of a more painterly, expressionistic style, Stieglitz had such feeling for innovation and talent, and so little bias about style *per se* (as witness his championing of the painterly Marin and the smooth, austere O'Keeffe), that he surely would have found their aims consistent with his own.

So Stieglitz must be seen as the first great believer in many of the painters included here and, in a real sense, as "godfather" of the Lane Collection itself. Nonetheless, most of these painters remain relatively unknown to the public even today, particularly in New England where the conservative Boston School has been dominant for so long. Even where they have been appreciated, they have been badly misread. Despite their brilliance — and there can be no doubting that Dove, Sheeler, and Davis rank among the American giants — they have somehow remained specialists' painters, known and admired by a few, unknown or misunderstood by many. This anomaly becomes particularly puzzling when one recalls the number of energetic, articulate champions with which the painters have been blessed over the years, beginning with Stieglitz, Halpert, and a number of other dealers, and including such early critics as Paul Rosenfeld, Edward Alden Jewell, and Elizabeth McCausland, and more recently museum curators and directors Frederick S. Wight, John R. Lane, and Barbara Haskell, among others.

Many reasons can be found for this. For one thing, Stieglitz may have oversold them as the *founders* of modern art in America, for ever since then they have been typed as pioneers only, as painters simply of the 'teens, the Armory Show decade. The scholar William Agee, for example, writes of Sheeler, Dove, Marin, O'Keeffe, and Bruce, among others, as "the older generation," born before 1885, "the artists who in the main were responsible for the first wave of modernism in this country prior to 1920."[4] This is not inaccurate in itself, but it typifies a limited view of these artists. This kind of faint praise has been reinforced by the sense that these painters' "experiments" somehow failed, that after bravely attempting something new, they were driven back toward a more realist art during the 'twenties. This widely held view seems invalid on several grounds. First, the work of painters who did, in fact, "retreat," developing away from abstraction toward figuration after 1920 (such as Hartley and Weber), did *not* necessarily decline qualitatively thereby; Hartley, for example, during the next decades produced landscapes and portraits of great power (see nos. 7 and 8). Second, the "retreat" simply didn't occur for many of the

major figures. O'Keeffe, for one, worked steadily with great force from the 'twenties through the 'fifties; and Sheeler, Dove, and Stuart Davis reached their highest levels during the 'thirties and 'forties, when their time was supposedly long past. And finally, even the European inventors evolved away from their abstract experiments of 1908-1913: Picasso turned from analytical cubism to a classical, figurative mode in the 'twenties and Duchamp made very few paintings of any kind after the famous *Nude Descending a Staircase,* for example. We overlook the fact that many of the best paintings of European modernism from 1920 to 1940 are figurative and "realistic" to an extent.

So, judged according to their own merits, or even in comparison with the European development, the Americans cannot be said either to have retreated or to have failed. There are many instances of careers cut short, as with John Covert, Alfred Maurer, or Patrick Henry Bruce, or of painters who failed to realize their early potential, but both patterns have long been part of our tradition. It has *always* been difficult to paint in America, and hardest of all to continue one's growth and progress after a return from European training — as one sees in Smibert's case in the eighteenth century, or in Vanderlyn's or Eakins's in the nineteenth.

Moreover, historians are inclined to see only one movement or style at a time as "dominant" and, therefore, valid. Thus, the 'thirties have been regarded chiefly as the heyday of the Regionalists and the American Scene painters, including Thomas Benton and Grant Wood. A great deal else was happening in this rich and complex decade besides the Regionalist "mainstream," including a new movement toward social protest in art; the arrival of surrealism, which captured popular imagination; the New Deal art programs, especially the W.P.A., and the many murals around the country that resulted; the founding of American Abstract Artists in 1936 and the birth of a purely abstract, nonobjective style; and finally the roots of Abstract Expressionism, which were then being laid by Gorky, deKooning, and others under the influence of Miró and Picasso.

All this has left little room for acknowledgment of the Stieglitz painters' extraordinary accomplishments in the 'thirties, and it has been even easier to rule them out of the 'forties and 'fifties altogether. But, to take one case, between 1939 and 1944 Dove reached lyrical heights, approaching a perfect purity of mood, of color, and of abstract form. His work prefigures Motherwell, Rothko, and others, yet because it is not clear whether or not he had any direct influence on the younger painters, it has been considered aesthetically insignificant. Much the same problem occurs with other painters. For example, Stuart Davis's *Medium Still Life,* O'Keeffe's *Red Tree, Yellow Sky,* and Sheeler's *Ore into Iron* (nos. 84, 64, and 51) were all painted in 1952 and 1953. These painters were 59, 65, and 70 years old, respectively, at the time of these works, and the leaders of the next generation — Pollock, Kline, and deKooning — were all then at the height of their powers. As a result, the continuing creativity of this "pioneer" group was generally overlooked by critics and the public. In 1934, Stieglitz had been called a "prophet without honor in his own country;"[5] the same term could be applied to a Sheeler or a Dove — painters whose art grew and grew, but who for years were ahead of their times, and who then suddenly seemed out-of-date.

It is easy today to forget the struggles that the early painters faced. As late as 1935, one critic scoffed at Stieglitz's "Manhattan contempt," accusing him of not knowing "what the rest of the country looks like, tastes like, smells like, or feels like," and speaking of his "metropolitan charlatanry."[6] According to Forbes Watson, many museum trustees of the period considered modern art part of the "Red Menace."[7] One group in 1937 indicted surrealism as "a move by international communism in their war on standards in religion, industry, society, and the arts."[8] And all this was happening after twenty years of progress, long after the Armory Show of 1913. Acceptance of modern art had doubtless improved since the early 'twenties, when one Massachusetts educator attacked modern art as "introspective, morbid, too often actually degenerate,"[9] or since the *New York Times* article at the time of the Armory Show, which had warned of "the general movement discernible all over the world, to disrupt and degrade, if not to destroy, not only art, but literature and society, too."[10]

American society has always been suspicious of the arts, and the Stieglitz painters worked in a particularly difficult, hostile environment. Moreover, the way they were seen in the early years affects the way we see them today. From 1913 on, virtually all modern art was considered "Cubism." Arthur Jerome Eddy, in the first American book on the modern movement, *Cubists and Post-Impressionism* (1914) considered under the Cubist rubric Picasso and Braque, as well as Picabia, Duchamp, Klee, and Kandinsky (he especially admired the latter as "the most extreme"). Only one American painter drew his attention: this was Dove, described as "almost the only man in this country who has persistently painted in Cubist fashion for any length of time . . . ."[11] Subsequent critics here and abroad have sorted out the various European painters and have articulated their disparate styles with care, but Dove and Sheeler and the other Americans to this day have simply, and most inaccurately, remained "Cubists." For fifty years, the Stieglitz painters have been credited only with "making an adaption of cubism suitable for America," in Frank Mather's words.[12] Recently this line of thought has been carried on by Barbara Rose — her chapter on these painters is called "After the Ball: Cubism in America," and by John Wilmerding, who comments that "only a few other Americans [besides Man Ray] pushed beyond orthodox cubist painting to such advanced and independent solutions . . .," and who speaks of Weber and Davis as "perhaps the closest and most consistent followers of the cubist movement."[13] Wilmerding speaks of Sheeler's "interest in machine forms tempered by a cubist background," and sums up by commenting that "this style has been well termed 'precisionism' (sometimes also immaculate or cubist realism), a concept relating both to the technique of execution and to the mechanical subject matter."[14] These terms have a respectable history, for in the 'twenties Henry McBride noted the "immaculate" qualities of O'Keeffe, and in 1930 Samuel Kootz spoke of the "Immaculate School."[15] John I.H. Baur helped establish the term "Precisionism," and in 1960 there was a large exhibition called "The Precisionist View in American Art": the catalogue speaks of the "photographic realism" of O'Keeffe and Sheeler, and finds in their work "the essences and heights of the movement."[16]

Nearly every American painter of the period did pay verbal and pictorial homage to Picasso and to Cézanne, and no one could deny the seminal importance of Cubism in Paris in the years between 1906 and 1913 for American painting and indeed for much subsequent painting in the West. Every one of the major Stieglitz painters except O'Keeffe worked in Paris between 1907 and 1913, and Kootz surely spoke for his generation in declaring that "France is the breeding ground for all that has been most significant in modern painting." [17] But to see these artists *primarily* in terms of their European learning experience is to misjudge them badly. For in fact America has *always* looked to Europe for sophisticated, up-to-date style. And the American has — equally traditionally — come home from Europe to adapt what he has learned to American environment and American taste. The American painter necessarily works with an eye to our need for both specificity and idealization. What resulted — in the Stieglitz generation, as in every generation before it back to 1670 — was an American art.

Sam Hunter correctly credits Alfred Stieglitz with having "held in balance the conflicting claims of native romanticism and European aesthetic formalism," [18] and it is this strongly romantic aspect, so much in keeping with past American art, that has been almost totally overlooked. Painters of the Stieglitz generation were highly conscious of their American roots, for there they found reinforcement for their own subjects and especially for their own style. Thus, one finds Sheeler in his autobiographical manuscript of 1938 speaking knowledgeably of Bingham, Homer, and Eakins, then going on to discuss the early nineteenth-century folk painters, whose structure he admired, and the still-life master Raphaelle Peale, whose *After the Bath* (Nelson Gallery - Atkins Museum, Kansas City, Missouri) he particularly relished for its extraordinary, subtle handling of whites. Sheeler found his roots appropriately in those firm, direct, and mysterious folk portraits, which maintain their appeal today; he also found precedent in Peale's masterwork of 1823, with its forceful, centrally composed image (the great white cloth) and with its quiet but insistent sensuality, to be seen both in the barely visible nude figure behind the "towel" and in the smooth but evocative paint handling.

Marsden Hartley spoke for his generation in proclaiming his love for Albert Ryder, whom he called "the last of the romantics, the last of that great school of impressive artistry, as he was the first of our real painters and the greatest in vision." [19] Hartley summed up Ryder as "the painter-poet of the imminent in things," [20] and it is this very quality of imminence, the ability to paint nature's motion and her potentialities, that marks Hartley's own work as well as Dove's. Dove himself was not an essayist, but he too paid Ryder homage in his own work, especially in *Clouds* (no. 12), which takes on much of the older painter's mood and palette.

In 1921 Hartley wrote of Ryder, Homer Martin, and George Fuller as "the originators of American indigenous painting," but a few years later he could refer to John Singleton Copley as "the most American of all the artists who form the background of American painting from its inception until the present day." [21] He recognized that "the special quality that gives the Copley pictures their particular distinction is a national one," and he finds in Copley "something of the capacity of Zubaran for driving simple monochrome to a high pitch of tonal richness and

beauty." He concluded, wistfully, perhaps speaking of himself while describing the colonial master: ". . . if you find him too cold, you will miss his finest distinctions." [22]

Historians have exaggerated the relative flatness, linearity, and lack of visible brushwork in American painting of the eighteenth and nineteenth centuries, just as they have overstated the precise "immaculate" technique of the twentieth-century masters. In the early period, one finds the marine painter Fitz Hugh Lane at one end of the spectrum, though even *his* very smooth surfaces with their nearly invisible brushstrokes do not approach the enamel-like finish seen in much German and French academic painting of the period, as, for example, in Gérôme or Meissonier. Others who have been considered purely linear painters are simply not so — witness Copley, who certainly never employed the sweeping manner of a Rubens, but who nonetheless handled paint with flair and dexterity. And Homer, Eakins, Ryder, Inness, Whistler — the late nineteenth-century American masters — were all in their different ways superbly able handlers of visible brushwork, of pure technique.

Among the twentieth-century painters, there is a similar range, from Marin's energetic, broad strokes that put him at the "painterly" end, to Davis, Sheeler, and O'Keeffe at the other, quietist, extreme. Early on, the critic Henry McBride perceptively commented that "the best O'Keeffe's seem wished upon the canvas." [23] O'Keeffe's brushwork is not invisible, but it is feathery, rhythmical, and very fine indeed. Her technique gives no suggestion of fragility, but rather her certain, light touch seems to come from the mind of a builder and explorer.

Sheeler thought about technique a great deal, and to regard him as "photographic" or lacking in touch or craft would be the grossest error. At the start, he worked with the impressionist colors and decorative brushwork of his teacher William Merritt Chase, but soon gave these up (Sheeler reported that Chase never spoke to him again after hearing that he was exhibiting at the Armory Show) and by 1912 and 1913 he was working with resonant Cézannesque colors applied rather thickly, as one sees in *Still Life, Spanish Shawl* (no. 40). He never copied the great French master literally, but clearly he had him on his mind at this time. At one point he spent months studying every inch of "a small Cézanne which Arensberg . . . lent him for a time, low in key but rich in color, one of the simpler still lifes . . . ." [24] By 1916 to 1918 both his vision — the ability at pure picture-making — and his technique had matured. More and more he admired the Flemish fifteenth-century masters, especially the Van Eycks, for what he called their "concealment of Means." He loved their craftsmanship, commenting that their pictures "seem to have been breathed upon the canvasses." Sheeler summed up his own development: "I have come to favor the picture which arrives at its destination without the evidence of a trying journey, rather than the one which shows the marks of battle." [25] The paintings of the next generation, of Kline and Pollock and the "abstract expressionists," simply *were* the marks of battle. Those of Sheeler and O'Keeffe and many of their contemporaries, American and European — and one thinks of many masters from Klee and Léger to De Chirico and Magritte — were quietly and carefully made; they're "non-painterly," like the early Flemish, and as Vermeer and Ingres had been.

The Stieglitz painters thought not only about Picasso and Cézanne but also about Ryder and Copley and their American predecessors. Moreover, in general, they painted like the earlier Americans, with restraint, a lack of bravura technique, and with the same seriousness. There was still little room for wit in a land where the artist lived in such a fragile, tentative relationship to the society. They believed, with Stieglitz, in the moral imperative of art, in its "divine power to reveal life," in its ultimate importance. They were drawn together by Stieglitz, by their allegiance to the ideals of "291," and by their common aims and frustrations; like passengers in a lifeboat, they looked inward for security and support. In the years following the Armory Show, they were very much a New York School and, as such, the central group in American art, playing somewhat the same role as Cole, Durand, and other members of the Hudson River School had from 1825 to 1870, or as Chase and his group had in the 'eighties, or Henri and his friends two decades later. The "New York School" of Pollock and deKooning in the 'forties, in turn, grew out of the Stieglitz group in spirit, and they were followed in the 'fifties by yet another — perhaps last — New York movement, this time with Johns and Rauschenberg in the vanguard.

In the early years, when Stieglitz was most active as a promoter of modern painting, it was difficult for painters to work outside of New York City. Sheeler, sharing a studio with Morton Schamberg, was isolated in Philadelphia and Bucks County during the 'teens, and he wrote that life there "seemed much like being shipwrecked on a deserted island." The reason was simple, as he reported it: "Whatever was happening that was stimulating and conducive to work was taking place in New York." [26] And at the center of New York was Stieglitz and his gallery. Over the years he presided over a nearly continuous conversation "about anything and everything, art, poetry, politics, life in general," [27] which aimed to reassure the initiated and to convert the newcomers. His circle included "his" painters, of course — Marin, Dove, Hartley — as well as writers, collectors, photographers, and critics. By 1918 he was close to O'Keeffe; they married in 1924, and thereafter the group seemed even more like a family with its close interrelationships. Demuth, for example, made now-famous "portraits" of Marin, Hartley, Dove, and O'Keeffe and on his death, he left his oil paintings to O'Keeffe, almost the only person who appreciated them. Dove and Alfred Maurer had worked closely together in France; Marsden Hartley wrote appreciatively of the work of Marin, O'Keeffe, and Demuth. And Dove and O'Keeffe had a special, long-lasting friendship, beginning when she saw one of his early pastels; carrying on through the 'teens, when his work apparently influenced her; and then through an additional two-and-a-half decades, when they corresponded and visited frequently. Toward the end O'Keeffe became increasingly direct in her admiration and support for Dove, and it was she who regularly hung his exhibitions at Stieglitz's last gallery, An American Place. In addition, the relationships crossed age barriers: Stieglitz encouraged younger dealers like Edith Halpert and their rising painters such as Crawford and Spencer; Stuart Davis — by the 'thirties an acknowledged master — was friendly with Arshile Gorky, who finally found himself with his great work of the 1940s, and they wrote mutually admiring articles about each other. And surely the spirit that dominated in the New York School of the

'forties, the cohesive spirit of a beleaguered avant-garde group whose aims and whose very lives meant nothing to their culture as a whole, finds precedent in the Stieglitz circle at "291" around the time of the Armory Show.

The Stieglitz painters had many areas of mutual interest, none more important than their common recognition of the photograph as valid, high art. This revolutionary acceptance again served to set the Stieglitz group apart, to isolate them, and photography itself — and particularly the important work of both Stieglitz himself and of Paul Strand — played a role as each of the painters sought his own vision and style. Stieglitz's New York gallery, after all, had opened in 1905 as "The Gallery of the Photo-Secession" and was devoted exclusively to photography at the start. Paintings, drawings, and prints had virtually taken over the exhibition schedule by 1910, interrupted only by occasional shows of Stieglitz and Strand. However, the importance of photography for the Stieglitz circle is greater and more lasting than this would indicate. For one thing, the full story of the Stieglitz-O'Keeffe relationship has yet to be told, though one suspects his work in photography played a significant role as she developed her own special way of seeing. Similarly, the Stieglitz-Sheeler relationship, both personal and artistic, needs investigation; they were two of the supreme photographers of their respective ages, and Sheeler is totally unique in developing a distinct and surely equal creativity in the more traditional mediums of drawing and painting. And even Dove, whose pictures seem so un-photographic, was highly aware of the medium; in 1922 he wrote an article defending photography as true art, and two of the Stieglitz *Equivalent* photographs, studies of clouds, always hung in his studio.

The Stieglitz painters were also drawn together by their own special literary qualities — not that their work is "literary" in subject matter, but rather that they, as a group, were highly aware of American writing, both past and present, and many were also articulate authors themselves. Earlier generations of American painters and writers did not generally travel in the same circle, though there are some important exceptions from the early nineteenth century, such as Washington Allston's friendship with Samuel Taylor Coleridge, or the group of "Knickerbocker" writers and painters friendly with Thomas Cole and William Cullen Bryant in New York. The avant-garde, leftist band in New York gathered around Stieglitz and the poet William Carlos Williams (1883-1963) was made up of painters and writers who formed a cohesive group that stood at the forefront of American culture. Stieglitz always drew admirers of all kinds, for he talked with everyone, searching, educating, probing for truth. In 1934 a remarkable volume entitled *America and Alfred Stieglitz* was prepared as a tribute to him; it was edited by five distinguished figures, including Waldo Frank (a self-described "social revolutionary" who was an important and prolific novelist), Lewis Mumford (without doubt the central cultural and architectural critic of the era, whose book *The Brown Decades* [1931] remains a key study of ante-bellum art), the sympathetic art critic Paul Rosenfeld, and Dorothy Norman (an editor and photographer who was a long-time friend of Stieglitz). These writers were unabashed admirers of Stieglitz and the artists, and many others of equal distinction were also in close contact with the painters. The pattern had been established in the early years, when Stieglitz was corresponding with Gertrude Stein

in Paris, and when Weber, Dove, Sheeler, and many other temporary members of the Stein circle gained contact with latest Paris styles in both art and literature. Later, William Carlos Williams played something of a central role, for his objectivist poetry corresponds in some ways to the objective, abstracted paintings that were being made. Williams had a lifelong friendship with Sheeler and admired his work for its "bewildering directness"; he also had a long friendship with Hartley and was particularly close to Demuth. Williams himself, of course, was the subject of Demuth's best-known "portrait," *I Saw the Figure 5 in Gold* (1928; Metropolitan Museum of Art); Demuth also "did" writers Eugene O'Neill (see no. 56), Gertrude Stein, and apparently Wallace Stevens, as well as his painter-friends. [28]

Painters of the Stieglitz circle felt drawn to earlier American writers, to the Transcendentalists and especially to Walt Whitman. They looked to Whitman as their spiritual predecessor and, in the process, they began to think and write in ways that echo Whitman. In *Leaves of Grass* Whitman wrote:

> *I heard you ask'd for something to prove this puzzle the New World,*
> *And to define America, her athletic Democracy,*
> *Therefore, I send you my poems that you behold in them what you wanted.*

Although there are Whitmanesque aspects to the work of both Winslow Homer and Thomas Eakins, both were, in the end, isolated, pessimistic figures, and neither felt big enough to sing of democracy, "to define America." Stieglitz and the painters around him took on a new attitude, one of confidence, despite their isolation in the midst of plenty, despite the difficulties of painting here, and, as Whitman's heirs, they dreamed that their work would speak of America, to America.

In 1921 Stieglitz made his famous autobiographical statement: "I was born in Hoboken. I am an American. Photography is my passion. The search for Truth is my obsession." [29] One almost hears his sonorous tones. In four short sentences, which read like poetry, we have the fact of his ordinary birthplace, which recalls our democratic system (elsewhere he wrote: "my teachers have been life — work — continuous experiment . . . Anyone can build on their experience with means available to all."); then his statement of nationality, made proudly; his profession, art — also as his passsion — which gives meaning to his life; and finally his constant search for Truth — the special mission and the unique ability of the poet and the artist. Stieglitz and Sheeler and Dove, like Whitman, also found Truth in fact — fact examined and dissected (as Dove spoke about examining the colors of a butterfly's wing) — fact that becomes universal. As Whitman said:

> *If you would understand me go to the heights on water-shore,*
> *The nearest gnat is an explanation and a drop on the motion of waves a key,*
> *The maul the oar and the handsaw second my words.*

In his bold little book *Adventures in the Arts* of 1921, Marsden Hartley wrote about Ryder, Homer, and Arthur B. Davies, Emily Dickinson and Henry James, the French painters Henri Rousseau and Odilon Redon, about "Dada" and the nobility of the "Red Man." Hartley was writer, painter, and critic. His most telling chapter is called "Whitman and Cézanne": here he cut through the differences of nationality and medium to a common search for "living-ness" in things, for their universality, "the

breathing of all things, the urge outward of all life toward the light . . . ." [30]

He found Whitman and Cézanne to have the same rank: "They have done more, these modern pioneers, for the liberation of the artists, and for the 'freeing' of painting and poetry than any other men of modern time." Hartley saw the modern American artist as truly free for the first time — free to learn from French style, free to identify with Whitman's spirit, free finally to paint America as the great poet sang it.

Stieglitz and Hartley were not alone in their ability as writers, for theirs was in fact the first truly eloquent generation of American painters. The earlier romantics Washington Allston and Thomas Cole were able enough writers, but the modern group spoke with a profound and measured voice. Marin proclaimed of his work and of Maine with a rich, poetic tone, while Sheeler in his *Autobiography* wrote less pretentiously, with prose that is clear and fine. Man Ray wrote about himself and Hans Hofmann wrote about the nature of art; George L.K. Morris was a frequent explicator of the abstract, and Ben Shahn's *Shape of Content* is a moving essay on the arts (wherein he showed a special sympathy toward Eakins). Stuart Davis played an active role in art politics of the 'thirties and his essays are direct, thoughtful expositions of the modern stance. He was also the most profoundly theoretical painter of a theoretically minded generation, and he left behind an enormous "internal monologue" of over ten thousand pages of unpublished notes and journals. John R. Lane has brought the importance of this work to our attention, but the problem of fully deciphering Davis's elusive system remains for the future. [31]

Of course, there was only one truly important subject for these painters, and they dealt with it in conversation, in their writings — in a sense, in every painting or drawing — this was the question of their integrity and their survival. Stieglitz spoke for generations of American painters when he wrote Gertrude Stein in November of 1913: "Times are terrifically hard over here . . . . There is no real feeling for art, or love for art, in the United States as yet. It is still considered a great luxury: something which is really not necessary." [32] Slowly, things improved over Stieglitz's lifetime. By the 'twenties both Marin and O'Keeffe — two of the painters in whom he believed most strongly — were selling, and American attitudes were beginning to evolve. (Stieglitz regarded Dove as highly, but saw him as consistently so far ahead of his time that any widespread appreciation was simply out of the question.) The artists themselves constantly questioned their own identities, and their worth. In 1921 Hartley could ask, "Why is there no art in America? ", [33] and he expressed only mild optimism that there would ever be one. By 1930, Stuart Davis wrote a now well-known letter to the critic Henry McBride on the question of Americanness; looking to Copley, Eakins, and Ryder, he asked rhetorically, "Has any American artist created a style which was unique in painting, completely divorced from European models? " and he answered, "No." Defending himself, he defended his generation as well: "I insist that I am as American as any other American painter . . . . While I admit the foreign influence I strongly deny speaking their language." [34] The *Times* critic Edwin Alden Jewell entitled his book of 1939 *Have We an American Art?*, and found us only at "our dawn of promise." [35] However the critic Elizabeth McCausland, who wrote superbly on such nineteenth-century painters as George Inness and E.L.

Henry, as well as on the moderns Hartley and Maurer, suggested (in her essay "Stieglitz and the American Tradition") that "Stieglitz derives from the American tradition, he exemplifies the American character"; she traced his "integrity of spirit" to Emerson and Whitman, and saw that it existed equally in Marin, Dove, and O'Keeffe. [36]

In her essay on Stieglitz, McCausland also observed: "Romanticism has dominated the American scene and the American mind . . . ." She saw no essential distinction here between painting in the nineteenth and the twentieth centuries. With this key, and with the artists' own statements about themselves and their aspirations, we begin to see how badly they have been misread. Sheeler has been seen simply as photographic, as a celebrator of industrial America; O'Keeffe as cold and contrived; Hartley as unfulfilled; Dove as an early modernist who "failed" because he never reached either Dada or pure abstraction. Their urban themes have been seen only to "present a hard-edged invincible utopia." [37] Actually these painters, making use of a new way of looking, worked directly in the American romantic tradition. Americans have never much cared for realism in their art, as witness the public rejection of David G. Blythe in his time and Thomas Eakins in his. We have wanted our paintings to portray our ideals and our dreams, but within a pragmatic, concrete framework. American art has not been style-less, but it has been restrained and essentially conservative. We have responded to the resonant, close harmonies of Inness's greens, Heade's greens and grays, Lane's violets — colors that are fragile, ephemeral, hard even to describe — and we find the same delicate harmonies, the same definite, light brushwork in the works of Sheeler and Dove and their contemporaries.

O'Keeffe, more than any other American, establishes her own terms, and she never allows a slip. Paintings that do not satisfy her rigorous standards are destroyed. Biographers and critics are subjected to the artist's own iconic image. Most of the writing on her painting is either hers or stems from her, and she has been as careful in presenting her own verbal images as she is in making pictorial ones. Her own writing is simple, direct, and completely captivating; she writes as an icon — and a Stieglitz product — should. As Sanford Schwartz writes, her "every sentence seems to have been held up to the light, and tapped for soundness." [38] She takes herself and her work completely seriously; she speaks eloquently of herself and her art, while revealing nothing.

O'Keeffe's paintings are about the American land. She sees it as mythic, powerful, clearly wrought. Her style was established by the late 'teens and early 'twenties, as seen in *Lightning at Sea* (no. 58): already she was painting the real force of nature as one with the abstracted sexual forms of the human body. Her contemporaries knew well that she was a portrayer of passion, of sensuality: Rosenfeld spoke of her "fiery passion . . . with safeguarding purity of edge." [39] But her vision was instinctual, rather than intellectual: she simply painted things the way she saw them, and she planned no conscious symbolism. Her evocative flowers look back to Heade's; she had never known of his work, though she reached the same place, through the same forces. Her paintings are neither realistic, nor surreal, nor imaginary. She takes the

21

commonplace — the white flower, the barn near Lake George, the skull in the desert, the simple door in a New Mexico patio — and raises it, changes its scale, makes of it an image. She paints boldly, seizing on a tiny piece of wood, magnifying it into a great fiery icon against an end-of-the-world yellow sky. Her paintings are transcendental, they regard the earth as holy; they speak religiously. O'Keeffe's subjects are the essential ones, they are Whitman's — love, death, the flowering of life, the search for symbol. She paints crosses in the wilderness, like Cole and Church: her animal skulls become symbols of martyrdom. She paints the barn and the church equally, as places of sustenance; but the holiest and most private place of all, her own walled patio, she makes into a public icon, just as Stieglitz's photographs made her own body a public possession.

Stieglitz made the metaphorical comment: "When I make a picture, I make love." [40] His own series of photographs of O'Keeffe are purely sensual: surely, in making them, he was making a kind of love to her. And O'Keeffe's work is no less evocative: from the direct sexual imagery of *Lightning at Sea* (no. 58) to the almost equally explicit flowers, even in the barns and skulls, one feels woman painting herself. Her contemporaries knew what she was doing: Hartley saw her paintings as "living and shameless private documents," and he admired her both for her toughness and for her "unqualified nakedness of statement." [41] And Paul Rosenfeld saw in Hartley's own work "large phallic shapes". He went on to say, "As men have done in all baroque ages . . . so Hartley too, in his, stresses in what he shapes the sexual interests of the mind;" he rationalized this by looking to the American past, and found Hartley's search "not really different from that . . . of the men of the older American school." [42] Of course their much admired hero, Whitman, was the sensualist above all, "singing the body electric" as he listed fact after fact, image after image, more open in his lustfulness than anyone in his time or for many decades to come.

The paintings of Arthur G. Dove are even more closely tied to the land and to the American tradition than O'Keeffe's, yet they are also somehow more advanced and more modern than hers. Her style becomes relatively static after 1930, while his shows a constant, orderly growth brought on by his constant experiments with medium, color, and form, and by his willingness to take chances. He hit upon his "breeder idea," his discovery of an underlying order in nature, his own special way of seeing and depicting things, very early — it was apparent in the pastels of 1911 — but he was never satisfied; working within his basic mode, he felt a need always to search for new means of expression. For forty years he simply went about painting, exploring new ideas without giving himself away, surviving and reaching greatness in a difficult time, with minimal support or understanding. In Dove the man there is great matter-of-factness. One feels a straightness to him, a modesty and a stability that are belied by the large scope of the paintings, by their poetry, their passion, and their color.

The critic Paul Rosenfeld recognized his stature near the start of his career, and he associated him immediately with Whitman in saying, "Dove begins a sort of 'Leaves of Grass' through pigment." [43] Whereas O'Keeffe painted the land and its objects as symbol, from above, Dove celebrated the earth and painted her natural forms from within, as living organisms. He was a landscapist from the beginning, his temperament

akin to that of the early Thomas Cole, who identified with nature, exulting in his own fear and excitement as a sudden storm swept across his path. Dove is widely credited with making purely abstract paintings by 1910 or 1911, thus ranking with Kandinsky as a modern pioneer. But Dove virtually never stepped over the boundary between observed nature and truly nonobjective painting: his works always begin with observation of fact and place, and the series called "Abstractions No. 1-6" of 1910 very clearly represent shorthand notations for a church in a landscape, trees with a pond, a white building in a field, and so on. Here, as elsewhere, he was not a European painter but an American and, as such, he sometimes disappointed the critics. Thus, in the 'twenties, living on his boat and restricted by limited space and money to the use of simple, findable materials, Dove made a series of highly inventive collages and constructions. Two of the best known are *Huntington Harbor I* (1926; Phillips Collection) and *Long Island* (1925; Museum of Fine Arts, Boston); in the former he used sand, canvas, wood, and paint; in the latter, twigs, sand, mussel shells, autumn leaves, and a cutout paper car — the most "advanced" found materials — but he used them to make landscape, and only landscape: here there is simply none of the biting humor, the satire, the transformation of materials that characterizes European cubism and Dada. These collages are "naive" in the sense that all American art is naive: in them their creator professes the simple belief that art comes from the land, and that a picture should be beautiful. Even Man Ray, in his most Duchampian works, never quite escaped his Americanness — his ultimate desire to make the work of art decorative and appealing, to give it some referential basis. Dove indulged in whimsy but no more; there is no caricature, no comment, no bitterness in him, or indeed in almost any American painter before the 1950s.

Dove's work of the 'twenties, whether in pure oil — a rare medium for him in this decade — or using common, "non-artistic" materials, is highly inventive. His vision was idiosyncratic, and his mind was curious and probing. The images can be calm and sensuous, as in *Clouds* (no. 12) — a study of the sky's dark rhythms, an homage to Ryder — and in *The Sea I* (no. 11), an extraordinary "collage" wherein image again far surpasses the artist's materials; in the latter one recalls the subtlest nighttime marines of a Heade or a Lane. Even here, stretching gauze over sheet metal, pasting on a paper moon, there is no sense of the artist's hand — only a perfect silvery image.

At the same time, Dove was creating livelier but no less original pictures. The angular forms of his *Outboard Motor* (no. 13) take on a somewhat human look — a kind of humorous anthropomorphism carried to greater extremes in some of the Phillips Collection pictures, such as *Life Goes On* ( (1934). An equal inventiveness, with even greater energy, is found in Dove's "musical" pictures of the 'twenties, of which the best known are *George Gershwin, Rhapsody in Blue Part I* (1927; Private Collection) and *George Gershwin — I'll Build a Stairway to Paradise* of the same year (no. 14).

The correlations between music and art — their similarities of structure, sensuality, and even terminology — were very much on the mind of this generation of painters. Stieglitz had given Dove a copy of Kandinsky's book *Concerning the Spiritual in Art* (1911); there Kandinsky discussed Debussy and Schönberg, among others, conclud-

ing that "the various arts of today learn from each other and often resemble each other." [44] He reported that music was the teacher for painters, as it had long been "the art which has devoted itself not to the reproduction of natural phenomena, but rather to the expression of the artist's soul . . . ." The methods of music, indeed, could be applied to painting, for those artists seeking "for rhythm in painting, for mathematical, abstract construction, for repeated notes of color, for setting color in motion." [45]

Dove himself echoed these thoughts in his own words, in a letter to Samuel Kootz; speaking of his own maturing style, he reported, "Then there was the search for a means of expression which did not depend upon representation. It should have order, size, intensity, spirit, nearer to the music of the eye." [46] Beginning in the twenties, Dove's work became musical in several senses. For one thing, there were the several paintings that he dedicated to Gershwin. In *Rhapsody in Blue* he attached a real wire spring to the picture surface, while in *Stairway to Paradise* he repeated the same image purely in paint on the right side of the composition. The falling black and silver forms here seem like musical notes: they're close to the flake-like shapes that Kandinsky used to illustrate "Bassoon" in his book of 1912, *Sounds*. Dove's use of reds, black, and silver with a more subtly graded pink to the left and gray to the right give the whole composition a definite jazzy look — not surprising in view of the fact that he played the popular Gershwin tune over and over again on his phonograph while making the picture, consciously experimenting to see what effect this would have on his work. [47]

There is no way of knowing how extensively Dove had read Kandinsky, or what works he had seen, and in a sense it's not important, for musical correlations were widespread at the time. Feininger, for example, identified with "the architectonic side of Bach, whereby the germinal idea is developed into a huge polyphonic form . . .," and he wrote: "I consider my drawings and sketches as melodies, the completed paintings, organized and orchestrated in color, like a large-scale composition for the organ and orchestra." [48] Interestingly, Dove wrote of the same composer in a comparison of Bach, John Marin, and the painter Paul Klee, concluding: "I sometimes wonder whether these three are not grounded on the same love. One [Bach] in his own realm of sound, one [Marin] in his own sensation of space, and one [Klee] in a colored measurement of life trying to combine the other two." [49] Dove himself was musically oriented: he had a fine ear and a good singing voice, and he listened to music frequently, his taste ranging from popular tunes to classical, with a special love for Bach.

Many of Dove's paintings not only convey sounds of various kinds, from the falling notes of *Stairway to Paradise* and the snapping winter quiet of *Snow Thaw* (1930; Phillips Collection) to the resonant hoots of the well-known *Fog Horns* (1929; Colorado Springs Fine Arts Center); they are also painted with a musician's sense of structure. The painter's tools are shapes and colors, and Dove handles these as clearly and carefully as a musician would. In *Sunrise I* (no. 18), for example, Dove works in triads, or threes, as he often does — like a composer using three-quarter time. He employs only three hues, the primaries of red, yellow, and blue (here his pigments are rose madder, Naples yellow, and ultramarine blue), though by the time

the colors are mixed with each other and with black and white they become wholly transformed. The major theme is the orange sun, which is surrounded by two sets of three concentric circles: the first includes light orange, lighter orange, then a white-orange, and the second set reverses and enlarges the same theme, the circles now going from a light brown that recalls the central orange, followed by a flat gray-blue, and then by a richer, dark blue. Then a second theme is introduced, with the phallic form to the left, its blue head repeating the dark blue color; it is echoed and reinforced by the blue dot to the right, with its meandering (umbilical?) cord of light green. This, again, is one of three minor colors making up the background of the composition, the others being a medium olive-green below and a blue-green above. Dove works with discernible brushstrokes in parallel bands, each stroke like a note, each subtly different from the one beside it.

*Sunrise I* is relatively simple in composition, technique, and color, but the musical pattern it suggests can be found in every mature work of the artist. *Motor Boat* (no. 20), *Neighborly Attempt at Murder* (no. 24), and many others are similarly made, based as they are on a series of three-part variations, and these are far more complex. As in many of Dove's works, there is a rhythm and order to their construction that parallels musical technique. Dove spoke of "practicing scales" [50] as he worked on a picture and, though he was well read and surely knew the writings of Klee, Kandinsky, Eddy, and others on this subject, it is impossible to know whether he consciously emulated musical practice in his painting.

Though Dove wrote very little about his technique or about theory, certain definite conclusions can be drawn. For one, he was a superb colorist: he mixed all his colors himself, and his work demonstrates both his keen intuition for the emotive properties of color and a thorough grounding in traditional color theory. His paintings of the 'thirties are particularly subtle and complex coloristically: frequently he achieves an astonishing range of blues and greens, grays, and browns. In this decade his colors are from the earth, they are somber and muted, and the works themselves seem to be about organic process, about birth and decay, about the meaning of a sunrise or the flowering of a plant. He worked within a limited range of hues and limited intensity as well; there are no sharp contrasts, but each color and each shape varies a little from the one next to it, and informs it. Frequently working within a range of greens — the "most difficult" hue, according to many theorists — he recalls both the color and the mood of the mature landscapes of George Inness, which are, themselves, so much about color and about nature's potentialities.

More is known about Dove's study of technique, for his son William Dove has, fortunately, retained his father's hand-ground colors and his books on the subject. Among others, he owned *The Book of Art of Cennino Cennini* (London, 1899), Max Doerner's *The Materials of the Artist and their Use in Painting* (1934), Hilaire Hiler's *Notes on the Technique of Painting* (1935), and Ralph Mayer's *Artist's Handbook of Materials and Techniques* (1940) — the publication dates alone suggesting his continuous, ongoing inquiry into the nature of painting. In the front of Doerner is pasted a copy of the Harvard theoretician Denman W. Ross's influential color theory diagram, though according to his son, Dove had major reservations about it. [51] The passages that Dove marked up most extensively deal with the use of tempera

grounds and wax emulsions and the varying optical effects of waxes and of different varnishes. Shortly after acquiring the Doerner book, around 1935, he began his unfortunately short-lived practice of keeping a record of the materials — pigments, ground, canvas, and varnish — he used in each painting. At the same time he began to experiment increasingly with wax emulsions, apparently inspired by reading Doerner. In a much-thumbed section, Doerner described the mixture of resin oils with wax as producing "a misty, pleasingly dull and mat appearance, and great brightness and clarity"; [52] an excellent recent study speculates that this description "which actually fits so many of Dove's paintings [may have] piqued his curiosity to try this medium." [53] Dove had always experimented with different finishes, as is evident in his use of silver paint in the "propellers" in *Outboard Motor* of 1927 (no. 13), but his experiments now become more regularized and more complex. The paintings of the late 'thirties show increasing attention to surface — as in *Sunrise I,* with its matte areas contrasting with the deep, almost shiny, blue circle — and this concern for surface and tone intensifies in the early 'forties in such paintings as *Evening Blue* of 1941 (no. 25) and *Square on the Pond* of 1942 (no. 26). All this is perfectly in keeping, once again, with our native painters' traditional approach to surface: Dove carried on Copley's concern for textures and Eakins's interest in crafting the areas of a painting so that each one has its own feel, its own way of reflecting light.

Dove was a landscapist in the American tradition. But rather than recording the scene as he saw it (like the more literal-minded members of the Hudson River School), he painted the spirit of a place as recorded in his mind's eye. He painted not objects and icons, like his friend O'Keeffe, but rather nature herself as he witnessed it — her potentiality, her growth, her warmth; he portrayed the movement of clouds and water, the pulsing force of sunrise and of the moon, of trees bending to the wind, all as pure form. His landscapes came from visual memory and from private emotion, as they did for Heade or Ryder; never traveling to see great sights, he found extraordinary views all about him and within himself.

Dove's method was like that of the nineteenth-century landscapists, for he sketched extensively from nature while walking, sailing, or, later, being driven around in his automobile. In a given year he might make two hundred or more tiny watercolor sketches, all based on observation. Back in the studio he would select a few to make into finished paintings. Such studies exist for a number of the Lane Collection pictures, and in general the painting is nearly identical to the sketch. Even late pictures that approach pure abstraction, such as *Evening Blue* (no. 25), *That Red One* (no. 30), or *Roof Tops* (no. 27) closely follow these quick notations made from nature. Dove's gifted vision simply enabled him to see the things around him — the sunsets, buildings, storms, and boats — in terms of a few simple shapes and colors. His statement to Samuel Kootz suggests that he was conscious of his gift: "Feeling that the 'first flash' of an idea gives its most vivid sensation, I am at present in some of the paintings trying to put down the spirit of the idea as it comes out. To sense the 'pitch' of an idea as one would a bell." [54]

Dove took risks, but he left nothing to chance. Looking at his paintings, one might guess that their lyrical, evocative forms and colors are the result of improvisation and pure instinct, but this would be a total misconception. Dove was surely a poet in

paint; he indeed accomplished a "Leaves of Grass" in pigment, and he did so with all the craft and precision, all the inventiveness, all the technical knowledge and pure love for his materials that Whitman had.

Charles Sheeler's work, like that of Dove and the others, has been much misunderstood: it has been seen as cold and objective; as simplistic, uncolored, Cubist; he has been judged solely an industrial painter and, as such, the celebrator of America's factories and mills. These errors are understandable in a sense, for Sheeler's art requires harder looking than almost any other American's; his underlying sensuality of tone, the subtlety and strength of construction, and the real meaning of his work are elusive indeed.

Sheeler did not seek icon, like O'Keeffe, nor nature's underlying form, like Dove; instead he sought image — image that speaks a formal language only, is dead-pan and carries no obvious symbolism. He descended not from the history of American landscape, like Dove and O'Keeffe, but rather from the still-life tradition. He was the finder rather than the synthesizer. He was the picture-maker extraordinary, whether holding a camera, a brush, or a crayon. And he carried on the search with perhaps the purest pictorial eye that we have known in America. Constance Rourke early recognized Sheeler's gift: "Design seems a latent order which he has revealed rather than something that has been superimposed." [55] Moreover, Sheeler himself was perfectly clear about what he was doing; his basic source, he reported, was "the visual world." Then, he said, "I try to arrive at an organization of forms which represent my equivalent of the organization I see around me in nature. There I stop without trying to give expression to any hid or underlying meanings." [56] He was incapable of Cubism, though he certainly understood its implications, for he was the American always, seeking beauty in form. He circled the subject, seeking a picture, hoping to find the right combination of abstract form in the purest reality, just as Heade wandered through the anonymous marshes seeking the right combination of receding haystacks and winding river. He was drawn to industrial sites for their beauty, no more and no less; thus he admired modern bridges because "they are efficiently designed for their function," and, crucially, because "they are invariably beautiful without the separate consideration of Beauty being imposed on them." [57]

In all of Sheeler's work there is a basic tension, an underlying anomaly: in his words, "I had come to feel that a picture could have incorporated in it the structural design implied in abstraction and be presented in a wholly realistic manner." [58] Dove's work is also abstract and realistic, but it is one and then the other: in *Motor Boat* (no. 20), one's eye alternates, seeing just pure color and form, then a recognizable scene. Sheeler did something else: he realized both aims simultaneously. Through his arduous selection process, through his eye, reality becomes abstraction and abstraction reality.

Sheeler's style was formed in the mid-'teens, at about the same time as O'Keeffe's. He executed the small well-known *Landscape* (no. 42) in 1915, with an eye still on his European teachers, in a style that combines the vision of Cézanne's watercolors with some of the method of analytical Cubism. About the same year, his own special vision is seen for the first time in his photographs of the interior of his Bucks County

house. Using bright lights on the vertical posts and horizontal stair risers, he made solid American reality into black-and-white abstraction, into modern American art. Two years later he took an ever firmer step in the seminal black-and-white drawing entitled *Barn Abstraction* (Philadelphia Museum of Art, the gift of Sheeler's friend Walter Arensberg), and a few years thereafter he was accomplishing the same thing in his paintings.

Sheeler's work refers to the American tradition in many ways. Like Heade in the marshes or Church in the Andes, he knew beforehand what the subject was going to look like: it was simply a matter of finding it. There's a consistent vision to his work — a way of composing, a way of seeing — throughout his life. The diagonal beams, the steep, unrealizable angles, the flattening of form that occur in *Newhaven* (no. 46) are found in *New England Irrelevancies* (no. 52), painted twenty-one years later. One could lay an outline of one painting over the other and find essentially the same pattern. And it makes no difference what his medium was: the same strong forms, the same subtle values are found in the paintings, the drawings, and the photographs.

Sheeler's concern was with form, but not with place. His new house in Ridgefield, Connecticut (in no. 46), served his interests as well as the earlier one in Bucks County, Pennsylvania. He painted landscape and still life, but they were the same for him. Apples can be rounded and forbidding in one picture (no. 43), flattened and decorative in another (no. 44). The branches of flowering forsythia in *Spring Interior* (no. 45) are painted not for their springlike mood, not for their symbolism, but as carriers of color and form; they're strictly a foil against which are played the stairs and fireplace behind. Sheeler often employed a surprising element of form or color that gives the viewer a slight jolt and reminds him that a painter is at work: we see this in the intense blue form on the right side of *Lunenburg* (no. 54), or in the whimsical curvilinear canal or river in *New England Irrelevancies* (no. 52). Sheeler's pictures are based on reality, but they're also irrational; in his flattened spaces there is always an element of mystery, of the unknowable. In *Begonias* (no. 53), three pots of common houseplants make up the nominal subject, but Sheeler's real concern is the undefinable — a meandering white cord, the strange niche, the lack of stems, a floating, transparent third pot. Here, or in architectural pictures such as *Lunenburg,* we are likely to think of the photographic double exposure, given his interest in the sister medium. But more telling is Sheeler's own explanation of his intention: "When we look at any object in nature we inevitably carry over a memory of the object we have just previously seen." Reporting his own discovery of the subconscious, he concludes: "Since then I have endeavoured to combine the memory and the present in a given painting." [59] This describes Sheeler and American painting: the memory and the present — the memory of Gothic cathedrals, the present of mill and factory; the memory of Shaker crafts, the reality of earning a living as a museum photographer; the memory of a rural past, seen in the surviving but irrelevant empty barns.

Sheeler's work has been thought cold and colorless, though, in fact, it pulses with the subtlest tones. Strangely, even he was defensive when challenged about his color, saying: "Am I a colorist? If you want to look at it in one way, I am not. Values undoubtedly come first with me . . . ." [60] He was not a bravura colorist, not a

Hofmann or a Stuart Davis, and his interest did lie in the close study of value and tone, in subtle changes rather than grandiose effect. To see *New England Irrelevancies* together with *Ore into Iron* (no. 51), however, is to see a great colorist at work. These paintings hum with resonant tones; they are small symphonies of varying hues and values. The palette in each is identical — lavenders and pale gray-pinks dominate, echoed by earthy browns and yellows, tempered by patches of blue and white — not the colors of present, of mills and tanks, but the colors of memory, the tender hues of American romanticism. One painting is linear, vertical, reticent — classical perhaps; one is curvilinear, voluptuous, baroque. Showing the two sides of Sheeler, they show the two sides of man.

Neither Dove nor O'Keeffe, surprisingly, had much apparent influence on younger painters, but Sheeler's work did affect a number of other artists, notably Niles Spencer and Ralston Crawford. These two were friends, and each admired Sheeler; though their work was occasionally exhibited together with his, neither man was simply a Sheeler imitator. Spencer was closest to him; he painted still-life and urban landscape with an increasing tendency toward abstraction, as Sheeler had. But the paintings themselves are very different. For one thing, Spencer worked all his life within a limited, somber range of earth colors, with browns, brick reds, and gray-greens dominating. His pictures are somber and carefully wrought, they're dense and obdurate. If it seems inaccurate to type Sheeler as "Precisionist," an artist who celebrates the urban and industrial scene, then such terms become ludicrous applied to Spencer. His paintings seem more pessimistic than optimistic: they portray places with no sign of human life, without sunlight or motion or sound. *Near New London* (no. 70) is typical Spencer in its craftsmanship, its carefully balanced colors, its overall grayness. It seems contructed out of blocks rather than painted. Yet the artist is careful, indeed, with form and space: once in the painting, there is no place to go; the eye slides just to the right and then the left, with blank walls and slightly skewed perspective adding to a sense of repeated emptiness.

Crawford's mentality was quite different. Though his spaces are no more populated than Spencer's, they are easier of entry: his colors are brighter and more intense, with sharp value contrasts, and he frequently painted bright sunlight and shadow. Real light seems impossible for Spencer, whereas Crawford's pictures are often *about* light — which seems appropriate given his parallel interest in photography. Traveling to New Orleans in the 'fifties, Crawford visited the same cemeteries that had drawn Edward Weston's attention in 1941, and some of the same motifs around the stacked outdoor graves appealed to both. Thus, Weston's photographs show small bottles and canisters holding flowers, which were attached to the graves, and these appear in magnified and abstracted form in both of Crawford's New Orleans paintings in the Lane Collection (nos. 91 and 92).

Stuart Davis has rightly been called "almost the only American painter of the 20th century whose works have transcended every change in style, movement, or fashion."[61] There can be no question of his stature, but there is widespread debate about the meaning of his painting. Some have thought his work to be especially American and others have seen it as much influenced by French art; he has been judged a pioneer and a latecomer; a realist and an abstractionist; a natural colorist

and a brilliant theorist; the last of the older generation and an influential link to key later movements, including Abstract Expressionism and Pop. Anomalously, there is truth in each of these views.

In many ways Davis comes from the American tradition and is kin to Sheeler and Dove. His paintings begin with nature, like theirs: "I always start with something I have just seen, remembered music, or something that is immediately in front of me, or something I read." [62] His style was discrete: as early as 1922, as if already opposing the style that Pollock and Kline developed in the 'forties, he said that a painting "should first of all be impersonal . . . not a seismographic chart of the nervous system at the time of execution." [63] Proud of Americanness ("I am an American . . . . I studied art in America. I paint what I see in America . . . ."), he nonetheless defended his knowledge of European style: "I don't want people to copy Matisse or Picasso, although it is entirely proper to admit their influence." And he correctly said, "I don't make paintings like theirs. I make paintings like mine." [64] Like many of the best American painters, including Homer and Eakins, he left no followers and had little apparent effect on younger artists. Like them, he was in a sense stylistically conservative at the time (during the 1940s and '50s) that he produced his best work. With Davis, as with so much of American art, the notion of an avant-garde, or even of a stylistic mainstream, seems not very useful, and may muddy more important inquiries.

Davis's work had integrity from the beginning, however much he acknowledged the lead of other painters. *Portrait of a Man* (no. 74) resembles the work of Shinn and the other illustrators whom he knew, but it's already also Davis himself; one can see it in his interest in numbers and letters as symbols, and in the flattening of space, all of which signal his abstract way of looking at reality. Davis advanced slowly; in the years just after the Armory Show, when Dove, O'Keeffe, and Sheeler all found their mature styles, he struggled slowly to work out the answers on his own. *Gloucester Street* (1916; no. 75) shows him turning still toward the Eight, while in the early 'twenties, with *ITLKSEZ* (1921; no. 77) and *Apples and Jug* (1923; no. 78), he had clearly found Picasso and Léger. These paintings must not be dismissed: Davis was still himself while working with the French idiom. *Apples and Jug,* especially, foretells his future direction with its use of a few, bold colors — yellow, orange, and two shades of green, together with black, white, and gray. This limitation of palette, the emphasis on still life dominated by four or five major forms, the strong use of black and white — all are departures from French cubism and all describe his own way of picture-making.

Davis's own mature style blossomed in 1927 and 1928 with the "Egg Beater" series (see no. 80), interestingly, made just months before the artist's first and only trip to Paris. Here he set up a still-life composition and then abstracted beyond any recognition both the observed forms and the space that contained them. These are not nonobjective paintings like those of Mondrian or George L.K. Morris but, rather, are extensions of American experience with still life and landscape. As Davis pointed out so often, the underlying structure of *all* paintings is abstraction of form and color, and he simply painted structure. In 1940, after doing relatively little painting in the 'thirties, he achieved his first completely realized pictures in a handful of

masterpieces including *Report from Rockport* (Lowenthal Collection) and the superlative *Hot Still-Scape for Six Colors — 7th Avenue Style* (1940; no. 82). These paintings burst with the same kind of physical and spatial energy as the work of Pollock and de Kooning a few years later, and they have even greater coloristic impact. Davis responded to the same cultural needs as the Abstract Expressionists, and he produced results parallel to theirs — the distinction being one of style. He pushed traditional American style — its linearity, its reticence of paint-handling, its grounding in nature — as far as it could go and he made of it an enormously powerful idiom.

Davis's little painting entitled *Eye Level* (no. 83), dating from the early 'fifties, explodes with color and energy: it's rawer, more colorful, and more direct than anything by Léger, the French master with whom Davis has been compared. Davis's paintings, like Dove's, seem unplanned and simple, though each is, in fact, a sophisticated essay on color theory. *Eye Level* makes use of a triad of primaries — red, yellow, and blue — but its intensity rests on what colorists call the "harmony of split complements"; here, the blue is contrasted with its complement (or opposite), orange, *and* with the hues on each side of orange, the very intense yellow-orange of the background and the red (tending to orange) of the central form. Use of high-intensity primaries gives the painting its power, as well as a primitive directness.

Quite different is his *Medium Still Life* (no. 84). Its sophisticated, refined effect results from harmonic use of a triad of tertiary colors — yellow-orange, dark blue-green, and an intense red-violet — employed in combination with a pair of complementary colors, the background blue contrasted with its orange opposite, each heightening the intensity of the other. Black and white are used effectively to define form and to restrain the color reactions. As so often with Davis, the result is elegant, powerful abstraction that holds one's eye on its surface, while also recalling the basic forms of still life.

There are cultural and psychic connections between Davis and the "action painters." Despite the basic distinction of his austere surfaces and their painterly ones, there exist stylistic affinities, as in the mural-related "overallness" of their compositions and in the high emotional intensity of their work. In addition, there were personal connections that linked him both to the older Stieglitz group, many of whom he knew and exhibited with at the Downtown Gallery and elsewhere, and to the younger painters such as his friend Gorky, Pollock, and de Kooning (he and de Kooning exhibited together through the 'forties). In the later years, however, he became uncomfortable with the younger expressionist painters: as John R. Lane points out, his "commitment to a materialistic and objective approach to painting clashed with [their] subjective and subconscious content . . . ." [65] Stuart Davis may not have represented simply a conservative minority, for his own kind of content and manner reappear in still-younger hands once the short heyday of action painting is over, and one can now look back on the past twenty years of painting in America by such figures as Rauschenberg, Lichtenstein, and Indiana and find that Stuart Davis not only linked up closely with the American tradition in painting but he foretold its future style as well.

A recent critic writes perceptively that "except for Demuth . . . all the painters in the Stieglitz circle worked from landscape . . . . They weren't interested, in their art, in society, history, or personality. They were private, lyric poets of places and moods that stayed the same regardless of society — Lake George, New Mexico, the Maine coast, Marin's northern New Jersey, Dove's Long Island and his upstate New York." [66] In these subjects and in their style, the modern painters were direct descendants of the American landscape school. They trekked to New Mexico driven by the same need for subject matter, for continuity, for the picturesque, that took the Hudson River School painters to Newport and Niagara. The Stieglitz painters were no less selective than the earlier artists; like them, they painted from nature, but a nature carefully chosen and distilled. The paintings have as much to do with inner observation as with "reality." Thus, the spacious, pure paintings that O'Keeffe painted at "Ghost Ranch" looking off toward the Pedernal (nos. 63-64) give no hint of her long, losing battle, in the years after the Second World War, to keep the ranch private and unsullied: increasing numbers of tourists and vehicles were coming into her valley, the road was widened and paved, electric poles began to march across the red hills, but *her* vision remained pure. [67] Equally, Dove's extraordinary, steady growth, his ability to see nature in terms of mass and color, his intuitive sense of the magical — all these are part of the man, and they render unimportant the facts of his movements, his personal struggles, his lack of audience. Similarly, Sheeler found geometric perfection and pictorial clarity everywhere. His pictures are inventive, his images are romantic and memorable wherever he went, from the early years in Pennsylvania to the decade in New York and the later period in Connecticut. The paintings — like those of his contemporaries — deal with the American's search for a place in the land, and with the artist's fragile existence, with his need to paint romance disguised as fact, with his extraordinary inventiveness and courage.

**NOTES**

1. Paul Rosenfeld (as "Peter Minuit"), "291 Fifth Avenue," *The Seven Arts*, November 1916, p. 61.

2. William I. Homer, *Alfred Stieglitz and the American Avant-Garde* (Boston, 1977), pp. 79-80.

3. Ibid., p. 289.

4. William C. Agee, *The 1930's: Painting and Sculpture in America* (New York: Whitney Museum of American Art, 1968), p. 1.

5. Elizabeth McCausland, "Stieglitz and the American Tradition" in *America and Alfred Stieglitz*, ed. by Waldo Frank et al. (New York, 1934), p. 231.

6. George H. Roeder Jr., *Forum of Uncertainty: Confrontations with Modern Painting in Twentieth Century American Painting* (Ann Arbor, Michigan, 1980), p. 171.

7. Ibid., p. 169.

8. Ibid., p. 169.

9. Ibid., p. 105.

10. Ibid., p. 15.

11. Arthur Jerome Eddy, *Cubists and Post-Impressionism* (Chicago, 1914), p. 48.

12. Frank J. Mather, "Recent Visionaries - The Modernists," in *The American Spirit in Art* (New Haven, 1927).

13. John Wilmerding, *American Art* (London, 1976), pp. 179, 176.

14. Ibid., p. 181.

15. Samuel M. Kootz, *Modern American Painters* (Norwood, Massachusetts, 1930).

16. *The Precisionist View in American Art* (Minneapolis: Walker Art Center, 1960), essay by Martin L. Friedman, Introduction. A more recent, balanced view is found in Karen Tsujimoto, *Images of America: Precisionist Painting and Modern Photography* (San Francisco: Museum of Modern Art, 1982).

17. Kootz, op. cit., Foreword.

18. Sam Hunter, *American Art of the 20th Century* (New York, 1972), p. 73.

19. Marsden Hartley, *Adventures in the Arts* (New York, 1921), p. 41.

20. Ibid.

21. Ibid., p. 172.

22. Ibid., p. 175.

23. *Georgia O'Keeffe* (Amon Carter Museum, Fort Worth, Texas), p. 17, quoting Henry McBride, "Georgia O'Keeffe's Exhibition," New York Sun, January 14, 1933.

24. Constance Rourke, *Charles Sheeler: Artist in the American Tradition* (New York, 1938), p. 45.

25. Charles Sheeler, "Autobiography" (unpublished MS.), collection of Archives of American Art, Washington, D.C., n.p.

26. Ibid.

27. William I. Homer, op. cit., p. 78.

28. Abraham A. Davidson, "Demuth's Poster Portraits," *Artforum* 17 (November 1978), pp. 54-57.

29. Dorothy Norman, *Alfred Stieglitz: An American Seer* (New York, 1960), p. 142.

30. Hartley, op. cit., p. 33.

31. John R. Lane, *Stuart Davis: Art and Art Theory* (New York: Brooklyn Museum, 1978).

32. Norman, op. cit., p. 135.

33. Hartley, op. cit.

34. Stuart Davis, "The Place of Abstract Painting in America" (letter to Henry McBride, 1930), in *Stuart Davis*, Diane Kelder, ed. (New York, 1971).

35. Edward Alden Jewell, *Have We an American Art?* (New York, 1939), p. 206.

36. McCausland, op. cit., p. 228.

37. *The Precisionist View in American Art* (see note 16), p. 28.

38. Sanford Schwartz, *The Art Presence* (New York, 1982), p. 123.

39. Paul Rosenfeld, *Port of New York* (New York, 1924), p. 208.

40. Norman, op. cit., p. 13.

41. Hartley, op. cit., p. 116.

42. Rosenfeld, op. cit., pp. 95-96.

43. Rourke, op. cit., p. 110.

44. Wassily Kandinsky, *Concerning the Spiritual in Art* (1914; Dover ed. 1977).

45. Ibid.

46. Dove letter to Samuel Kootz, written in 1910s, quoted in Samuel Kootz, op. cit., p. 38.

47. From conversation of author with William Dove, November 7, 1982.

48. Alfred Frankenstein, "Interview with Feininger," *American Magazine of Art* 31 (May 1938), pp. 278-283.

49. Frederick S. Wight, *Arthur G. Dove* (Berkeley, 1958), p. 82.

50. Ibid., p. 38.

51. From conversation of author with William Dove, August 1982.

52. Max Doerner, *The Materials of the Artist and Their Use in Painting* (New York, 1934), p. 154.

53. Justine S. Wimsatt, *"Wax Emulsion, Tempera or Oil? Arthur Dove's Materials, Techniques and Surface Effects,"* American Institute for Conservation of Historical Artistic Works, *Reprints of Papers Presented to the Tenth Annual Meeting* (Milwaukee, May 26-28, 1982).

54. Kootz, op. cit., p. 38.

55. Rourke, op. cit., p. 110.

56. Letter to R.F. Piper from Charles Sheeler, Archives of American Art (n.d.).

57. Letter to Leslie Cheek from Charles Sheeler, Archives of American Art (n.d.).

58. Rourke, op. cit., p. 143.

59. Charles Sheeler, notes in Archives of American Art (n.d.).

60. Rourke, op. cit., p. 175.

61. H.H. Arnason, *Stuart Davis Memorial Exhibition* (Washington, D.C., 1965), Introduction, p. 49.

62. Diane Kelder, ed., *Stuart Davis: A Documentary Monograph* (New York, 1971), p. 102.

63. Ibid., p. 33.

64. *Stuart Davis Memorial Exhibition 1894-1964* (Washington, D.C.: National Collection of Fine Arts, Smithsonian Institution, 1965), p. 42.

65. John R. Lane, op. cit., p. 72.

66. Sanford Schwartz, *The Art Presence* (New York, 1982), p. 58.

67. Laurie Lisle, *Portrait of an Artist: A Biography of Georgia O'Keeffe* (New York, 1980).

# AFTER STIEGLITZ:
# EDITH GREGOR HALPERT AND THE TASTE
# FOR MODERN ART IN AMERICA

by Carol Troyen

When Alfred Stieglitz opened the doors of the Intimate Gallery in 1925, "modernism" was fairly well established in New York — and, in fact, had been used to describe so many different artists' styles from the imitative to the avant-garde that Virgil Barker proposed that the term "modern art" be given a ten-year rest. [1] Stieglitz's own 291 Gallery, founded in 1905, had led the way, being the first in America to show the works of Picasso, Matisse, Cézanne, and Picabia, and then introducing a group of young American artists, including John Marin, Marsden Hartley, Max Weber, and Arthur G. Dove. But by the time he opened his second gallery, the Intimate, after an eight-year hiatus, the artists whose work he had championed had become known, if not widely accepted. The exhibitions that introduced modern art to American audiences — the Armory Show of 1913 and the 1916 Forum Exhibition, which included 193 works by seventeen American painters organized by critic Willard Huntington Wright at the Anderson Galleries — were history, and had established the names of its participants (although not always favorably) in the minds of critics and connoisseurs. The modern painters were organized: The Society of Independent Arts, an alliance of several different artists' groups believing in the cause of modern art and dedicated to the principle of "no jury, no prizes," had its first annual exhibition in 1917; the Société Anonyme, founded by Katherine Dreier and Marcel Duchamp in 1920, eventually included the work of 169 artists from twenty-three countries and was dedicated to "the promotion of the study in America of the progressive in art." [2] More short-lived but no less vital were the gallery-sponsored associations such as Modern Artists of America and the New Gallery Art Club. The "Salons of America," established in 1922 by *Arts* magazine founder Hamilton Easter Field, promoted and exhibited modern American art, as did the Whitney Studio Club, dedicated to the introduction of all styles of new American art to as wide an audience as possible. And by the mid- 'twenties, numerous commercial galleries were showing modern art almost exclusively, among them the Daniel Gallery (founded in 1913), Montross (founded in 1914), the Modern Gallery (organized by Maurice De Zayas in 1915), and Stieglitz's gallery, which had moved uptown from its orginal location at 291 Fifth Avenue to the Anderson Galleries building at Park Avenue and Fifty-ninth Street.

The exhibition with which Stieglitz inaugurated his new gallery on March 9, 1925, was the largest and most ambitious he had ever organized. "Alfred Stieglitz Presents Seven Americans" contained 159 works by five painters — Demuth, Dove, Hartley, Marin, and O'Keeffe — and two photographers — Paul Strand and Stieglitz himself — who would become the mainstays, indeed almost the only participants, of Stieglitz's exhibition programs for the next twenty years. The exhibition was a landmark. Almost everything in the show had been produced during the previous year and was being shown to the public for the first time. "Seven Americans" included many works that have since become famous, such as Demuth's "portraits" of Duchamp, Marin, and O'Keeffe, as well as O'Keeffe's Lake George pictures. At the same time, the show, and the gallery's policy of restricting itself to the work of these seven artists, indicated that Stieglitz had embarked on a more conservative path and was cutting himself off from the diversity of styles and ideas that had been the source of so much energy at "the small laboratory known as '291.'" Stieglitz had become increasingly insistent on his own views of modern art and increasingly

intolerant of others; he no longer saw his gallery as a "laboratory" but as an institution dedicated to preserving "America without that damned French flavor." [3]

While the Intimate Gallery was hosting "Seven Americans," another gallery was being readied by a disciple of Stieglitz's who would perpetuate his original program of finding and encouraging young American artists. Edith Gregor Halpert, born Edith Gregor Fivoosiovitch in Odessa in 1900, came to the United States at age six. She talked her way into classes at the National Academy of Design when she was only fourteen and studied there with Leon Kroll; a more important aspect of her education was her frequent visits to Montross Gallery and especially to 291. Her marriage in 1918 to the painter Samuel Halpert solidified her commitment to the cause of modern art and linked her to another group of avant-garde painters (including Marguerite and William Zorach) who were not connected to Stieglitz or otherwise represented in New York. By the early 1920s, inspired by Stieglitz's example, she had determined to subordinate her own artistic ambitions to the cause of seeking out and promoting new talents, a cause she would serve for the rest of her career.

## The Downtown Gallery in the 1920s: "Something for Everybody"

In November of 1926, Halpert rented three first-floor rooms at 113 West 13th Street and opened Our Gallery, dedicated to "the leading tendencies in contemporary American art . . . [with] no bias in favor of any school." West 13th Street was the heart of a lively Greenwich Village neighborhood in the twenties: the area was populated by artists' studios; the avant-garde magazine *The Dial* — which had published T.S. Eliot, e.e. cummings, and Marianne Moore — had its offices in the same block; and the Whitney Studio Club, established in 1914 on West 8th Street, was a near neighbor. Our Gallery, which changed its name to the Downtown Gallery a year after its founding, reflected the energetic and informal spirit of its Greenwich Village surroundings and, as such, was very different from Knoedler's, Macbeth's, Kraushaar's, and the other established galleries uptown at 57th Street. The Downtown Gallery showed works of art in "a home-like fashion. . . antiques are sprinkled in among the modern works, and the rooms are invitingly decorated in an informal way." Coffee was served at the gallery; visitors were invited to sit down and chat with Halpert about the objects on the walls; the decor was meant to show the prospective customer that modern art need not be intimidating but could suit the dimensions of the modern home. Halpert's efforts were immediately successful. Reviewers of the opening show called the new enterprise "epoch-making" and found "a true art atmosphere" there; at the same time, the gallery was found to present "so attractive an appearance that one reviewer found it hard to leave it." [4]

Halpert's was the first professional gallery in Greenwich Village; the inaugural show — featuring the work of Niles Spencer, Max Weber, William Zorach, and others — included a few artists who had made their debuts with dealers in modern art such as Stieglitz or Charles Daniel but, for the most part, presented avant-garde figures otherwise unrepresented in New York. Over the next few years, Halpert would add Stuart Davis, Charles Sheeler, and other pioneers of modern American painting to her roster. She would inherit many of Charles Daniel's artists when his gallery

closed in 1931, and would utimately represent all the painters of Stieglitz's inner circle: Demuth, Dove, Hartley, Marin, and O'Keeffe. As Stieglitz's energy and health declined in the 1930s, Halpert succeeded him at the head of the crusade to promote modern American art in New York. From her stable the history of early twentieth-century American art can be written; she directed public attention to talented artists as diverse as Stuart Davis, Ben Shahn, and Charles Demuth, never faltering in the face of the rival claims of movements she did not show (such as regionalism and surrealism) and despite the long indifference of museums. Associated with her gallery from the 'thirties until her death in 1970 would be most of the great collectors of the art of this period, from Abby Aldrich Rockefeller to William H. Lane, whose collection this exhibition celebrates. Collectors like Mrs. Rockefeller in the 'thirties, Milton and Edith Lowenthal and Roy Neuberger in the 'forties, and Lane in the 'fifties shared with Halpert the conviction that these artists — Sheeler, Davis, Dove, O'Keeffe, and others — were creators of a vital American style, not one merely derivative of European modernism, and one far more sophisticated in its craftsmanship and more innovative in its formal concerns than was generally thought. Indeed, Halpert's activities on behalf of these artists is the second chapter of the now well-known history of American modernism begun by Stieglitz and 291.

By the time Halpert opened her gallery, museums were beginning to acknowledge modern art. As early as 1913, the Newark Museum held an exhibition of Max Weber's work. The Brooklyn Museum had an exhibition of American watercolors in 1921 that included Marin and Demuth (although not O'Keeffe or Dove), and the Pennsylvania Academy of the Fine Arts organized "Later Tendencies in Art" that same year. Even the august Metropolitan Museum of Art held a modernist exhibition — more or less. In May of 1921, the Museum opened a "Loan Exhibition of Modern French Painting," which included works by Gauguin, Seurat, and Van Gogh, the most recent art ever to have been displayed there. The show was greeted with a few cheers, some sarcasm, and — from a vocal minority — almost violent ill will. Four months after the exhibition opened, an anonymous "Committee of Citizens and Supporters of the Museum" circulated a four-page "Protest Against the Present Exhibition of Degenerate 'Modernistic' Works in the Metropolitan." The flyer maintained that the artists in the exhibition made up "a coterie of European Traffickers in fraudulent art . . . a small group of neurotic Ego-Maniacs in Paris who styled themselves . . . worshippers of Satan — the God of ugliness." The Committee further suggested that "these forms of so-called art are merely a symptom of a general movement throughout the world having for its object . . . the Revolutionary destruction of our entire social system . . . this 'Modernistic' degenerate cult is simply the Bolshevik philosophy applied to art." [5]

By the 1920s, this hysterical sort of reaction to modern art was relatively rare (although charges of insanity and subversion would recur in the next decade). Modern art was being better understood, and the objections to it were more serious and thoughtful. Of modernism's detractors, the most eloquent was Royal Cortissoz, who, in reviewing "Seven Americans" for the New York Tribune, accused the artists (except Stieglitz) of a failure of craftsmanship. [6] Other frequent criticisms

leveled against the new art were an exaggerated preoccupation with technique at the expense of subject matter, obscurantism, elitism, and an overdependence on the styles and forms of Europe. Ironically, the quest for an art free of European influences ("We have profited little by the culture of western Europe"), [7] and the attendant desire for a truly American style drawn from American subjects was not unlike the philosophy of Stieglitz and had been advocated by American critics for nearly 100 years; witness Ralph Waldo Emerson writing in "The American Scholar" in 1837: "We have listened too long to the courtly muses of Europe." [8]

Responding to the protests against the views of Stieglitz and other modernists was a group of progressive critics, among them Paul Rosenfeld, Forbes Watson, and Henry McBride, who published their essays in magazines such as *Arts* and *The Dial*. McBride defended the elitism of modern art by reminding his readers that Rembrandt and other great artists of the past had a small public, and that no serious painting had ever appealed to a large audience. [9] Writing in Watson's *Arts*, William Zorach claimed that the modern artist was not being deliberately vague or self-indulgent in his use of abstraction; rather, by reducing his subject to its purest essentials, he could create a work with universal meaning. [10] Samuel Kootz, in his prescient history of American modernism written in 1930, portrayed the modernists not as undisciplined radicals but as participants in a classical tradition encompassing both Seurat and Cézanne and Leonardo, Michelangelo, and Rembrandt. Such artists as Demuth, Sheeler, Preston Dickinson, and Peter Blume were able to "construct a picture along sound architectural lines" and "are probably as perfect craftsmen as are to be found in painting today." [11] And although Paul Strand, as spokesman for the Stieglitz position, would claim (in a review of the Brooklyn Museum's watercolor show) that the works of Marin and Demuth were "an affirmation that a truly indigenous expression is as possible in America as in Europe," [12] most defenders of American modernism in the 1920s celebrated the connection with European art, past and present. Modernism had come to stand for cultural internationalism and a deep-seated sense of history against an isolationist view.

On a more concrete level, the defenders of modernism supplied various forms of assistance to the viewer still puzzled by the new abstract art. In an admiring review of an exhibition of Marin's watercolors, critic Virgil Barker suggested various techniques "for those to whom Marin's watercolors present problems in optics," such as "the half-shut eyes, pushing the picture farther away. Still another is to look at the picture intensely for only a moment and then immediately close the eyes tightly, letting the image remain on the retina for as long as it will." [13]

Edith Halpert, for her part, devised a number of clever and innovative exhibitions designed to entice people to look at modern art and to convince them that in the variety of styles called "modern" there was something for everyone. From the founding of her gallery in 1926, Halpert's exhibition program was ambitious and creative: she put on ten to twelve shows a year, some of which highlighted one artist but most of which were group shows illustrating a particular theme ("Americans Abroad," "Paintings of New York," "Flowers," etc.) drawn from her diverse stable of artists. In the early years she showed many different kinds of modern art, including works of the older generation, such as Davies and Kuhn, witty caricatures by Peggy

Bacon and "Pop" Hart, figure paintings by Bernard Karfiol, and abstractions by Weber. In 1927 she inaugurated print annuals with works chosen by a rotating committee of artists. Both artists and the public were delighted with these shows, often held right before Christmas, with prices seldom higher than $50. Even more popular were the spring housecleaning shows with which she closed the season. Entitled "Something for Everybody," these shows featured works by Halpert's regular stable all priced at $100 or less. Compared with prices charged by other dealers — Charles Daniel at the time was asking $1,200 for a Marin watercolor and $750 for a Demuth, and Stieglitz, when he would quote prices at all, was often high, e.g., $6,000 for a Marin watercolor sold to Duncan Phillips in 1927 — the Downtown Gallery offered bargains indeed, and was praised in the press for bringing art "down from the financial heights to a democratic level." [14]

Halpert's acumen at marketing her artists was coupled with a good eye, and even in her first years of operation she discovered and added to her roster artists who came to be considered the most influential of the period. One of the first new painters she took on was Stuart Davis, to whom she gave a one-man show in December 1927. Davis's debut was not, however, an unqualified success, and at least one reviewer confessed that he was still uncomfortable with modernism: "It is perhaps our own limitation that Mr. Davis' conscientious abstractions make a very limited appeal. Often interesting and decorative in their color, the geometric deductions of his "Percolator" and "Matches" leave us rather cold and as for the abstraction of the rhythm of "Egg Beater" we were equally puzzled . . . . Two or three representational watercolors, resting on the floor as if unworthy of wall space are apparently there to assure the skeptical that Mr. Davis can also come off quite well doing the conventional thing." [15]

Potential customers also seemed perplexed by Davis's brilliant abstractions. Of the works mentioned in the review, all remained unsold for at least ten years. The "Egg Beater," possibly *Eggbeater No. 1,* was bought by Duncan Phillips in 1939; *Matches* was still for sale in 1946, when Halpert held a large Davis retrospective (it was subsequently bought by the Chrysler Museum, Norfolk); *Percolator* was sold only in 1956 to the Metropolitan Museum of Art.

The year that Halpert introduced Stuart Davis began a momentous era for modern art, especially for European modernism. In that year the second half of John Quinn's collection — with its great Matisses, Brancusis, and Picassos — was sold at auction, causing great excitement and yielding by far the largest sum ever to be generated by the sale of recent art. Also in 1927, A.E. Gallatin, another far-sighted collector, opened his "Museum of Living Art" in the reading room of Washington Square College at New York University with a show of seventy paintings and watercolors encompassing "the most important and recent developments of twentieth century painting." The exhibition, though predominantly European (including works by Picasso, Gris, and Brancusi — and Léger's great *City),* did contain a few American pictures: watercolors by Demuth and Marin and Sheeler's seminal *Bucks County Barn.* [16] The most important show of the season was the "International Exhibition of Modern Art," which the Société Anonyme had organized for the Brooklyn Museum

in November and December 1926; a smaller version of the show (still including ninety-five paintings by twenty-two artists) was presented at the Anderson Galleries early in 1927. In the Société's view, as in Gallatin's, the most vital contemporary art was European; less than a quarter of the works were by American artists.

In the late twenties, the commercial galleries and artists' associations continued their presentations of modern American art, with few new artists of real interest — the notable exception being Thomas Hart Benton — arriving on the scene. The Whitney Studio Club continued to offer a diverse diet of shows by artist-members: in 1927, works by Glenn O. Coleman, Leon Hartl, and Stuart Davis were shown there. The Frank H. Rehn Gallery on Fifth Avenue looked backward and gave shows to the Boston School, to a group of artists (Kroll, McFee, Speicher) strongly influenced by turn-of-the-century French painting, and to the gallery's mainstay, Edward Hopper. Charles Daniel's gallery, still the most prestigious and successful outpost for American modernism, presented in the spring of 1927 a new series of pastels by Preston Dickinson and group shows including works by Spencer, Sheeler, Man Ray, Kuniyoshi, and Hartley. Daniel's business had been hurt when Stieglitz opened the Intimate Gallery in 1925 and took with him the artists (Demuth, Marin, etc.) that Daniel represented profitably while Stieglitz was without a gallery (1917-1925). Nevertheless, some of his best customers, including Lillie P. Bliss, Arthur J. Eddy, Albert Barnes, and Ferdinand Howald, remained loyal.

It was Howald (who would eventually own twenty-eight Marins; twenty-eight Demuths; many works by Hartley, Prendergast, and Dove; and great works by Picasso, Gris, and Derain) who became the most effective supporter of American modernism during the 1920s. Howald made his fortune from mining in Ohio and West Virginia. He was a retiring man whose initial purchases illustrated the refined side of Armory Show taste: in 1913 he commissioned family portraits by Speicher and Kroll, which gave a continental flavor to his home in Columbus, Ohio. But after meeting Charles Daniel (from whom the bulk of his collection would come) in the late 'teens, his taste became more adventurous and eclectic. In addition to Stieglitz-circle artists bought from Daniel in the 1920s, [17] Howald's collection included works by Glackens, Lawson, Luks, and other members of the Eight; figurative subjects by Davies and Pascin; abstractions by Dove and Schamberg; and elegant still lifes by Sheeler and Demuth. He subsidized the incomes of Rockwell Kent and Oscar Bluemner, and gave Man Ray a $500 stipend with which to travel to Europe in 1921. Howald's collection was installed in the Columbus Gallery of Fine Arts in 1931.

Stieglitz presented one-man shows of the work of Dove, Marin, Lachaise, and O'Keeffe in 1927; by this time, he had begun a fruitful relationship with a distinguished collector that paralleled that of Daniel and Howald. Stieglitz's collector was Duncan Phillips, who began his career writing reviews and essays critical of modernism. Phillips's first purchases exhibited conventional taste: old master paintings and then Impressionist works, including Renoir's ever-popular *Luncheon of the Boating Party*. In 1918 he founded the Phillips Memorial Gallery in Washington in honor of his father and brother. Phillips met Stieglitz in the mid-1920s and, with the dealer's guidance, he formed the first collection of modern American art in the nation's capital.

In 1926, Phillips acquired from Stieglitz his first paintings by Arthur Dove, the artist of Stieglitz's inner circle whose work, perhaps because it was the most challenging, was the least understood. But Phillips responded, and in 1926 he acquired *Waterfall* and the magical *Golden Storm;* by the end of the decade, he had acquired three more Doves (including *Huntington Harbor,* one of the early collages) and had arranged to pay Dove a stipend of $50 a month in exchange for first choice among the works shown at Dove's annual exhibitions. That stipend, together with Phillips's regular purchases, was Dove's main source of support for the rest of his career. Ironically, although they corresponded regularly (their letters, like the paintings and stipend checks, always passing first through Stieglitz's hands), Dove and Phillips met only once, in 1936, under Stieglitz's roof at An American Place. [18]

Dove's work was featured in the first major exhibition presented at the Phillips Memorial Gallery: "An Exhibition of Paintings by Eleven Americans and an Important Work by Redon." The show, held in February of 1926, included works by Kent, O'Keeffe, Speicher, Weber, Kuhn, Tack, Maurer, Knaths, and Hartley, as well as Dove, and introduced Washington audiences to a variety of styles.

Modern art was then beginning to be known outside New York. Three years later, Bostonians were given their first opportunity since the Armory Show to see modern American painting, when the Society for Contemporary Art (run by Harvard undergraduates Lincoln Kirstein, Edward M.M. Warburg, and John Walker) present-ed the first in a series of exhibitions of modern art. That show, with works borrowed from New York dealers, included paintings by Bellows, Prendergast, Burchfield, Demuth, Marin, and others, along with Stieglitz's photographs of Georgia O'Keeffe's hands. Clearly, the influence of the avant-garde was spreading, and the biggest event in the American art world since the Armory Show would also occur at the close of the decade: the founding of the Museum of Modern Art.

The Museum of Modern Art, which opened its doors in November of 1929, made its international aspirations clear from the very beginning. It would model itself after the Tate and the Luxembourg, and would attempt to gather, in the words of an introductory brochure published by the Museum's founders, "a very fine collection of the immediate ancestors, American and European, of the modern movement" as well as works "of the most important living masters especially those of France and the United States," but from other countries as well. The purpose of this gathering was to be educational: "Through such collections American students and artists and the general public could gain a consistent idea of what is going on in America and the rest of the world." The Museum would furthermore provide a place, which otherwise did not exist in New York, where "visiting foreigners could be shown a collection which would fairly represent *our own* accomplishment in painting and sculpture." Although the Museum would never fully live up to its second goal, and until the advent of Abstract Expressionism would slight American artists, it surely fulfilled the prediction with which the founders concluded and became "the greatest museum of modern art in the world." [19]

The establishment of the Museum of Modern Art was seen as "the final apotheosis of modernism and its acceptance by respectable society," [20] an assessment borne out

by the reaction to the Museum's first exhibition. That show, featuring the work of Cézanne, Van Gogh, Gauguin, and Seurat (much the same group that had distressed a segment of the Metropolitan Museum's public only eight years before), was attended by 47,000 people during the four-week run of the show, including 5,300 on the last day. [21] The Museum's second show, "19 Americans," was less popular but no less conservative: although among the artists in the exhibition were some "modernists" like O'Keeffe and Marin, most represented an older generation (Sloan and Lawson) or, like Karfiol, Sterne, and Speicher, were influenced by a French aesthetic. The Museum acquired from that show three works (Burchfield's *Railroad Gantry* and figure paintings by Karfiol and Kenneth Hayes Miller) that betray the same cautious taste.

The second exhibition dedicated to *"our own* accomplishment," "46 Painters and Sculptors under 35 Years of Age," held in 1930, was equally mediocre, and it was not until the Museum's third attempt, "Painting and Sculpture by Living Americans" (December 1930 — January 1931), that contemporary American works of distinction were shown. Works were borrowed from An American Place, the Downtown Gallery, and the Daniel Gallery, as well as from private collectors, and included such landmark works as Sheeler's *Upper Deck* (1929; now at the Fogg Art Museum), Hartley's *Portrait of My Friend* (1914; now at the Metropolitan Museum and titled *Portrait of a German Officer*), and Spencer's *Ordnance Island, Bermuda,* a surprising loan by the distinguished collector Sam Lewisohn, who otherwise favored French Impressionist and post-Impressionist works. Unfortunately for the Museum, the policy of buying a few works from the exhibition for the permanent collection was not continued here. Nevertheless, the Museum of Modern Art was an important stimulus for American artists, and provided them with a great benefactor who in the 1930s became Halpert's best customer and collaborator in the promotion of American modernism — Abby Aldrich Rockefeller.

The first meeting between Halpert and Mrs. Rockefeller, a founder of the Museum of Modern Art, is now legend. In 1928, Halpert presented an exhibition of American marine paintings to which Mrs. Rockefeller had loaned, anonymously, a Homer watercolor. Visiting the gallery, she (still unknown to Halpert) expressed interest in the seascapes by Marin and Zorach that flanked her Homer, but was told that the works were not for sale except "to the idiot who owns the Homer and doesn't have the descendants to go with it." Mrs. Rockefeller then announced, "I am the idiot," and bought the Zorach for $250 and the Marin for $750. [22] This was the beginning of the Abby Aldrich Rockefeller Collection of contemporary American art, and of a long and productive association between the two women.

Over the course of the next ten years, Mrs. Rockefeller bought over 375 American paintings and drawings, many of which came from Halpert. Her taste ran to watercolors and other small works, and she preferred artists such as Marin, Burchfield, Weber, and O'Keeffe to more traditional figure painters, whether academic or regionalist. Many of the works she bought during this period — Demuth's *Stairs, Provincetown* (1920), Burchfield's *Interurban Line* (1920), Sheeler's *American Landscape (Ford Factory at River Rouge, Mich.,* 1930) — have come to be seen as representing the quintessential styles of these artists; her gift of much of the

collection to the Museum of Modern Art in 1935 has helped enshrine those styles (perhaps to the detriment of the artists' later work) in the minds of historians and the public.

Through Halpert, Mrs. Rockefeller became acquainted with several of the artists she collected, paid them stipends from time to time, and gave commissions to artists she especially admired. At her request, Sheeler painted a series of pictures representing the buildings at Colonial Williamsburg, which the Rockefellers were in the process of restoring; Marguerite Zorach made a large tapestry portrait of the Rockefeller family; and Ben Shahn, in an unlikely marriage of artist and subject, painted portraits of the Rockefeller horses, for which he was paid $250 each. [23]

The terms of Mrs. Rockefeller's gift to the Museum of Modern Art underscores her dedication to the cause of American art. The only restriction she made was that no work by a living American could be sold except to buy another (superior) example by the same artist. Her gift to the Museum made it an early stronghold for the pioneers of modernism, yet her interest in this area was neither shared nor continued by the Museum's other benefactors or its staff. One collector has remarked that "if it weren't for Mrs. Rockefeller, there would be no American art [from this period] at the Modern," and the assessment is very nearly correct; of the Museum of Modern Art's collection of Demuths, Doves, Marins, Sheelers, etc., almost all were the gifts of Philip Goodwin, the Museum's architect, [24] and Mrs. Rockefeller, or were purchased from funds she provided.

Her patronage enabled Halpert to expand during the years when other galleries (including Charles Daniel's), hard hit by the Depression, were forced to close. In April of 1930, Halpert opened her Daylight Gallery, an annex constructed in the backyard of her West 13th Street building. The gallery, which aimed to "show how works of art may be used as elements in modern building" (in the words of her press release), had doors designed by William Zorach, wall plaques by Reuben Nakian, and a floor pattern designed by Marguerite Zorach. Again, Halpert's ability to create a charming and sympathetic environment was lauded by critics, who also praised her eye: "Eminently worthy of its background, however, is the exhibition itself . . . there are, for instance, capital things like the study in pure objective form, *Upper Deck* by Charles Sheeler, who finds the ventilating equipment aboard a modern steamship admirably suited to his taste for subject matter. . . ." [25]

The new Daylight Gallery with its much-admired decor was only one of many ways Halpert generated interest in her artists. Beginning in the early 1930s she put on a series of innovative shows with catchy titles or intriguing themes, generally drawn from her standard roster of artists, which attracted customers and critical attention. Some of these shows simply demonstrated her flair for clever marketing. In 1941, she hung a show titled "What is Wrong with this Picture?" Included were paintings such as Blume's *South of Scranton* (1931; Metropolitan Museum of Art), Spencer's *Across the Tracks* (1934; Allentown Art Museum, Allentown, Pennsylvania), and Sheeler's *Americana* (1931; collection of Milton and Edith Lowenthal). The show's title referred to the fact that these pictures were in the dealer's mind masterworks and some were prize winners (e.g., the Blume, which had been awarded a medal at

the Carnegie Institute International in 1934), but even after ten years they had not sold. Questionnaires were distributed to the gallery's visitors, who were asked to identify the problem with the pictures displayed. Critics generally were taken with the ploy and noted that it accomplished Halpert's purpose: making people look hard at the pictures.

Some of the shows Halpert devised during this period were echoes of exhibitions held by New York museums (especially the Museum of Modern Art), to capitalize on the enthusiasm they generated. The first of these was "33 Moderns," a response to the Modern's "19 Americans," which she put on in 1930 at the Grand Central Art Gallery, for the over 100 works in the show exceeded the capacity of Halpert's space. There was some overlap with the Modern's show, but Halpert's selection presented a more interesting and diverse group, including works by Lozowick, the Zorachs, Ault, Sheeler, Shahn, and Davis.

In December 1934, Halpert presented "Practical Manifestations in Art," following the Modern's pioneering "Machine Art" show of the previous March. "Practical Manifestations" juxtaposed paintings and examples of furnishings and industrial designs by Halpert's artists to demonstrate that they shared an aesthetic and a high level of craftsmanship. Thus, Sheeler's *Americana* was juxtaposed with a coffee service he designed, dress fabric by Davis accompanied photographs of his mural at Radio City Music Hall, and so forth. Through this show, Halpert's artists were able to benefit from the enthusiasm for contemporary design generated by the Modern's exhibition. In addition, "Practical Manifestations" allowed Halpert to expound upon one of her favorite themes: that art was not just for museums or for wealthy collectors in their mansions, but was part of everyday life. In her catalogue she celebrated the popularization of modern art that had worried critics a decade before: "Art is now becoming a living factor in the home."

### "I paint the American scene": Modern Art in the 1930s.

In the 1930s, critics of modernism had shifted from questioning the talent and craftsmanship of new artists to suspecting their patriotism. "Americanness" in the arts was the key issue, and the New York art community was accused of being closer to Europe than to America. An attendant issue was the rivalry between representational art and abstraction. The chief advocate of representational, indigenous art was Thomas Craven, who, in the 1920s, had defended modernism in *The Dial* and other publications, but who, by the 1930s, had become a convert to American scene painting and a champion of Thomas Hart Benton. Craven wrote in a lively, blustery, hyperbolic style; he was in love with the American frontier and with Yankee ingenuity. One of his favorite targets was Stieglitz; he claimed that the art shown at An American Place was "alien to the current drive for an explicitly native art. The new trend of painting," he claimed, was inaugurated by Benton and was representational, with subjects drawn from American life, and with "clearly defined meanings which may be shared and verified by large numbers of people." He suggested that the abstractions of Dove and other members of Stieglitz's group, in addition to being elitist, were vague and "elusive apparitions." [26] The only artist among them to merit his praise was Marin, whom he — like many others — saw as

a true Yankee. For that facet of his personality and for his brilliantly colored and emphatically masculine images of the Maine coast, Marin was hailed by Craven as Winslow Homer's successor.

Craven demanded an art free of history, claiming that the "land of machines" needed no artistic tradition. He counseled painters to choose American subjects: "for the genuine artist, America holds an unprecedented variety of experiences, an untilled field of overwhelming richness. The spirit of the frontier . . . is fused and intermingled with the most complicated industrial technology." And for American artists, he proposed those as the ingredients of great themes and great art. [27]

Craven represented the majority position in those years and, rather than confronting this rather narrow view directly, Halpert chose to turn the "Americanness" issue to her own and her artists' advantage by some inventive promoting. To a landscape show with which she opened the 1930 season Halpert appended the slogan "Paint America First!," thereby implying a patriotic motivation behind abstract canvases by Davis and others. In 1932, she tried to emphasize the regional character of Marsden Hartley's art by entitling a one-man show of his Dogtown (Gloucester, Mass.) landscapes "Pictures of New England by a New Englander." The show's brochure also printed a poem by Hartley called "The Return of the Native." Hartley had been under attack in recent years, both from critics like Craven and from supporters like Stieglitz and McBride, for spending too long in Europe and for producing pictures too derivative of European models. [28] The Dogtown landscapes, however, come closer than any of the previous work to the writhing, heaving, expressively distorted forms of regionalists like Benton and Curry; this fact, and Halpert's emphasis on the Americanness of his subject matter, may have spared him the critics' wrath, even if the show was not a great success.

In a similar fashion, in her spring show of 1935, "14 Paintings by 14 American Contemporaries," Halpert stressed the "regional" character of her artists — Davis, Sheeler, O'Keeffe, Spencer, and others — by explaining that only two of the fourteen artists in the show came from New York. She also argued that their art, with its universal language, represented the "true American scene" and was diametrically opposed to the "limited provincialism" of the "Benton-Wood-Curry School, which has received so much attention of late." [29] Davis's contribution to the show best illustrated the compromise Halpert was trying to achieve. Although the hot colors and fragmented planes of American Waterfront: Analogical Emblem (painted for the WPA; now in the collection of Mr. and Mrs. Norman Halper) would have irritated Craven, he would have been no less pleased than his left-wing counterparts by the ropes, winches, ladders, and other equipment of the American working man clearly displayed in the picture. [30] Furthermore, works such as Sheeler's American Interior or O'Keeffe's White Barn with Cart would certainly have satisfied Craven's dictum that artists paint American subjects (as Stieglitz's and Halpert's artists, in fact, nearly always had).

Halpert had far greater credibility with artists and critics on the left. Her shows in which everything was priced at $100 or less, held at Christmas time and at the close of the season, were always hailed as public-spirited. She represented several "social realist" painters, among them Ben Shahn and Jack Levine, and in 1932 gave the first

public show to Shahn's *Passion of Sacco and Vanzetti,* which drew, according to the *New York Sun* critic Henry McBride, large crowds of "unusual people," who behaved before the drawings as though they were in church. [31] Prominent among the political radicals in Halpert's group of artists was Stuart Davis. He helped form the Artists' Union and in 1935 became the principal editor of its magazine *Art Front;* the next year he served as the national executive secretary of the Artists' Congress. Davis was also active in the WPA in those years, as were several of Halpert's younger artists, and a show of their work at the Downtown Gallery caught the attention of Eleanor Roosevelt, who recommended the show in her column "My Day." [32]

Although it had been established with the purpose of promoting American art, the Whitney Museum at this time actually did little more than the Museum of Modern Art to sustain public interest in the painters Halpert and Stieglitz represented. The Museum, an outgrowth of the Whitney Studio Club, was founded after an offer to join the Club's collection and exhibition program with the Metropolitan Museum's was rejected by Edward Robinson, the Metropolitan's director. The Whitney remained Halpert's neighbor in Greenwich Village, expanding its quarters to take up an entire building on West 8th Street. Led by Gertrude Vanderbilt Whitney, the founder and president, and Juliana Force, the Museum's director, the Whitney was a discerning, if infrequent, customer of the Downtown Gallery, acquiring, among other works, Weber's *Chinese Restaurant* (1915) in 1931 and Sheeler's *River Rouge Plant* (1932) the next year. Furthermore, Halpert's major artists (Spencer, Davis, Sheeler, and Blume) and those Stieglitz had begun to share with her (Marin, O'Keeffe, and Hartley) were well represented in the Whitney's Biennials, beginning with the inaugural exhibition in 1932. Yet no work by these artists was bought with the $20,000 set aside for purchases from the show and, of the 157 artists participating, these pioneers of modernism made up a very small group, the preponderance being regionalists and other figurative painters.

The Whitney's emphasis on figurative painters in its acquisitions and its exhibition program left Halpert's artists without the forum for public exhibition they had hoped for; the Museum's policy against presenting one-man shows of living artists (except for Thomas Hart Benton, whose murals were shown under the title "Arts of Life in America" in 1932) deprived them of an opportunity for individual recognition. [33] Nor were they being shown at the Museum of Modern Art (except for the perennially popular John Marin, who was given a small one-man show there in 1936); both there and in many commercial galleries in New York they were being passed over in favor of surrealists, regionalists, representational painters like Hopper, and the painters of the American Abstract Artists' Group (Morris, Holty, Ferren, and so on). [34]

The Whitney did produce one exhibition in the 1930s that paid tribute to the artists promoted by Stieglitz and Halpert. "Abstract Painting in America," consisting of 125 works painted between the Armory Show and 1935, showed "abstract" works of almost all types, including paintings by MacDonald-Wright, Davis (*Eggbeater No. 3;* no. 80), Demuth (*My Egypt,* which the Whitney subsequently acquired), Graham, and Pach. The only group not included was the American Abstract Artists; their spokesman, George L.K. Morris (incidentally, the only member of the group ever represented by Halpert), reacted bitterly and criticized the painters in the show for

not being true abstractionists but rather being "stalled in various ill-digested ferments of impressionism, expressionism and half-hearted cubism." [35]

Most critics, however, admired the show, and especially praised artists of the Stieglitz group. Oddly, none of these artists or of Halpert's were represented by recent works (Hartley's paintings were all from the 'teens, Sheeler showed one work of 1919 and one of 1924, O'Keeffe showed five works of the 'twenties), both because their works of the early 'thirties were not considered abstract enough to be included and because the exhibition's organizers, attempting a historical survey of American abstraction, associated these artists with the era of World War I. It is true that most of the artists in the group were painting in a more representational style in the 1930s: Demuth's watercolor still lifes date from this period, as do Sheeler's interiors such as *Newhaven* (no. 46), and as innovators in abstraction they were supplanted by younger artists such as John Graham, Arshile Gorky, and Balcomb Greene, who were working in more obviously abstract styles. Yet the Whitney's implication that Hartley, Dove, Sheeler, and the others were an older generation has contributed to the current view that these artists' effect on the development of modern art was limited to one brief period only, and has caused their later work to be viewed less seriously.

Even at the time of the exhibition, "Abstract Painting in America" was felt to mark the end of an era; critics asserted that the "religious fervor" expressed by painters in the early years of abstract painting was no longer in evidence and that the pioneers of abstraction had become elder statesmen. The change was blamed, in part, on the commercialization of abstract art ("when abstract design was joyfully adopted by advertising agencies and window decorators, its death knell as a significant movement had definitely sounded") [36] and, in part, on the passage of time. Most of the "pioneers" were by this time in their mid-fifties; the death in 1935 of Charles Demuth, perhaps the most critically acclaimed of these artists, underscored that belief.

Ironically, although by the mid- 'thirties these artists were considered the founding fathers of the modernist movement in America, almost none of their work had been acquired or even shown by the nation's major museums, such as the Metropolitan or Boston's Museum of Fine Arts. They fared a little better in Chicago, where several of their works, including Sheeler's *Newhaven* (no. 46) and Dove's *Red Barge* (now in the Phillips Collection), were shown at the Art Institute's mammoth "Century of Progress" exhibition in 1933; however, few of their works had entered that institution's permanent collection. The Museum of Modern Art, during the 1930s, continued to ignore Stieglitz's and Halpert's artists. In fact, no American was included in its landmark exhibition "Cubism and Abstract Art" of 1936, and in the survey of modern art mounted as the Museum's Fifth Anniversary exhibition in 1934 and 1935 only a quarter of the artists included were American. That show, drawn from the Modern's permanent collection and the collections of its trustees and friends, reflected the predominant taste of the era. Few collectors of consequence were specializing in early twentieth-century American art. The major patrons of contemporary art of the era, such as A.E. Gallatin, James Thrall Soby, or Sam Lewisohn, [37] were oriented toward Europe and a few American artists who worked

closely in the shadow of the Europeans. The biggest supporters of Stieglitz's and Halpert's painters were out-of-towners: Phillips, of course, and Edward W. Root. The son of Theodore Roosevelt's famous secretary of state, Root was an art critic and professor at Hamilton College, who over a period of thirty-five years quietly amassed a collection of twentieth-century American art that would extend from Luks to Pollock, and included Dove, Marin, Gorky, Hopper, and Bolotowsky. The collection was presented to Utica's Munson-Williams-Proctor Institute in 1956.

Halpert took on several new artists during the 1930s, notably Sheeler (who had his first one-man show at the Downtown Gallery in 1931, at the same time his photographs were being shown at the Julien Levy Gallery), Preston Dickinson, and Karl Knaths; she was one of the first dealers to show Gorky, who was included in her spring 1931 "$100 or Less" exhibition.

Halpert's business was enriched by her increased collaboration with Stieglitz, who began to share his artists with her (the only dealer with whom he did so) in the 1930s. Marin and Demuth first appeared in an exhibition of watercolors held at the Downtown Gallery in 1931; they, along with O'Keeffe, participated in exhibitions "lent by An American Place" regularly thereafter. In 1936 Halpert initiated the practice, modeled no doubt after Stieglitz's, of dedicating her Daylight Gallery exclusively to a group of six artists (Marin, O'Keeffe, Sheeler, Karfiol, Kuniyoshi, and Laurent) who had, in her view, "definitely established their significance in the world of art." She also gave one-man shows to Hartley (in 1932) and Marin (in 1939). The only painter of the Stieglitz group that she did not show was Arthur Dove; she began to represent him only after Stieglitz's death in 1946.

Halpert's most unusual addition to the Downtown Gallery stable in the 1930s was not a contemporary artist schooled in abstraction but a nineteenth-century still-life painter and master of realistic description: William Harnett. A small dealer brought Harnett's *Faithful Colt* to Halpert's attention in the mid-'thirties; inquiries ferreted out other works, and by 1939 she had enough for an exhibition, which she called "Nature-Vivre." In his own time, Harnett was admired for his ability to fool the eye with startlingly vivid renderings of still-life objects, but Halpert, in her catalogue introduction, praised the "modern" qualities of his design, and noted that paintings like his make clear the connection between contemporary art and the art of America's past: "While his recognition in the nineteenth century may have been due to his 'artistic composition' and his reputation as 'the most realistic painter of his age,' our present interest in Harnett is based on more contemporary considerations. We marvel at the fact that he anticipated a style practiced today by the vanguard in France and in this country. His color is brilliant, the painting flawless, and the composition organized in abstract pattern. But it is Harnett's combination of meticulous realism with an arbitrary juxtaposition of unrelated objects that may be said to provide a link between Dutch art of the seventeenth century and sur-realism of the twentieth. The contemporary school of imaginative realism is enriched by another American ancestor presented in this exhibition."

Frequent visitors to the Downtown Gallery would have recognized this theme from Halpert's folk art exhibitions. She had been selling American folk art, gathered during

summer trips to New England, since 1929. Her principal customer was once again Abby Aldrich Rockefeller, who bought many of the masterpieces now at Colonial Williamsburg from the Downtown Gallery. The folk material proved to be more profitable than modern art, and for many years it subsidized the gallery's other interests. In 1932, while presenting a group show of works by Davis, Sheeler, and others, Halpert opened a new room in her gallery devoted exclusively to folk art. Like Harnett's work, the material in that gallery demonstrated her conviction that her favorite contemporary artists were thoroughly American in their character and ancestry. She claimed that her folk art room was "the first gallery of its kind in the country, and will be used chiefly to demonstrate the fact that American contemporary artists have a background and a tradition other than French art. We want to prove that American art does not arise suddenly out of the 1906 and subsequent movements." [38]

Harnett was included, along with Cole, Eakins, Homer, and other established masters of nineteenth-century American art, in "Trois Siècles d'Art aux Etats-Unis," an exhibition organized by the Museum of Modern Art and sent to Paris in 1938. *The Faithful Colt,* which Halpert had sold to the Wadsworth Atheneum for $300 three years before, was the only pre-1900 still life in the show. But far more important than the elevation of Harnett to the rank of the textbook masters was the exhibition's emphasis on American modernism. This ambitious show — which included not only painting, sculpture, and prints but also sections on architecture, photography, and film — was a survey of American art dating back to the seventeenth century, assembled by the Museum of Modern Art at the invitation of the French government; it included about 190 paintings and watercolors, of which 116, or nearly two-thirds, were by twentieth-century artists. All "schools" were represented — regionalists, abstractionists, surrealists, social realists — along with the pioneers of modernism Stieglitz and Halpert had been promoting. About one-third of the twentieth-century artists in the show were represented by Halpert or "shared" by her with Stieglitz.

In his introduction to the catalogue, Alfred H. Barr, Jr., explained American modernists to the French in terms of the French styles that he believed had molded them: Marin, he said, showed the influence of Cézanne and cubism; Dove "made effective use of the Cubist-Dada device of combining in his pictures real objects with painted surfaces." And of works like Demuth's *My Egypt* (1927; now in the Whitney Museum), Blume's *South of Scranton* (1931; now in the Metropolitan Museum of Art), and Sheeler's *Ephrata* (1934; now in the Museum of Fine Arts, Springfield) he noted: "The extraordinary technical refinement of [these artists] has caused some critics to speak of an 'immaculate' or 'precisionist' school of American painting" [39] — thus giving the Modern's stamp of approval to a stylistic pigeonhole that would limit subsequent appreciation of their work.

Barr's efforts at explaining American painting were in vain. The French objected to the pictures and flocked instead to the film and architecture sections. French critics castigated the paintings, calling them "second-rate" and far behind English art (itself not much admired by the French). The most vitriolic comment came from the critic of the *Gringoire,* Andre Villeboeuf: "Here is painting justly called 'international';

without origin, without taste; marked only by an originality that accents the indecency of its arrogance, the puerility of its vanity." [40]

Although the exhibition failed to please the French, its effects at home on the newly enfranchised modern art were positive. "Trois Siècles d'Art aux Etats-Unis" was a tribute to the intellectual ambitions and organizational talents at the Museum of Modern Art, for it was the first survey of American art ever attempted on so comprehensive a scale. And for twentieth-century artists, especially those represented by Halpert, the show was a source of prestige, for many of them had never before exhibited abroad. Delightedly, she welcomed them back from Paris with a small-scale version of the Jeu de Paume show called "Americans at Home" — thirty-two works by artists who had been in the Modern's show.

The acceptance of the "pioneers of modernism" signaled by the Jeu de Paume show was underscored the following year, when the Museum of Modern Art — probably at the urging of its enthusiastic patron Abby Rockefeller — gave Sheeler a one-man show (including paintings and photographs), the first such exhibition given by that Museum to an artist represented by Stieglitz or Halpert since its Weber show of 1930. Halpert responded the next year with "Power" — a show of Sheeler's six paintings (including *Rolling Power,* 1939; now in the Smith College Art Museum) commissioned for reproduction in the December 1940 issue of *Fortune* magazine. In the same year, Halpert moved her Downtown Gallery uptown to 51st Street, as though to acknowledge the acceptance of her artists by the mainstream.

## The Museums and the Collectors

During the 1940s, the pioneers of modernism, both European and American, began entering public collections. In 1941, the Société Anonyme, which had circulated eighty-four exhibitions in over twenty years, gave its collection to the Yale University Art Gallery. A.E. Gallatin's Museum of Living Art collection was accepted by the Philadelphia Museum of Art in 1942 (after a sudden eviction from its premises at New York University).

But the Museum of Modern Art contined to be ambivalent toward American modernism. Perhaps in response to the American Abstract Artists' protest against its "Italian Masters" show, the Museum published "American Art and the Museum" in its November 1940 *Bulletin.* This policy statement argued somewhat defensively that the Museum's commitment was to modern art and to the principle that art should have no boundaries, and then listed its efforts on behalf of American art, emphasizing particularly its exhibitions of American architecture and design (areas in which no other museum was active), its one-man shows of living Americans (pointing to eight since 1930), and the Jeu de Paume exhibition. In fact, the majority of the Museum's exhibitions from the late 'thirties, like its Fifteenth Anniversary Show ("Art in Progress") of 1944 and its series of exhibitions drawn from private collections of friends of the Museum, included little American art. Still, the Museum did organize several important exhibitions during this period: the "Realists and Magic Realists" exhibition of 1943 focused attention on a group of young surrealist painters and, in 1943 and 1944, "Romantic Painting in America" identified a tradition "at least as strong as the much advertised American love of fact and detailed local color," while

establishing — as Halpert always maintained — artists like Marin and Hartley as the descendants of Cole, Homer, and Ryder. [41]

The most important indicator of the change in attitude toward these artists, however, was neither the gifts to Yale and the Philadelphia Museum nor the Modern's intermittent efforts, but the Metropolitan Museum of Art's belated awakening to the work of twentieth-century American artists. Although since 1906 the Hearn Fund had provided the Metropolitan with funds expressly intended for the purchase of American art, little was spent through the 1930s. The few "moderns" that were bought with Hearn money in that period were either French-inspired artists such as Kronberg and Sterner, or Miller, Speicher, Myers, and other artists affiliated with the Art Students' League. Despite protests by various critics, purchases were infrequent and conservative [42] — the Metropolitan owned no abstraction, no work by progressive American painters, until the 1940s, when Hartley's *Lobster Fisherman* (1940-1941) and Marin's *Off Cape Split* (1938) were acquired.

The turning point for the Metropolitan was "Artists for Victory," a patriotic wartime show held in 1942, in which the Museum was "turned over to the artists": the "Artists for Victory, Inc.," representing twenty-three New York art societies, chose the juries of admission, while the Metropolitan chose the jury of awards. From over 14,000 entries, some 500 paintings, 300 works of sculpture, and 500 prints were chosen; among the prizewinners were Ivan Albright (*That Which I Should Have Done, I Did Not Do* — best in show), John Steuart Curry (*Wisconsin Landscape* — first prize), and Peter Blume (*South of Scranton* — a second prize), along with Marsden Hartley (*Lobster Fisherman* — a fourth prize) and Niles Spencer (*Waterfront Mill* — a sixth prize). The Museum purchased the last four and, although the taste for realism dominated both the selection and the awards, the show was nonetheless the first evidence of the Museum's interest in any art that could be called avant-garde. It should be noted, however, that many of the contemporary artists included in the show were in their fifties and that the more radical of these painters were either not among the prizewinners (Davis and Stella) or not included at all (Dove and O'Keeffe). Also absent were Gorky, Kline, Hofmann, Rothko, Baziotes, and all others of the new generation of avant-garde painters then working in New York.

The Metropolitan's collection of American modernists was enhanced significantly by the Stieglitz bequest, which came to the Museum in 1948. No other museum in New York benefited from Stieglitz's will — he had always resented the Museum of Modern Art for its favoring of European modernists and for showing American artists in their shadow; likewise, he was critical of the Whitney for championing realist, figurative painters, especially the regionalists — and he chose to distribute his collection (culled from forty-one years of exhibitions at 291, the Intimate Gallery, and An American Place) to five institutions across the country whose efforts on behalf of modern art, or whose principles, he sanctioned. The Philadelphia Museum received some paintings, as did the Art Institute of Chicago (which had represented the modernists richly in its Century of Progress Expositions of 1933 and 1934); the newly founded National Gallery of Art received a few works, and Fisk University received 101 objects, a collection believed to be "the finest on modern art in the

South" and providing the nucleus of a new art gallery at Fisk to be hung by Georgia O'Keeffe. By far the largest group of works — some 450 paintings, drawings, and watercolors — went to the Metropolitan Museum, which had, in fact, done relatively little for modernism in Stieglitz's lifetime, but which could assure him — and his artists — the highest form of immortality. [43]

Stieglitz died in July 1946, Arthur Dove a few months later. Demuth had died ten years before; Hartley, who had broken with Stieglitz in 1937, died in 1943. Marin, though still active, spent most of his time in Maine. O'Keeffe ran An American Place for a few years, then, having settled Stieglitz's estate and dispersed his collection, moved permanently to Abiquiu, New Mexico, in 1949. These events marked the end of an era; they also marked a new period of activity for Halpert, who became the official representative of the artists formerly associated with An American Place.

The artists who had been with Stieglitz and the folk art she handled kept Halpert's business brisk in the 1940s, despite competition from galleries showing the new avant-garde styles. In 1942, Peggy Guggenheim opened the Art of this Century Gallery and over the next four years gave one-man shows to Pollock, Hofmann, Motherwell, Rothko, and others. Samuel Kootz began in 1945 to show Baziotes, Gottlieb, Motherwell, and Hofmann, as well as recent Picassos, in the space once occupied by the Daniel Gallery. Sidney Janis's gallery, founded in 1948, originally showed Europeans such as Léger, Kandinsky, Miró, and Mondrian, and then added Americans: Pollock, DeKooning, Gorky, Guston, and Kline. In the 1940s, as in the 1920s, the art galleries were the focal points for the avant-garde; the museums, which had dominated in the 1930s, were now less active in this sphere.

Although others had supplanted them as the most revolutionary and innovative in the 'forties and 'fifties, the Downtown Gallery's artists were still very much in the public eye. Stuart Davis was greatly admired by the new generation of painters who considered him their spokesman and mentor. Sheeler, who during the war worked as a photographer for the Metropolitan Museum, began to have retrospective shows all over the nation: at Dayton (1944), at the Addison (1946), at the Walker in Minneapolis (1952), at Detroit (1954), and finally, in a major touring exhibition originating at the University of California at Los Angeles (1954). Most telling was the critical community's gradual acceptance of Dove, whose work was energetically marketed by Halpert. In 1954, she presented a retrospective of the watercolors by Demuth and Dove, with commentaries for the catalogue provided by the Museum of Modern Art's Andrew Ritchie and Alfred Barr. The curators at the Modern had long admired the work of Demuth, but their interest in Dove was relatively new. Barr's comment is particularly revealing: "Arthur Dove . . . anticipates by 35 years the current interest in a kind of abstraction which depends for its effect upon free, fluent form and color informed by a deep, poetic feeling for nature . . . he should be honored not only for the quality of his lonely art but for his importance as a precursor of the strongest current in mid-century American paintings." Once seen as a pale shadow of vital European movements, Dove and his contemporaries, in the eyes of the Modern's chief spokesman, were now to be understood as the harbingers of America's own great style, Abstract Expressionism.

John Marin was the most successful artist associated with the gallery. His work had sold well since the 1920s, when watercolors (always the most popular of his works) brought four figures; his prices remained consistent for the next two decades. An apotheosis of sorts came in 1948, when *Look* magazine announced that a committee of artists and museum directors had selected Marin as the preeminent artist then working in the United States — ahead of Weber, Feininger, Burchfield, and others placed in the "Top Ten." [44] Marin's joining the Downtown Gallery in 1950 was thus a cause for special celebration. Although she had shown his works before — in 1939, in a special arrangement with Stieglitz — Halpert on this occasion planned an elaborate installation of only Marin's work, designed by Edward Larrabee Barnes. The establishment of the "Marin Room" marked "the first time that a room in a gallery has been devoted to a living artist." [45]

After the war, a new group of collectors who became specialists in early twentieth-century American art began to patronize the Downtown Gallery. One of them, Roy Neuberger, began in the 1930s as a supporter of contemporary art but, as time passed, he became interested in earlier American painting as well. His favorite artist was Milton Avery, whose works — over 100 — he bought from Paul Rosenberg; he also bought Crawford, Davis, Sheeler, and Spencer from the Downtown Gallery, as well as (in 1950) his great Dove: *Holbrook's Bridge to the Northwest* (1938). [46] Another great collector of the period was George Hopper Fitch. Encouraged by Halpert and Juliana Force of the Whitney, Fitch assembled a brilliant collection of twentieth-century American watercolors, including O'Keeffe's breathtaking *Red Canna* (1920), much of which he has recently given to Yale. Inspired by the Metropolitan's "Artists for Victory" exhibition, Edith and Milton Lowenthal began collecting on a large scale about 1943. Their interest in Weber, Hartley, Jacob Lawrence, and others naturally led them to the Downtown Gallery; it was they who bought Sheeler's *Americana,* much touted in Halpert's 1934 "What is Wrong with this Picture?" exhibition, and Shahn's *Passion of Sacco and Vanzetti,* which they later gave to the Whitney. Their major interest, however, was the work of Stuart Davis. Halpert gave them first refusal of Davis's works in the 1940s and, as a result, they acquired at least seven Davises in that decade, including *Report from Rockport* and *Arboretum by Flashbulb.*

That the artists Halpert had been championing were increasingly considered a closed chapter in the history of American art is borne out by other events in the art world. In 1946, the Whitney presented an exhibition entitled "Pioneers of Modern Art in America," featuring the work of Dove, Davis, Hartley, Weber, Bluemner, and others, all from the late 'teens and early 'twenties. By representing these artists only by their early work, the show gave them a fixed and rather restricted place in the history of American art, obscuring the fact that many of them continued working through the 'thirties and 'forties, and — as is the case with Dove, Davis, and others — produced their best work when they were no longer "pioneers."

Like the Whitney show, the Museum of Modern Art's 1951 exhibition "Abstract Painting and Sculpture in America" did not acknowledge the work produced by the "pioneers" during the 'thirties and 'forties, although the selection was intended as a survey of abstract art from 1913 to 1951. The Modern's by now familiar views on

these artists were expressed once again: that they looked to Europe for inspiration (in his introduction to the catalogue, Andrew Ritchie spends most of his discussion on European art) and that the greatest contribution made by Dove, Hartley, Marin, and others is that they paved the way for the new American painting. Elsewhere, Sidney Janis consigns these artists to the past, and sees them as transitional figures: "Though insecure in their ultimate evaluation of the importance of their cultural revisions, they nevertheless straddle the gap between the European trail-blazers and our own younger generation." [47] The dependence of American modernists on European styles had come to be regarded as historical fact.

That Halpert's artists were seen as part of history rather than of the present was underscored when the collectors with whom she had worked began to give their collections to museums. Joseph Hirshhorn and Seymour Knox, to whom she sold paintings in the 'forties and 'fifties, formed museums from their collections in the 1960s, as did Roy Neuberger at the end of the decade. More recently, Fitch and the Lowenthals curtailed their collecting and gave many important works to Yale and the Brooklyn Museum, respectively. Halpert herself began working directly with museums. She had a strong interest in geographical distribution, for she was eager to have her artists known by the most varied audiences possible; consequently, she placed works in public collections not only in New York but also in San Francisco, Los Angeles, Richmond, Toledo, Minneapolis, and other cities. In Wichita, she guided the formation of the twentieth-century segment of the Roland P. Murdock Collection, a collection of American art assembled in Murdock's memory for the Wichita Art Museum.

A better market accompanied the approbation of the art museums, especially in the case of Stuart Davis. Although in the 1930s his art was much admired by critics and peers, Davis sold so few paintings that he could take the pauper's oath required of most painters hired by the Federal Arts Project of the WPA. His 1946 retrospective at the Downtown Gallery presented many major works from the two previous decades, including several paintings from the "Egg Beater" series that had never sold. Yet by the 1950s, Davis's major works were eagerly sought by museums. And in the 1973 auction of Halpert's own collection, Davis's 1940 work *Hot Still-Scape for Six Colors* (no. 82) brought one of the highest prices realized by a twentieth-century American painting up to that time.

By the 1950s, Halpert, too, had come to view her artists as a part of history — and saw no less plainly her own role in it. Her group shows of this period often took the form of surveys, i.e., retrospectives of the work of one artist, or overviews of a decade. "In 1940" (presented in March 1950) was one of these exhibitions. It included many of the major works of the era (such as Crawford's *At the Dock No.2*, owned by Roy Neuberger, and Levine's *City Lights*, in the Lowenthal Collection) that she had handled. In 1959, in conjunction with the Worcester Art Museum, the Downtown Gallery showed the Dial Collection — the artists, and often the specific pictures, assembled by publisher-critic Scofield Thayer for reproduction in *The Dial's Living Arts* portfolio of 1923. And in 1962, Halpert presented "Abstract Painting in America, 1903-1923," with most works — including Demuth's *White Architecture*, Hartley's *Painting No. 2*, and Dove's *Indian Spring* (nos. 55, 6, and 10 in the present

exhibition) — borrowed back from the collectors to whom she had sold them to create a historical survey of the period. Halpert did not slight the contemporary efforts of her stable, but her presentation of their new works was often coupled with works of the past. This was the case in her "Recurrent Image" show of 1956, which paired early and late works by the same artist (such as Davis's *Eggbeater No. 3* [1927] and his *Medium Still Life* [1953; nos. 80 and 84] in an effort to demonstrate her theory that artists in their maturity frequently return to compositional motifs generated in their early years. Like so many of Halpert's shows, "The Recurrent Image" did make people *look* and take seriously all phases of an artist's production.

For an artist such as Arthur G. Dove, who had not yet won the recognition his work deserved, Halpert's exhibition program was especially ambitious. Dove suffered more than most artists from being pigeonholed as a "pioneer of abstraction"; as a consequence, his later work was little known, despite its graphic power and evocative, spiritual quality. Halpert took over the Dove estate after both he and Stieglitz died in 1946 and began a vigorous campaign to promote his works. Beginning in 1947, she gave Dove a one-man show almost every year, stimulating public interest by continually introducing new aspects of his work: paintings in 1947 and 1952, watercolors in 1949 and again in 1954 (with Demuth's), and collages in 1955. She solicited commentaries and reviews from critics and scholars like Barr and Ritchie and Thomas Hess,[48] lent generously from the Dove estate to shows all over the country, and kept prices low.

The most significant of the Dove shows was put on in 1956, when, following a conversation with a sympathetic collector and fellow Dove enthusiast, Halpert investigated a group of paintings stored in a New York warehouse by Dove's son after the artist's death. The cache contained many of Dove's paintings from the 1940s — arguably his best work — much of which had been shown only once, at An American Place. Halpert presented these pictures in a "Special Exhibition of Paintings by Dove," which included *Neighborly Attempt at Murder* and *Dancing Willows* (nos. 24 and 29). Halpert's exhibition, followed two years later by a major traveling retrospective organized by Frederick S. Wight for the Art Galleries of the University of California at Los Angeles, finally generated for Dove public recognition comparable to that enjoyed by Stieglitz's other artists.

During the next decade, Halpert was increasingly troubled by ill health, and the activities of the Downtown Gallery (which moved to the Ritz Towers in 1965) diminished. There was no decline, however, in her efforts on behalf of the American artist. She continued to seek out and encourage new talent; New York audiences were introduced to young artists as diverse as Walter Meigs and Karl Zerbe in her showrooms, and exhibitions of "Progressive American Art" were presented every season at the Downtown Gallery.[49] In 1959, she organized and took to Moscow the "U.S. National Art Exhibition," a controversial survey of twentieth-century American art (including Sheeler's *Lunenburg* [no. 54] and Marin's *Movement — Sea and Sky* [no. 2]), which confused President Eisenhower far more than the Russian audiences for which it was designed. In 1962 Halpert joined the board of the Corcoran Gallery of Art in Washington and had two shows drawn from her own collection mounted

there. In 1963 she organized, with Sam Hunter, the exhibition "American Modernism: The First Wave" for the Rose Art Museum at Brandeis; this show was followed, in 1968, by an exhibition at the University of Connecticut Museum of Art — "Edith Halpert and the Downtown Gallery" — which saluted both her collection and her role as a champion of American modernism. Not only her artists but Halpert herself had become part of history.

Halpert died in 1970. Her hopes to have her own collection in the nation's capital were disappointed when no agreement could be reached with the Corcoran, and in 1973 the collection was dispersed at auction in New York. The record prices realized at that sale vindicated her judgment as an entrepreneur, but the dispersal of her collection, rather than its preservation in prominent institutions as Stieglitz's had been, may account for the delayed recognition of her achievements as a connoisseur and tastemaker. Nonetheless, her discerning eye and the effectiveness of her work on behalf of the American artist are indicated by the high esteem in which her artists are now held. Her goal of broad geographical representation for these artists was realized toward the end of her life, when major American museums mounted large-scale retrospectives of the work of the painters she championed — Dove (Art Galleries of the University of California at Los Angeles in 1958, and Whitney Museum in 1975), Davis (National Collection of Fine Arts in 1965, and Brooklyn Museum in 1978), Sheeler (National Collection Fine Arts in 1968), and Hartley (Whitney Museum in 1980). Their works are studied intently by young artists, are eagerly sought by collectors, and are given pride of place in twentieth-century galleries in public institutions across the country. The present exhibition, the first celebrating the work of this group of American modernists ever to be held at the Museum of Fine Arts, at last enables Boston to participate in the distinguished tradition of education and connoisseurship that stretches back to Alfred Stieglitz and Edith Gregor Halpert.

## NOTES

1. Virgil Barker, writing in The Arts 11 (February 1927), p. 59. Other critics, among them Forbes Watson, the editor of The Arts, expressed concern that modern art's progressive component was being diluted by its increased popularity. Watson noted, somewhat ruefully, that modern painting had "become news," but then acknowledged that the presence of "modern" design in advertising indicated that "modern art has made phenomenal progress toward universal popularity." ("Our Fifth Birthday," The Arts 12 [December 1927], p. 293.)

2. George Heard Hamilton, "The Société Anonyme at Yale," Collection of the Société Anonyme: Museum of Modern Art 1920 (New Haven, 1950), pp. XIX–XXII.

3. Stieglitz to Paul Rosenfeld, 1923, as quoted in Sasha M. Newman, Arthur Dove and Duncan Phillips: Artist and Patron (Washington, D.C.: Phillips Collection, 1981), p. 31.

4. Christian Science Monitor, November 18, 1926; New York Journal of Commerce, January 6, 1927; New York Post Literary Review, November 20, 1926.

5. Russell Lynes, Good Old Modern: An Intimate Portrait of the Museum of Modern Art (New York, 1973), p. 43.

6. "Other artists have known their purpose

which, as they claim, is to express themselves. But they have babbled in strange, outlandish idioms, missing the language of art. That language is, among other things, a language of craftsmanship . . . flout it and you land in uncouth obscurity." (Royal Cortissoz, "291," *Personalities in Art* [New York, 1925], pp. 421-422.)

7. See Thomas Craven, *Men of Art* (New York, 1934), especially pp. 508ff., and Thomas Hart Benton, "Form and the Subject," *Arts* 4 (June 1924), pp. 303-308. Benton concludes his essay with the following claim: "A revival of interest in subject will get the artist out of his narrow Bohemianism, may possibly in time make him part of the world which, heaven knows! is justified in its indifference to his concern with napkins and vegetables, and certainly will start going a finer compositional activity than we have today. America offers more possibilities in the field of theme to her artists than any country in the world, and it is high time that native painters quit emulating our collectors by playing the weathercock to European breezes."

8. Ralph Waldo Emerson, "The American Scholar," reprinted in *American Literature: The Makers and the Making* 1, Cleanth Brooks, R.W.B. Lewis, Robert Penn Warren, eds. (New York, 1973), p. 711.

9. Henry McBride, quoted in George H. Roeder, Jr., *Forum of Uncertainty* (Ann Arbor, Michigan, 1978), p. 65.

10. William Zorach, "The New Tendencies in Art," *The Arts* 2 (October 1921), p. 10.

11. Samuel Kootz, *Modern American Painters* (New York, 1930), pp. 3, 18.

12. Paul Strand, "American Watercolors at the Brooklyn Museum," *The Arts* 2 (December 1921), p. 151.

13. Virgil Barker, "The Watercolors of John Marin," *The Arts* 5 (February 1924), pp. 64-83. Barker's defense of modern art was not the only one to include amusing tricks and devices aimed at making it palatable and comprehensible. Following an exhibition of the same title mounted in 1949 at the Museum of Modern Art in celebration of its twentieth anniversary, Robert Goldwater and René d'Harnoncourt published a pamphlet explaining "Modern Art in Your Life" — the ubiquity of modern styles (in furni-

ture, magazine layouts, record jackets, etc.), and how to enjoy them.

14. *New York Evening Post,* May 31, 1929.

15. *Art News,* December 10, 1927.

16. *A.E. Gallatin Collection, "Museum of Living Art"* (Philadelphia Museum of Art, 1954), p. 5.

17. Howald did not get along well with Stieglitz. Apparently he resented Stieglitz's vigorous promotion of Marin, Dove, and especially O'Keeffe: he never bought a work by O'Keeffe, nor did he buy anything from the Intimate Gallery. See Mahonri Sharp Young, "Ferdinand Howald and His Artists," *American Art Journal* 1 (Fall 1969), p. 121.

18. For an excellent discussion of the relationships between Dove, Stieglitz, and Phillips, see Sasha M. Newman, *Arthur Dove and Duncan Phillips: Artist and Patron* (Washington, D.C.: Phillips Collection, 1981), pp. 9-47.

19. "A New Art Museum," quoted in Alfred H. Barr, Jr., *Painting and Sculpture in the Museum of Modern Art, 1929-1967* (New York: Museum of Modern Art, 1977), p. 620.

20. Lloyd Goodrich in *Nation,* December 4, 1929.

21. Russell Lynes, *Good Old Modern: An Intimate Portrait of the Museum of Modern Art* (New York, 1973), p. 65.

22. Aline Saarinen, *The Proud Possessors* (New York, 1958), p. 359.

23. For Abby Aldrich Rockefeller's collection, see Dorothy C. Miller, "Contemporary American Paintings in the Collection of Mrs. John D. Rockefeller, Jr.," *Art News: The 1938 Annual* 36 (March 26, 1938), pp. 105ff.

24. Among the many works given by Goodwin to the Museum are Sheeler's crayon drawing *Stove* (1931), Demuth's still-life watercolor *Eggplant and Tomatoes* (1926), and Dove's whimsical collage *The Intellectual* (1925).

25. Carlyle Burrows in the *New York Herald Tribune,* April 27, 1930.

26. Thomas Craven, *Modern Art: The Men, The Movements, The Meaning* (New York, 1934), pp. 312-313.

27. Ibid., p. 270.

28. Barbara Haskell, *Marsden Hartley* (New York: Whitney Museum of American Art, 1980), p. 79.

29. "Mrs. Halpert's American Scene Differs from Mid-Western School," *Art Digest* 9 (March 15, 1935), p. 10.

30. Davis himself was an eloquent spokesman for Halpert's position that progressive painting was not un-American, and he did a great deal to reconcile the divergent impulses of artists on the right and the left. In an essay entitled "Abstract Art and the American Scene," he wrote: "I am an American, born in Philadelphia of American stock. I studied art in America. I paint what I see in America, in other words, I paint the American scene . . . . I don't want people to copy Matisse, or Picasso, although it is entirely proper to admit their influence. I don't make paintings like theirs. I make paintings like mine." (Davis in *Parnassus,* March 13, 1941.)

31. "Ben Shahn's 'The Passion of Sacco and Vanzetti,' " *New York Sun,* April 16, 1932, reprinted in *The Flow of Art. Essays and Criticisms of Henry McBride,* Daniel Catton Rich, ed. (New York, 1975), p. 291.

32. In "My Day" for December 11, 1936 (carried in the *New York World Telegram*), she stated: "Here some erstwhile WPA painters and art workers have some work on exhibition at prices which you and I can perhaps afford. In the collection you will surely find something you would like to look at day in and day out!"

33. A series of monographs concerning twentieth-century American artists that the Whitney published in the 1930s reflects the same emphasis. The majority of those chosen were representational painters of the 'twenties and 'thirties: Hopper, Miller, Brook, and so on, or their forefathers: Henri, Sloan, Glackens. Of the pioneers of modernism, only Demuth was represented in the original series, with books on Marin and Sheeler planned but never issued.

34. During the 1930s, the Frank K.M. Rehn Gallery showed Kroll, Luks, Feuer, and Hopper; Julien Levy, whose gallery opened in 1931, showed Man Ray, Joseph Cornell, Dali, Tchelitchew, and other surrealists, American and European; abstract artists like Holty, Morris, Ferren, and Hiler were shown at the Reinhardt Gallery and at the Squibb Building Galleries; and Macbeth, in existence since 1892 and the first gallery to show American art exclusively, showed Lawson, Jerome

Myers, Curry, and Irving R. Wiles. Stieglitz, of course, continued to show O'Keeffe, Dove, Demuth, Marin, and Hartley at An American Place.

35. Morris, quoted in John Elderfield, "American Geometric Abstraction in the Late 30s," *Artforum* 11 (December 1972), p. 38.

36. Mary Morsell, "Whitney Museum Holds Exhibition of Abstract Art," *Art News* 33 (February 16, 1935), p. 3.

37. The core of Lewisohn's collection had been inherited from his father, Adolph Lewisohn. It emphasized French art, Impressionist and post-Impressionist; Lewisohn's taste for contemporary art was eclectic, including all artistic movements "with the exception of two, the cubist, or abstract, and the surrealist," which he considered hopelessly hindered by "obscure personal jargon" — a surprisingly narrow attitude for an otherwise great collector, but one echoed by Stephen Clark, Chester Dale, and other contemporaries (including Duncan Phillips at first). The American works Lewisohn owned were primarily by artists like Sterne and Speicher. See *The Lewisohn Collection*, with introduction by Theodore Rousseau, Jr. (New York: Metropolitan Museum of Art, 1951), pp. 9-10. Soby, on the other hand, specialized in surrealist painting and assembled a particularly fine group of De Chiricos. The American works he acquired in the 'thirties and 'forties were also surrealist influenced: Berman, Blume, Cornell, and so on.

38. Halpert, quoted in " 'Expand:' Is Retort to Depression: Add New Floor to Downtown Gallery," Chicago *Post*, October 11, 1932.

39. Alfred H. Barr, Jr., "Painting and Sculpture in the United States," *Trois Siècles d'Art aux Etats-Unis* (New York: Museum of Modern Art and Paris: Musée du Jeu de Paume, 1938), p. 29. The terms "precisionist" and "immaculate" had been applied to Sheeler's work as early as 1917. See John Paul Driscoll, "Charles Sheeler's Early Work: Five Rediscovered Paintings," *Art Bulletin* 62 (March 1980), p. 124, note 1.

40. Quoted in Russell Lynes, *Good Old Modern: An Intimate Portrait of the Museum of Modern Art* (New York, 1973), p. 187.

41. James Thrall Soby, *Romantic Painting in America* (New York: Museum of Modern Art, 1943), pp. 5, 40.

42. See Charles Downing Lay, "The Hearn Fund," *Arts* 11 (March 1927), pp. 139-142.

43. Although most of the Metropolitan's trustees, administrators, and curators objected to modern art, the importance of the Stieglitz circle was acknowledged in the 1940s by the Museum's fifth director, Francis Henry Taylor. William Ivins, the farsighted curator of prints at the Metropolitan, was an admirer of American modernism; his purchase of Stieglitz photographs and his cordiality to both Stieglitz and O'Keeffe undoubtedly affected Stieglitz's decision. See Calvin Tompkins, *Merchants and Masterpieces* (New York, 1970), pp. 295-313.

44. *Look* magazine 12 (February 3, 1948), p. 44.

45. Publicity release for the Downtown Gallery's Marin Room, as quoted in Sheldon Reich, *John Marin: A Stylistic Analysis and Catalogue Raisonné* (Tucson, 1970), p. 227.

46. For the Neuberger collection, see Daniel Robbins, *The Neuberger Collection. An American Collection* (Providence: Museum of Art, Rhode Island School of Design, 1968).

47. Sidney Janis, *Abstract and Surrealist Art in America* (New York, 1944), p. 33.

48. See, for example, Hess's laudatory review of the 1947 Dove retrospective exhibition in *Art News* 45 (January 1947), pp. 22-23, 62.

49. These shows continued to win favorable publicity, and were written up from time to time in national news magazines. See, for example, "Back Bay Prodigies," *Newsweek* 29 (May 5, 1947), p. 97, or "New Crop of Painting Protégés," *Life* magazine 32 (March 17, 1952), pp. 87-88, 91.

# ILLUSTRATIONS

John Marin's expressive watercolor style was formed by about 1911 or 1912; it never changed significantly, but grew richer and surer over the years. His watercolors won the admiration of his fellow painters and they sold well. Alfred Stieglitz, the photographer and gallery owner who did so much to win a foothold for modern art in America, thought Marin's art epitomized Americanness. Observing that various artists objected to Marin's not being "modern," Stieglitz countered: "In answer to such criticism, my sole comment was, 'His work is full of life. He is a natural singer.'"

**1. John Marin**  *Deer Isle, Maine,* 1927
Watercolor on paper, 14½ x 16¼ in.

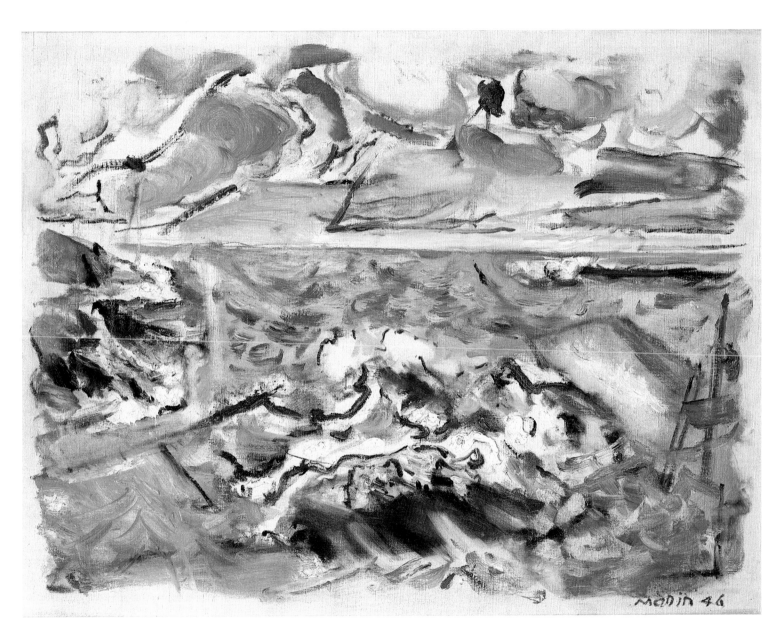

Marin turned to oils increasingly during his late years, and in 1946 and 1947 he made a powerful series of paintings of sea and sky. His style had always been energetic and expressive, but here he was particularly conscious of the abstract element in his work. Late in 1947 he reported from Cape Split, Maine: "Using paint as paint is different from using paint to paint a picture. I'm calling my pictures this year 'Movement in Paint' and not movements of boat, sea or sky, because in these new paintings — although I use objects — I am representing paint first of all and not the motif primarily."

**2. John Marin** *Movement — Sea and Sky,* 1946
Oil on canvas, 22 x 28 in.

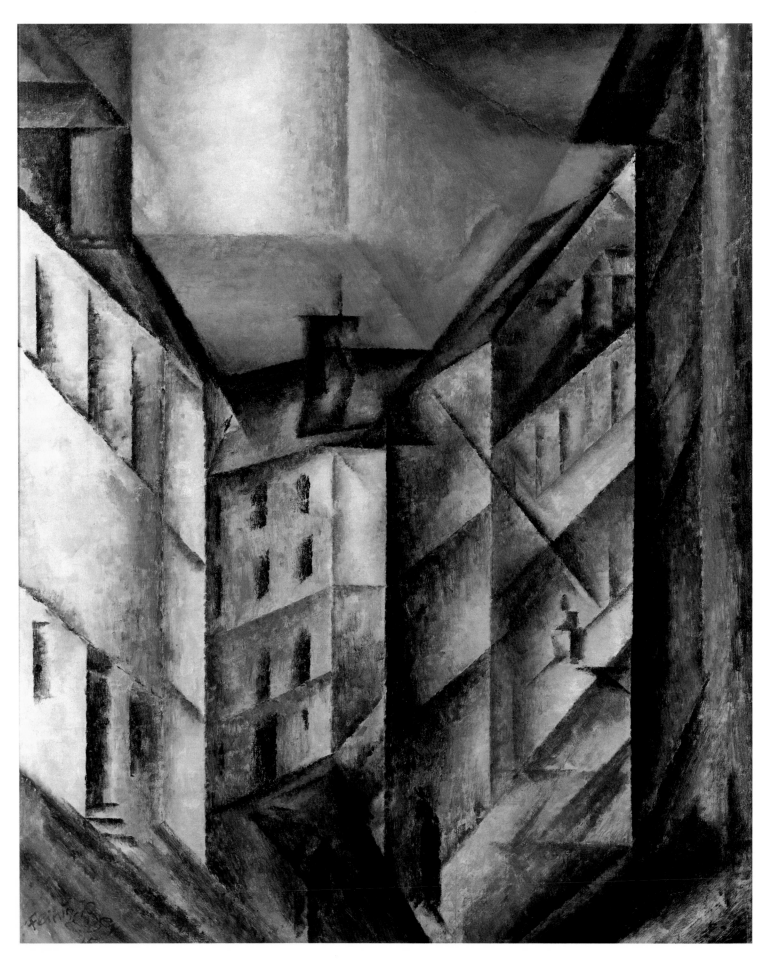

**3. Lyonel Feininger**  *Schlossgasse,* 1915
Oil on canvas, 39½ × 31¾ in.

The Museum of Modern Art acted courageously in
organizing a joint Hartley-Feininger show in 1944,
for the war was on and both painters were closely
associated with Germany. Feininger was born to
German parents in New York, and spent the years
between 1916 and 1936 painting and teaching in
Germany, a respected member of the avant-garde.
Hartley's background was American, but in 1913
he was in Munich exhibiting with the "Blue Rider"
group, and many of his best abstractions of
1915-1916 are based on German military symbols.
The Modern, in holding its exhibition, made an
important statement: that art transcends questions
of both politics and nationality.

Hartley's landscape The Hill was probably made
near Stoneham, Maine; he had not yet been abroad
and was beginning to develop his own style.
Feininger's Schlossgasse (which translates as "Blind
Alley" or "Dead End") is a typical, mature work; it is
a desolate urban scene with buildings blocking out
the light and human figures hardly visible.

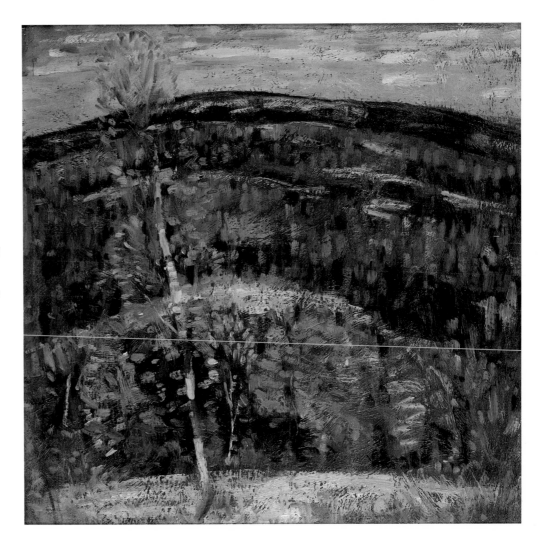

**4. Marsden Hartley**  *The Hill,* ca. 1907-1908
Oil on artist's board, 12¼ × 12¼ in.

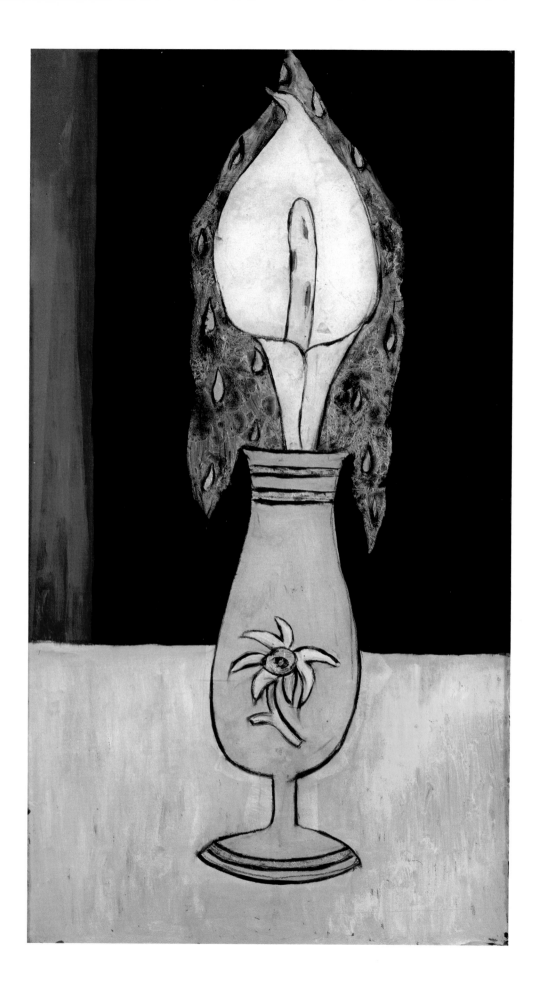

**5. Marsden Hartley**  *Tinseled Flowers,* 1917
Tempera and tinfoil on glass, 17 × 9¼ in.

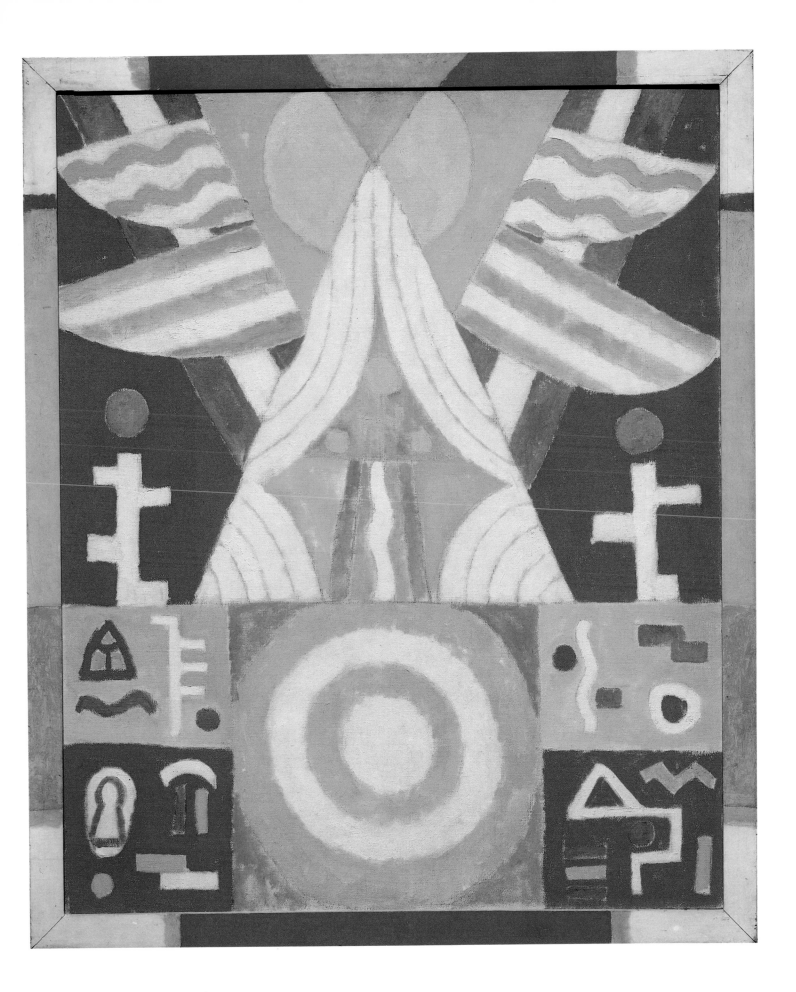

**6. Marsden Hartley** *Painting No. 2,* 1914
Oil on canvas, 39½ × 32 in. (with frame: 42⅜ × 34¾)

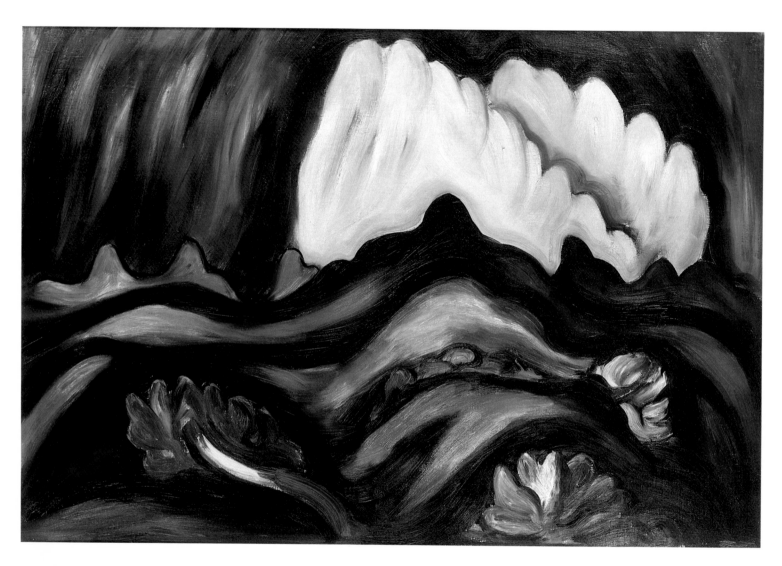

Hartley admired Albert Pinkham Ryder above all earlier American painters. He wrote: "Ryder was the last of the romantics, the last of that first school of impressive artistry, as he was the first of our real painters and the greatest in vision." Hartley had been in New Mexico in 1918 and 1919, and when he painted New Mexico Recollection in 1923, he must have been recalling both the dramatic western scenery and his admiration for Ryder's intensely personal, dark landscapes.

In the late 'thirties Hartley began a series of memorable, rather fierce "portraits" of men who were long since dead. One portrays Ryder with a long beard, dressed in a woolen jacket and fisherman's hat. He did the young Lincoln in 1940, then The Great Good Man in 1942. Late that year he wrote: "I work grand these days and finished a swell (if I do say it myself) 40 x 30 head and shoulders portrait of Lincoln. I am simply dead in love with that man; I took the particular arrangement from one of the original Brady photo replicas, modifying it somewhat. . . . It is the one great face for me and I never tire of looking at it."

**7. Marsden Hartley** *New Mexico Recollection,* 1923
Oil on canvas, 29 x 41½ in.

**8. Marsden Hartley** *The Great Good Man*, 1942
Oil on masonite, 40 × 30 in.

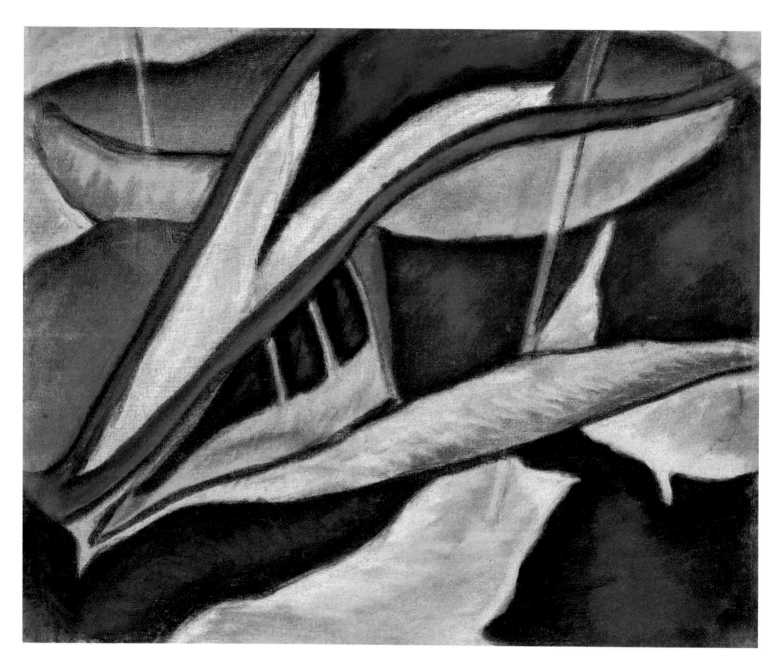

From 1907 to 1909 Dove was in France, where he worked in a style owing something to the Impressionists and something to Matisse. Back in New York, in 1910 and 1911, he quickly shaped his own approach. In the work of these years one sees the artist developing a "breeder idea" — a way of seeing and painting in a distinctive manner by which nature was distilled and then re-formed on canvas — that would serve as the foundation for a creative lifetime.

Many of Dove's exploratory efforts were done in the powdery chalk medium of pastel. *Yachting* may well be one of the series of pastels called "The Ten Commandments" that Dove made during 1911. They were exhibited in New York and then Chicago in 1912, and in the latter city, particularly, they drew many derisive comments from the press. Stieglitz reported: "So the pictures went up, and, of course they were over the heads of the people . . . they were beautiful, they were not reminiscent of anyone else."

**9. Arthur G. Dove**  *Yachting,* ca. 1911
Pastel on linen, 18 × 21½ in.

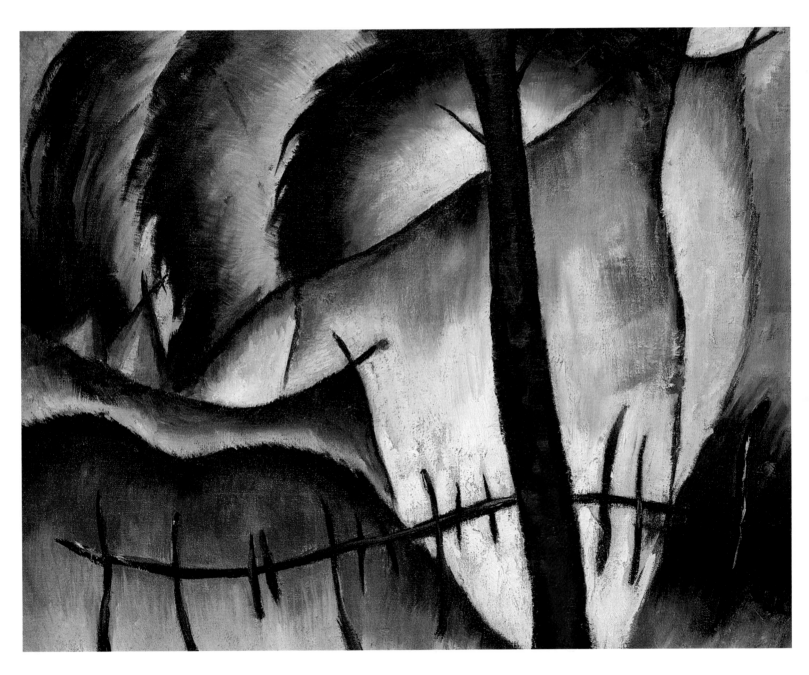

By 1914, Dove's style was fully formed. In that year he said: "I gave up my more disorderly methods (impressionism); in other words, I gave up trying to express an idea by stating innumerable little facts, the statement of facts having no more to do with the art of painting than statistics with literature. . . . I no longer observed in the old way, and not only began to think subjectively, but also to remember certain sensations purely through their form and color, that is by certain shapes, planes, light, or character lines determined by the meeting of such planes."

**10. Arthur G. Dove**  *Indian Spring,* 1923
Oil on canvas, 18 × 22 in.

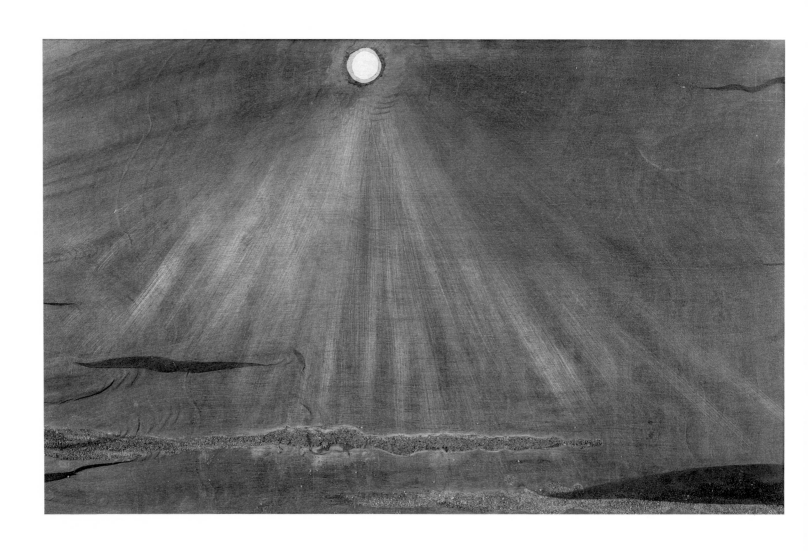

**11. Arthur G. Dove** *The Sea I,* 1925
Cloth, sand, and paper on sheet metal, 13 x 21 in.

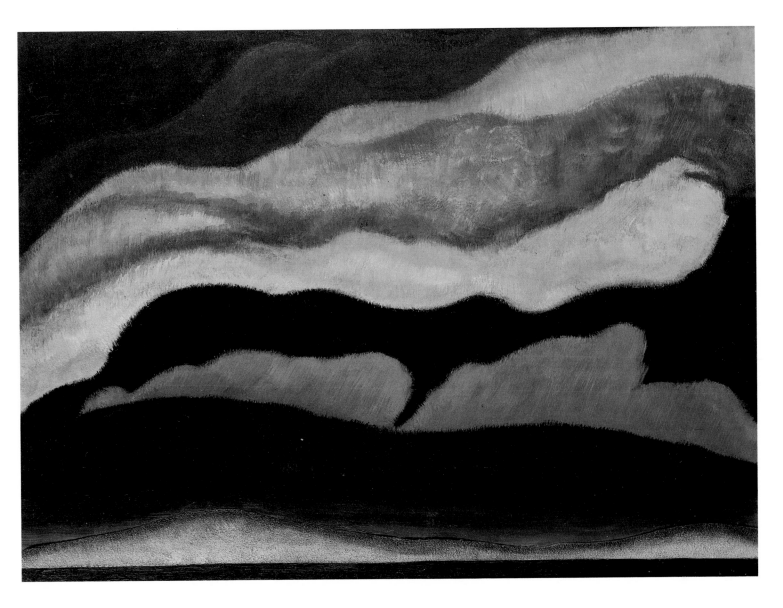

Many modern American painters, from Hartley to Pollock, have admired Albert Ryder's work: to them he seemed the only nineteenth-century American painter who painted what he felt. Both Ryder's brooding landscapes and his tragically unrecognized talent undoubtedly gave solace to painters like Hartley and Dove, who must have known at times that their pictures would be appreciated only after their deaths.

In Clouds, Dove paid direct homage to Ryder, painting the drama of a stormy sky with the use of oil paint on sheet metal and a strip of sandpaper attached near the bottom. For Sea I he used different materials: a thin gauze is stretched over sheet metal, sand was applied below, and a paper moon above. Both collages were made in the years from 1920 to 1927, when Dove was living a frugal existence in cramped space on board his sailboat, the Mona.

**12. Arthur G. Dove**   *Clouds,* 1927
Oil and sandpaper on sheet metal, 15 × 20 in.

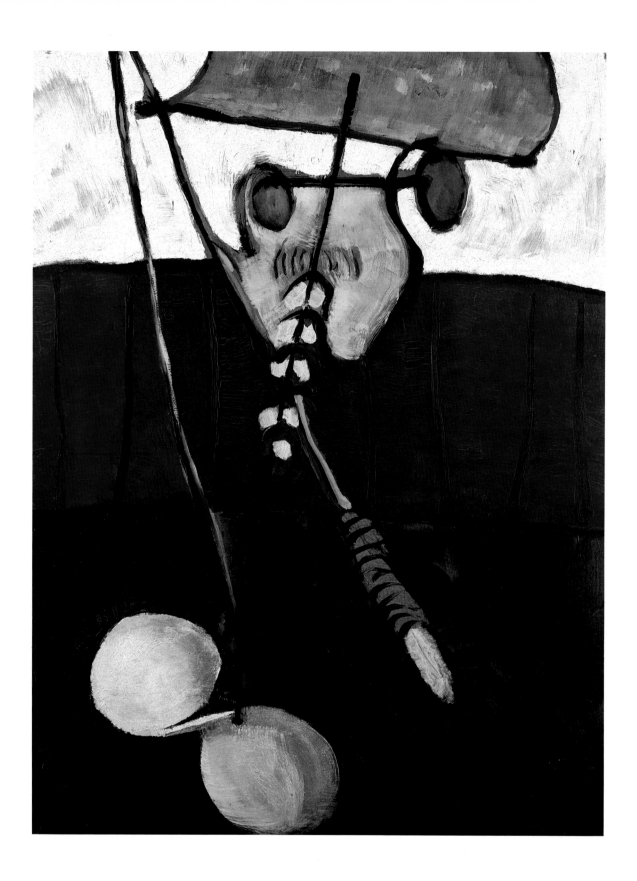

**13. Arthur G. Dove** *Outboard Motor,* 1927
Oil and metallic paint on sheet metal, 20 × 15 in.

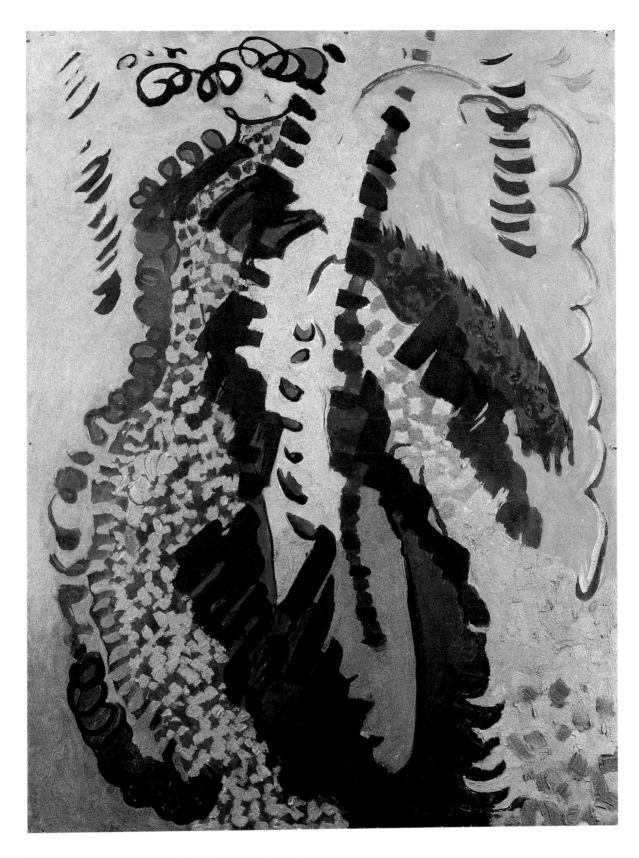

Dove made three works in 1927 based on the music of George Gershwin (1898-1937): Rhapsody in Blue I and II, referring to Gershwin's popular piece of 1924, and I'll Build a Stairway to Paradise, after the song composed in 1922 for a musical called "George White's Scandals of 1922," which featured W.C. Fields in a leading role and had music by Paul Whiteman's orchestra. In other cases, Dove's titles seem to have been assigned as quizzical afterthoughts, but these pictures seem so lyrical and so "jazzy" that one senses the artist painting them as musical equivalents.

**14. Arthur G. Dove** *George Gershwin — I'll Build a Stairway to Paradise,* 1927
Oil and metallic paint on artist's board, 20 x 15 in.

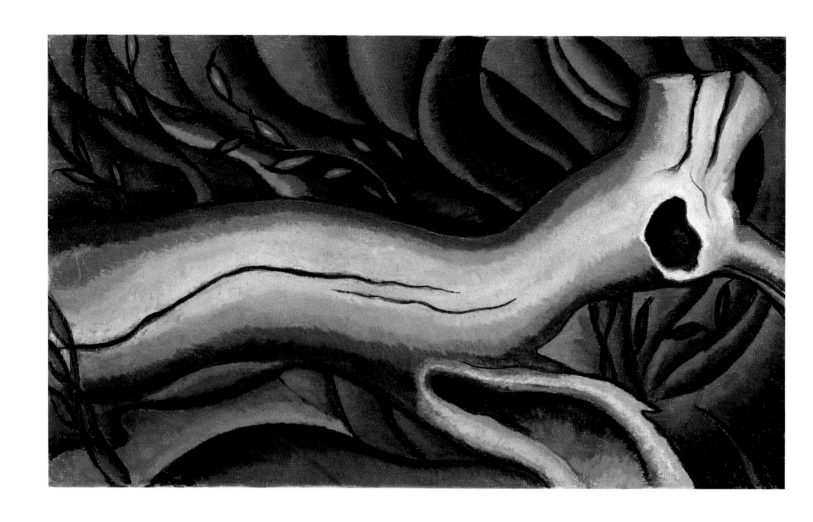

**15. Arthur G. Dove**  *Tree Trunk,* ca. 1929
*Pastel on linen,* 22 × 36 in.

In the period from about 1928 to 1933, Dove did a series of landscapes that are both realistic and highly imaginative. Tree Trunk (no. 15) is one; obviously based on observed nature, it is also stylized and evocative.

Another of this group, Wednesday — Snow, was probably painted in the large upstairs room at the Ketewomeke Yacht Club in Halesite on Huntington Harbor, Long Island, where Dove was resident caretaker. Two tall pilings still stand in the water outside the clubhouse. There's a dreamy feeling here, a gentle other-worldliness, rather than Dove's more usual mood of excited expectancy in nature.

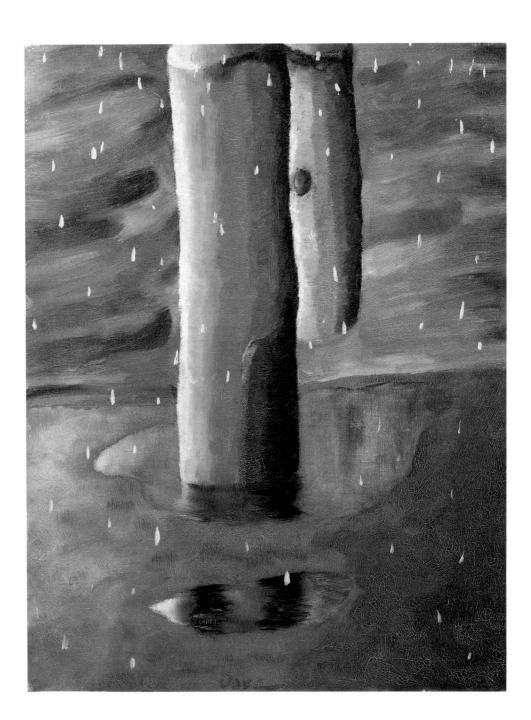

**16. Arthur G. Dove**  *Wednesday — Snow,* 1931
Oil on canvas, 24 x 18 in.

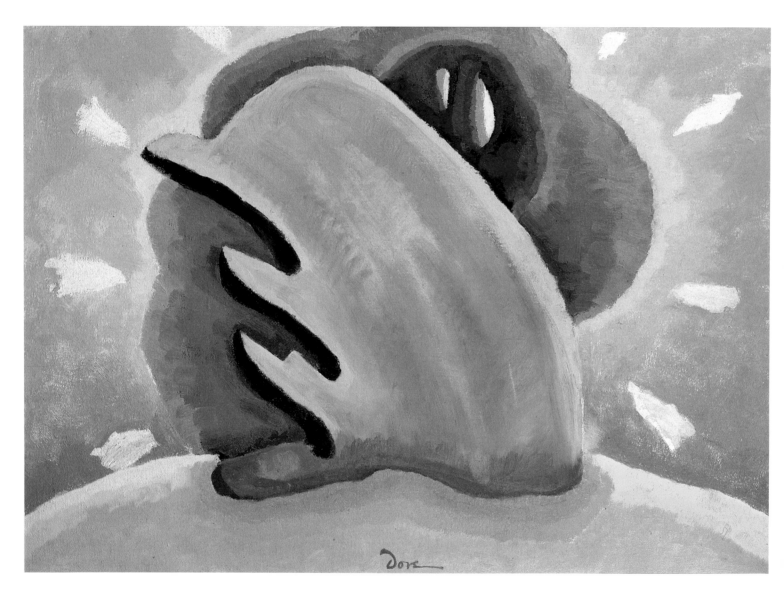

Marsden Hartley wrote of Cézanne's feeling for "the magnetic tendency of one thing toward another in nature, that trees and hills and valleys and people were not something sitting still for his special delectation, but that they were constantly aspiring to fruition."

Dove's work of the 'thirties, particularly, displays this sense of aspiration and growth in nature: in Summer there is an expression of flowering, of imminence.

**17. Arthur G. Dove**  *Summer*, 1935
Oil on canvas, 25 × 34 in.

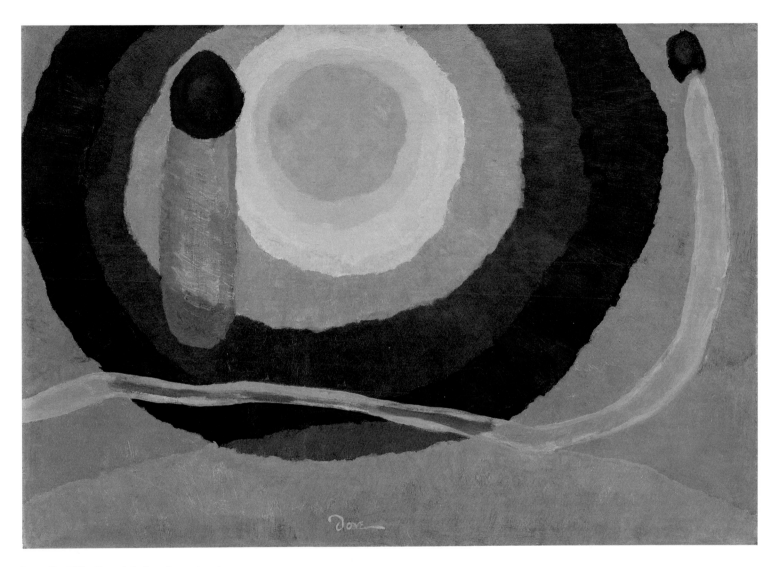

Dove, like O'Keeffe and Gorky, often painted shapes that seem sexually suggestive. In 1930 he referred, in a letter to Stieglitz, to "the bursting of a phallic symbol into white light," possibly describing what appears in this painting of sunrise.

According to the painter's records, Sunrise I was painted with tempera, a water-soluble medium that usually results in a flatter, drier appearance than oil paint. He listed just three pigments in this painting — Naples yellow, ultramarine blue, and rose madder (a deep red) — though white and presumably black were also employed, as he created a broad and subtle range of oranges, blues, grays, and olive greens.

**18. Arthur G. Dove** *Sunrise I*, 1937
Tempera on canvas, 25 x 35 in.

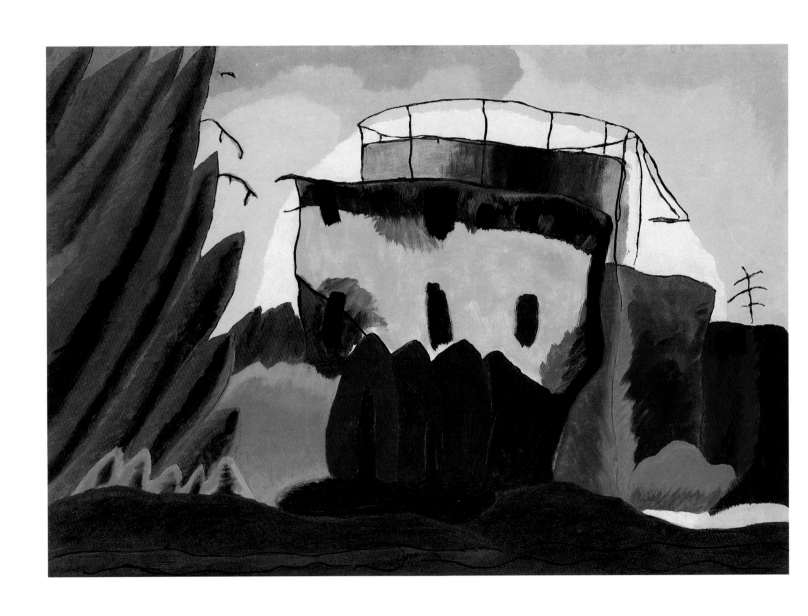

**19. Arthur G. Dove**  *Tanks,* 1938
Oil and wax emulsion on canvas, 25 × 35 in.

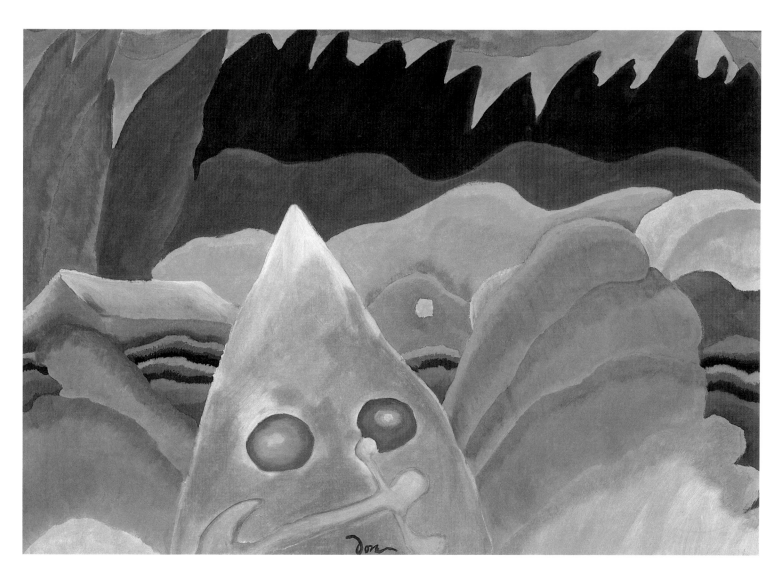

Motor Boat is classic Dove. It reminds us of his lifetime concern with the sea, beginning with Yachting (no. 9); continuing in the 'twenties, when he made small collages and paintings while living on his boat; and surviving even in the years from 1933 to 1938, when he was landlocked in Geneva, New York (near Seneca Lake, where this may have been painted).

Like every Dove, Motor Boat can be seen as abstraction — as a complex of forms and colors with a distinct emotional content — or it may be viewed as reality, as an observed scene with the prow of a boat rushing toward land, with waves splashing up on each side and houses and waving trees on shore visible in the near-darkness. Dove's

pictures demand to be seen in both ways at once: they are optical in a sense, and the viewer's eye jumps back and forth between the clues about reality and the abstraction involved in picture-making.

**20. Arthur G. Dove**  Motor Boat, 1938
Tempera on canvas, 25 × 35 in.

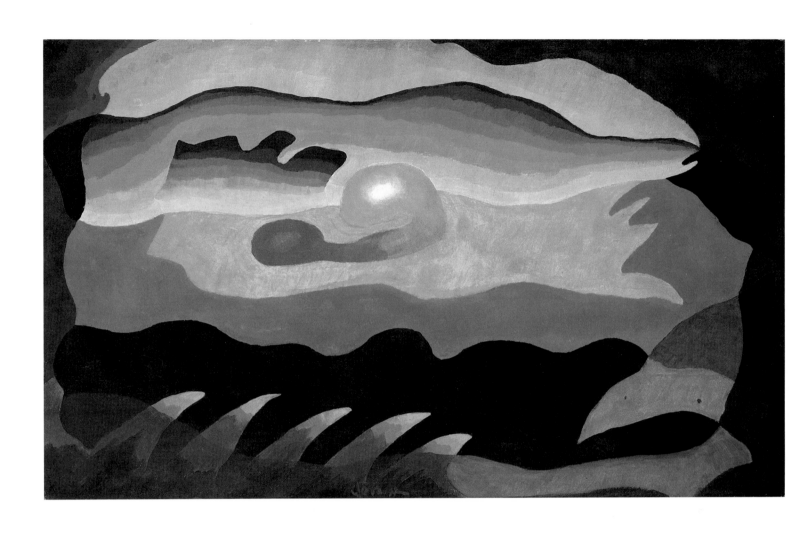

**21. Arthur G. Dove**  *What Harbor*, 1939
Oil on canvas, 16 × 26 in.

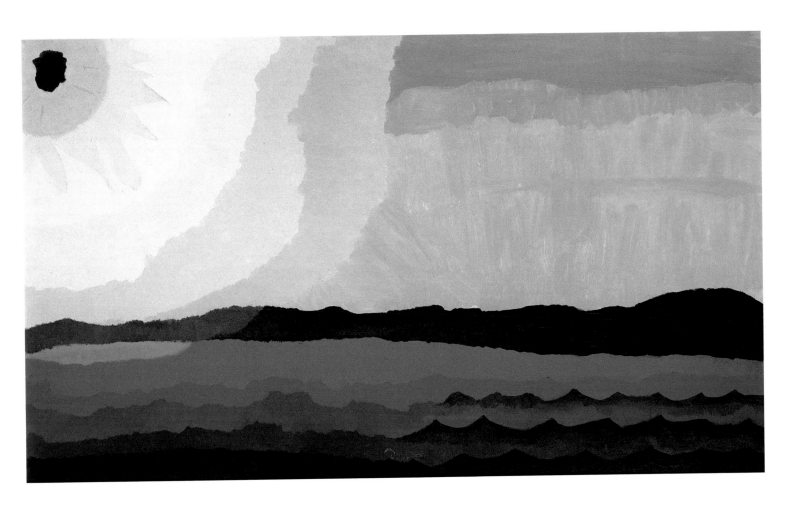

**22. Arthur G. Dove**   *Sun on the Lake,* 1938
Oil and wax emulsion on canvas, 22¼ × 36 in.

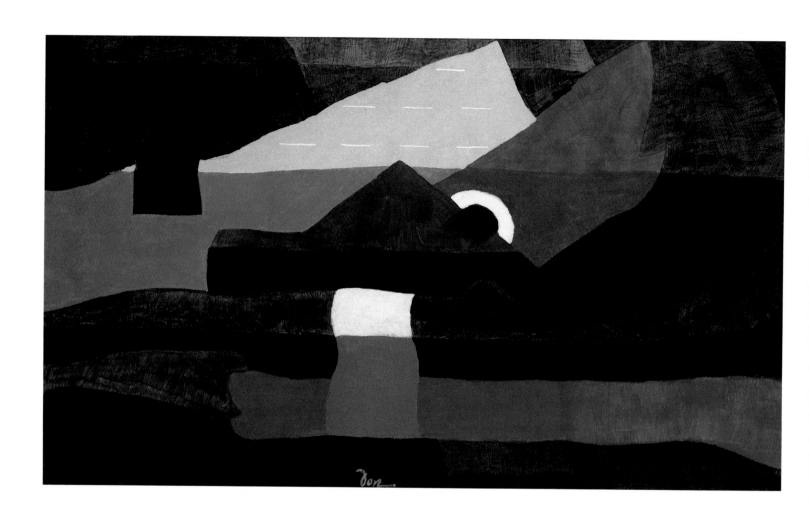

**23. Arthur G. Dove** *Traveling,* 1942
Oil on canvas, 16 x 26 in.

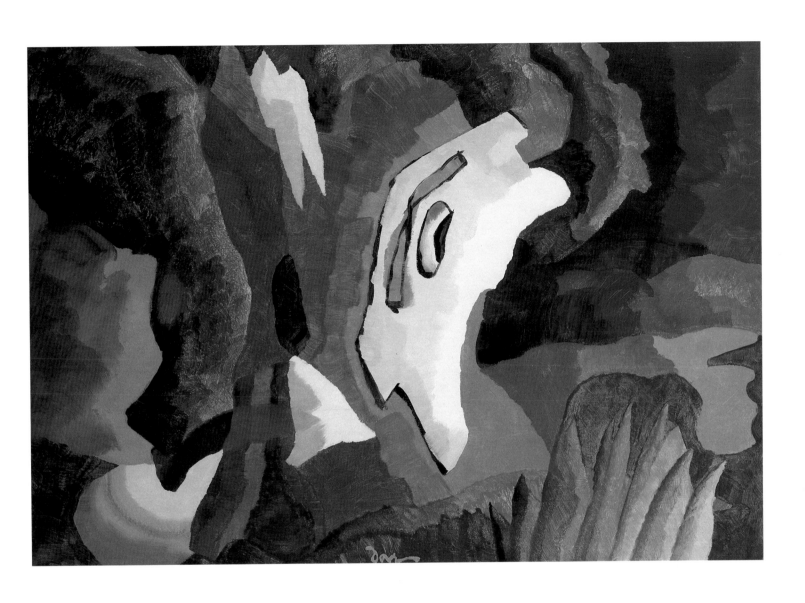

**24. Arthur G. Dove** *Neighborly Attempt at Murder*, 1941
Oil and wax emulsion on canvas, 20 x 28 in.

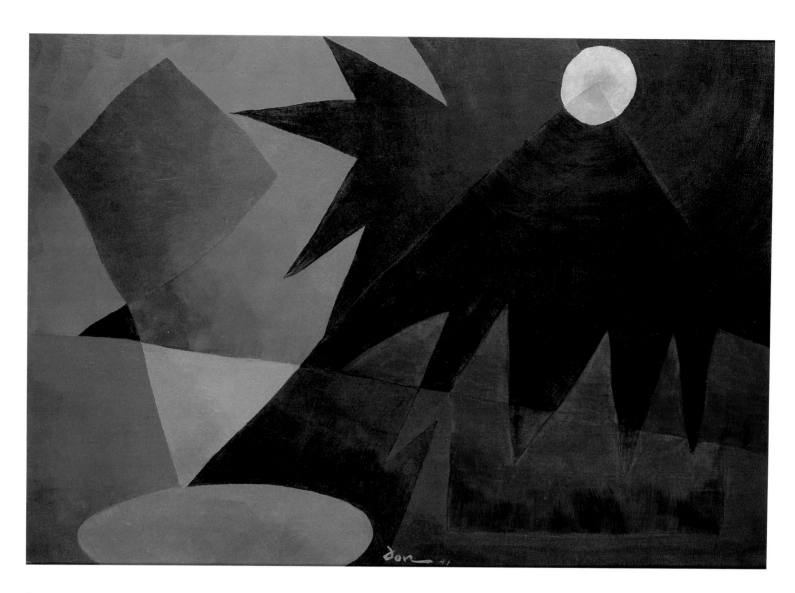

During the war years Dove lived in a tiny converted post office in Centerport, Long Island. His front door stood a few feet from what must have been a busy road, even then, and his back porch rested on rickety pilings at the top of Centerport Harbor. In 1939 he suffered a heart attack, complicated by Bright's disease, and he was weak and immobile during these last years. Yet in this unlikely situation, Dove made a series of luminous, lyrical pictures, condensing observed reality as he had from the start, seeing nature in terms of distinct planes and geometric shapes.

**25. Arthur G. Dove**   *Evening Blue (Firmament),*
1941
Oil and wax emulsion on canvas, 20 × 28 in.

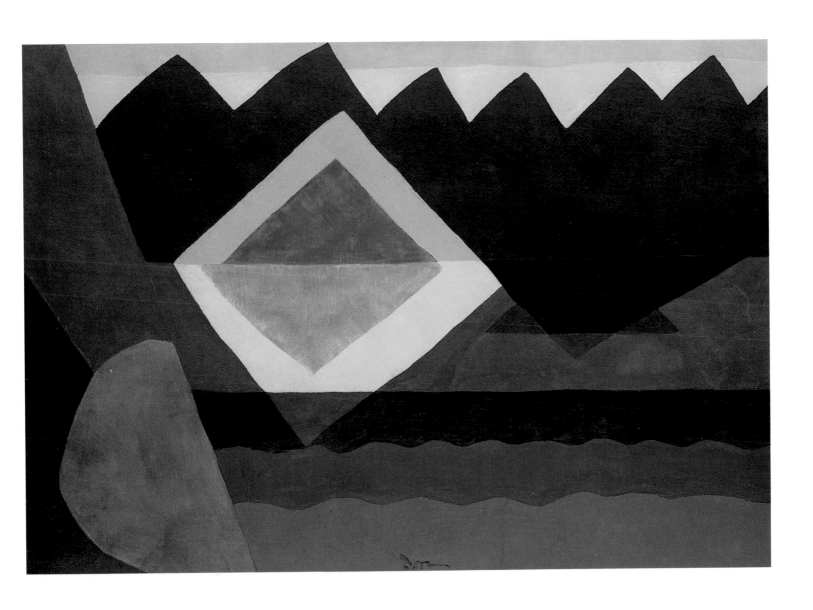

**26. Arthur G. Dove**  *Square on the Pond,* 1942
Oil and wax emulsion on canvas, 20 × 28 in.

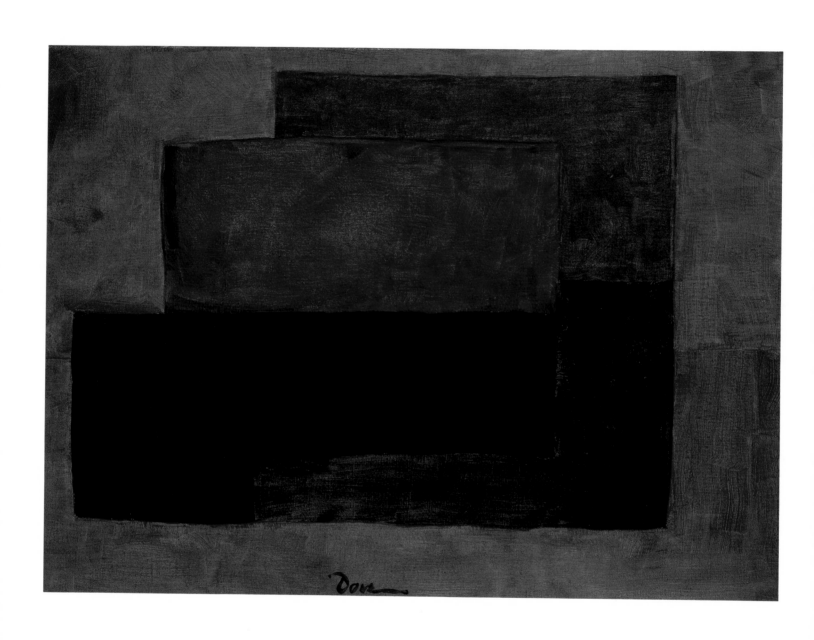

**27. Arthur G. Dove** *Roof Tops*, 1943
Oil on canvas, 24 × 32 in.

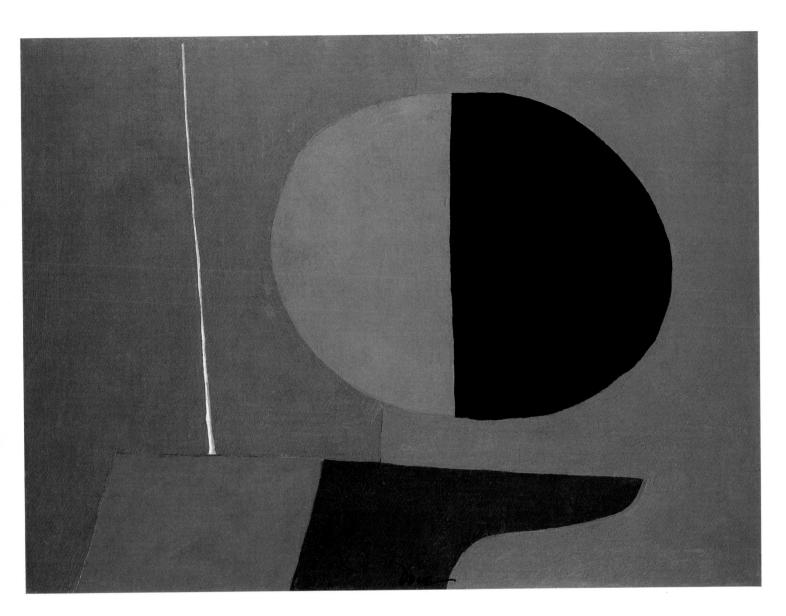

In October 1946, a month before his death, Dove wrote his patron Duncan Phillips for the last time: "You have no idea what sending on those checks means to me at this time. After fighting for an idea all your life I realize that your backing has saved it for me and I meant to thank you with all my heart and soul for what you have done. It has been marvelous. So many letters have been written and not mailed and owing to having been in bed a great deal of time this summer, the paintings were about all I could muster up enough energy to do at what I considered the best of my ability. Just before Stieglitz's death I took some paintings to him that I considered as having something new in them. He immediately walked right to them and spoke of the new ideas. His intuition in that way was remarkable and I am so glad to have been allowed to live during his and your lifetimes. It has really been a great privilege for which I am truly thankful."

**28. Arthur G. Dove** *Flagpole, Apple Tree and Garden,* 1943-1944
Oil and wax emulsion on canvas, 24 x 32 in.

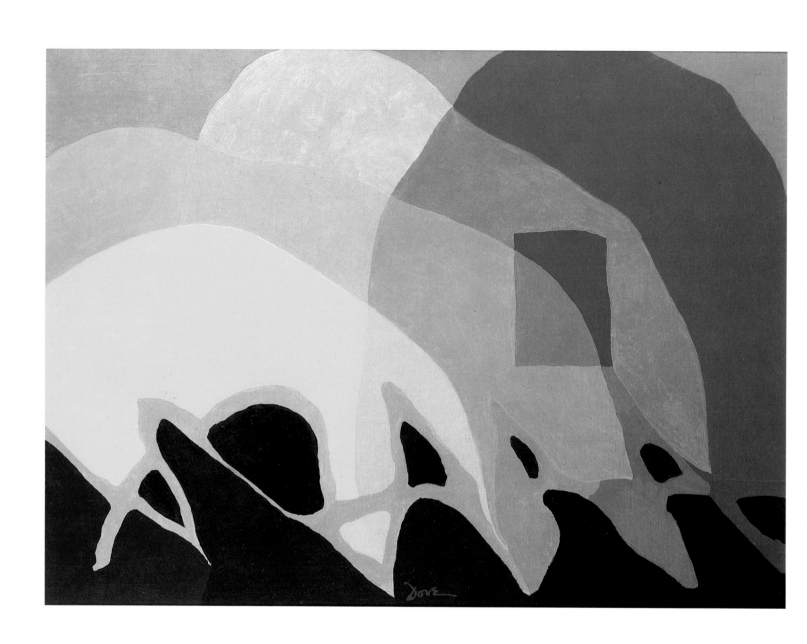

**29. Arthur G. Dove** *Dancing Willows, 1943-1944*
Tempera on canvas, 27 x 36 in.

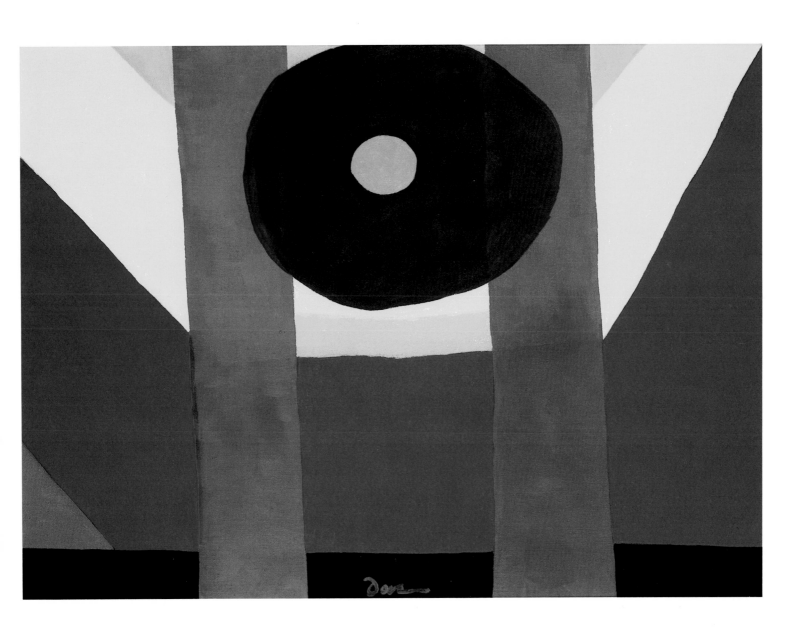

**30. Arthur G. Dove** *That Red One,* 1944
Tempera on canvas, 27 × 36 in.

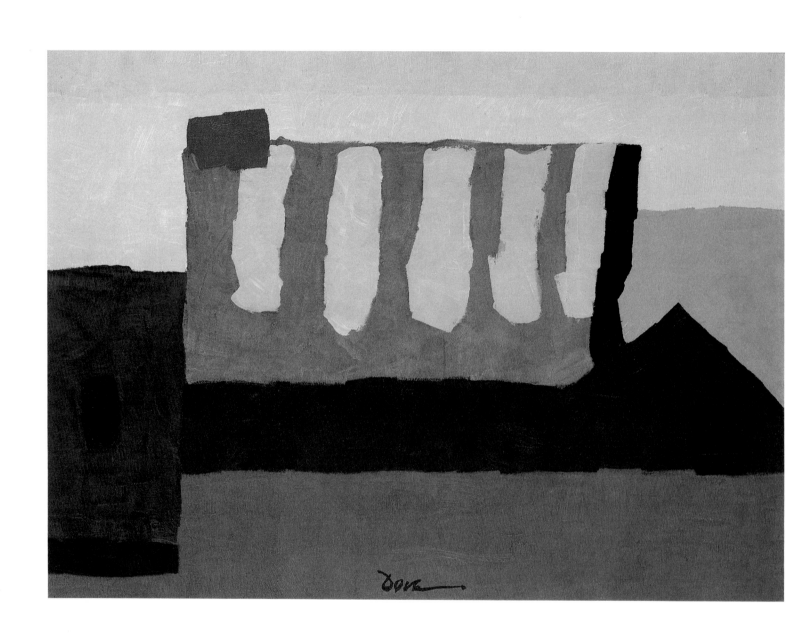

**31. Arthur G. Dove** *Pieces of Red, Green, and Blue,*
1944
Oil and wax emulsion on canvas, 18 x 24 in.

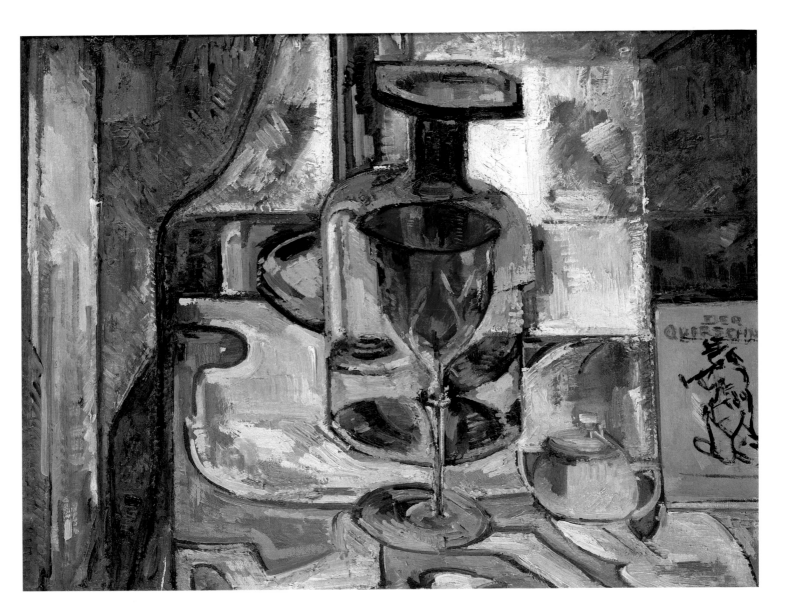

Hans Hofmann was an active teacher and painter in Germany for nearly three decades before he moved to this country in 1932, yet practically none of his early paintings has survived. Most of his Paris work (1904-1914) was destroyed on the eve of World War I, and his German work, stored in a Munich warehouse, burned during the Second World War.

Green Bottle thus has special interest, as it is a work of 1921 that the artist brought with him to the U.S. All of the concerns of the later Hofmann are discernible here: the painting being rooted in observed reality — here a wine glass, bottle, painter's palette, and a German art magazine, Der Querschnitt, resting on a table — the flatness of space, the dense brushwork, and the use of reds and greens with a yellow rectangle.

**32. Hans Hofmann**   *Green Bottle*, 1921
Oil on canvas, 17¾ x 22¾ in.

Hofmann was a teacher and theorist who influenced many important painters of the time. He frequently said that nature was his source and in 1957 he wrote: "My own work is initiated through inner vision. I sense the mysteries in nature and reveal them through the act of creation. There is no end in nature and none to inner vision — and therefore none to conceptual growth."

**33. Hans Hofmann** *Integration,* 1944
Casein on gessoed plywood, 30 × 24 in.

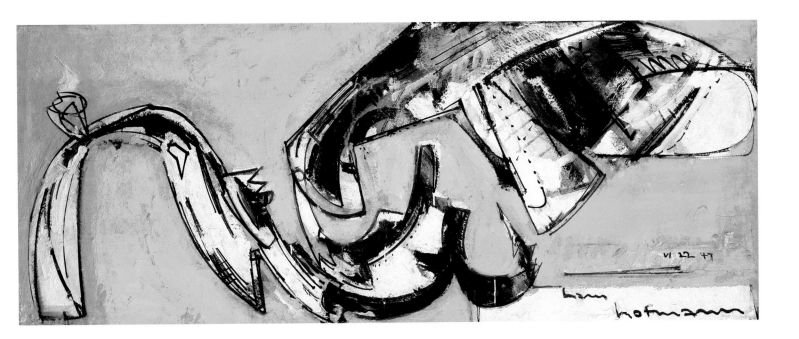

Artists have always known that the "abstract" qualities of a work of art are the ones that count — fine color harmonies, form, and composition — but the viewer frequently has trouble seeing these qualities. Hofmann stated the problem this way: "The general misunderstanding of a work of art is often due to the fact that the key to its spiritual content and technical means is missed. Unless the observer is trained to a certain degree in the artistic idiom, he is apt to search for things which have little to do with the aesthetic content of a picture. He is likely to look for purely representational values when the emphasis is really upon music-like relationships."

Hofmann's wife Maria, or Miz (pronounced Meets), as she was generally known, frequently gave his paintings their titles. In this case, she named the picture Embrace, as the artist told her it had been inspired by his seeing two germs under a microscope: they were moving slowly together and finally touched.

**34. Hans Hofmann** *Embrace*, 1947
Casein on gessoed plywood, 23⅝ × 57 in.

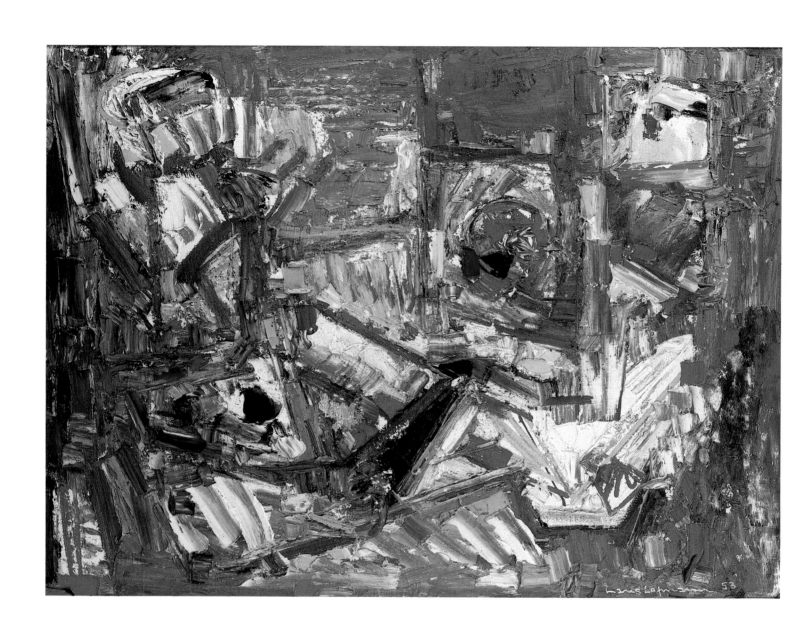

**35. Hans Hofmann**  *Composition No. 4, 1953*
Oil on canvas, 36 × 48 in.

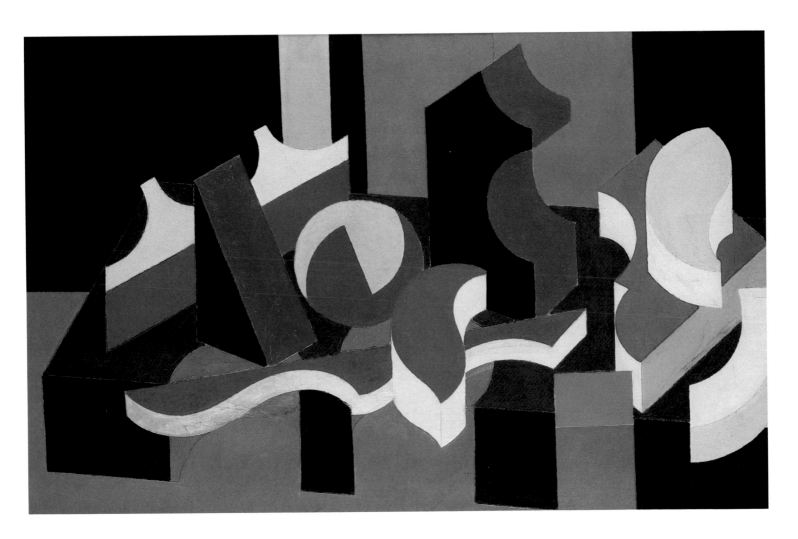

Bruce lived a lonely life in Paris; practically his only friend was Henri-Pierre Roché, who tried in vain to persuade several leading collectors to buy his work. After Bruce's suicide in 1936, Roché recalled: "Painting was the passion of his life. . . . It was both his sorrow and his joy. It overwhelmed him. He wanted to escape it. Several times he announced emphatically that he gave it up. He returned to it after a few months. . . . For several years he exhibited in the Indépendents. He stopped because no one realized the problems he was posing for himself, and because the . . . profound work that he was accomplishing had been considered no more than nicely colored decorated surfaces."

In 1933, Bruce gave Roché about fifteen of his paintings, including this one, and then destroyed the rest.

**36. Patrick Henry Bruce** *Forms (Peinture)*, ca. 1919-1920
Oil on canvas, 23¾ x 36¼ in.

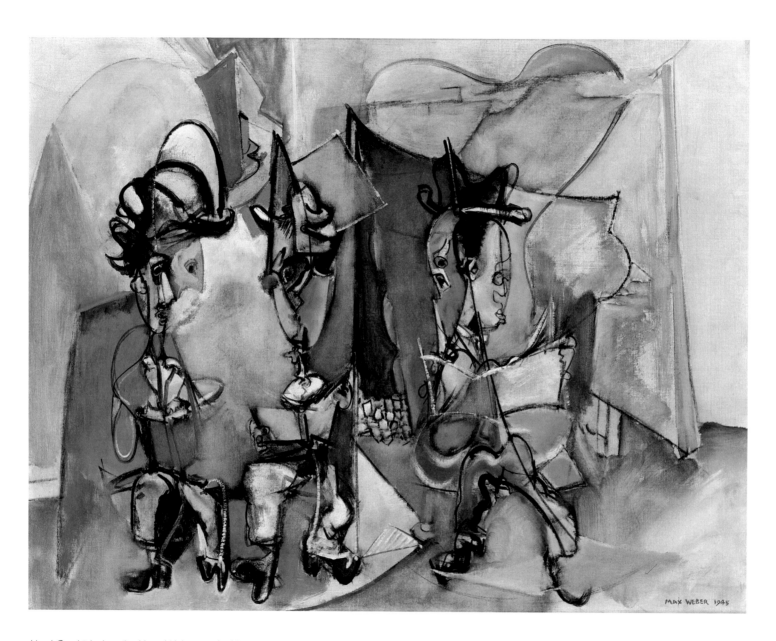

Lloyd Goodrich described how Weber made this painting: "In the case of one of his finest recent works, *Three Literary Gentlemen*, which was based on a small more naturalistic oil, he drew the larger composition in charcoal in one morning, starting with fairly representational figures of three men seated reading, and gradually translating them into more abstract equivalents. That afternoon he began painting, continued next morning, and went to lunch intending to paint more in the afternoon; but when he looked at it again he exclaimed, 'It's finished!' . . . Here as in other cases his method was one of controlled improvisation."

**37. Max Weber**  *Three Literary Gentlemen*, 1945
Oil on canvas, 29¼ x 36 in.

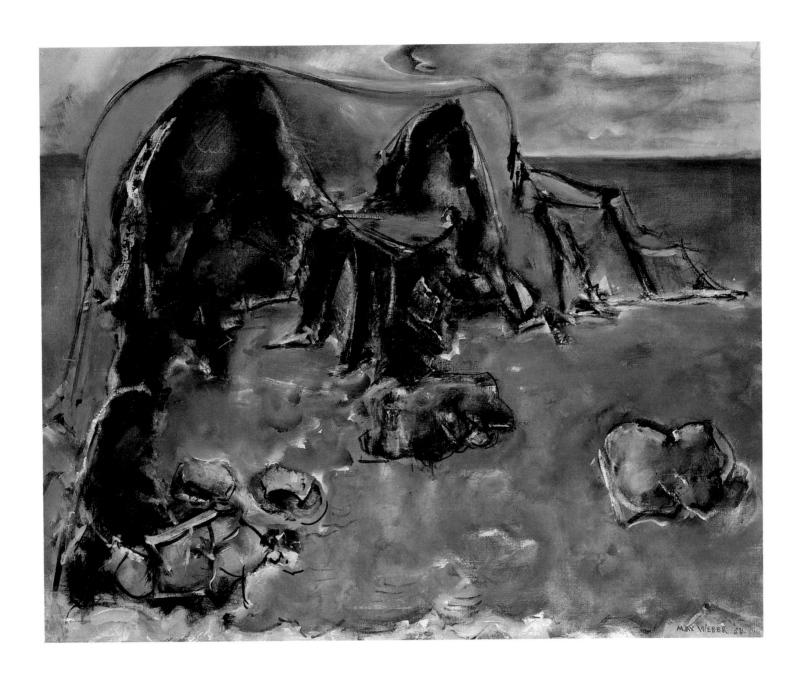

**38. Max Weber** *Pacific Coast,* 1952
Oil on canvas, 25 × 30 in.

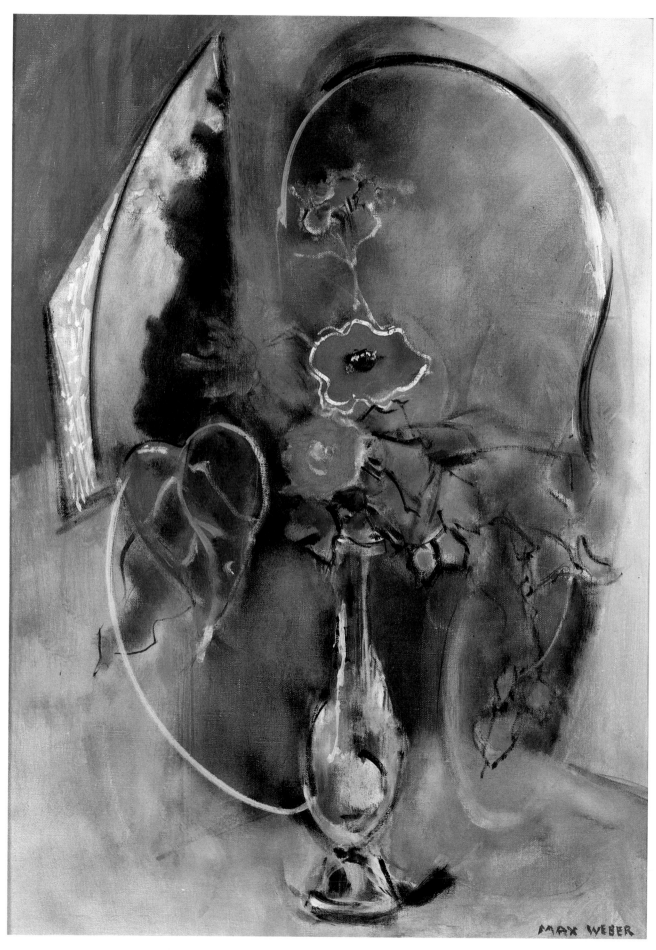

**39. Max Weber**  *Red Poppies*, 1953
Oil on canvas, 27 × 19 in.

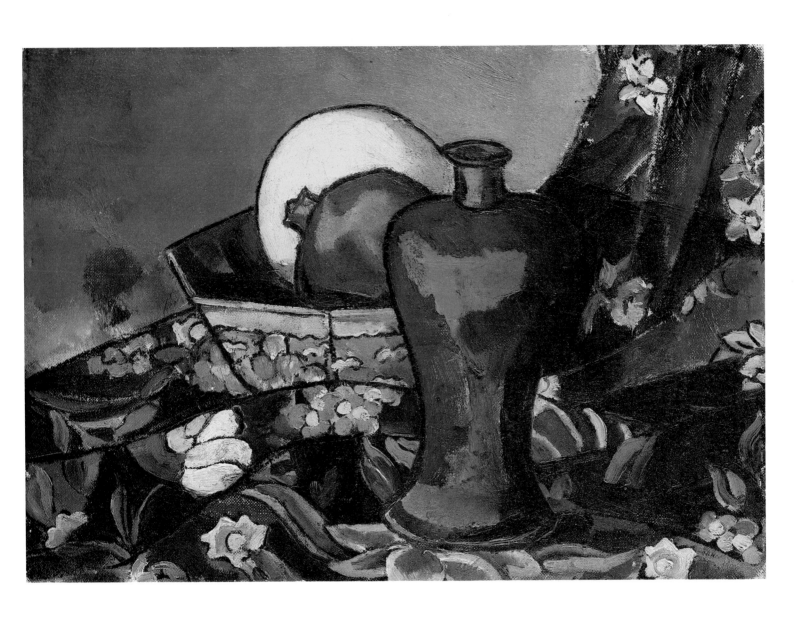

**40. Charles Sheeler**  *Still Life — Spanish Shawl,*
1912
Oil on canvas, 10¼ × 14¼ in.

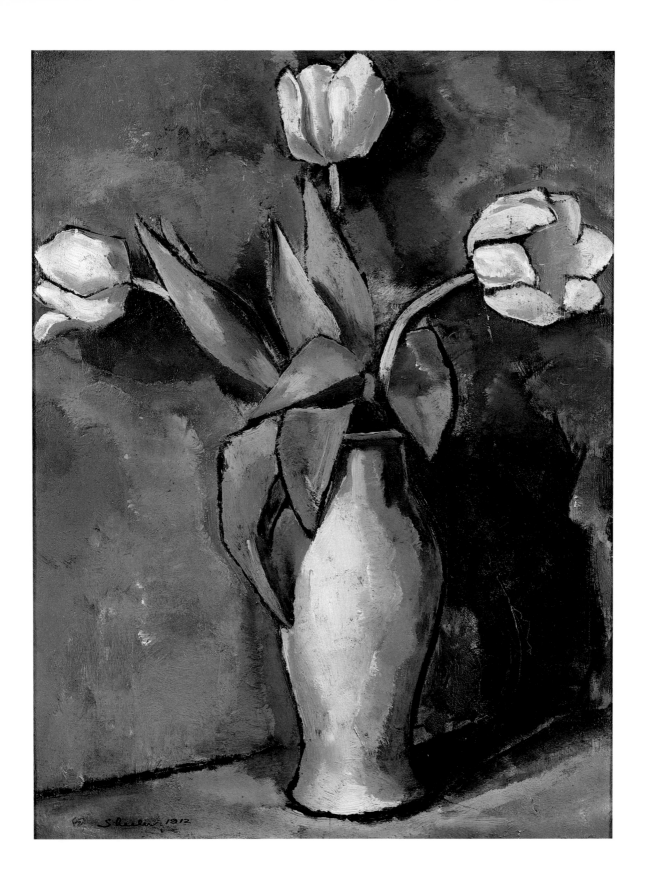

**41. Charles Sheeler**  *Three White Tulips,* 1912
Oil on wood, 13¾ x 10½ in.

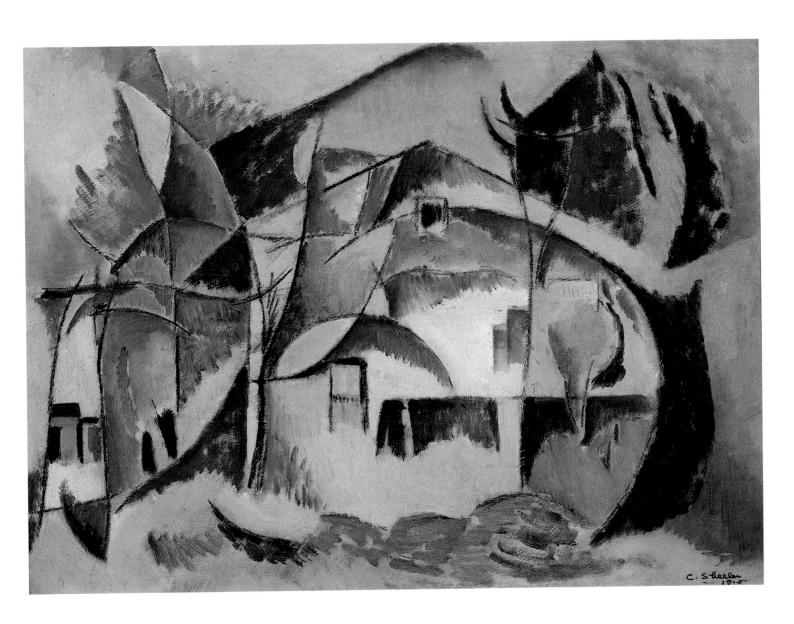

Sheeler was represented by several works in the famous Armory Show of 1913 in New York, including Still Life — Spanish Shawl (no. 40). He wrote that "the show aroused a variety of responses — fury, ridicule, curiosity and serious consideration," and he pointed to Duchamp's Nude Descending a Staircase as the most controversial work: "It represented the very antithesis of what we had been taught. For in it, the statement was all important and the means by which it was presented skillfully concealed. Following the Armory Show and largely influenced by it, my work dealt with abstract forms."

**42. Charles Sheeler** *Landscape,* 1915
Oil on wood, 10½ x 14 in.

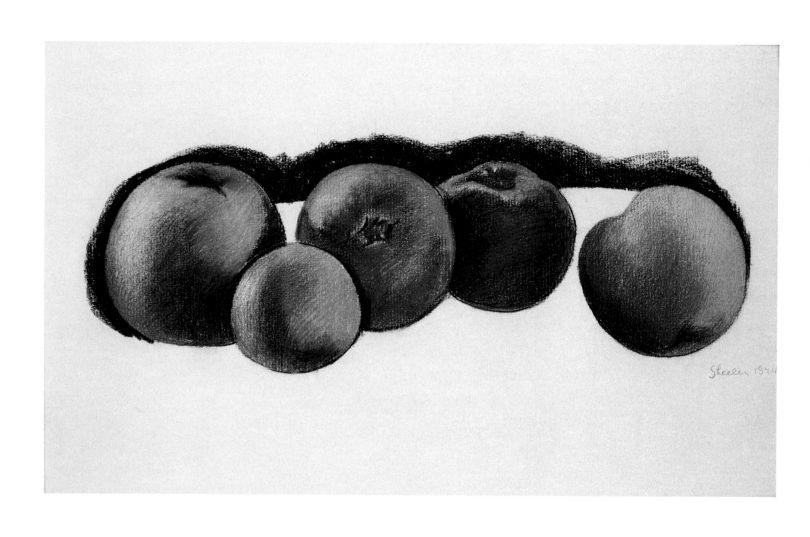

**43. Charles Sheeler** *Apples,* 1924
Colored crayons on paper, 7¾ × 11½ in.

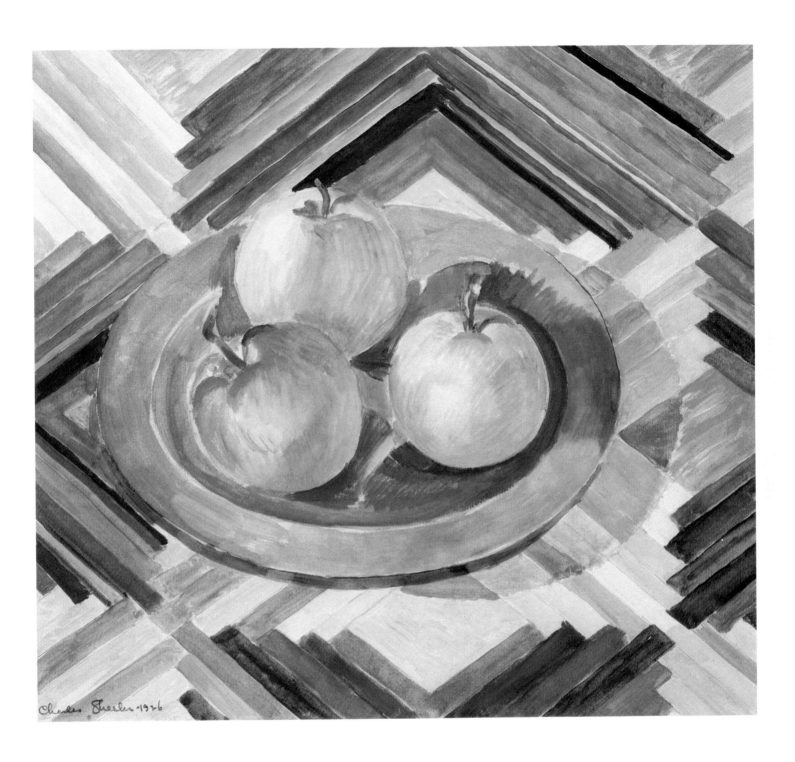

**44. Charles Sheeler** *Apples on Pewter Plate,* 1926
Tempera on paper, 12 × 13 in.

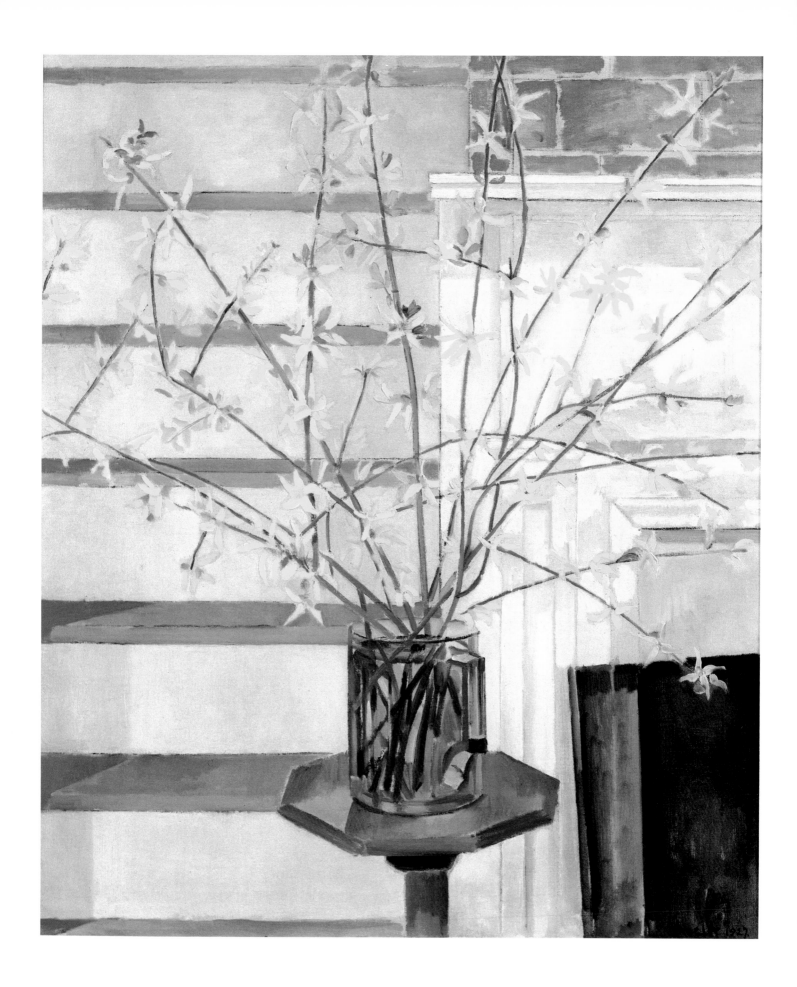

**45. Charles Sheeler** *Spring Interior*, 1927
Oil on canvas, 30 × 25 in.

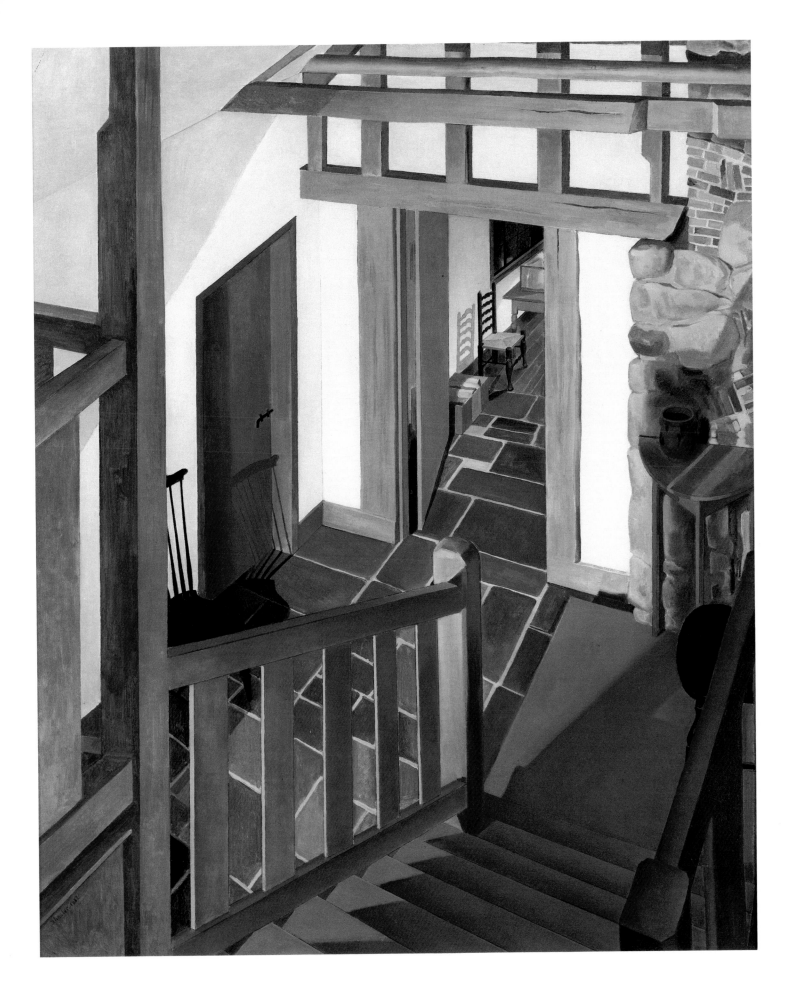

**46. Charles Sheeler** *Newhaven*, 1932
Oil on canvas, 36 x 29 in.

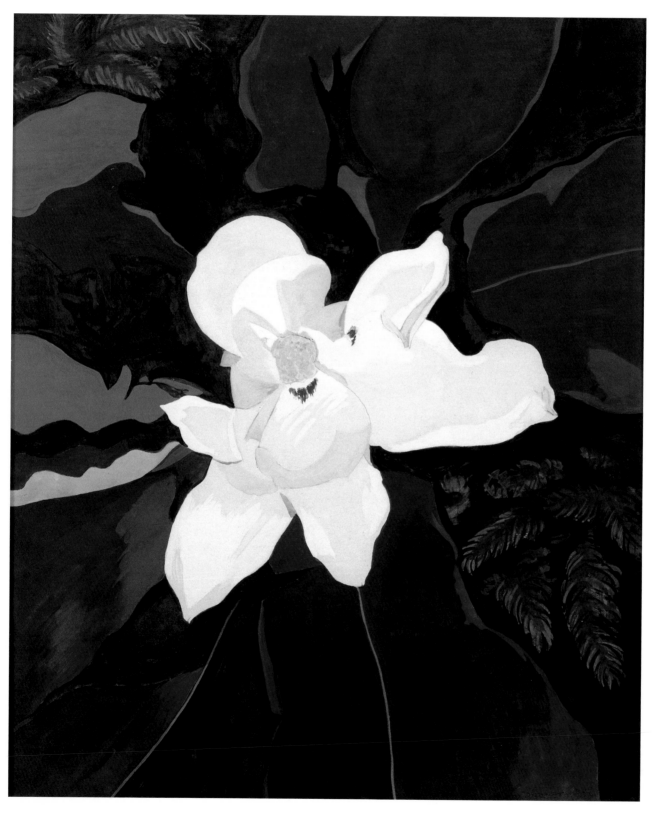

**47. Charles Sheeler** *Magnolia*, 1946
Tempera on artist's board, 16½ x 13½ in.

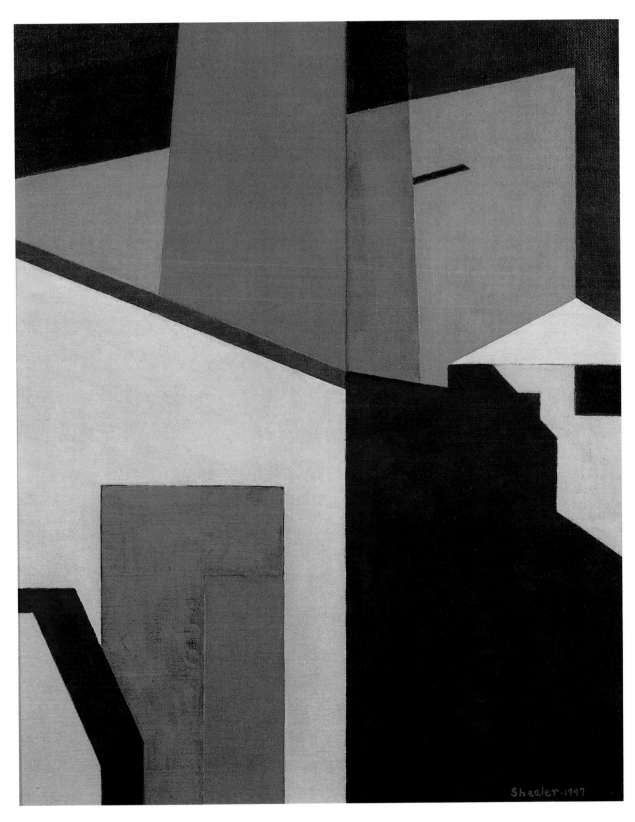

**48. Charles Sheeler** *Architectural Planes,* 1947
Oil on canvas, 15 × 12 in.

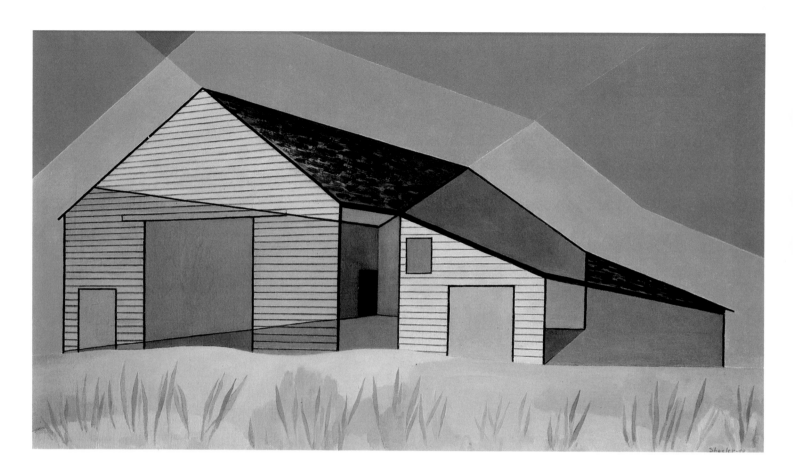

Sheeler took pride in his painting technique. Seeing it as continuing a noble tradition, he wrote: "There are other artists, such as Holbein and the Van Eycks, who exemplify concealment of means in setting forth the statement. . . . The means and the end are as though fused together. Their pictures, achieved with such rare skill of craftsmanship, seem to have been breathed upon the canvasses, giving no evidence of a beginning or ending."

**49. Charles Sheeler** *Massachusetts Barn,* 1948
Oil on canvas, 14 x 24 in.

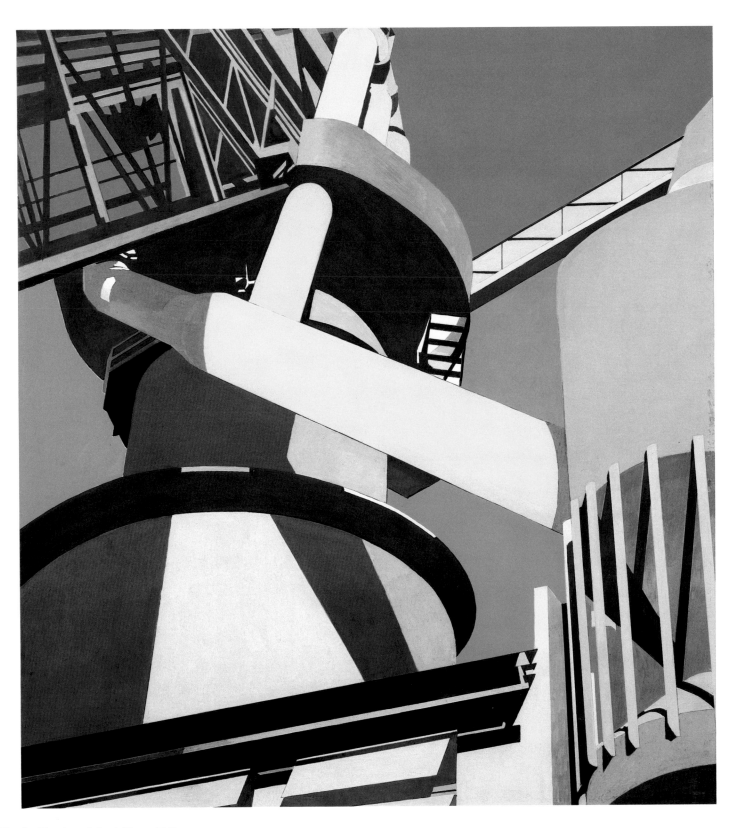

**50. Charles Sheeler** *Industrial Forms*, 1947
Tempera on artist's board, 22 × 20 in.

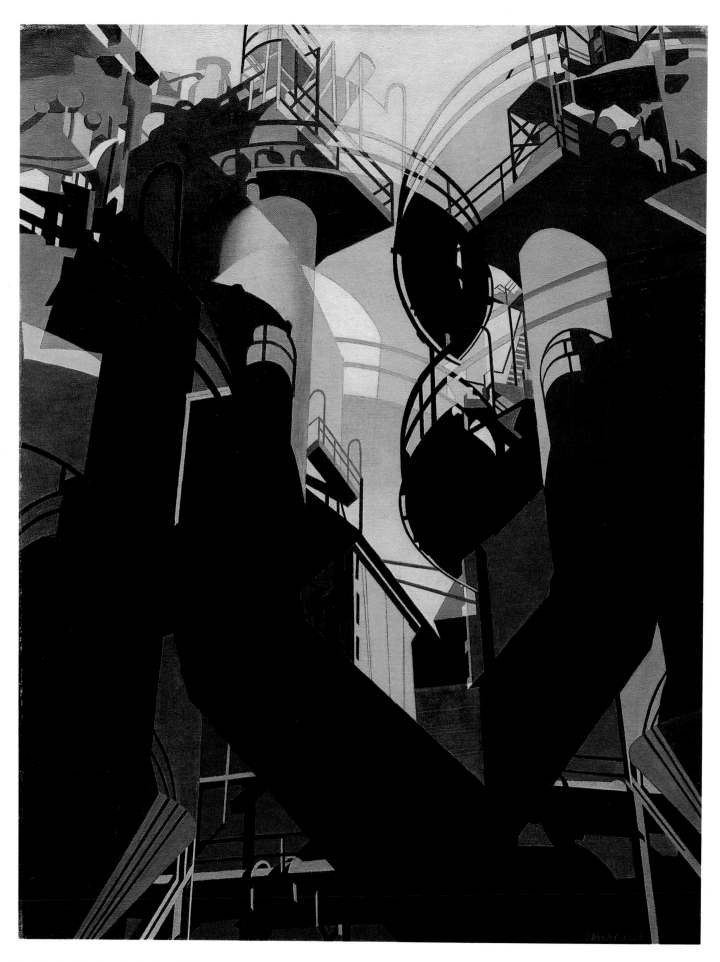

**51. Charles Sheeler**  *Ore into Iron,* 1953
Oil on canvas, 24 x 18 in.

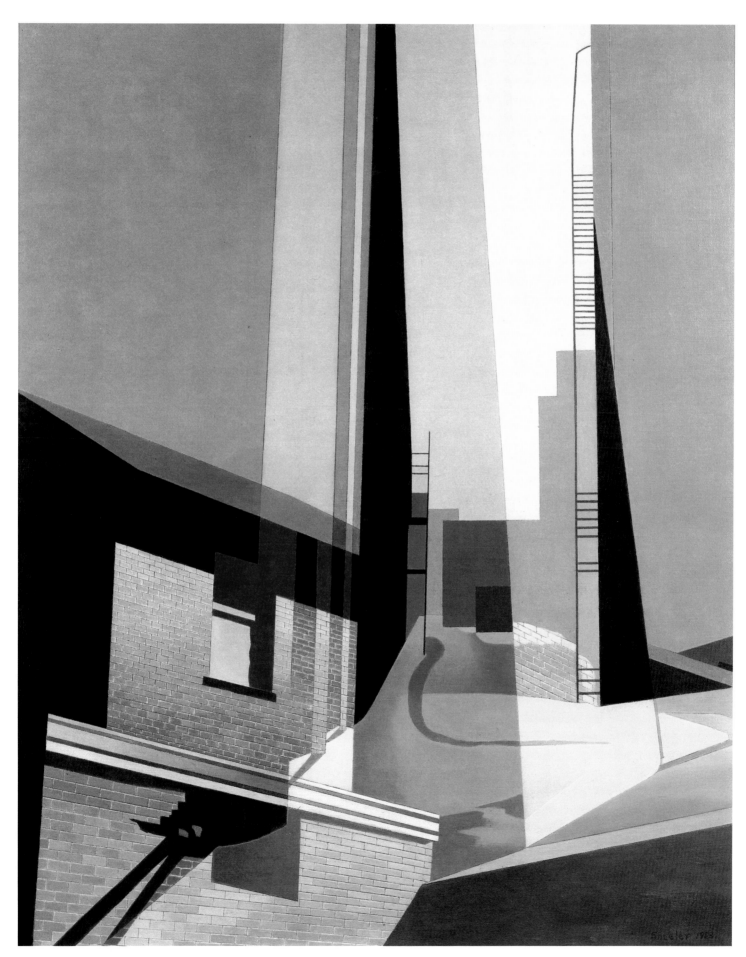

**52. Charles Sheeler** *New England Irrelevancies,*
1953
Oil on canvas, 29 x 23 in.

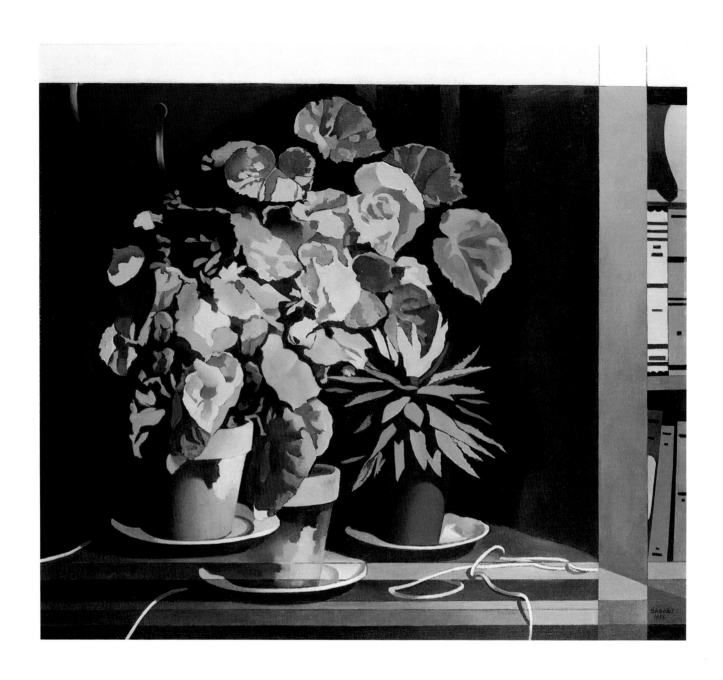

**53. Charles Sheeler** *Begonias,* 1955
Oil on canvas, 25 × 27 in.

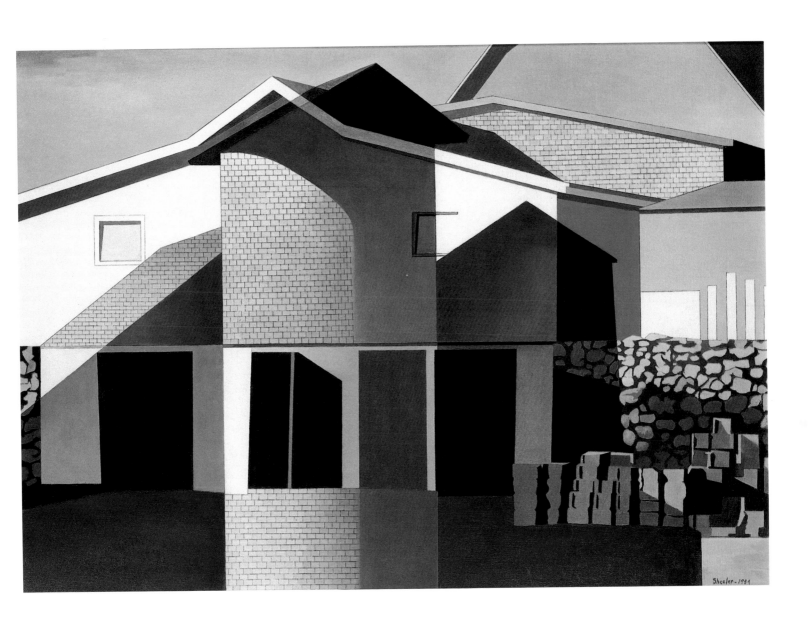

**54. Charles Sheeler** *Lunenburg*, 1954
Oil on canvas, 25 × 34 in.

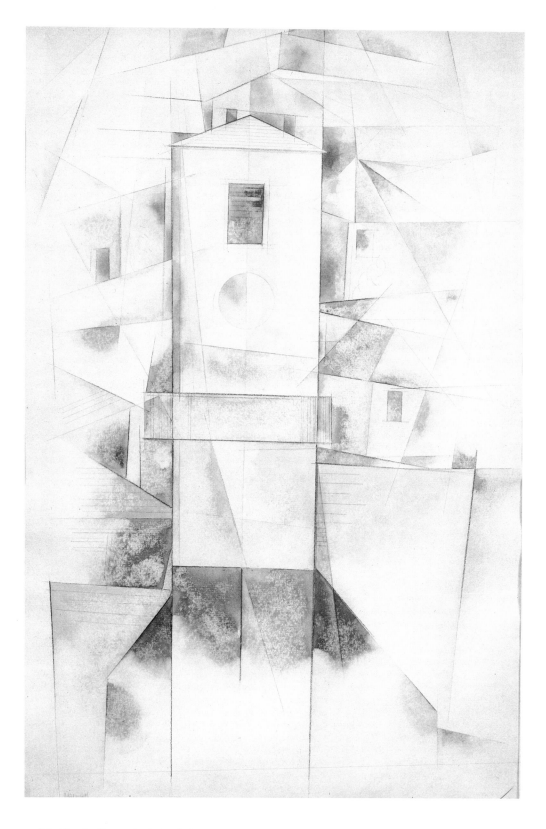

At least eight of Demuth's best oil paintings of the 'twenties were painted in homage to artists and writers, apparently as gestures of his friendship and admiration. Demuth painted such "portraits" of Marin, Hartley, Dove, and O'Keeffe, and of two leading literary figures, the poet William Carlos Williams and — in this picture — of the playwright Eugene O'Neill. Current art and stage publications are scattered on the table with a bottle and red and blue theater masks — these apparently referring both to O'Neill, who used them in his plays, and to the eighteenth-century painter Pietro Longhi, who included masked, dancing figures in his pictures of the Venetian aristocracy.

**55. Charles Demuth** *White Architecture,* 1917
Graphite and watercolor on paper, 17½ x 11½ in.

**56. Charles Demuth**  *Longhi on Broadway*, 1927
Oil on artist's board, 34 x 27 in.

O'Keeffe made drawings, pastels, and watercolors from an early age. After her studies, she worked as a commercial artist and later as an art teacher in public school and college. In November 1915, at the age of 28, she was teaching in Columbia, South Carolina, when a friend showed some of her charcoal drawings to Alfred Stieglitz in New York. He recognized their quality and exhibited them in May of 1916 without the artist's knowledge or consent. The following April Stieglitz devoted an entire show at his Gallery 291 to O'Keeffe watercolors. Most depicted houses and landscapes, clouds, and atmospheric effects, quickly brushed; the only figurative work in the series, Portrait — Black, in the same style, seems to depict a female figure carrying something. Later in the year, O'Keeffe did a series of large-breasted female nudes in watercolor.

**57. Georgia O'Keeffe** *Portrait — Black*, 1916
Watercolor on paper, 12 x 9 in.

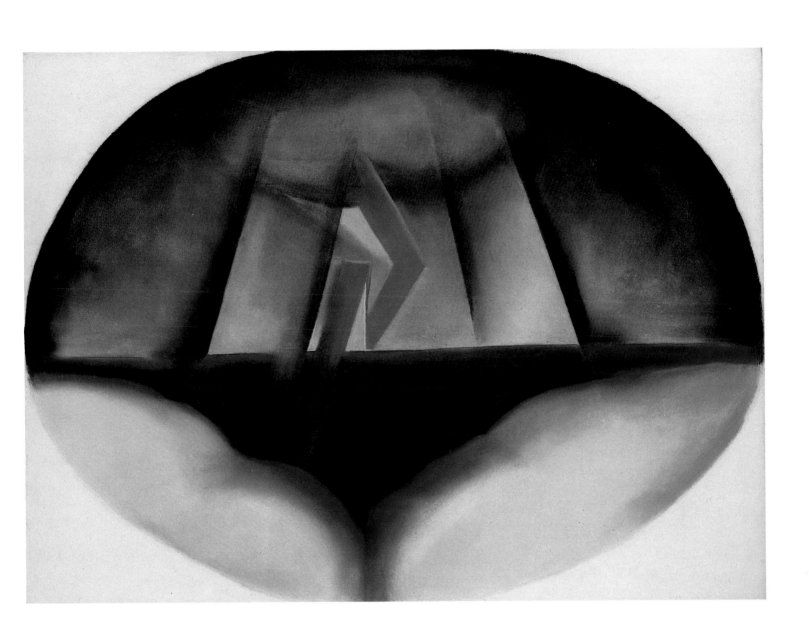

**58. Georgia O'Keeffe**   *Lightning at Sea*, 1922
Pastel on paper, 19 x 25½ in.

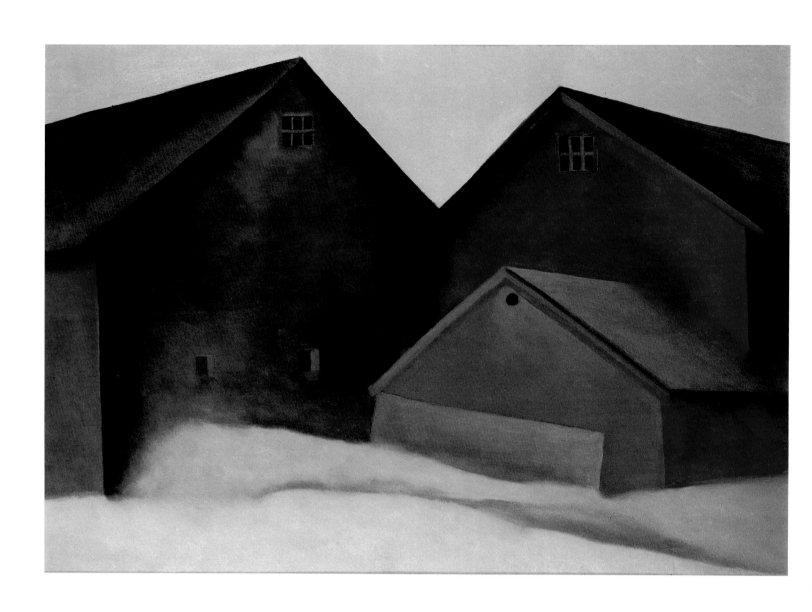

**59. Georgia O'Keeffe**  *Ends of Barns, 1922*
Oil on canvas, 16 × 22 in.

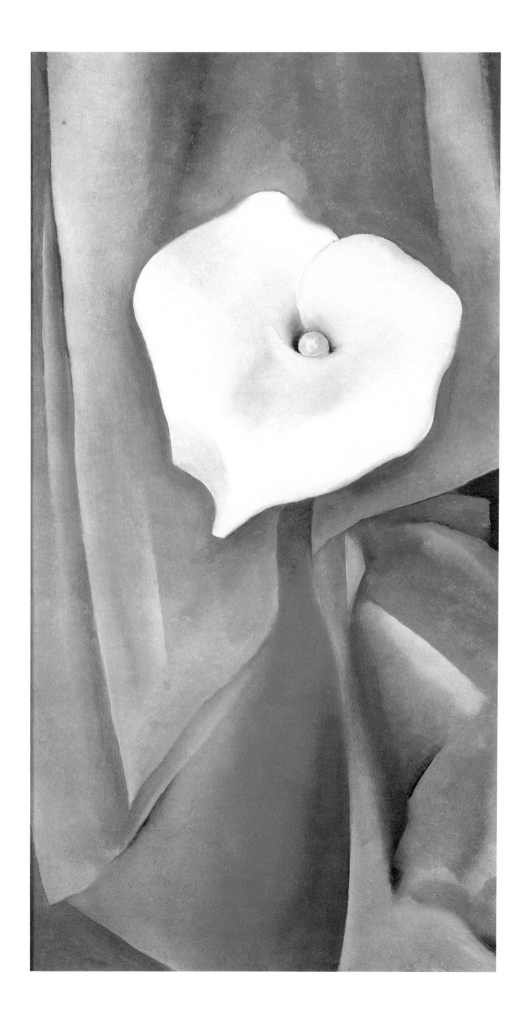

**60. Georgia O'Keeffe**  *Calla Lily on Grey*, 1928
Oil on canvas, 32 x 17 in.

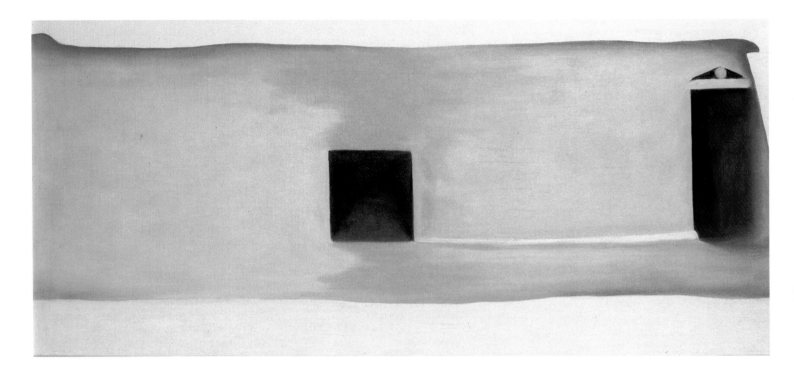

O'Keeffe wrote: "When I first saw the Abiquiu house it was a ruin with an adobe wall around the garden broken in a couple of places by falling trees. As I climbed and walked about in the ruin I found a patio with a very pretty well house and a bucket to draw up water. It was a good-sized patio with a long wall with a door on one side. That wall with a door in it was something I had to have. It took me ten years to get it — three more years to fix the house so I could live in it — and after that the wall with a door was painted many times."

O'Keeffe bought the house in 1946 and painted the patio often. During 1955 she made a series of pictures — culminating in Patio with Black Door — trying to get door, sky, and wall just right, maintaining the reality of this place while also creating abstraction. A critic described this painting as a "stripping down of theme not to its bare bones but to its essence," and went on to say: "The black door in 'Patio' is impenetrable; the pattern which is the pavement leads off to where we cannot follow."

**61. Georgia O'Keeffe**   *In the Patio No. IV, 1948*
Oil on canvas, 14 x 30 in.

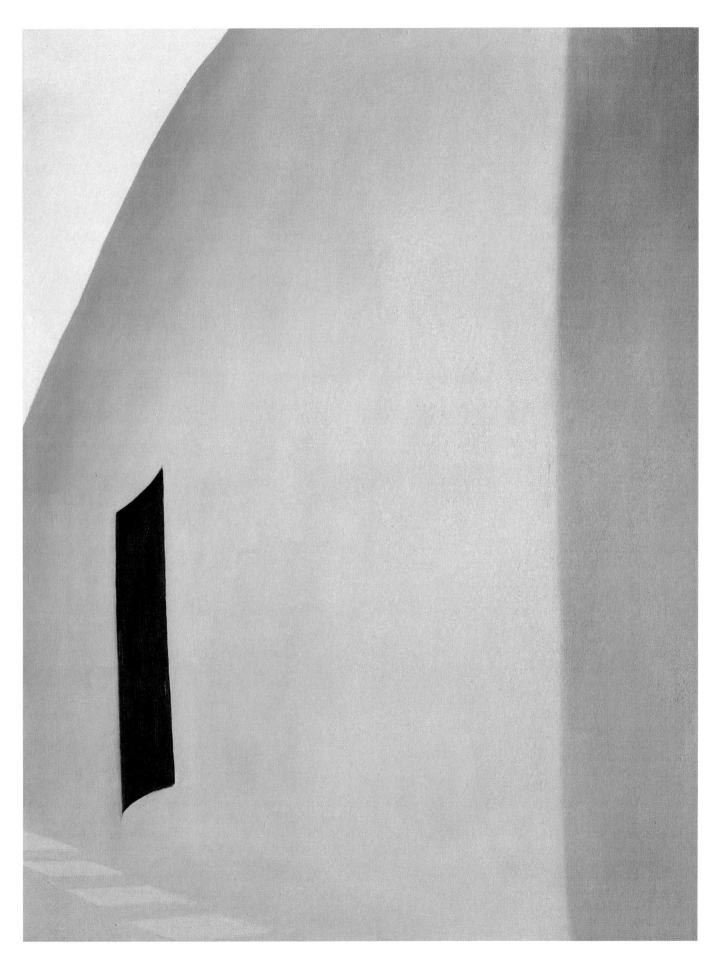

**62. Georgia O'Keeffe**   *Patio with Black Door,* 1955
Oil on canvas, 40 × 30 in.

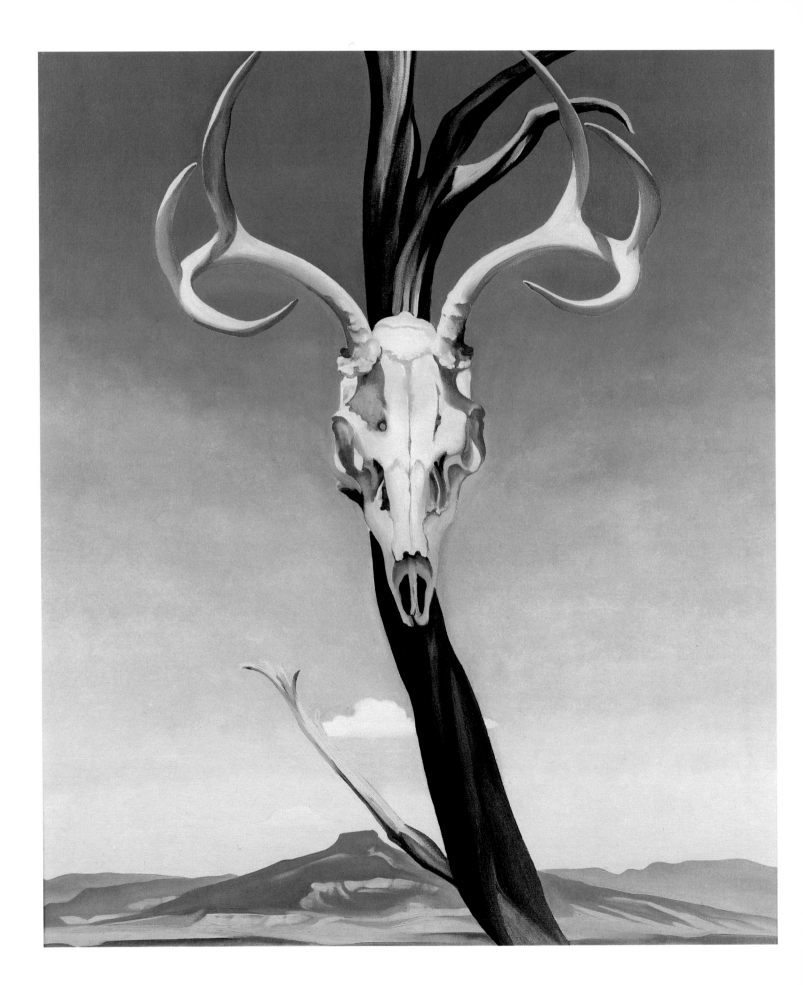

**63. Georgia O'Keeffe** *Deer's Skull with Pedernal,*
1936
Oil on canvas, 36 × 30 in.

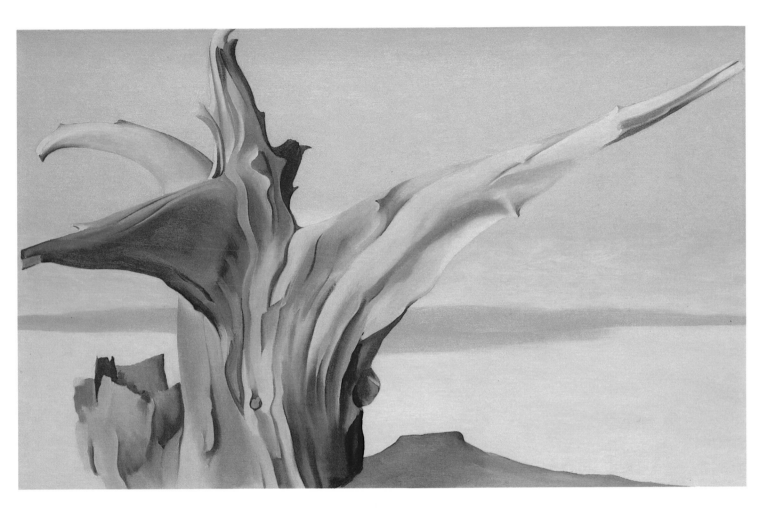

In 1936 the artist wrote: "I have wanted to paint the desert and I haven't known how. I always think that I cannot stay with it long enough. So I brought home the bleached bones as my symbols of the desert. To me they are as beautiful as anything I know. To me they are strangely more living than the animals walking around — hair, eyes and all with their tails twitching. The bones seem to cut sharply to the center of something that is keenly alive on the desert even tho' it is vast and empty and untouchable — and knows no kindness with all its beauty."

Both of these desert paintings were made a few miles from Abiquiu at "Ghost Ranch," where O'Keeffe first stayed in June of 1934; in 1940 she bought an adobe dwelling and she still spends long summers there. The view from her studio is across a river valley toward a picturesque, flat-topped

mountain the Pedernal, which can be seen in the distance in both pictures. In one, she painted a deer's skull hung on a tree against a bright blue sky; the scene reminds one of a crucifixion. In Red Tree, Yellow Sky she caught the desert in a more violent mood. An enormous bare tree trunk reaches out to each corner of the canvas. Surprisingly, O'Keeffe's model for this form was a small piece of wood — three or four inches high — that she picked up one day in the desert.

**64. Georgia O'Keeffe**   *Red Tree, Yellow Sky*, 1952
Oil on canvas, 30 x 48 in.

**65. Joseph Stella**  *Nocturne,* ca. 1926-1928
Watercolor on paper, 21¼ × 30 in.

Both Joseph Stella and Man Ray were painters of European extraction who became important, if not quite central, figures in the American avant-garde in the years just after the Armory Show of 1913. Stella brought to his pictures of the Brooklyn Bridge an understanding of Italian Futurism and of the American idiom, and Man Ray became a leading "Dada" artist in New York and later in Paris. Both are represented here by beautiful landscape watercolors quite unrelated to their best-known work. Man Ray was living in the New Jersey countryside during 1912 and 1913, and writes in his autobiography of making a "series of romantic expressionist paintings of figures in the woods as well as a few landscapes inspired by the camping trip and the country around where we lived"; he then "carried them into town one by one and was able to dispose of them among friends, adding to our income."

Man Ray's watercolors are brightly colored, energetic, and nervous, as compared with the broad, dark blue washes that Stella used in his nocturnal view of an Italian hill town. Man Ray gave up traditional drawing and watercolor shortly after the Armory Show, while Stella continued to make elegant drawings in various mediums throughout his life.

**66. Man Ray** *Landscape*, ca. 1912-1913
Watercolor on paper, 13½ x 9½ in.

**67. Mark Tobey**  *Burned Over,* 1947
Tempera on paper, 19 x 25 in.

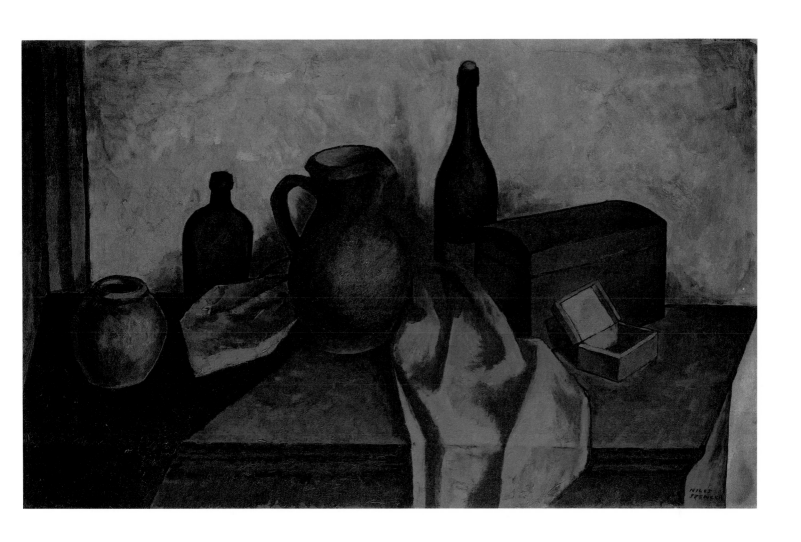

**68. Niles Spencer** *The Red Table*, 1927
Oil on canvas, 21 x 35 in.

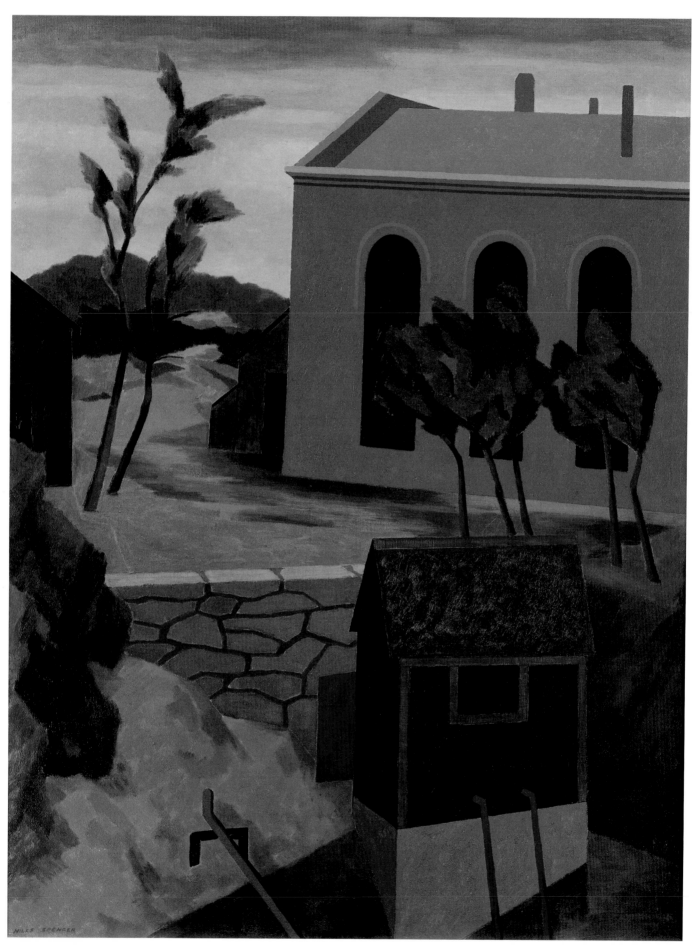

**69. Niles Spencer** *Power House,* 1936
Oil on canvas, 40 x 30 in.

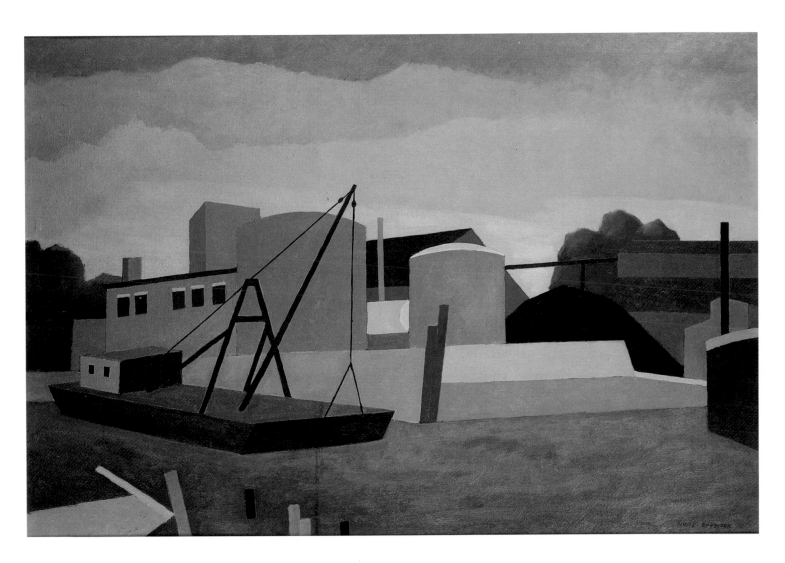

Ralston Crawford wrote in tribute to Spencer that "His presence and his manner of speech were quiet, restrained — rather uncommunicative." As so often happens, the art reflects the artist: Spencer's paintings are quiet and restrained. He worked for a lifetime in subtly modulated grays and browns, occupied always with blocky forms, with airless and uninhabited spaces. Spencer's style is sometimes confused with Sheeler's, but it shouldn't be: Sheeler is a poet, a bravura picture-maker, while Spencer works in prose. But if one probes them, his paintings do communicate: they speak of silence, of stillness; they represent urban and rural scenes where nothing grows and nothing moves.

**70. Niles Spencer**  *Near New London,* 1940
Oil on canvas, 25 × 36 in.

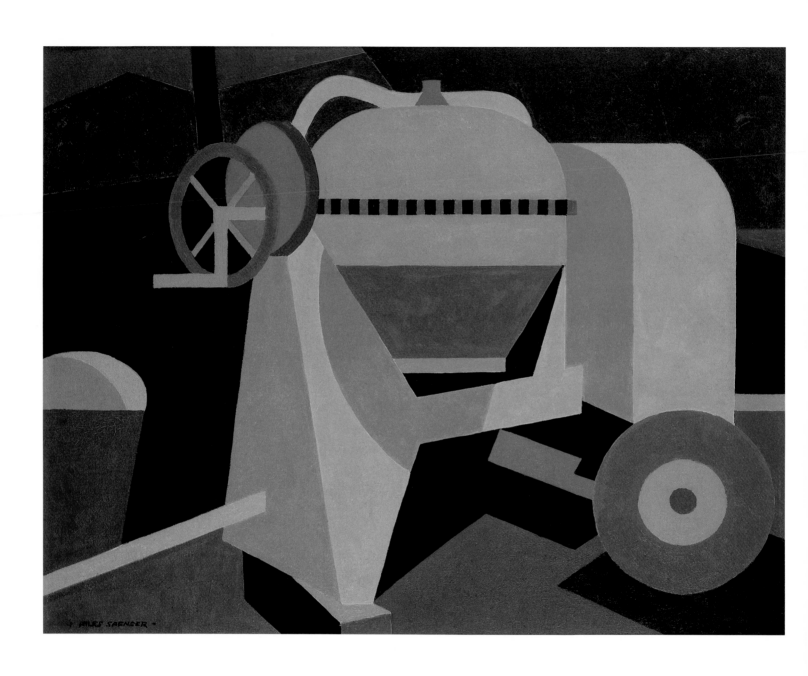

**71. Niles Spencer**  *The Cement Mixer*, 1949
Oil on canvas, 16⅛ x 20¼ in.

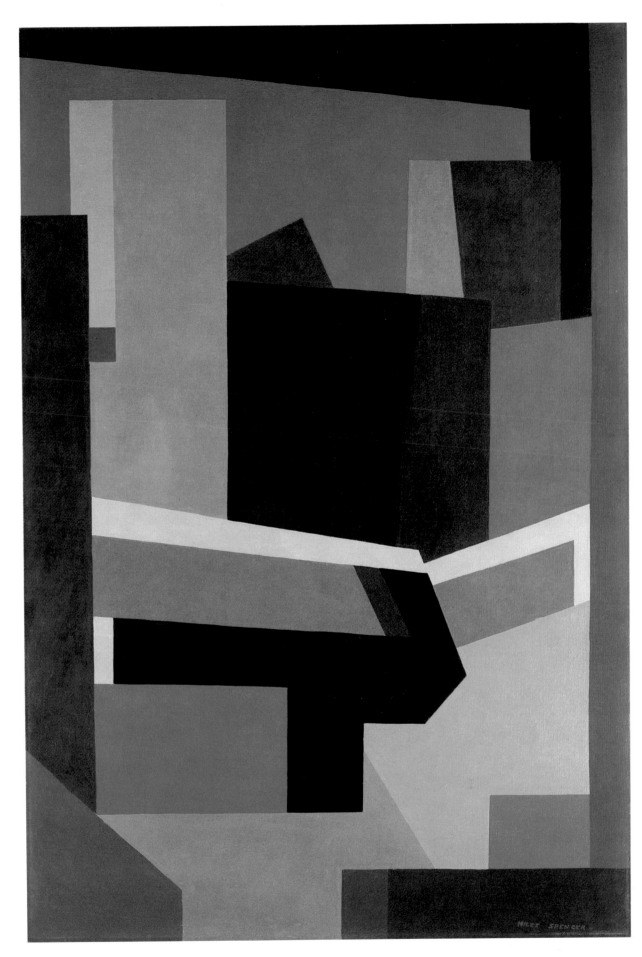

**72. Niles Spencer**  *Above the Excavation,* 1950
Oil on canvas, 50 x 34 in.

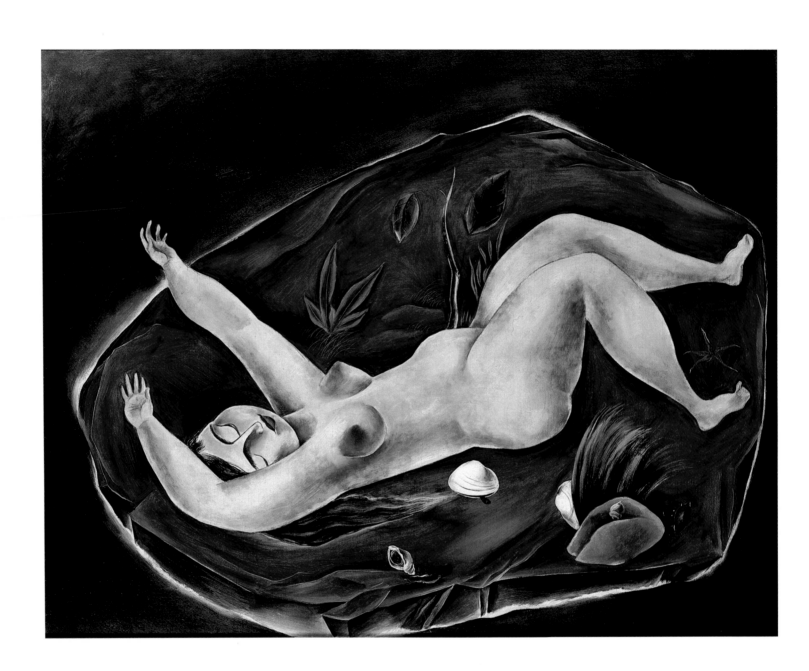

**73. Yasuo Kuniyoshi**  *Island of Happiness,* 1924
Oil on canvas, 24 x 30 in.

Stuart Davis was seventeen, living in New York and studying with Robert Henri, when he made this work. Edith Halpert always considered it to be a self-portrait, but the artist preferred simply to call it Portrait of a Man. In its commonplace subject and illustrator's style it recalls the work of Henri and other members of the "Ashcan School," particularly Shinn, but the use of flattened, carefully worked out space and the numbers and letters on the wall looks ahead to Davis's mature production.

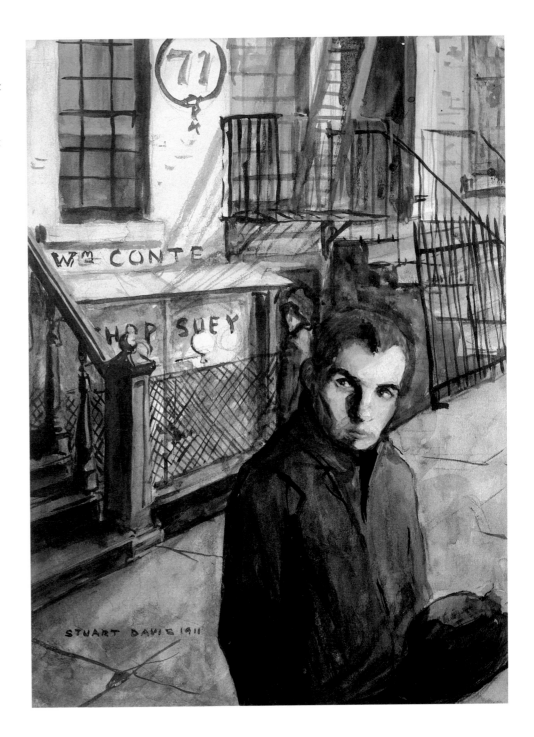

**74. Stuart Davis**  *Portrait of a Man*, 1911
Watercolor on paper, 15 × 11 in.

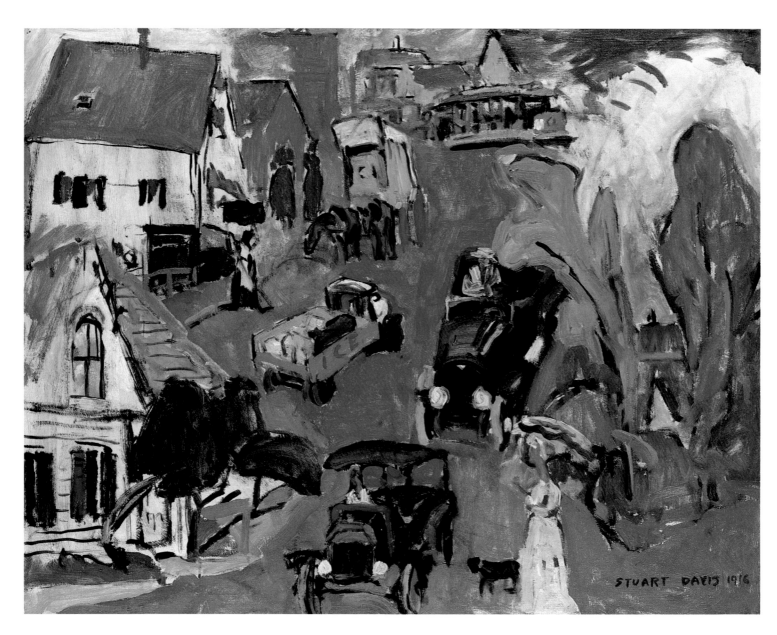

Davis wrote: "[In 1914] I went to Gloucester, Mass., on the enthusiastic recommendation of John Sloan. . . . A very important thing about the town at that time was that the pre-fabricated Main Street had not yet made its appearance. Also the fact that automobiles were very few and their numerous attendant evils were temporarily avoided." But the painter added: "I would not want my reference to the evils of the automobile as being indicative of opposition to mechanized progress. I have even drawn and painted automobiles on occasion, and for several years introduced filling station pumps into my landscapes."

**75. Stuart Davis** *Gloucester Street,* 1916
Oil on canvas, 24 x 30 in.

**76. Stuart Davis**  *Rurales No. 2, Cuba,* 1919
Watercolor on paper, 18 x 23½ in.

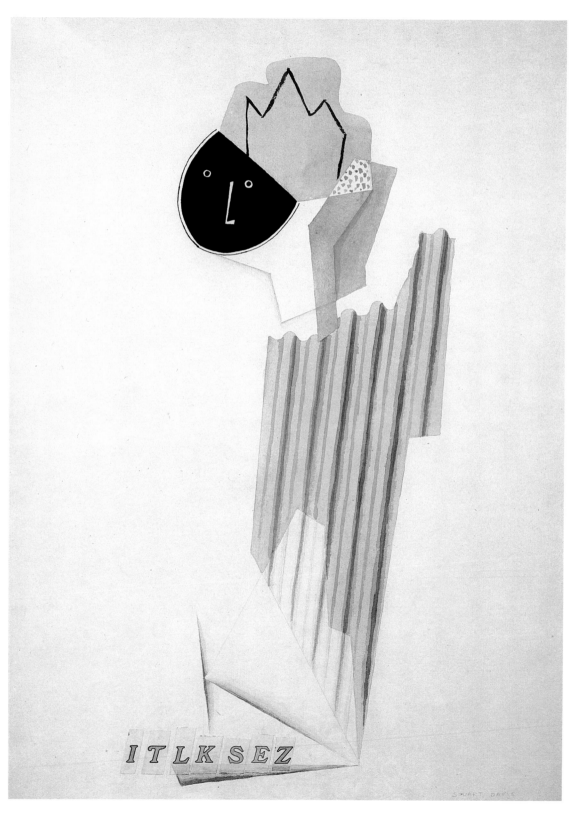

**77. Stuart Davis** *ITLKSEZ*, 1921
Watercolor and collage on paper, 22 x 16 in.

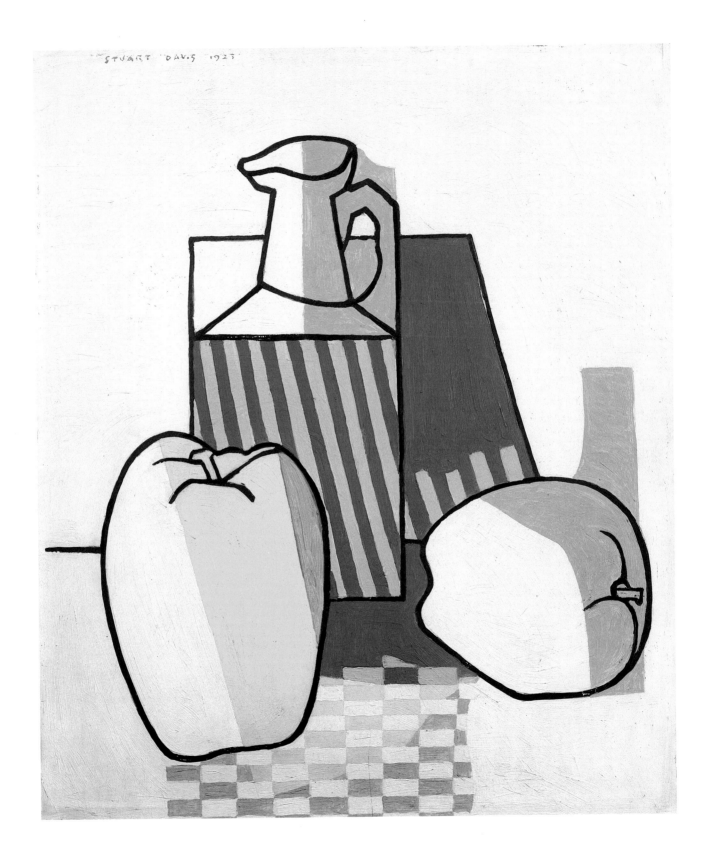

**78. Stuart Davis**  *Apples and Jug,* 1923
Oil on composition board, 21¾ × 17¾ in.

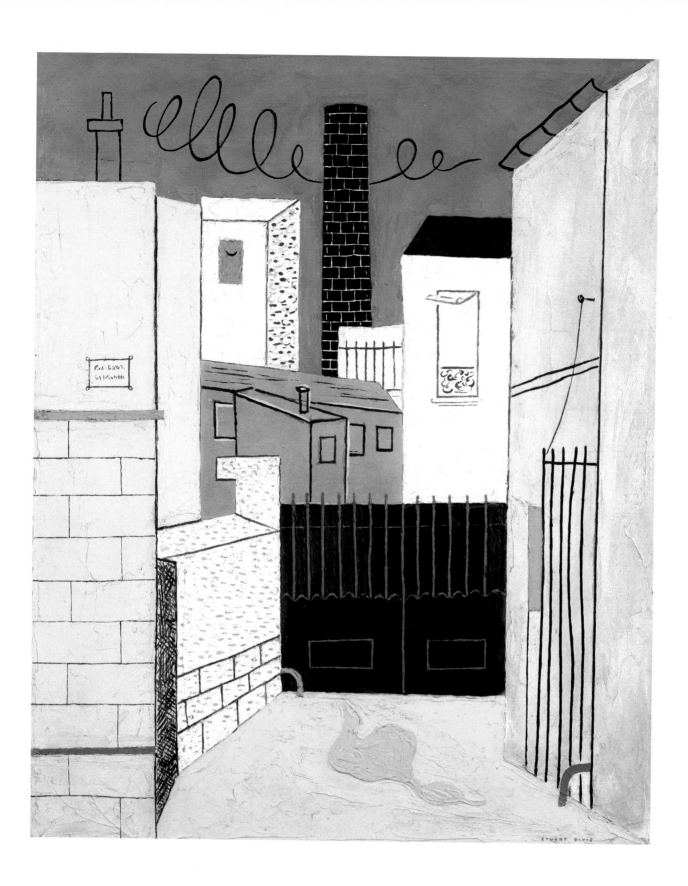

**79. Stuart Davis** *Adit No. 2,* 1928
Oil on canvas, 29 x 24 in.

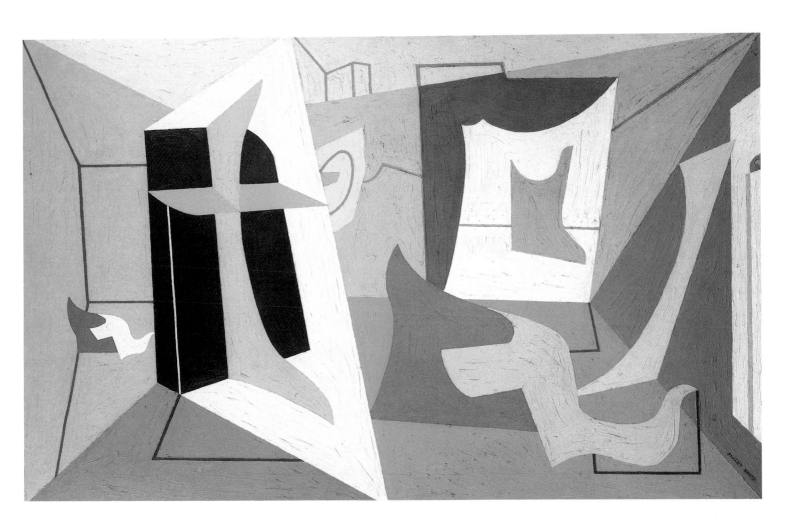

Stuart Davis described how, in 1927 and 1928, he "nailed an electric fan, a rubber glove, and an eggbeater to a table and used it as my exclusive subject matter for a year." He went on: "The pictures were known as the Eggbeater series and aroused some interested comment in the press, even though they retained no recognizable reference to the optical appearance of their subject matter."

Critics have rightly seen in this series a dramatic step for Davis, and the beginning of his rich, abstract style. Davis himself said, "You may say that everything I have done since has been based on that eggbeater idea. . . ."

**80. Stuart Davis** *Egg Beater No. 3, 1927-1928*
Oil on canvas, 25 × 39 in.

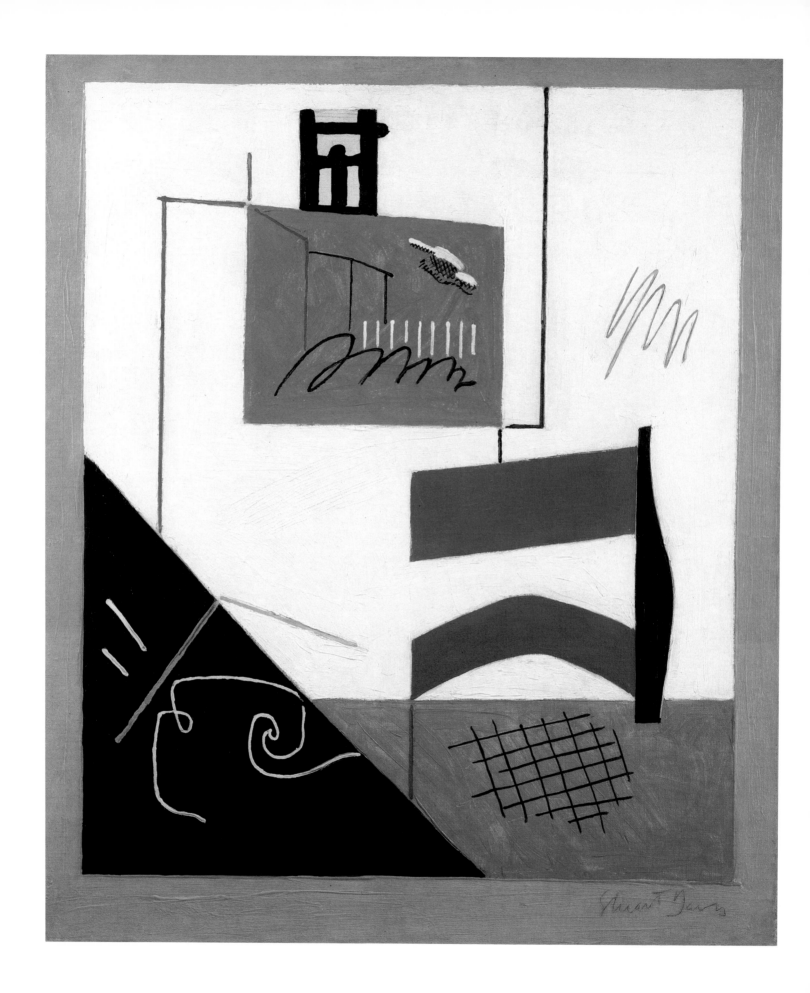

**81. Stuart Davis**  *Interior*, 1930
Oil on canvas, 24 x 20 in.

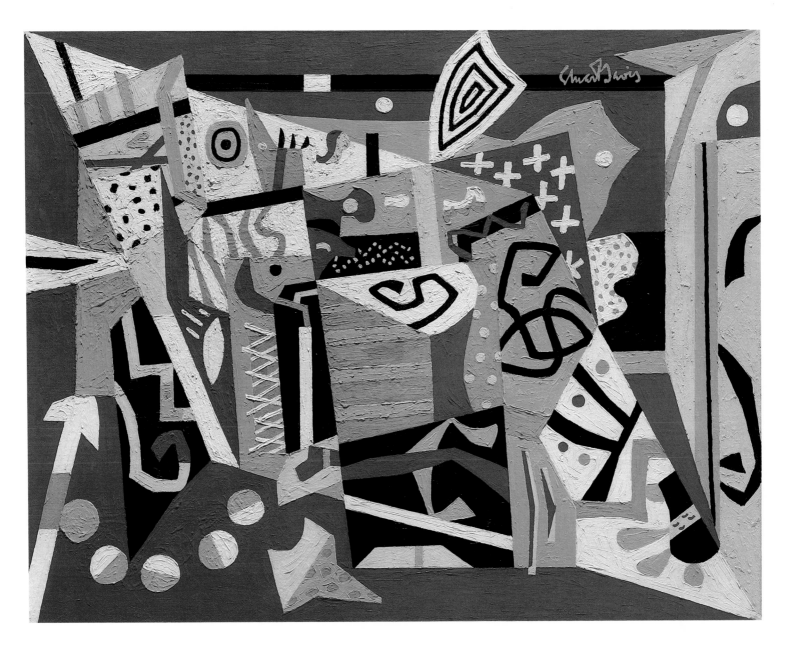

Stuart Davis said: "Hot Still-Scape for Six Colors
— 7th Avenue Style is composed from shape and
color elements which I have used in painting
landscapes and still-lifes from nature. Invented
elements are added. Hence the term 'Still-Scape.' It
is called 'Hot' because of its dynamic mood, as
opposed to a serene or pastoral mood. Six colors,
white, yellow, blue, orange, red, and black, were
used as the materials of expression. They are used
as the instruments in a musical composition might
be, where the tone-color variety results from the
simultaneous juxtaposition of different instrument
groups. It is '7th Avenue Style' because I have had
my studio on 7th Avenue for 15 years.

"The subject matter of this picture is well within the
everyday experience of any modern city dweller.
Fruit and flowers; kitchen utensils; Fall skies; hori-
zons; taxi-cabs; radio; art exhibitions and reproduc-
tions; fast travel; Americana; movies; electric signs;

dynamics of city sights and sounds; these and a
thousand more are common experience and they
are the basic subject matter which my picture
celebrates.

"The painting is abstract in the sense that it is highly
selective, and it is synthetic in that it recombines
these selections of color and shape into a new unity,
which never existed in Nature but is a new part of
Nature. An analogy would be a chemical like
sulphanilamide which is a product of abstract
selection and synthetic combination, and which
never existed before, but is nonetheless real and a
new part of nature.

"This picture gives value and formal coherence to
the many beauties in the common things in our
environment, and is a souvenir of pleasure felt in
contemplating them."

**82. Stuart Davis**   *Hot Still-Scape for Six Colors —
7th Avenue Style*, 1940
Oil on canvas, 36 x 45 in.

Jointly owned by the Museum of Fine Arts, Boston, and
the William H. Lane Foundation

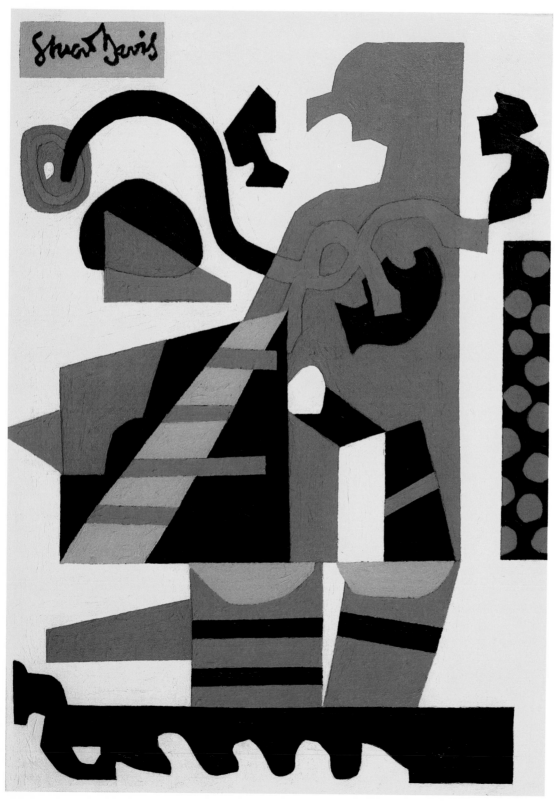

**83. Stuart Davis**  *Eye Level*, 1951-1954
Oil on canvas, 17 x 12 in.

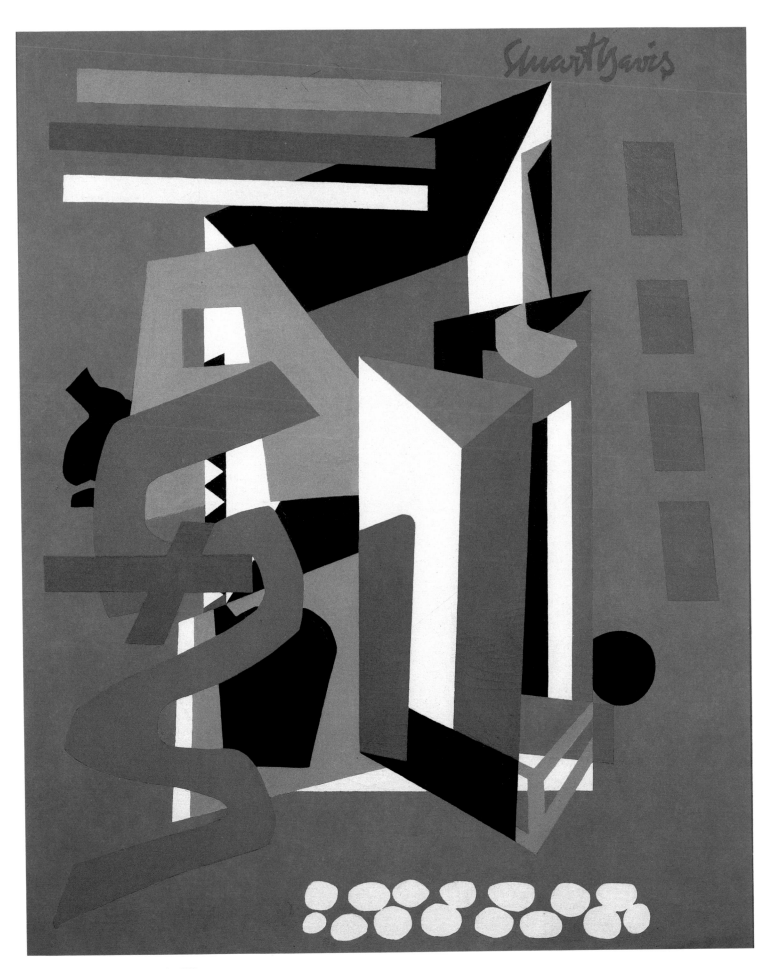

**84. Stuart Davis**  *Medium Still Life,* 1953
Oil on canvas, 45 x 36 in.

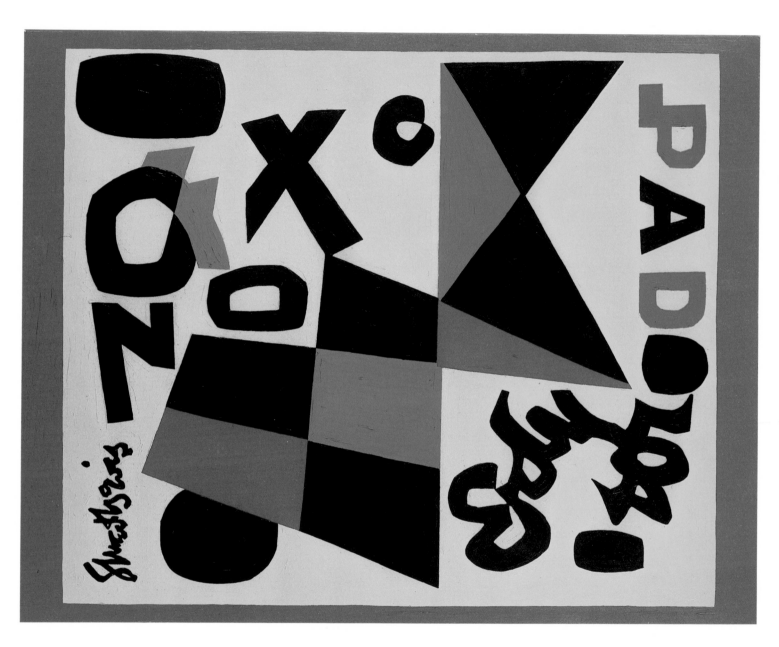

None of the titles Stuart Davis gave paintings is more apt than this one; Unfinished Business was indeed that, for the artist had first sketched its main form in 1932 in a drawing he referred to as Con figuration. It appears in a sketch of 1951, then as a central element in the mural of 1955, Allée. In 1960 and 1962 he experimented with it, turning the composition first on one end (so that "PAD" appears on top) and then on the other, with his signature on top. By this time he had worked out the word in the lower right corner, "Edy / as" or "Edyas," a pun developed from the word ideas. When he finally made the painting, he was two years from his death and was having cataract troubles. After he had completed it, his eyes cleared up and upon seeing the picture, he commented, "So that's what the colors look like!"

**85. Stuart Davis** *Unfinished Business,* 1962
Oil on canvas, 36 × 45 in.

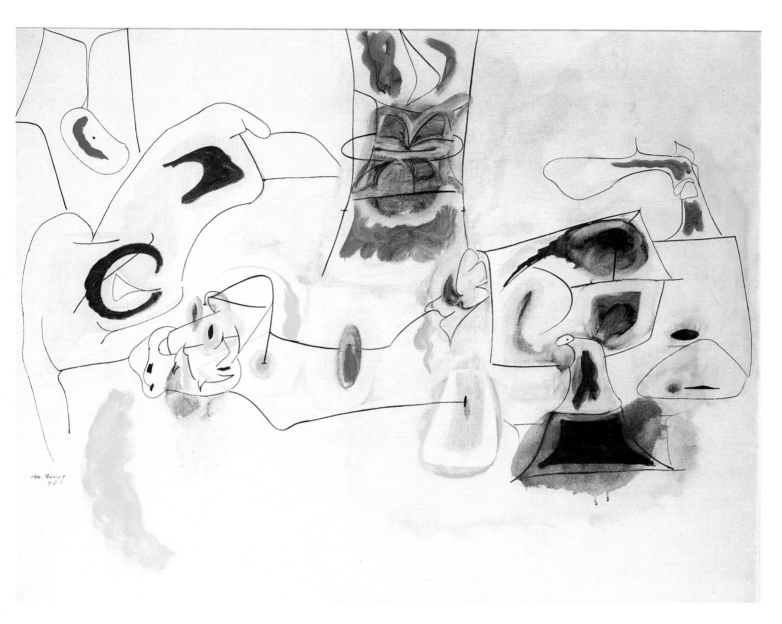

Gorky and Stuart Davis are very different as painters, for Gorky's work is soft and dreamlike, and relies on flowing line and on seeming accidents — paint drips and the like — while Davis's paintings are bright and geometric. But they are both rightly seen as pioneers of modern art in America, and, despite the difference in eye and background, they were friends in New York in the 'thirties. When Gorky wrote admiringly of Davis's approach ("He gives new shape to his experiences with new sequences. . . . He gives us symbols of tangible spaces, with gravity and physical law."), he might well have been describing his own way of painting.

André Breton reminded us that Gorky "maintains direct contact with nature — sits down to paint before her." Gorky lived on Good Hope Road in Roxbury, Connecticut, in 1944 and 1945, and the bucolic landscape there is doubtless reflected in this painting. At the same time, however, Breton warned us against "seeing in these compositions a still-life, a landscape, or a figure instead of daring to face the hybrid forms in which all human emotion is precipitated."

**86. Arshile Gorky**  *Good Hope Road*, 1945
Oil on canvas, 34 x 44 in.

**87. Abraham Rattner**  *The Last Judgment,* 1955
Watercolor on paper, 40 x 29½ in.

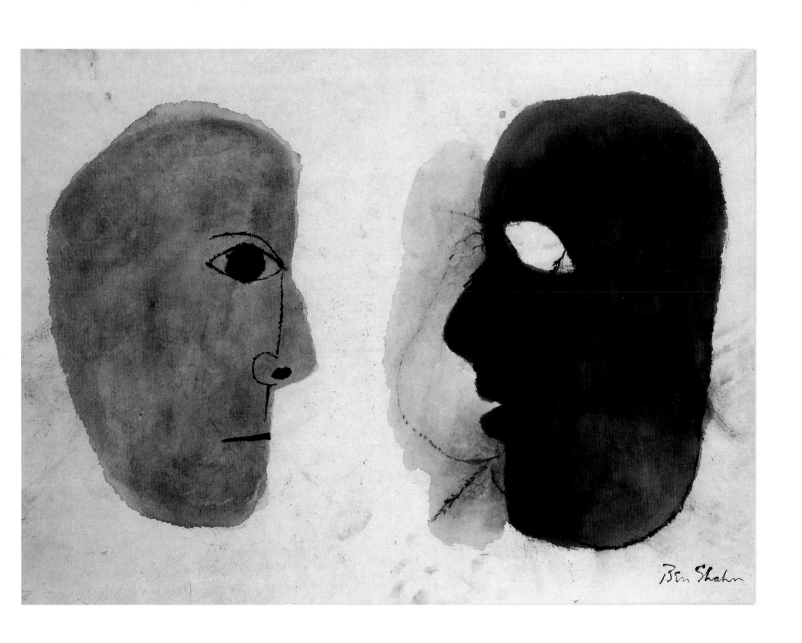

**88. Ben Shahn** *Confrontation,* 1964
Watercolor on rice paper, mounted on artist's board,
24 x 32 in.

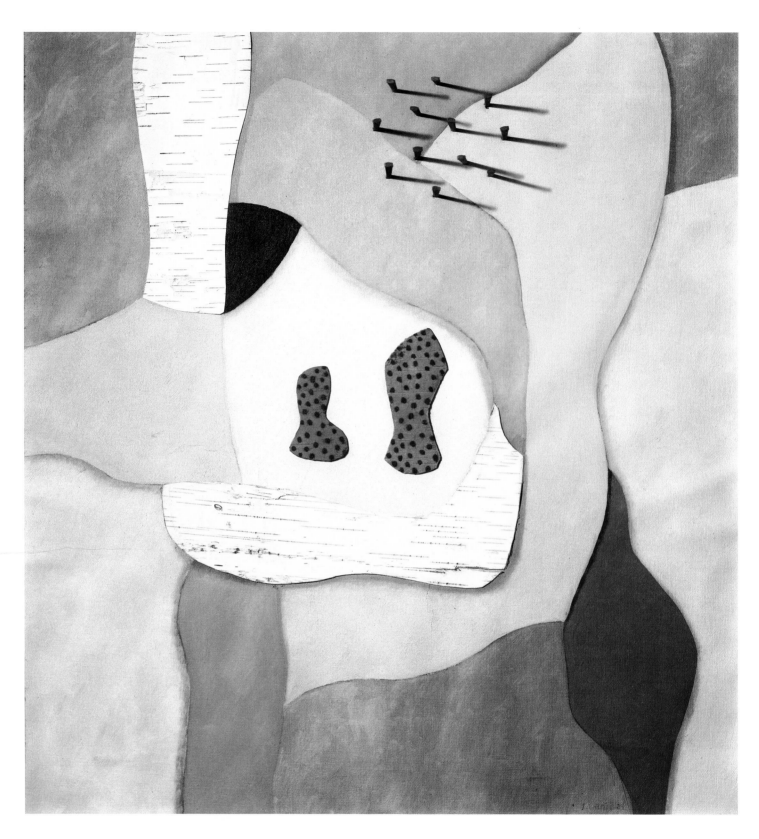

George L.K. Morris led an active life as a founder of the group called American Abstract Artists (begun in 1936), as a painter, and as a theorist and defender of the new art forms. In one essay, he explained, "The 'subject-painter' customarily takes his images from nature and conceives them as viewed through a window; Whistler was being true to his impressionist associations when he remarked that a painting should always be behind the frame. A key to the new direction might be found in Mondrian, whose frame deliberately pushes the canvas in front of its borders. The earliest abstractions (Delaunay, Kandinsky, etc.) did not deviate from the old window-concept. Rather it was cubism (particularly its later stages) that flattened the object-fragments over the picture surface and paved the way for contemporary abstraction. This was of course a revolutionary step. But it is easy for the artist to go much further now; he can dispense with the subject entirely and produce an 'object' that exists with an independent life of its own."

**89. George L.K. Morris** *Composition with Birch Bark*, 1939
Oil with birch bark and nails on canvas, 27½ x 25¼ in.

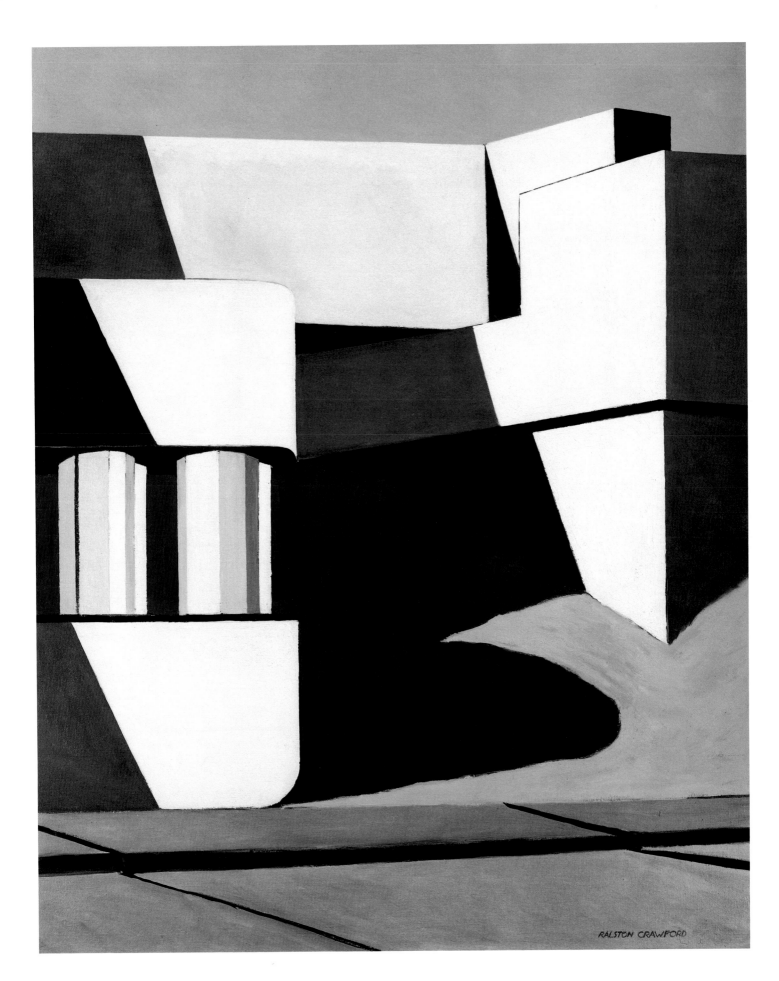

**90. Ralston Crawford**   *Maitland Bridge No. 2,*
1938
Oil on canvas, 40 × 32 in.

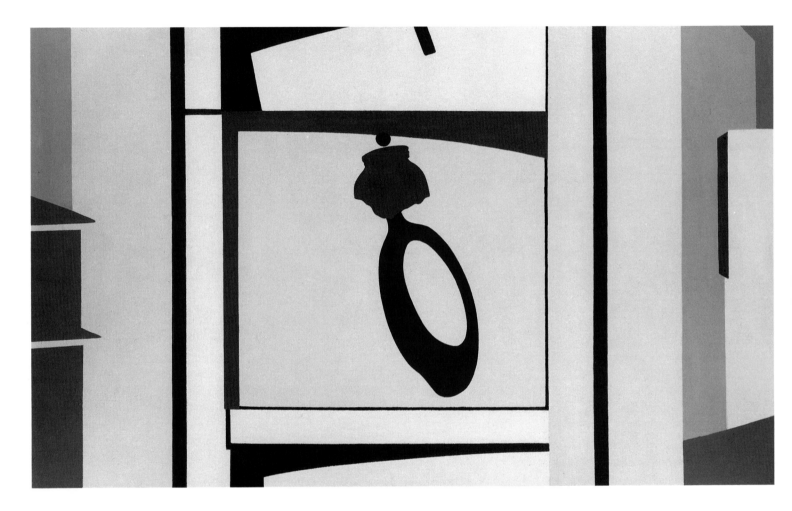

Beginning in 1950 Crawford made frequent trips to New Orleans in order to sketch, paint, and make photographs. He was enchanted with the New Orleans cemetery, where the photographer Edward Weston also worked for a period. Crawford's paintings look like pure abstractions, but in fact they are made something like high-contrast, close-up photographs and are based on things he saw in the cemetery. New Orleans No. 3 brings to mind a window and perhaps a window shade. Actually, it is a bright-sunlight view of an above-ground burial vault. A hanging screw-cap glass jar that held flowers has broken and the bottom has fallen away. The sunlight striking directly through the circular remnant effects a dramatic shadow.

New Orleans No. 7 (opposite) is based on a similar view: here we see a tin cup with a cross attached to the grave, with the suggestion of cracked masonry walls behind.

**91. Ralston Crawford**  New Orleans No. 3, 1953
Oil on canvas, 28 x 45 in.

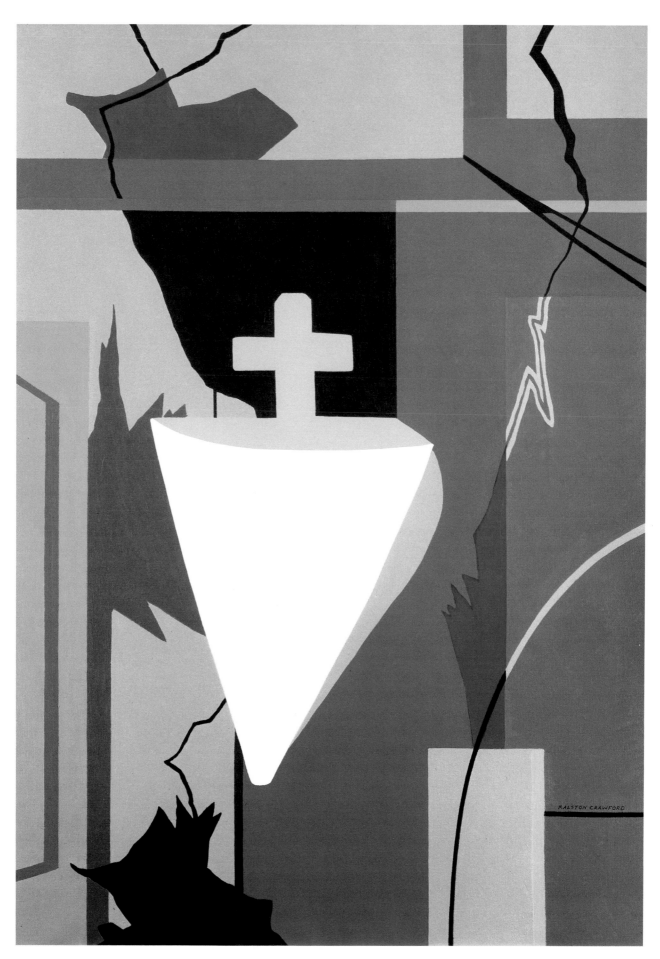

**92. Ralston Crawford** *New Orleans No. 7,*
1954-1956
Oil on canvas, 40 x 28 in.

**93. Morris Graves** *Spirit Bird,* 1956
Tempera on paper, 32 x 24 in.

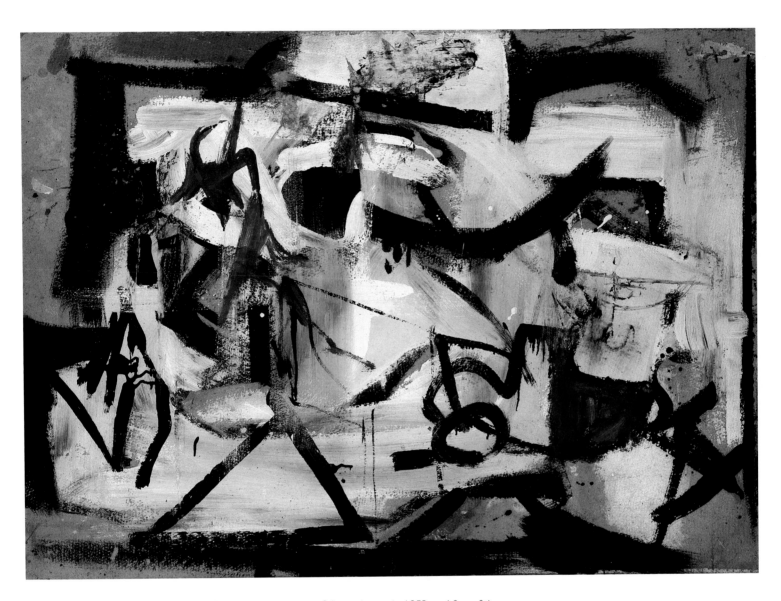

For about a year, beginning in mid-1948, Kline worked on a series of richly colored, quickly painted abstractions. They developed from years of more literal work: as Kline reports, "Previous to this I planned painting compositions with brush and ink using figurative forms and actual objects with color." These pictures were transitional, for by late 1949 he was working on the large-scale black-and-white paintings that were seen in his first one-man show (in 1950) and brought him renown.

Only a handful of the colored abstractions of 1948 and 1949 have survived, as many were simply painted over subsequently with black-and-white paintings. Fortunately, the Lane Collection acquired a group of these pictures in 1953, and four of them are included here. Reality has become the art of painting itself; the tenuous connection with observed nature in the work of Hofmann (nos. 32-35) or Gorky has been eliminated here, and there remain only color, energy, and space.

**94. Franz Kline** *Gray Abstraction*, 1949
Oil on beaverboard, 31½ x 41⅞

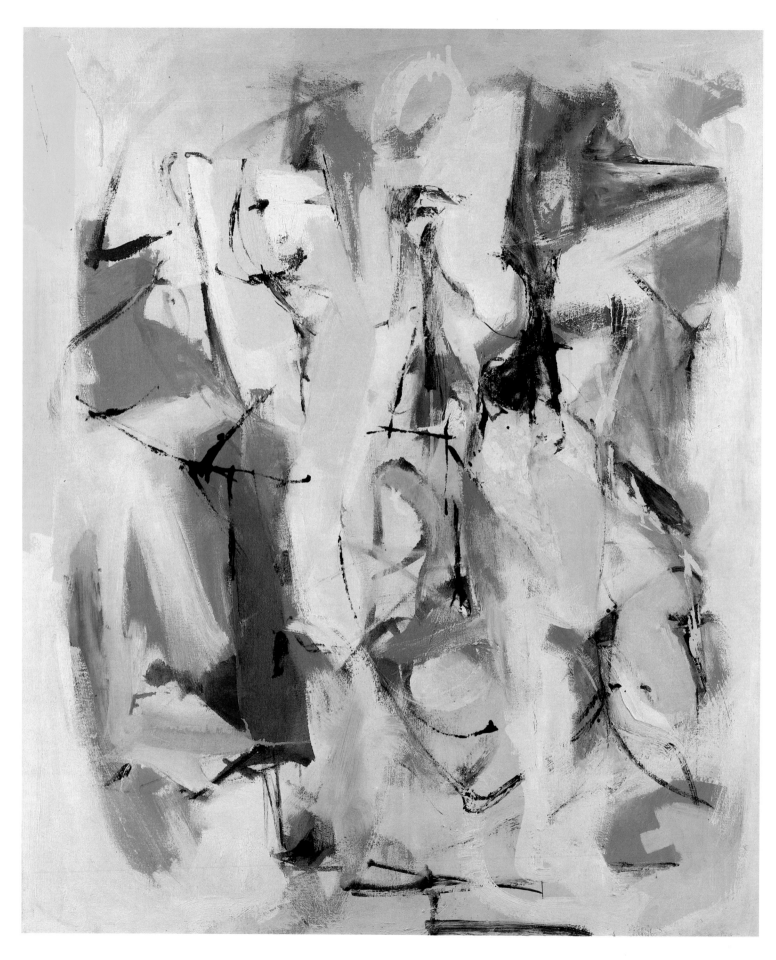

**95. Franz Kline**  *Yellow Abstraction,* 1949
Oil on canvas, 42 x 35 in.

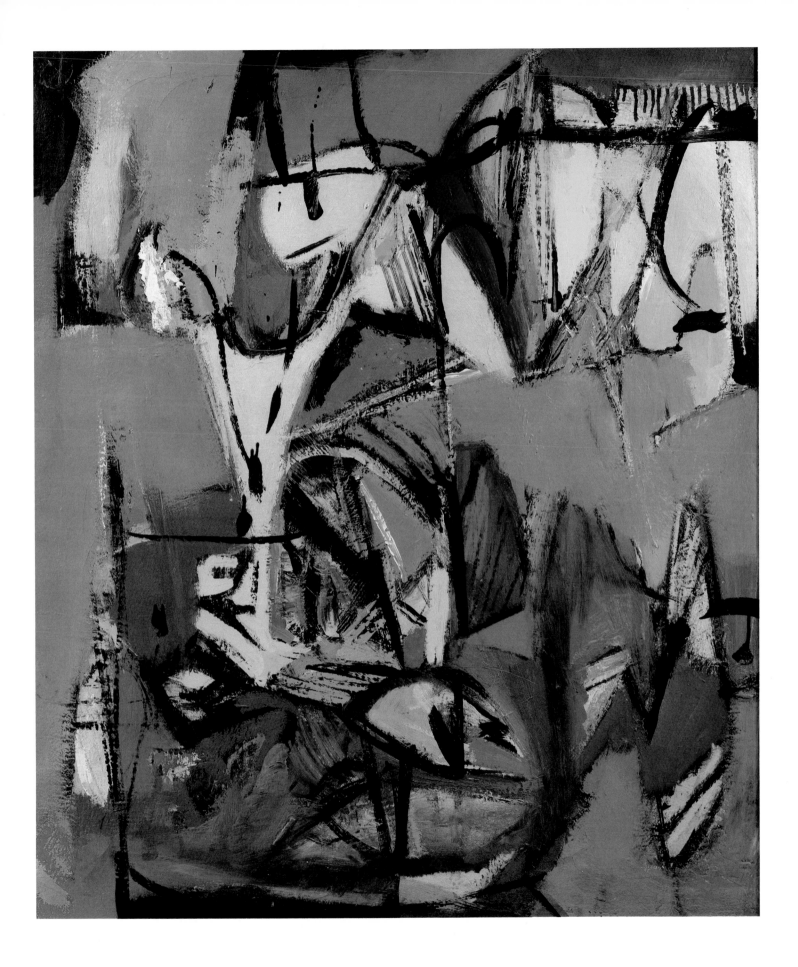

**96. Franz Kline**  *Purple Abstraction,* 1949
Oil on canvas, 38 × 32 in.

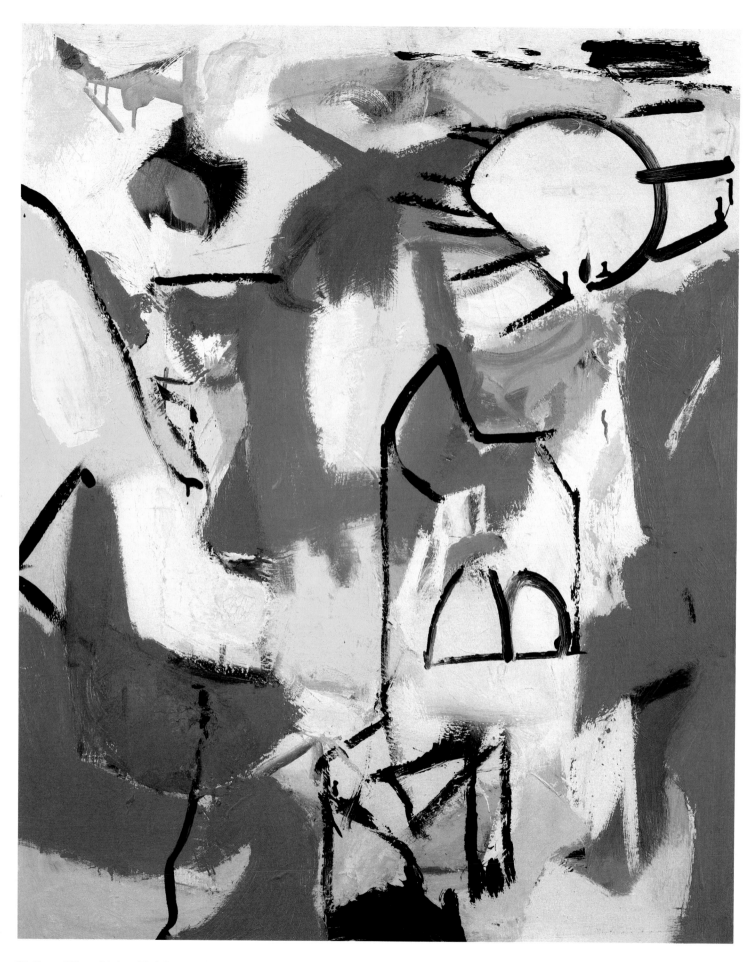

**97. Franz Kline**  *Black and Red, Green, and Yellow,*
1948
Oil on canvas, 40 x 32 in.

**98. Franz Kline**  *Square,* 1953
Oil on canvas, 36 x 30 in.

**99. Jacob Lawrence** *Café Comedian*, 1957
Casein on paper, 23 × 29 in.

Jacob Lawrence may be the best-known black painter in America. His work has been widely honored and exhibited; its colorful, staccato quality seems well attuned to his favorite subjects, the interior and exterior Harlem scenes he has been painting since the 1930s.

Another painter with a highly personal vision is Hyman Bloom of Boston. The direct and challenging imagery of *Female Corpse, Back View* presents a profoundly compassionate statement on the human condition.

When the painting was first exhibited in 1947, Professor Sydney J. Freedberg wrote, "It is astonishing that Bloom should have been able to devise a vocabulary of color, handling and design powerful enough not only to sustain but to equal the power of his content."

**100. Hyman Bloom**   *Female Corpse, Back View,*
1947
Oil on canvas, 68 × 36 in.

# SOURCES FOR COMMENTS ON ILLUSTRATIONS

**1**
Stieglitz's comment is from Dorothy Norman, *Alfred Stieglitz, An American Seer* (N.Y., 1960), p. 97.

**2**
The statement comes from *John Marin by John Marin*, Cleve Gray, ed. (N.Y., 1970), p. 96. In fact, Marin did give "color" titles to a half-dozen or so oils of this year, including, for example, *Movement in Red, Yellow, and Green* (estate of the artist).

**8**
Hartley's statement on Ryder comes from his *Adventures in the Arts* (N.Y., 1921), p. 41; the one on *The Great Good Man* is from a letter to Carl Sprinchorn (November 29, 1942), as quoted in *Lyonel Feininger / Marsden Hartley* (MOMA, N.Y., 1944), p. 88. The portrait of Ryder is in the Lowenthal Collection; the earlier portrait of Lincoln, called *Young Worshipper of the Truth* (1940), is at the Sheldon Memorial Gallery, Lincoln, Nebraska.

**9**
On the "Ten Commandments," see Sasha M. Newman, *Arthur Dove and Duncan Phillips* (Washington, D.C., 1981), p. 29, and William I. Homer, "Identifying Arthur Dove's 'The Ten Commandments,'" *American Art Journal* 12 (Summer 1980). The Stieglitz statement is from Frederick S. Wight, *Arthur G. Dove* (Los Angeles, 1958), p. 21.

**10**
The comment is from Arthur Jerome Eddy, *Cubists and Post-Impressionism* (Chicago, 1914), p. 48.

**16**
Other "realistic" paintings of this type are *Snow Thaw* (1930) and *Red Barge, Reflections* (1932), both in the Phillips Collection, Washington, D.C. *Wednesday — Snow* was a gift from the artist, or possibly Stieglitz, to Edward Alden Jewell (art critic for *The New York Times* from the 'twenties to the 'forties), a champion of the Stieglitz painters and the avant-garde and an admirer especially of Dove and Stuart Davis. Jewell's books include *Modern American Art* (N.Y., 1930) and *Have We An American Art?* (N.Y., 1939).

**17**
Hartley wrote of Cézanne and his admiration for El Greco in *Adventures in the Arts* (N.Y., 1921), pp. 32-33.

**18**
Dove letter to Stieglitz (December 5, 1930), Stieglitz Collection, Yale University Archives,

Beinecke Library, as quoted in Sasha Newman, *Dove*, p. 7 (see note 3). For this painting, the artist made an index card with a drawing of the composition and the following notes: "Sunrise I 1937 Tempera on half chalk ground Nap. yel ult. blue rosemadder." These cards for 1935-1937 are owned by William Dove. *Sunrise II* belongs to a private collector in Houston, while *Sunrise III* was bought by Katherine Dreier for the Société Anonyme collection, now at Yale University.

**25**
The sketch for *Evening Blue* is dated August 2, 1941. Estate of Arthur G. Dove.

**28**
The letter (probably written in late October 1946) is in Sasha M. Newman, *Arthur Dove and Duncan Phillips* (Washington, D.C., 1981), p. 63.

**33**
Hofmann's statement appears in the exhibition catalogue *Hans Hofmann, New Paintings,* January 7-26, 1957 (Kootz Gallery, New York).

**34**
Hofmann's statement appears in his essay "Painting and Culture" in *Hans Hofmann: Search for the Real, and Other Essays* (Cambridge, Mass., 1948), pp. 56-57; the story about the two germs was related by Hans Hofmann to William H. Lane in Provincetown, Mass., about 1960.

**36**
The quotation is from Roché's "Memories of P. Bruce" (dated March 10, 1938), reproduced in full in William C. Agee and Barbara Rose, *Patrick Henry Bruce, American Modernist* (N.Y., 1979).

**37**
The quotation is from Lloyd Goodrich, *Max Weber Retrospective Exhibition* (Whitney Museum, N.Y., 1949), p. 54.

**42**
Charles Sheeler's "Autobiography" was written in 1938 for the publisher Harcourt Brace, but was never published. It is written in longhand, unpaginated, and is owned by the Archives of American Art, Washington, D.C.

**51**
The quotation is from the Sheeler "Autobiography" (see above).

**56**
The most recent article on Demuth's "portraits" is Abraham H. Davidson, "Demuth's Poster Portraits," *Artforum* 17 (November 1978), pp. 54-57. The author identifies several of the periodicals including *L'Amour de l'Art* (the dark gray one, to the right) and *L'Art Vivant* (on which

the bottle is resting). However, the meaning of the two clearly visible titles, *Elsie* and *IF*, is obscure, and no one has suggested any reason for Demuth to identify O'Neill with an Italian painter, Longhi, whose name forms part of the title. By this time O'Neill had had many successful plays on Broadway, including the Pulitzer Prize-winning *Anna Christie* (1921), *The Hairy Ape* (1922), and *Desire Under the Elms* (1924).

**61** and **62**
The artist's statement is from Georgia O'Keeffe, *Georgia O'Keeffe* (N.Y., 1977), no. 82; the critic is Emily Genauer in the *N.Y. Herald Tribune* (April 3, 1955).

**63** and **64**
The artist's statement was originally written in the small catalogue "Georgia O'Keeffe: Exhibition of Oils and Pastels," for an exhibition held at An American Place, New York (January 22 - March 17, 1939).

**65** and **66**
The quotation is from Man Ray, *Self-Portrait* (Boston, 1963), p. 55. The Man Ray watercolor is dated on the basis of details found in his autobiography and on stylistic similarity with dated watercolors, including a landscape of 1913 in the collection of Brayton Wilbur, Jr., San Francisco. The Stella is dated on stylistic grounds; Professor Irma Jaffe (of Fordham University) concurs, and suggests that it might have been made either in Italy or in New York as an Italian reminiscence.

**70**
Crawford's memorial tribute to Spencer is found in Richard Freeman's book *Niles Spencer* (Louisville, 1965), pp. 19-21.

**74**
A further argument for its identification as a self-portrait might be in the number 71 on the wall behind the figure; inverted, it would be the painter's age at the time. Several works of 1912 show Davis working in a similar mode, especially *Tenement Scene* (in the Milwaukee Art Center); there a man again stands in the foreground, cut off at the waist, with railings, gates, signs, and windows behind him in a flat space.

**75** and **76**
The quotation is from the autobiography of the artist, published in *Stuart Davis*, Diane Kelder, ed., (N.Y., 1971), p. 25. Davis wrote here of first driving an auto into Gloucester and of being "ambushed by a cop on horseback." Interestingly, he used the same terminology in discussing *Rurales No. 2* (no. 76) with William H. Lane: he

referred to this Havana street scene informally as "the country cop." According to Downtown Gallery records, this work was *originally* titled *Rurale-Havana;* a second watercolor of the same size and year shows the "country cop" on horseback in profile in the foreground (it was called *Rurale-Havana No. 2).*

**80**
The quotation is from the autobiography of the artist, published in *Stuart Davis,* Diane Kelder, ed. (N.Y., 1971), p. 26. Lane (1978) illustrates two gouache studies for *Egg Beater No. 3* (cat. nos. 15 and 16), neither of which is close to the final composition. There is a detailed pencil study (cat. no. 17; now in the Whitney Museum, N.Y.) dated June 16, 1928, and very close to the painting; there exists also a smaller tempera version (private collection). It is not known which two of the four finished "Egg Beater" oils were the ones Davis took with him to Paris in 1928 and 1929.

**82**
Goodrich, Lloyd. "Rebirth of a National Collection," *Art in America* 53, no. 3 (June 1965), pp. 78-89, esp. 87.

**85**
The 1932 drawing is recorded in a photograph in Downtown Gallery records (Archives of American Art); sketches of May 1951, July 1952, July 1953, and 1960 are in the Stuart Davis papers, Harvard University. The artist's comment was made to William H. Lane in late 1962.

**86**
Gorky's statement is taken from his article "Stuart Davis," in *Creative Art* 9 (September 1931), pp. 212-219. Davis wrote a piece called "Arshile Gorky in the 1930's: A Personal Recollection," in *Magazine of Art* 64 (February 1951), pp. 56-58.

Breton's statement comes from his essay "The Eye-Spring-Arshile Gorky," which appeared in the Julien Levy Gallery exhibition catalogue of Gorky's work (N.Y., March 1945).

Jim M. Jordan, in *The Paintings of Arshile Gorky: A Critical Catalogue* (N.Y., 1981), notes that he has "been unable to locate" *Good Hope Road I,* the Lane Collection painting. He discusses Gorky's *Good Hope Road II* of 1945 (Thyssen-Bornemisza Collection), which has apparently been mistitled (it was originally called *Hugging);* it is related stylistically to the Lane painting, but is in no sense sequential to it.

**89**
The statement is from George L.K. Morris's essay "Aspects of Picture Making," which appears with essays by Albers, A.E. Gallatin, Karl Knaths, Léger, Moholy-Nagy, and Mondrian in the American Abstract Artists catalogue for 1946.

**94**
Kline's statement, made in 1955, is quoted in *The New Decade, 35 American Painters and Sculptors* (Whitney Museum, N.Y., 1955).

**99** and **100**
The statement comes from Sydney J. Freedberg, "This Month in New England," in *Art News,* February 1947, p. 52.

# CATALOGUE

* For complete titles, dates, and locations of exhibitions, see "List of Exhibitions" p. 176, and "William H. Lane Foundation Exhibitions," p. 181. All of the latter are here abbreviated as "WHLF."

## JOHN MARIN (1870-1953)

**I**

*Deer Isle, Maine,* 1927
Watercolor on paper, 14½ × 16¼ in.
Signed l.r.: "Marin 27"

*Provenance:*
the artist; Intimate Gallery; Downtown Gallery; to present owner, 1959.

*Selected Bibliography:*
Reich, Sheldon. *John Marin: A Stylistic Analysis and Catalogue Raisonné.* Tucson, 1970 (illus. vol. 2, p. 576).

*Exhibitions:*
Intimate Gallery, 1928; WHLF, Slater Mem. Museum, 1960; Corcoran and Currier Galleries, 1962; U.S.I.A. tour in Berlin and Hamburg, 1962; WHLF, Univ. of New Hampshire, 1963; WHLF, De Cordova Museum, 1963; WHLF, Springfield, 1964; WHLF, Univ. of Vermont, 1966; WHLF, Fitchburg Art Museum, 1968-69; WHLF, Amherst, 1973; WHLF, Andover, 1973-74; WHLF, Danforth Museum, 1978; WHLF, Utica, 1979; WHLF, Univ. of Conn., 1979; WHLF, De Cordova Museum, 1981.

**2**

*Movement — Sea and Sky,* 1946
Oil on canvas, 22 × 28 in.
Signed l.r.: "Marin 46"

*Provenance:*
the artist; Downtown Gallery; to present owner, 1952.

*Selected Bibliography:*
Wight, Frederick S. *John Marin — Frontiersman,* Los Angeles and Berkeley, 1956 (illus.).
*Art in America* 49, no. 2 (illus. p. 49).
Reich, Sheldon. *John Marin: A Stylistic Analysis and Catalogue Raisonné.* Tucson, 1970 (illus. vol. 2, p. 747).

*Exhibitions:*
An American Place, 1947; Downtown Gallery, "Annual," 1947; Whitney Museum, 1947; Univ. of Illinois, 1948; Corcoran Gallery, 1949; Penn. Academy, 1951; WHLF, Andover, 1953; WHLF, Fitchburg Art Museum, 1953-54; M.I.T., 1954; WHLF, Slater Mem. Museum, 1954; De Cordova Museum, 1954; UCLA tour, "Marin," 1955-56; Arts Council Gallery, 1956; WHLF, Slater Mem. Museum, 1957; WHLF, De Cordova Museum, 1955; Corcoran Gallery and Toledo Museum, 1957; Whitney Museum loan exhibition, 1958; WHLF, Currier Gallery, 1958; WHLF, Univ. of Vermont, 1958-59; WHLF, Fitchburg Art Museum, 1959; U.S.I.A. tour in Moscow and Whitney Museum, 1959; Boston Univ., 1960; Corcoran and Currier Galleries, 1962; U.S.I.A. tour in Berlin and Hamburg, 1962; Colby tour, 1963-64; WHLF, Andover, 1973-74; WHLF, Utica, 1979; WHLF, Bowdoin, 1980.

## LYONEL FEININGER (1871-1956)

**3**

*Schlossgasse,* 1915
Oil on canvas, 39½ × 31¾ in.
Signed l.l.: "Feininger 15"

*Provenance:*
the artist; Meyer-Brodnitz, Berlin; Ludwig Fischer, Frankfurt-am-Main (probably Feininger's dealer); brought to U.S. by Dr. Max Fischer (son of Ludwig); Alan Gallery (acquired from Curt Valentin); to present owner, 1953.

*Selected Bibliography:*
Hess, Hans. *Lyonel Feininger.* N.Y., 1959 (illus. p. 261).
Gluhman, Joseph W. "Lyonel Feininger: The Early Paintings" (Ph.D. thesis, Harvard, 1970, p. 277).

*Exhibitions:*
Der Sturm, 1917; Galerie Richter, 1919; Buchholz Gallery, 1944; WHLF, Andover, 1953; WHLF, Fitchburg Art Museum, 1953-54; WHLF, Vassar, 1954; WHLF, Slater Mem. Museum, 1954; WHLF, De Cordova Museum, 1954-55; WHLF, Smith, 1955; WHLF, Wellesley, 1955; ICA, Boston, 1955; Univ. of Iowa, 1955; Des Moines Art Center, 1955; WHLF, Mt. Holyoke, 1956; ICA, Boston, 1957; WHLF, Worcester Art Museum, 1957; WHLF, Radcliffe, 1957; Univ. of Iowa, 1958; WHLF, Currier Gallery, 1958; WHLF, M.I.T. group show, 1959; WHLF, Univ. of New Hampshire, 1963; WHLF, De Cordova Museum, 1963; WHLF, Springfield, 1964; Pasadena Art Museum and tour, 1966; WHLF, M.I.T., 1967-68; WHLF, Univ. of Conn., 1975; WHLF, Utica, 1979.

## MARSDEN HARTLEY (1877-1943)

**4**

*The Hill,* ca. 1907-1908
Oil on artist's board, 12¼ × 12¼ in.
Signed l.l.: "Marsden Hartley"

*Provenance:*
the artist; New Gallery; to present owner, 1954.

*Exhibitions:*
WHLF, Slater Mem. Museum, 1954; WHLF, De Cordova Museum, 1954-55; WHLF, Univ. of Conn., 1975; WHLF, Bowdoin, 1980.

° **5**

*Tinseled Flowers,* 1917
Tempera and tinfoil on glass, 17 × 9¼ in.
Unsigned

*Provenance:*
the artist; collection of Alfred Stieglitz; Weyhe Gallery; to present owner, 1955.

*Exhibitions:*
Ogunquit School, 1917.

**6**

*Painting No. 2,* 1914
Oil on canvas, 39½ × 32 in. (with frame 42⅜ × 34¾ in.)
Signed on reverse (on backing): "Painting No. 2 / by Marsden Hartley"

*Provenance:*
the artist; Alfred Stieglitz; Georgia O'Keeffe; Downtown Gallery; to present owner, 1953.

*Selected Bibliography:*
Haskell, Barbara. *Marsden Hartley.* N.Y.: Whitney Museum of American Art, 1980 (fig. 37).

*Exhibitions:*
WHLF, Andover, 1953; WHLF, Fitchburg Art Museum, 1953-54; WHLF, Vassar, 1954; WHLF, Slater Mem. Museum, 1954; WHLF, De Cordova Museum, 1954-55; WHLF, Smith, 1955; WHLF, Wellesley, 1955; WHLF, Worcester Art Museum, 1957; WHLF, Radcliffe, 1957; Downtown Gallery, N.Y., "Abstract Painting," 1962; Univ. of Iowa, 1962; WHLF, Univ. of New Hampshire, 1963; Corcoran Gallery, 1963; WHLF, De Cordova Museum, 1963; WHLF, Springfield, 1964; Smithsonian, "Abstract Art," 1965-66; "Seven Decades," 1966; WHLF, Amherst, 1973; WHLF, Andover, 1974; WHLF, Univ. of Conn., 1975; WHLF, Utica, 1979; WHLF, Bowdoin, 1980.

**7**

*New Mexico Recollection,* 1923
Oil on canvas, 29 × 41½ in.
Unsigned

*Provenance:*
the artist; Babcock Gallery; to present owner, 1958.

*Exhibitions:*
WHLF, Currier Gallery, 1958; WHLF, Mt. Holyoke, 1959; WHLF, Slater Mem. Museum, 1960; WHLF, Univ. of New Hampshire, 1963; WHLF, Springfield, 1964; WHLF, Univ. of Vermont, 1966; WHLF, Univ. of Conn., 1975; WHLF, Utica, 1979; Whitney Museum and tour, 1980-81.

° Works indicated by symbol are shown in Boston only.

**8**

*The Great Good Man,* 1942
Oil on masonite, 40 × 30 in.
Signed l.r.: "MH 42"

*Provenance:*
the artist; Babcock Gallery; to present owner,
1958.

*Selected Bibliography:*
McCausland, Elizabeth. *Marsden Hartley.* Minne-
apolis, 1952 (p. 10).

*Exhibitions:*
MOMA, 1944; WHLF, Currier Gallery, 1958;
U.S.I.A. tour, 1959-60; WHLF, Univ. of New
Hampshire, 1963; WHLF, De Cordova Museum,
1963; "The Painter and the Photograph,"
1964-65; WHLF, Univ. of Vermont, 1966;
WHLF, Amherst, 1973; WHLF, Andover,
1973-74; WHLF, Utica, 1979; WHLF, Bowdoin,
1980; American Antiquarian Society, 1981;
WHLF, De Cordova Museum, 1981.

## ARTHUR G. DOVE (1880-1946)

° **9**

*Yachting,* ca. 1911
Pastel on linen, 18 × 21½ in.
Unsigned

*Provenance:*
the artist; Downtown Gallery; to present owner,
1953.

*Selected Bibliography:*
Baur, John I.H. "Modern American Art and Its
Critics." *Art in America* 39 (February 1951;
pp. 53-65, illus. p. 61).

*Exhibitions:*
California tour, 1947; Utica, 1947; Houston
Contemporary Arts Museum, 1951; Brooklyn
Museum, 1951; Norfolk Museum, 1953; WHLF,
Andover, 1953; WHLF, Fitchburg Art Museum,
1953-54; WHLF, Vassar, 1954; WHLF, Slater
Mem. Museum, 1954; WHLF, Wellesley, 1955;
WHLF, Deerfield Academy, 1956; WHLF, Mt.
Holyoke, 1956; WHLF, Worcester Art Museum,
1961; Baltimore Museum, 1964; Downtown Gal-
lery, N.Y., 1967; WHLF, Currier Gallery, 1972.

**10**

*Indian Spring,* 1923
Oil on canvas, 18 × 22 in.
Unsigned

*Provenance:*
the artist; Downtown Gallery; to present owner,
1954.

*Selected Bibliography:*
*Christian Science Monitor,* Aug. 7, 1961.

*Exhibitions:*
WHLF, Deerfield Academy, 1956; WHLF, Mt.
Holyoke, 1956; WHLF, Slater Mem. Museum,
1957; WHLF, Worcester Art Museum, 1961;
Downtown Gallery, N.Y., "Abstract Painting,"
1962; WHLF, Univ. of New Hampshire, 1963;
WHLF, Radcliffe, 1964; Michigan State Univ.,
1968; WHLF, Currier Gallery, 1972; WHLF,
Bowdoin, 1980.

° **11**

*The Sea I,* 1925
Cloth, sand, and paper on sheet metal, 13 × 21
in.
Signed on reverse: "Sea I / 1925 / Dove"

*Provenance:*
the artist; Downtown Gallery; to present owner,
1956.

*Selected Bibliography:*
Genauer, Emily. "Dove at Downtown." *N.Y.
Herald Tribune,* Nov. 6, 1955.
Mellow, James R. "Sticks and Stones and Human
Hair." *N.Y. Times,* Jan. 17, 1971.

*Exhibitions:*
Downtown Gallery, "Dove Collages," 1955;
WHLF, Worcester Art Museum, 1961; Smithso-
nian, "Abstract Art," 1965-66; Univ. of Maryland,
1967; Dintenfass Gallery, 1970-71.

**12**

*Clouds,* 1927
Oil and sandpaper on sheet metal, 15 × 20 in.
Unsigned

*Provenance:*
the artist; Downtown Gallery; to present owner,
1953.

*Selected Bibliography:*
*Time* magazine, Aug. 11, 1961.

*Exhibitions:*
Intimate Gallery, 1927; California tour, 1947;
Univ. of North Carolina, 1947; N.Y. Board of
Education, 1948; Houston Contemporary Arts
Museum, 1951; WHLF, Fitchburg Art Museum,
1953-54; WHLF, Vassar, 1954; WHLF, Slater
Mem. Museum, 1954; WHLF, De Cordova
Museum, 1954-55; Downtown Gallery, "Dove
Collages," 1955; WHLF, Deerfield Academy,
1956; WHLF, Mt. Holyoke, 1956; UCLA tour,
1958-59; WHLF, Worcester Art Museum, 1961;
Univ. of Maryland, 1967; Michigan State Univ.,
1968; Dintenfass Gallery, 1970-71; WHLF, Cur-
rier Gallery, 1972; WHLF, Amherst, 1973;
WHLF, Andover, 1973-74; San Francisco Muse-
um and tour, 1974-76; WHLF, Danforth Muse-
um, 1978; South Carolina, 1980.

**13**

*Outboard Motor,* 1927
Oil and metallic paint on sheet metal, 20 × 15 in.
Unsigned

*Provenance:*
the artist; Downtown Gallery; to present owner,
1961.

*Exhibitions:*
Intimate Gallery, 1927; Kantor Gallery, 1956;
WHLF, Worcester Art Museum, 1961; WHLF,
Currier Gallery, 1972; WHLF, Univ. of Conn.,
1975.

**14**

*George Gershwin — I'll Build a Stairway to
Paradise,* 1927
Oil and metallic paint on artist's board, 20 × 15
in.
Signed on reverse: "George Gershwin — I'll
build a stairway to paradise / April 1927 Dove"

*Provenance:*
the artist; his gift to Edward Alden Jewell, N.Y.;
Downtown Gallery; to present owner, 1957.

*Selected Bibliography:*
Jewell, E.A. "Arthur Dove's New Work." *N.Y.
Times,* Dec. 18, 1927 (sec. 9, p. 12).

*Exhibitions:*
Intimate Gallery, 1927; Downtown Gallery,
"Dove," 1947; Kantor Gallery, 1956; UCLA tour,
1958-59; WHLF, Slater Mem. Museum, 1960;
WHLF, Worcester Art Museum, 1961; Smithso-
nian, "Abstract Art," 1965-66; Michigan State
Univ., 1968; WHLF, Currier Gallery, 1972; San
Francisco Museum and tour, 1974-76; WHLF,
Danforth Museum, 1978; WHLF, Utica, 1979;
WHLF, Bowdoin, 1980.

° **15**

*Tree Trunk,* ca. 1929
Pastel on linen, 22 × 36 in.
Signed on reverse (on stretcher): "Dove"

*Provenance:*
the artist; Downtown Gallery; to present owner,
1956.

*Selected Bibliography:*
Rosenfeld, Paul. "The World of Arthur G. Dove."
*Creative Art* 10 (June 1932; pp. 426-430, illus. as
"Abstraction").
McCausland, Elizabeth. "Painter's Progress
Shown in Arthur G. Dove's Work." *Springfield
Sunday Union and Republican* [Mass.], Apr. 9,
1953 (sec. E, p. 6; illus. as "Abstraction").

*Exhibitions:*
National Alliance, 1929; Downtown Gallery,
"Dove," 1956; WHLF, Currier Gallery, 1958;

**DOVE** (cont'd):

WHLF, Fitchburg Art Museum, 1959; WHLF, M.I.T., 1961; WHLF, Worcester Art Museum, 1961.

**16**

*Wednesday — Snow,* 1931
Oil on canvas, 24 x 18 in.
Signed at bottom, center: "Dove"

*Provenance:*
the artist; Downtown Gallery; to present owner, 1957.

*Exhibitions:*
An American Place, 1932; WHLF, Worcester Art Museum, 1957; WHLF, Worcester Art Museum, 1961.

**17**

*Summer,* 1935
Oil on canvas, 25 x 34 in.
Signed at bottom, center: "Dove"

*Provenance:*
the artist; Downtown Gallery; to present owner, 1956.

*Selected Bibliography:*
*Time* magazine, Aug. 11, 1961.

*Exhibitions:*
An American Place, 1935; An American Place, 1936; Downtown Gallery, "Dove," 1956; WHLF, Worcester Art Museum, 1957; WHLF, Slater Mem. Museum, 1957; UCLA tour, 1958-59; WHLF, Worcester Art Museum, 1961; WHLF, De Cordova Museum, 1963; Michigan State Univ., 1968; WHLF, Currier Gallery, 1972; WHLF, Univ. of Conn., 1975.

**18**

*Sunrise I,* 1937
Tempera on canvas, 25 x 35 in.
Signed l.c.: "Dove"

*Provenance:*
the artist; Downtown Gallery; to present owner, 1954.

*Exhibitions:*
An American Place, "Dove," 1937; Worcester Art Museum, 1938; Downtown Gallery, "Summer," 1954; Cornell Univ., 1954; Univ. of Nebraska, 1954; WHLF, Slater Mem. Museum, 1954; WHLF, De Cordova Museum, 1954-55; WHLF, Smith, 1955; WHLF, Wellesley, 1955; WHLF, Deerfield Academy, 1956; WHLF, Worcester Art Museum, 1957; Whitney Museum and tour, 1958-59; WHLF, Mt. Holyoke, 1959; Boston Univ., 1960; WHLF, Worcester Art Museum, 1961; Corcoran Gallery, 1963; "Seven Decades," 1966; WHLF, Univ. of Vermont, 1966; Whitney Museum, 1968; WHLF, Currier Gallery, 1972; San Francisco Museum and tour, 1974-76; Indianapolis and Berkeley, 1977-78; WHLF, Utica, 1979.

**19**

*Tanks,* 1938
Oil and wax emulsion on canvas, 25 x 35 in.
Signed l.c.: "Dove"

*Provenance:*
the artist; Downtown Gallery; to present owner, 1953.

*Selected Bibliography:*
Ray, Martin W. "Arthur G. Dove, The . . . Boldest Pioneer." *Arts Magazine* 32 (September 1958; pp. 34-41).
*Worcester Evening Gazette,* July 10, 1961.

*Exhibitions:*
An American Place, 1938; California tour, 1947; Univ. of North Carolina, 1947; N.Y. Board of Education, 1949; Virginia State College, 1950; WHLF, Andover, 1953; WHLF, Fitchburg Art Museum, 1953-54; WHLF, Vassar, 1954; WHLF, Slater Mem. Museum, 1954; WHLF, De Cordova Museum, 1954-55; WHLF, Wellesley, 1955; WHLF, Deerfield Academy, 1956; WHLF, Mt. Holyoke, 1956; WHLF, Worcester Art Museum, 1957; WHLF, Radcliffe, 1957; UCLA tour, 1958-59; WHLF, Worcester Art Museum, 1961; WHLF, Univ. of New Hampshire, 1963; WHLF, M.I.T., 1966-67; WHLF, Currier Gallery, 1972; WHLF, Andover, 1973-74; WHLF, Univ. of Conn., 1975; Dintenfass Gallery, "Dove," 1980; WHLF, Bowdoin, 1980; WHLF, De Cordova Museum, 1981.

**20**

*Motor Boat,* 1938
Tempera on canvas, 25 x 35 in.
Signed at bottom, center: "Dove"

*Provenance:*
the artist; Downtown Gallery; to present owner, 1956.

*Exhibitions:*
An American Place, 1938; WHLF, Slater Mem. Museum, 1957; WHLF, Mt. Holyoke, 1959; WHLF, Worcester Art Museum, 1961; WHLF, Radcliffe, 1962; WHLF, Springfield, 1964; WHLF, Currier Gallery, 1972.

**21**

*What Harbor,* 1939
Oil on canvas, 16 x 26 in.
Signed at bottom, center: "Dove 39"

*Provenance:*
the artist; Downtown Gallery; to present owner, 1957.

*Selected Bibliography:*
Coates, Robert. "The Art Galleries: 17 Men." *New Yorker,* May 3, 1952 (pp. 95-96).
Porter, Fairfield. "Reviews and Previews: Arthur Dove." *Art News* 51 (May 1952; p. 46).

*Exhibitions:*
An American Place, 1940; Des Moines, "Artist's Vision," 1952; Downtown Gallery, "Dove," 1952; WHLF, Worcester Art Museum, 1957; WHLF, Worcester Art Museum, 1961; WHLF, Currier Gallery, 1972; WHLF, Univ. of Conn., 1975.

**22**

*Sun on the Lake,* 1938
Oil and wax emulsion on canvas, 22¼ x 36 in.
Signed l.c.: "Dove"

*Provenance:*
the artist; Downtown Gallery; to present owner, 1954.

*Selected Bibliography:*
Jewell, E.A. "Dove in Retrospective." *N.Y. Times,* Jan. 12, 1947 (p. X9).
*Journal of American Association of University Women,* January 1956.

*Exhibitions:*
An American Place, 1938; Downtown Gallery, "Dove," 1947; Contemporary Arts Museum, Houston, 1948; Contemporary Arts Museum, Houston, 1951; AFA tour, 1952-53; WHLF, De Cordova Museum, 1954-55; WHLF, Wellesley, 1955; WHLF, Deerfield Academy, 1956; WHLF, Mt. Holyoke, 1956; WHLF, Currier Gallery, 1958; WHLF, Univ. of Vermont, 1958-59; U.S.I.A. tour, 1959-60; WHLF, Worcester Art Museum, 1961; WHLF, Fitchburg Art Museum, 1965; WHLF, Currier Gallery, 1972; WHLF, Amherst, 1973; WHLF, Andover, 1973-74.

**23**

*Traveling,* 1942
Oil on canvas, 16 x 26 in.
Signed at bottom, center: "Dove"

*Provenance:*
the artist; Downtown Gallery; to present owner, 1957.

*Exhibitions:*
An American Place, 1942; Downtown Gallery and tour, "Dove," 1947; Walker Art Center, Minneapolis, "Dove," 1954; UCLA tour, 1958-59; WHLF, Worcester Art Museum, 1961; Michigan State Univ., 1968; WHLF, Currier Gallery, 1972; San Francisco Museum and tour, 1974-76.

**24**

*Neighborly Attempt at Murder,* 1941
Oil and wax emulsion on canvas, 20 x 28 in.

*Signed at bottom, center: "Dove"*

*Provenance:*
the artist; Downtown Gallery; to present owner, 1956.

*Exhibitions:*
An American Place, "Dove," 1941; An American Place, group show, 1941; Phillips Gallery, 1942; Downtown Gallery, "Dove," 1956; WHLF, Worcester Art Museum, 1957; WHLF, M.I.T., group show, 1959; WHLF, M.I.T., 1961; WHLF, Worcester Art Museum, 1961; WHLF, Currier Gallery, 1972; Worcester Art Museum, 1978-79; Dintenfass Gallery, "Dove," 1980.

**25**
*Evening Blue (Firmament),* 1941
Oil and wax emulsion on canvas, 20 × 28 in.
Signed at bottom, center: "Dove 41"

*Provenance:*
the artist; Downtown Gallery; to present owner, 1956.

*Exhibitions:*
An American Place, 1942; California tour, 1947; Contemporary Arts Museum, Houston, 1951; Atlanta, 1952; WHLF, Slater Mem. Museum, 1957; WHLF, Currier Gallery, 1958; WHLF, Univ. of Vermont, 1958-59; WHLF, Mt. Holyoke, 1959; WHLF, Worcester Art Museum, 1961; WHLF, Springfield, 1964; WHLF, Currier Gallery, 1972.

**26**
*Square on the Pond,* 1942
Oil and wax emulsion on canvas, 20 × 28 in.
Signed at bottom, center: "Dove"

*Provenance:*
the artist; Downtown Gallery; to present owner, 1957.

*Selected Bibliography:*
Coates, Robert. "The Art Galleries: 17 Men." *New Yorker,* May 3, 1952 (pp. 95-96).

*Exhibitions:*
An American Place, 1942; Downtown Gallery, "Dove," 1952; Des Moines Art Center, "Artist's Vision," 1952; Contemporary Arts Museum, Houston, 1954; Randolph Macon, 1954; UCLA tour, 1958-59; WHLF, Slater Mem. Museum, 1960; WHLF, Worcester Art Museum, 1961; WHLF, Univ. of Vermont, 1966; Michigan State Univ., 1968; WHLF, Currier Gallery, 1972; San Francisco Museum and tour, 1974-76; WHLF, Utica, 1979.

**27**
*Roof Tops,* 1943
Oil on canvas, 24 × 32 in.
Signed at bottom, center: "Dove"

*Provenance:*
the artist; Downtown Gallery; to present owner, 1956.

*Selected Bibliography:*
Devree, Howard. "Pioneer Modernist: Arthur Dove's Expressionist Abstraction." *N.Y. Times,* Apr. 27, 1952.
Coates, Robert. "The Art Galleries: 17 Men." *New Yorker,* May 3, 1952 (pp. 95-96).
George, Laverne. "Arthur Dove." *Art Digest* 29 (Dec. 15, 1954; p. 11).
*The World of Abstract Art.* Ed. by American Abstract Artists. N.Y., 1957 (illus. p. 102).
Ray, Martin W. "Arthur G. Dove, The . . . Boldest Pioneer." *Arts* magazine 32 (September 1958; pp. 34-41).

*Exhibitions:*
An American Place, 1944; Contemporary Arts Museum, Houston, 1951; Downtown Gallery, "Dove," 1952; Rose Fried Gallery, 1953; Utica, 1953; Cornell Univ., 1954 (not in cat.); WHLF, Worcester Art Museum, 1957; UCLA tour, 1958-59; WHLF, Worcester Art Museum, 1961; WHLF, De Cordova Museum, 1963; Michigan State Univ., 1968; WHLF, Currier Gallery, 1972; WHLF, Amherst, 1973; San Francisco Museum and tour, 1974-76; WHLF, Danforth Museum, 1978; WHLF, Utica, 1979.

**28**
*Flagpole, Apple Tree and Garden,* 1943-1944
Oil and wax emulsion on canvas, 24 × 32 in.
Signed at bottom, center: "Dove"

*Provenance:*
the artist; Downtown Gallery; to present owner, 1956.

*Exhibitions:*
An American Place, 1944; UCLA tour, 1958-59; WHLF, Worcester Art Museum, 1961.

**29**
*Dancing Willows,* 1943-1944
Tempera on canvas, 27 × 36 in.
Signed at bottom, center: "Dove"

*Provenance:*
the artist; Downtown Gallery; to present owner, 1956.

*Exhibitions:*
An American Place, 1944; WHLF, Mt. Holyoke, 1956; Downtown Gallery, "Dove," 1956; WHLF, Currier Gallery, 1958; U.S.I.A. tour, 1959-60; WHLF, Worcester Art Museum, 1961; WHLF, Currier Gallery, 1972.

**30**
*That Red One,* 1944
Tempera on canvas, 27 × 36 in.

*Signed at bottom, center: "Dove"*

*Provenance:*
the artist; Downtown Gallery; to present owner, 1957.

*Selected Bibliography:*
*Time* magazine. "The Alchemist," Nov. 8, 1954.
Ray, Martin W. "Arthur G. Dove, The . . . Boldest Pioneer." *Arts* magazine 32 (September 1958; pp. 34-41).
*Newsweek* magazine, Aug. 14, 1961.
Hunter, Sam. *American Art of the Twentieth Century.* N.Y., 1972 (illus. p. 109).

*Exhibitions:*
An American Place, 1944; California tour, 1947; Boris Mirski Gallery, group show, 1949; Washington Univ., 1952; Downtown Gallery, "Mr. and Mrs.," 1952; Walker Art Center, "Dove," 1954; Cornell Univ., 1954; Downtown Gallery, Annual, 1954; Univ. of Iowa, 1955; WHLF, Worcester Art Museum, 1957; WHLF, Radcliffe, 1957; Univ. of Iowa, 1958; UCLA tour, 1958-59; WHLF, Worcester Art Museum, 1961; Downtown Gallery, 1963; WHLF, Univ. of New Hampshire, 1963; WHLF, De Cordova Museum, 1963; Whitney Museum, 1964; Michigan State Univ., 1968; WHLF, Currier Gallery, 1972; San Francisco Museum and tour, 1974-76; WHLF, Utica, 1979; WHLF, Bowdoin, 1980; WHLF, De Cordova Museum, 1981.

**31**
*Pieces of Red, Green, and Blue,* 1944
Oil and wax emulsion on canvas, 18 × 24 in.
Signed l.c.: "Dove"

*Provenance:*
the artist; Downtown Gallery; to present owner, 1954.

*Selected Bibliography:*
*N.Y. Times,* May 13, 1945.
Haskell, Barbara. *Arthur Dove.* San Francisco Museum of Art, 1974 (illus. p. 121, but not in the exhibition).

*Exhibitions:*
An American Place, 1944; An American Place, 1945; WHLF, De Cordova Museum, 1954-55; WHLF, Smith, 1955; WHLF, Wellesley, 1955; WHLF, Deerfield Academy, 1956; WHLF, Worcester Art Museum, 1957; UCLA tour, 1958-59; WHLF, Worcester Art Museum, 1961.

**HANS HOFMANN** (1880-1966)

**32**
*Green Bottle,* 1921
Oil on canvas, 17¾ × 22¾ in.
Inscribed on reverse: "green bottle 1921"

**HOFMANN** (cont.)

*Provenance:*
the artist; to present owner, 1953.

*Selected Bibliography:*
Wight, Frederick S. *Hans Hofmann.* Berkeley and Los Angeles, 1957 (p. 35, illus. p. 34).

*Exhibitions:*
Andover, 1948; WHLF, Fitchburg Art Museum, 1953-54; WHLF, Vassar, 1954; WHLF, Slater Mem. Museum, 1954; WHLF, De Cordova Museum, 1954-55; WHLF, Smith, 1955; WHLF, Wellesley, 1955; WHLF, Mt. Holyoke, 1956; WHLF, Slater Mem. Museum, 1957; WHLF, Mt. Holyoke, 1959; WHLF, Slater Mem. Museum, 1960.

° **33**

*Integration,* 1944
Casein on gessoed plywood, 30 × 24 in.
Signed l.r.: "Hans Hofmann 44"

*Provenance:*
the artist; Shore Gallery; to present owner, 1953.

*Exhibitions:*
WHLF, Fitchburg Art Museum, 1953-54; WHLF, Vassar, 1954; WHLF, Smith, 1955; WHLF, Wellesley, 1955; WHLF, Worcester Art Museum, 1957; WHLF, Slater Mem. Museum, 1957; WHLF, Currier Gallery, 1958; WHLF, Univ. of Vermont, 1966.

° **34**

*Embrace,* 1947
Casein on gessoed plywood, 23⅝ × 57 in.
Signed l.r.: "VI 22 47 / hans hofmann"

*Provenance:*
the artist; to present owner, 1953.

*Exhibitions:*
Betty Parsons Gallery, 1947; WHLF, Fitchburg Art Museum, 1953-54; De Cordova Museum, 1955; UCLA tour, 1957-58; AFA tour, 1959-60; Boston YWCA, 1961.

**35**

*Composition No. 4,* 1953
Oil on canvas, 36 × 48 in.
Signed l.r.: "Hans Hofmann 53"
Inscribed on reverse: "Composition / No. IV 53 / Hans Hofmann"

*Provenance:*
the artist; to present owner, 1953.

*Exhibitions:*
Kootz Gallery, 1953; WHLF, Fitchburg Art Museum, 1953-54; De Cordova Museum, 1954; WHLF, Slater Mem. Museum, 1954; WHLF, De Cordova Museum, 1954-55; WHLF, Wellesley,

1955; WHLF, Mt. Holyoke, 1956; WHLF, Worcester Art Museum, 1957; WHLF, Mt. Holyoke, 1959; Boston Univ., 1960; Boston YWCA, 1961; WHLF, De Cordova Museum, 1963; WHLF, Springfield, 1964.

**PATRICK HENRY BRUCE** (1881-1936)

**36**

*Forms (Peinture),* ca. 1919-1920
Oil on canvas, 23¾ × 36¼ in.
Signed on reverse (on stretcher): "Bruce"
Inscribed on reverse: "ceci est un Patrick Bruce    H.P. Roché"

*Provenance:*
the artist; Henri-Pierre Roché; New Gallery; to present owner, 1955.

*Selected Bibliography:*
Ashton, Dore. "Life and Movement without Recession." *Studio International* 170 (December 1965; p. 250, illus.).
Judson, William P. III. "Patrick Henry Bruce: 1881-1936" (Master's thesis, Oberlin College, 1968).
Wolf, Tom M. "Patrick Henry Bruce." *Marsyas* 15 (1970-1971; pp. 73-85).
Agee, William. "Patrick Henry Bruce: A Major American Artist of Early Modernism". *Arts in Virginia* 17 (Spring 1977; p. 22, pl. 7).
Agee, William, and Rose, Barbara. *Patrick Henry Bruce, American Modernist: A Catalogue Raisonné.* N.Y., 1979.

*Exhibitions:*
Knoedler, 1965; MOMA tour, 1967-68; WHLF, Univ. of Conn., 1975; Whitney Museum and tour, 1978-79; MFA Houston and tour, 1979-80; WHLF, Bowdoin, 1980; WHLF, De Cordova, 1981.

**MAX WEBER** (1881-1961)

**37**

*Three Literary Gentlemen,* 1945
Oil on canvas, 29¼ × 36 in.
Signed l.r.: "Max Weber 1945"

*Provenance:*
the artist; Downtown Gallery; to present owner, 1955.

*Selected Bibliography:*
*Max Weber.* American Artists Group Monograph. N.Y., 1945.
Goodrich, Lloyd. *Max Weber.* N.Y., 1949 (p. 54, illus. p. 52).
*Worcester Telegram* [Mass.], July 7, 1957 (illus.).
Baur, John, ed. *New Art in America.* N.Y., 1957 (illus. p. 69).

Baur, John. *Revolution and Tradition in Modern American Art.* Cambridge, Mass., 1958 (pl. 99).

*Exhibitions:*
Whitney Museum Annual, 1946; Univ. of Illinois, 1948; Whitney Museum and Walker Art Center, 1949; Art Gallery of Toronto, 1949; Brandeis Univ., 1957; WHLF, Worcester Art Museum, 1957; Dallas Museum, 1957; Downtown Gallery, "New Art," 1957; Whitney Museum Annual, 1958; Downtown Gallery, "Weber," 1958; Newark Museum, 1959; Boston Univ., 1960; American Academy and Boston Univ., "Weber," 1962; WHLF, De Cordova Museum, 1963; Whitney Museum, 1964; WHLF, University of Vermont, 1966; WHLF, M.I.T., 1967-68; WHLF, Amherst, 1973; WHLF, Univ. of Conn., 1975; WHLF, Utica, 1979; WHLF, Bowdoin, 1980; WHLF, De Cordova Museum, 1981.

**38**

*Pacific Coast,* 1952
Oil on canvas, 25 × 30 in.
Signed l.r.: "Max Weber '52"

*Provenance:*
the artist; Downtown Gallery; to present owner, 1955.

*Selected Bibliography:*
Werner, Alfred. *Max Weber.* N.Y., 1975 (illus. p. 189).

*Exhibitions:*
WHLF, Mt. Holyoke, 1956; Brandeis Univ., 1957; WHLF, Worcester Art Museum, 1957; WHLF, Slater Mem. Museum, 1957; De Cordova Museum, 1958; WHLF, Currier Gallery, 1958; Whitney Museum, 1959; WHLF, Mt. Holyoke, 1959; WHLF, M.I.T., 1961; WHLF, Radcliffe, 1962; WHLF, Fitchburg Art Museum, 1965; WHLF, Andover, 1973-74; WHLF, Univ. of Conn., 1975; WHLF, Danforth Museum, 1978; WHLF, Utica, 1979; WHLF, Bowdoin, 1980; WHLF, De Cordova Museum, 1981.

**39**

*Red Poppies,* 1953
Oil on canvas, 27 × 19 in.
Signed l.r.: "Max Weber"

*Provenance:*
the artist; Downtown Gallery; to present owner, 1956.

*Exhibitions:*
WHLF, Mt. Holyoke, 1956; Brandeis Univ., 1957; WHLF, Worcester Art Museum, 1957; WHLF, Radcliffe, 1957; Univ. of Minnesota, 1958; WHLF, Fitchburg Art Museum, 1959; WHLF, Slater Mem. Museum, 1960; WHLF, Univ. of New Hampshire, 1963; WHLF, Radcliffe, 1964; WHLF, Springfield, 1964; WHLF, Amherst Col-

lege, 1973; WHLF, Andover, 1973-74; WHLF, Univ. of Conn., 1975; WHLF, Utica, 1979; WHLF, Bowdoin, 1980.

## CHARLES SHEELER (1893-1965)

**40**

*Still Life — Spanish Shawl,* 1912
Oil on canvas, 10¼ × 14¼ in.
Signed on reverse: "Sheeler 1912"
Inscribed on reverse: "this picture was in the Armory show 1913    Charles Sheeler"

*Provenance:*
the artist; to present owner, 1953.

*Selected Bibliography:*
Dochterman, Lillian. "The Stylistic Development of the Work of Charles Sheeler" (Ph.D. thesis, University of Iowa, 1963; pp. 11, 51).

*Exhibitions:*
Armory Show, 1913; MOMA, 1939; Whitney Museum, "Pioneers," 1946; WHLF, Fitchburg Art Museum, 1953-54; WHLF, Slater Mem. Museum, 1954; WHLF, Deerfield Academy, 1956; WHLF, Downtown Gallery, 1956; WHLF, M.I.T., "Sheeler," 1959; WHLF, Katonah Gallery, 1960; Allentown Art Museum, 1961; Univ. of Iowa, 1963; WHLF, De Cordova Museum, 1963; Cedar Rapids, 1967; Smithsonian tour, 1968-69; WHLF, Currier Gallery, 1972; "Paris-New York," 1977.

**41**

*Three White Tulips,* 1912
Oil on wood, 13¾ × 10½ in.
Signed l.l.: "Sheeler 1912"

*Provenance:*
the artist; Parke-Bernet (acq. through Downtown Gallery); to present owner, 1953.

*Exhibitions:*
WHLF, Andover, 1953; WHLF, Fitchburg Art Museum, 1954; WHLF, Vassar, 1954; WHLF, Downtown Gallery, 1956; WHLF, Deerfield Academy, 1956; WHLF, M.I.T., "Sheeler," 1959; WHLF, Katonah Gallery, 1960; WHLF, Andover, 1973-74.

**42**

*Landscape,* 1915
Oil on wood, 10½ × 14 in.
Signed l.r.: "C. Sheeler"
Inscribed on reverse: "Landscape — 1915 Charles Sheeler"

*Provenance:*
the artist; to present owner, 1956.

*Selected Bibliography:*
Watson, Forbes. "Charles Sheeler." *Arts* 5 (May 1923; pp. 335-344).

*New York Sunday Herald Tribune,* April 8, 1956 (illus.).
Dochterman, Lillian. *The Stylistic Development of the Work of Charles Sheeler* (Ph.D. thesis, University of Iowa, 1963; p. 14).
Friedman, Martin. *Charles Sheeler.* N.Y., 1975 (p. 31, illus. p. 50).
Davidson, Abraham H. *Early American Modernist Painting 1910-1935,* N.Y., 1981.

*Exhibitions:*
"Forum Exhibition," 1916; MOMA, 1939; Whitney Museum, "Pioneers," 1946; WHLF, Downtown Gallery, 1956; WHLF, M.I.T., "Sheeler," 1959; "Precisionist View," 1960-61; Downtown Gallery, "Abstract Painting," 1962; Univ. of Iowa, 1962; Univ. of Iowa, 1963; Brandeis Univ., 1963; "Cubism," 1967; Smithsonian tour, 1968-69; WHLF, Currier Gallery, 1972; Delaware Art Museum, 1975; "Paris-New York," 1977.

**43**

*Apples,* 1924
Colored crayons on paper, 7¾ × 11½ in.
Signed l.r.: "Sheeler 1924"

*Provenance:*
the artist; New Gallery; to present owner, 1954.

*Selected Bibliography:*
Dochterman, Lillian. "The Stylistic Development of the Work of Charles Sheeler" (Ph.D. thesis, University of Iowa, 1963; p. 46).

*Exhibitions:*
UCLA tour, 1954-55; WHLF, Wellesley, 1955; WHLF, Downtown Gallery, 1956; WHLF, Deerfield Academy, 1956; WHLF, M.I.T., "Sheeler," 1959; WHLF, Katonah Gallery, 1960; Allentown Art Museum, 1961; Smithsonian tour, 1968; WHLF, Currier Gallery, 1972; Penn. State Univ. and Dintenfass Gallery, 1974.

**44**

*Apples on Pewter Plate,* 1926
Tempera on paper, 12 × 13 in.
Signed l.l.: "Charles Sheeler 1926"

*Provenance:*
the artist; Mrs. Charles H. Russell, Jr., N.Y.; Downtown Gallery; to present owner, 1953.

*Exhibitions:*
MOMA, 1939; Ball State, 1951; Des Moines Art Center, 1951; WHLF, Andover, 1953; WHLF, Fitchburg Art Museum, 1953-54; WHLF, Vassar, 1954; WHLF, Slater Mem. Museum, 1954; WHLF, De Cordova Museum, 1954-55; WHLF, Downtown Gallery, 1956; WHLF, M.I.T., "Sheeler," 1959; WHLF, Katonah Gallery, 1960; WHLF, Fitchburg, 1965; WHLF, Currier Gallery,

1972; Penn. State Univ. and Dintenfass Gallery, 1974.

**45**

*Spring Interior,* 1927
Oil on canvas, 30 × 25 in.
Signed l.r.: "Sheeler 1927"
Inscribed on reverse: "spring interior 1927 Charles Sheeler"

*Provenance:*
the artist; Juliana Force (?); Whitney Museum of American Art, 1931; Downtown Gallery; to present owner, 1954.

*Selected Bibliography:*
Rourke, Constance. *Charles Sheeler: Artist in the American Tradition.* N.Y., 1938 (pp. 142, 144; illus. p. 76).
Coates, Robert. "A Sheeler Retrospective - A Sisley Centennial." *New Yorker,* Oct. 14, 1939.
Born, W. *Still Life Painting in America.* Oxford, 1947 (p. 132).
Adlow, Dorothy. *Christian Science Monitor,* Apr. 20, 1956.
Dochterman, Lillian. *The Stylistic Development of the Work of Charles Sheeler* (Ph.D. thesis, University of Iowa, 1963; p. 46).
Yeh, Susan F. "Charles Sheeler and the Machine Age" (Ph.D. thesis, City University of N.Y., 1981; illus. p. 60).

*Exhibitions:*
MacDowell Club, 1937; MOMA, 1939; International Exposition, S.F., 1940; New Britain Museum, 1941; New Jersey State Museum, 1947; WHLF, Slater Mem. Museum, 1954; WHLF, De Cordova Museum, 1954-55; WHLF, Wellesley, 1955; WHLF, Deerfield Academy, 1956; WHLF, Downtown Gallery, 1956; WHLF, Mt. Holyoke, 1956; WHLF, Worcester Art Museum, 1957; WHLF, Radcliffe, 1957; WHLF, Currier Gallery, 1958; WHLF, M.I.T., "Sheeler," 1959; WHLF, Mt. Holyoke, 1959; WHLF, Katonah Gallery, 1960; WHLF, Slater Mem. Museum, 1960; Allentown Art Museum, 1961; Univ. of Iowa, 1963; Smithsonian tour, 1968-69; WHLF, Currier Gallery, 1972; WHLF, Amherst, 1973; WHLF, Andover, 1973-74; WHLF, Univ. of Conn., 1975; WHLF, Utica, 1979; WHLF, Bowdoin, 1980.

**46**

*Newhaven,* 1932
Oil on canvas, 36 × 29 in.
Signed l.l.: "Sheeler 1932"

*Provenance:*
the artist; Dr. Harry Blutman; Downtown Gallery; to present owner, 1957.

**SHEELER** (cont.)

*Selected Bibliography:*

Dochterman, Lillian. "The Stylistic Development of the Work of Charles Sheeler" (Ph.D. thesis, University of Iowa, 1963; p. 65).
Friedman, Martin. *Charles Sheeler.* N.Y., 1975 (illus. p. 105).

*Exhibitions:*

Downtown Gallery, 1932; Carnegie Institute, 1933; Chicago, "Century of Progress," 1934; MOMA, 1939; Boston, "Art Panorama," 1945; WHLF, M.I.T., "Sheeler," 1959; WHLF, Mt. Holyoke, 1959; WHLF, Katonah Gallery, 1960; Univ. of Iowa, 1963; WHLF, De Cordova Museum, 1963; "Seven Decades," 1966; WHLF, M.I.T., 1966-67; Smithsonian tour, 1968-69; WHLF, Currier Gallery, 1972; WHLF, Danforth Museum, 1978; WHLF, Utica, 1979; WHLF, Bowdoin, 1980; WHLF, De Cordova Museum, 1981.

**47**

*Magnolia,* 1946
Tempera on artist's board, 16½ × 13½ in.
Signed l.r.: "Sheeler 1946"

*Provenance:*

the artist; Downtown Gallery; to present owner, 1954.

*Exhibitions:*

Downtown Gallery, "Sheeler," 1946; Penn. Academy, 1946; Grand Central Art Galleries, 1947; Coleman Art Gallery, 1947; Des Moines Art Center, 1951; Frost Bros., San Antonio, 1951; Society of the Four Arts, 1952; WHLF, Slater Mem. Museum, 1954; WHLF, De Cordova Museum, 1954-55; WHLF, Wellesley, 1955; WHLF, Deerfield Academy, 1956; WHLF, Downtown Gallery, 1956; WHLF, Mt. Holyoke, 1956; WHLF, Worcester Art Museum, 1957; WHLF, M.I.T., "Sheeler," 1959; WHLF, Katonah Gallery, 1960; Allentown Art Museum, 1961; WHLF, Springfield, 1964; WHLF, M.I.T., 1967-68; WHLF, Currier Gallery, 1972; Univ. of Conn., 1979.

**48**

*Architectural Planes,* 1947
Oil on canvas, 15 × 12 in.
Signed l.r.: "Sheeler 47"
Inscribed on reverse (on backing): "Charles Sheeler 1947 Architectural Planes"

*Provenance:*

the artist; Downtown Gallery; to present owner, 1953.

*Selected Bibliography:*

Friedman, Martin. *Charles Sheeler.* N.Y., 1975 (p. 141; illus. p. 154).

*Exhibitions:*

Whitney tour, 1948; Downtown Gallery, "Sheeler," 1949; Perls Gallery, 1949; "Lighthouse Exhibition," 1951; Akron Art Institute (Ohio), 1951; Des Moines Art Center, "Forecast & Review," 1952; WHLF, Andover, 1953; WHLF, Fitchburg Art Museum, 1953-54; WHLF, Vassar, 1954; WHLF, Slater Mem. Museum, 1954; WHLF, De Cordova Museum, 1954-55; WHLF, Smith, 1955; WHLF, Wellesley, 1955; WHLF, Deerfield Academy, 1956; WHLF, Downtown Gallery, 1956; WHLF, Worcester Art Museum, 1957; WHLF, Slater Mem. Museum, 1957; WHLF, M.I.T., "Sheeler," 1959; Allentown Art Museum, 1961; Univ. of Iowa, 1963; Smithsonian tour, 1968-69; WHLF, Currier Gallery, 1972; WHLF, Danforth Museum, 1978; WHLF, Utica, 1979.

**49**

*Massachusetts Barn,* 1948
Oil on canvas, 14 × 24 in.
Signed l.r.: "Sheeler 48"

*Provenance:*

the artist; Downtown Gallery; to present owner, 1955.

*Selected Bibliography:*

*Christian Science Monitor,* July 29, 1957.
*N.Y. Times Magazine,* Feb. 14, 1960.

*Exhibitions:*

Carnegie Institute, 1948; Downtown Gallery, "Sheeler," 1949; Texas Christian Univ., 1949; Delaware Art Center, 1950; Florida State Univ., 1951; Frost Bros., 1951; Dennis Hotel, 1955; Ogunquit, 1955; De Cordova Museum, 1955; WHLF, Deerfield Academy, 1956; WHLF, Downtown Gallery, 1956; WHLF, Worcester Art Museum, 1957; WHLF, Slater Mem. Museum, 1957; WHLF, M.I.T., "Sheeler," 1959; WHLF, Mt. Holyoke, 1959; WHLF, Katonah Gallery, 1960; WHLF, Slater Mem. Museum, 1960; WHLF, Univ. of New Hampshire, 1963; WHLF, Currier Gallery, 1972; WHLF, Amherst College, 1973; WHLF, Univ. of Conn., 1975; WHLF, Danforth Museum, 1978; WHLF, Utica, 1979.

**50**

*Industrial Forms,* 1947
Tempera on artist's board, 22 × 20 in.
Signed l.r.: "Sheeler 1947"

*Provenance:*

the artist; Downtown Gallery; to present owner, 1958.

*Selected Bibliography:*

"5 Stars for February." *Art News,* February 1949 (p. 15).
*Houston Chronicle,* Jan. 7, 1951.

Dochterman, Lillian, "The Stylistic Development of the Work of Charles Sheeler" (Ph.D. thesis, University of Iowa, 1963; p. 53).

*Exhibitions:*

Penn. Academy, 1947; Dartmouth, 1948; Art Inst. of Chicago, 1948; Downtown Gallery, "Sheeler," 1949; Boris Mirski Gallery, group show, 1949; Utica, 1950; Contemporary Arts Museum, Houston, 1951; Detroit Inst. of Arts, 1954; UCLA tour, "Sheeler," 1954-55; Ogunquit, 1956; Landau Gallery, 1957; WHLF, Currier Gallery, 1958; WHLF, M.I.T., "Sheeler," 1959; WHLF, Mt. Holyoke, 1959; WHLF, Katonah Gallery, 1960; WHLF, M.I.T., 1961; WHLF, Univ. of New Hampshire, 1963; WHLF, De Cordova Museum, 1963; WHLF, Fitchburg Art Museum, 1965; WHLF, Univ. of Vermont, 1966; WHLF, Currier Gallery, 1972; WHLF, Amherst, 1973; WHLF, Univ. of Conn., 1975; Detroit Inst. of Arts, 1978; WHLF, Utica, 1979; WHLF, Bowdoin, 1980.

**51**

*Ore into Iron,* 1953
Oil on canvas, 24 × 18 in.
Signed l.r.: "Sheeler 1953"

*Provenance:*

the artist; Downtown Gallery; to present owner, 1953.

*Selected Bibliography:*

Coates, Robert. "The Art Galleries, Gauguin and Sheeler." *New Yorker,* Apr. 14, 1956.
Craven, George M. "Sheeler at 75." *College Art Journal,* Winter 1959 (p. 140; illus. p. 141).
Friedman, Martin. *Charles Sheeler.* N.Y., 1975 (p. 169, illus. p. 175).
Davidson, Abraham H. *Early American Modernist Painting 1910-1935.* N.Y., 1981.
Heller, Nancy, and Williams, Julia. "Charles Sheeler." *American Artist,* 40, no. 402 (Jan. 1976).

*Exhibitions:*

WHLF, Andover, 1953; WHLF, Fitchburg Art Museum, 1953-54; WHLF, Vassar, 1954; WHLF, Slater Mem. Museum, 1954; WHLF, De Cordova Museum, 1954-55; Worcester Art Museum, 1955; WHLF, Wellesley, 1955; WHLF, Deerfield Academy, 1956; WHLF, Downtown Gallery, 1956; WHLF, Mt. Holyoke, 1956; WHLF, Worcester Art Museum, 1957; WHLF, Slater Mem. Museum, 1957; Univ. of Montreal (McGill), 1958; WHLF, M.I.T., "Sheeler," 1959; WHLF, Katonah Gallery, 1960; Allentown Art Museum, 1961; Univ. of Iowa, 1963; WHLF, Springfield, 1964; Smithsonian tour, 1968-69; WHLF, Currier Gallery, 1972; WHLF, Univ. of Conn., 1975.

**52**

*New England Irrelevancies,* 1953
Oil on canvas, 29 x 23 in.
Signed l.r.: "Sheeler 1953"

*Provenance:*
the artist; Downtown Gallery; to present owner,
1953.

*Selected Bibliography:*
Wight, Frederick S. "Charles Sheeler." *Art in
America,* October 1954 (pp. 180-213; illus. p.
180).
Chanin, A.L. "Charles Sheeler: Purist Brush and
Camera Eye." *Art News,* Summer 1955 (pp.
40-41, 70-72; illus. p. 41).
Preston, Stuart. "Cubist Tradition." *N.Y. Times,*
Apr. 8, 1956 (p. XII, illus.).
Cohen, George M. "Charles Sheeler." *American
Artist,* January 1959 (pp. 66-67; illus. p. 37).
Dochterman, Lillian. "The Stylistic Development
of the Work of Charles Sheeler" (Ph.D. thesis,
University of Iowa, 1963; p. 93).
Friedman, Martin. *Charles Sheeler.*N.Y., 1975
(illus. p. 176).

*Exhibitions:*
WHLF, Andover, 1953; WHLF, Fitchburg,
1953-54; Penn. Academy, 1954; De Cordova
Museum, 1954; UCLA tour, 1954-55; WHLF,
Wellesley, 1955; WHLF, Deerfield Academy,
1956; WHLF, Downtown Gallery, 1956; WHLF,
Mt. Holyoke, 1956; WHLF, Worcester Art Mu-
seum, 1957; Whitney Museum loan exhibition,
1958; Downtown Gallery, "Sheeler," 1958;
WHLF, M.I.T., "Sheeler," 1959; American Acade-
my, "Sheeler," 1962; Univ. of Iowa, 1963; Smith-
sonian tour, 1968-69; WHLF, Currier Gallery,
1972; WHLF, Andover, 1973-74.

**53**

*Begonias,* 1955
Oil on canvas, 25 x 27 in.
Signed l.r.: "Sheeler / 1955"
Inscribed on reverse (on board): "Begonias /
Charles Sheeler / 1955 / Do not remove / this
board / C.S."

*Provenance:*
the artist; Downtown Gallery; to present owner,
1955.

*Selected Bibliography:*
"In the Galleries." *Arts* 30 (April 1956; illus. p. 52).
Swenson, Virginia. "Art for Everyone." *Indepen-
dent Republican* [Goshen, N.Y.], Apr. 12, 1958.
"Margaret Browning Writes." *Arts,* April 1958
(p. 55).
Friedman, Martin. *Charles Sheeler.* N.Y., 1975
(illus. p. 205).

*Exhibitions:*
Downtown Gallery, Annual, 1955; WHLF,
Deerfield Academy, 1956; WHLF, Downtown
Gallery, 1956; WHLF, Worcester Art Museum,
1957; Downtown Gallery, "Sheeler," 1958; De
Cordova Museum, 1958; WHLF, M.I.T., "Sheel-
er," 1959; Dallas Museum, 1959; WHLF, M.I.T.,
group show, 1959; WHLF, Katonah Gallery,
1960; WHLF, M.I.T., 1961; WHLF, Univ. of New
Hampshire, 1963; WHLF, Univ. of Vermont,
1966; Smithsonian tour, 1968-69; WHLF, Cur-
rier Gallery, 1972; WHLF, Univ. of Conn., 1975;
Dintenfass Gallery, "Sheeler," 1980; WHLF, Bow-
doin, 1980; WHLF, De Cordova Museum, 1981.

**54**

*Lunenburg,* 1954
Oil on canvas, 25 x 34 in.
Signed l.r.: "Sheeler 1954"

*Provenance:*
the artist; Downtown Gallery; to present owner,
1954.

*Selected Bibliography:*
*Tarrytown Daily News* [N.Y.], Sept. 2, 1954 (illus.).
Dochterman, Lillian. "The Stylistic Development
of the Work of Charles Sheeler" (Ph.D. thesis,
University of Iowa, 1963; p. 87).
Friedman, Martin. *Charles Sheeler.* N.Y., 1975
(illus. p. 177).

*Exhibitions:*
Downtown Gallery, Annual, 1954; WHLF, De
Cordova Museum, 1954-55; Whitney Museum,
1955; WHLF, Smith, 1955; Penn. Academy,
1956; WHLF, Downtown Gallery, 1956; WHLF,
Mt. Holyoke, 1956; WHLF, Radcliffe, 1957;
WHLF, Currier Gallery, 1958; WHLF, M.I.T.,
"Sheeler," 1959; U.S.I.A. tour in Moscow and
Whitney Museum, 1959; Boston Univ., 1960;
Allentown Art Museum, 1961; American Acade-
my, 1962; Univ. of Iowa, 1963; Smithsonian tour,
1968-69; WHLF, Currier Gallery, 1972.

## CHARLES DEMUTH (1883-1935)

**55**

*White Architecture,* 1917
Graphite and watercolor on paper, 17½ x 11½
in.
Signed l.l.: "C. Demuth 1917"

*Provenance:*
the artist; Locher Collection; Downtown Gallery;
to present owner, 1954.

*Selected Bibliography:*
*Christian Science Monitor,* Aug. 27, 1957.

*Exhibitions:*
MOMA, 1950; Downtown Gallery, "Demuth,"
1950; WHLF, Smith, 1955; WHLF, Worcester
Art Museum, 1957; Ogunquit, 1959; WHLF, Mt.
Holyoke, 1959; "The Precisionist View,"
1960-61; Downtown Gallery, "Abstract Painting,"
1962; Univ. of Iowa, 1962; Whitney tour, 1963;
Brandeis Univ., 1963; WHLF, De Cordova Muse-
um, 1963; WHLF, Springfield, 1964; WHLF,
Fitchburg Art Museum, 1965; WHLF, Univ. of
Vermont, 1966; UCSB tour, 1971-72; WHLF,
Amherst, 1973; WHLF, Andover, 1974; WHLF,
Univ. of Conn., 1975; WHLF, Danforth Museum,
1978; WHLF, Univ. of Conn., 1979; WHLF,
Utica, 1979; WHLF, De Cordova Museum, 1981.

**56**

*Longhi on Broadway,* 1927
Oil on artist's board, 34 x 27 in.
Signed l.l.: "CD"

*Provenance:*
the artist; Georgia O'Keeffe; private collection; to
present owner, 1956-1957.

*Selected Bibliography:*
*Sunday N.Y. Times,* Aug. 25, 1957.
*N.Y. Times Book Review,* May 15, 1960.
Farnham, Emily. *Charles Demuth: Behind a Laugh-
ing Mask.* Norman, Okla., 1971 (pp. 7, 184; pl. 6).

*Exhibitions:*
Intimate Gallery, "Demuth," 1929; Corcoran Gal-
lery, 1935; Whitney Museum, 1937; MOMA,
1950; Downtown Gallery, "Demuth," 1950;
Downtown Gallery, "MCMLIII," 1953; Walker
Art Center, "Fantasy," 1954; Univ. of Iowa, 1955;
Milwaukee Art Museum, 1955; Corcoran Gallery
and Toledo Museum, 1957; WHLF, Worcester
Art Center, 1957; WHLF, Radcliffe, 1957; Ogun-
quit, 1959; "Precisionist View," 1960-61; WHLF,
Radcliffe, 1962; WHLF, De Cordova Museum,
1963; WHLF, Springfield, 1964; Smithsonian,
"Abstract Art," 1965-66; William Penn Mem.
Museum, 1966; UCSB tour, 1971-72; WHLF,
Amherst College, 1973; WHLF, Andover,
1973-74; Washburn Gallery, 1974; WHLF, Univ.
of Conn., 1975; WHLF, Danforth Museum, 1978;
WHLF, Utica, 1979; WHLF, Bowdoin, 1980;
WHLF, De Cordova Museum, 1981.

## GEORGIA O'KEEFFE (1887-)

**57**

*Portrait — Black,* 1916
Watercolor on paper, 12 x 9 in.
Unsigned

*Provenance:*
the artist; Downtown Gallery; to present owner,
1958.

**O'KEEFFE** (cont.)

*Exhibitions:*
Downtown Gallery, "O'Keeffe," 1958; WHLF, De Cordova Museum, 1963; WHLF, Univ. of Conn., 1979.

° **58**

*Lightning at Sea,* 1922
Pastel on paper, 19 x 25½ in.
Unsigned

*Provenance:*
the artist; Downtown Gallery; to present owner, 1953.

*Exhibitions:*
Anderson Galleries, 1923; Downtown Gallery, "O'Keeffe," 1952; WHLF, Andover, 1953; WHLF, Fitchburg Art Museum, 1953-54; WHLF, Vassar, 1954; WHLF, Slater Mem. Museum, 1954; WHLF, De Cordova Museum, 1954-55; WHLF, Wellesley, 1955; WHLF, Mt. Holyoke, 1956; WHLF, Worcester Art Museum, 1957; WHLF, Currier Gallery, 1958; WHLF, Univ. of Vermont, 1958-59; WHLF, Fitchburg Art Museum, 1959; WHLF, Mt. Holyoke, 1959; Worcester Art Museum, 1960; Colby, 1964; Smithsonian, "Abstract Art," 1965-66; WHLF, Univ. of Conn., 1975; American Embassy, London, 1976-77.

**59**

*Ends of Barns,* ca. 1924
Oil on canvas, 16 x 22 in.
Unsigned

*Provenance:*
the artist; Downtown Gallery; to present owner, 1957.

*Exhibitions:*
WHLF, Worcester Art Museum, 1957; WHLF, Univ. of Vermont, 1966; WHLF, Bowdoin, 1980; WHLF, De Cordova Museum, 1981.

**60**

*Calla Lily on Grey,* 1928
Oil on canvas, 32 x 17 in.
Unsigned

*Provenance:*
the artist; Downtown Gallery; to present owner, 1955.

*Exhibitions:*
Intimate Gallery, "O'Keeffe," 1929; Dallas Museum, 1953 (called "1926"); Mayo Hill Gallery, 1953; WHLF, Wellesley, 1955; WHLF, Mt. Holyoke, 1956; WHLF, Worcester Art Museum, 1957; WHLF, Radcliffe, 1957; WHLF, Univ. of Vermont, 1958-59; WHLF, Mt. Holyoke, 1959; WHLF, M.I.T., 1961; WHLF, Univ. of New

Hampshire, 1963; WHLF, Springfield, 1964; "Seven Decades," 1966; WHLF, Univ. of Vermont, 1966; WHLF, Amherst, 1973; WHLF, Andover, 1973-74; WHLF, Univ. of Conn., 1975; WHLF, Bowdoin, 1980.

**61**

*In the Patio No. 4,* 1948
Oil on canvas, 14 x 30 in.
Unsigned

*Provenance:*
the artist; Downtown Gallery; to present owner, 1957.

*Selected Bibliography:*
O'Keeffe, Georgia. *Georgia O'Keeffe.* N.Y., 1976 (fig. 80).

*Exhibitions:*
An American Place, 1950; WHLF, Worcester Art Museum, 1957; De Cordova Museum, 1958; WHLF, Currier Gallery, 1958; WHLF, Mt. Holyoke, 1959; WHLF, Univ. of New Hampshire, 1963; WHLF, Amherst, 1973; WHLF, Andover, 1973-74; WHLF, Univ. of Conn., 1975; WHLF, Utica, 1979.

**62**

*Patio with Black Door,* 1955
Oil on canvas, 40 x 30 in.
Unsigned

*Provenance:*
the artist; Downtown Gallery; to present owner, 1955.

*Selected Bibliography:*
*Jerusalem Post,* Sept. 29, 1959.
O'Keeffe, Georgia. *Georgia O'Keeffe.* N.Y., 1976 (fig. 82).

*Exhibitions:*
Downtown Gallery, "O'Keeffe," 1955; De Cordova Museum, 1955; WHLF, Mt. Holyoke Museum, 1956; WHLF, Worcester Art Museum, 1957; WHLF, Radcliffe, 1957; Pomona, 1958; Univ. of Illinois, 1959; Whitney Museum, 1959; AFA Israel tour, 1959; Currier Gallery and Keene State, 1973.

**63**

*Deer's Skull with Pedernal,* 1936
Oil on canvas, 36 x 30 in.
Unsigned
Inscribed on back with O'Keeffe's star in pencil; also "Deer's Skull with pedernal   36"

*Provenance:*
the artist; Downtown Gallery; to present owner, 1953.

*Selected Bibliography:*
McBride, Henry. Review of An American Place

Show. *New York Sun,* Feb. 13, 1937 (p. 31).
McCausland, Elizabeth. Review of An American Place Show. *Springfield Sunday Union and Republican,* Feb. 14, 1937 (p. 6; called "Deer's Skull").
*Art Digest* 11 (Mar. 1, 1937; p. 13).
Lewisohn, Sam A. *Painters and Personality.* N.Y., 1937 (p. 255; pl. 122; called "Ram's Head with Pedernal").
*Journal of the American Association of University Women* 45, no. 2 (January 1952).
*N.Y. Times Book Review,* Oct. 10, 1954 (cover illustration).
*Keene Reformer* [N.H.], Aug. 15, 1973 (illus.).

*Exhibitions:*
An American Place, "O'Keeffe," 1937; Penn. Academy, 1939; MOMA, 1943; Philadelphia Museum, 1944; MOMA, 1946; WHLF, Andover, 1953; WHLF, Fitchburg Art Museum, 1953-54; WHLF, Vassar, 1954; WHLF, De Cordova Museum, 1954-55; WHLF, Smith, 1955; WHLF, Wellesley, 1955; WHLF, Mt. Holyoke, 1956; WHLF, Worcester, 1957; Whitney Museum loan exhibition, 1958; Worcester Art Museum, 1960; Mt. Holyoke, 1962; Currier Gallery and Keene State, 1962; Whitney Museum, 1968; Whitney tour, 1970-71; WHLF, Univ. of Conn., 1975; State Department tour, 1976-77; WHLF, Danforth Museum, 1978; WHLF, Utica, 1979; WHLF, Bowdoin, 1980; WHLF, De Cordova Museum, 1981.

**64**

*Red Tree, Yellow Sky,* 1952
Oil on canvas, 30 x 48 in.
Signed on reverse: "Red Tree Yellow Sky   52 / Georgia O'Keeffe / Abiquiu, N.M."

*Provenance:*
the artist; Downtown Gallery; to present owner, 1957.

*Exhibitions:*
Downtown Gallery, "O'Keeffe," 1955; Downtown Gallery, "New Mexico," 1957; WHLF, Worcester Art Museum, 1957; WHLF, Radcliffe, 1957; U.S.I.A. tour, 1959-60; WHLF, Univ. of New Hampshire, 1963; WHLF, De Cordova Museum, 1963; Whitney tour, 1970-71; WHLF, Utica, 1979; WHLF, Bowdoin, 1980.

**JOSEPH STELLA** (1877-1946)

**65**

*Nocturne,* ca. 1926-1928
Watercolor on paper, 21¼ x 30 in.
Signed l.r.: "Joseph Stella"

*Provenance:*
the artist; Downtown Gallery; to present owner, 1954.

*Exhibitions:*
Downtown Gallery, "Christmas Show," 1953;
WHLF, Slater Mem. Museum, 1954; WHLF, De
Cordova Museum, 1954-55; WHLF, Wellesley,
1955; WHLF, Worcester Art Museum, 1957;
WHLF, Slater Mem. Museum, 1957; WHLF,
Currier Gallery, 1958; WHLF, Fitchburg Art
Museum, 1959; WHLF, Mt. Holyoke, 1959;
WHLF, De Cordova Museum, 1963; WHLF,
Springfield, 1964; WHLF, Univ. of Conn., 1975;
De Cordova Museum, 1976-77; WHLF, Dan-
forth Museum, 1978; WHLF, Univ. of Conn.,
1979; WHLF, De Cordova Museum, 1981.

**MAN RAY** (1890-1976)

**66**
*Landscape*, ca. 1912-1913
Watercolor on paper, 13½ x 9½ in.
Signed l.r.: "Man Ray"

*Provenance:*
the artist; New Gallery; to present owner, 1956.
*Exhibitions:*
De Cordova Museum, 1976-77; WHLF, Univ. of
Conn., 1979.

**MARK TOBEY** (1890-1976)

**67**
*Burned Over*, 1947
Tempera on paper, 19 x 25 in.
Signed u.l.: "Tobey 47"

*Provenance:*
the artist; Willard Gallery; to present owner,
1955.
*Exhibitions:*
Colorado Springs Arts Center, 1950; Univ. of
Illinois, 1951; Des Moines Art Center, "Artist's
Vision," 1952; Univ. of Chicago, 1952; Art Assn.
of Indianapolis, 1953; European tour, 1955;
WHLF, Worcester 1957; WHLF, Slater Mem.
Museum, 1957; WHLF, Currier Gallery, 1958;
WHLF, Univ. of Vermont, 1958-59; WHLF,
Fitchburg Art Museum, 1959; WHLF, Mt. Holy-
oke, 1959; WHLF, Slater Mem. Museum, 1960;
Willard Gallery and European tour, 1961-62;
WHLF, Radcliffe, 1962; WHLF, De Cordova
Museum, 1963; WHLF, Springfield, 1964; WHLF,
Amherst, 1973; WHLF, Andover, 1973-74;
WHLF, Univ. of Conn., 1975; WHLF, Danforth
Museum, 1978; WHLF, Univ. of Conn., 1979;
WHLF, De Cordova Museum, 1981.

**NILES SPENCER** (1893-1952)

**68**
*The Red Table*, 1927

Oil on canvas, 21 x 35 in.
Signed l.r.: "Niles Spencer"
Inscribed on reverse: "The Red Table    Niles
Spencer"

*Provenance:*
the artist; Whitney Museum of American Art;
Downtown Gallery; to present owner, 1954.
*Exhibitions:*
Whitney Studio Club, 1927-28; De Young Mem.
Museum, 1935; Louisiana State Univ., 1938;
Amherst tour, 1941; College of Wooster, Ohio,
1945; Boston "Art Panorama," 1945; Tate Gal-
lery, 1946; WHLF, Slater Mem. Museum, 1954;
WHLF, De Cordova Museum, 1954-55; WHLF,
Mt. Holyoke Museum, 1956; WHLF, Worcester
Art Museum, 1957; WHLF, Radcliffe, 1957;
WHLF, Currier Gallery, 1958; WHLF, Univ. of
Vermont, 1958-59; WHLF, Fitchburg Art Muse-
um, 1959; WHLF, Slater Mem. Museum, 1960;
WHLF, Radcliffe, 1962; WHLF, De Cordova
Museum, 1963; WHLF, Springfield, 1964; Univ.
of Kentucky and tour, 1965-66; WHLF, M.I.T.,
1966-67; WHLF, Amherst, 1973; WHLF, Ando-
ver, 1973-74; WHLF, Univ. of Conn., 1975;
WHLF, Danforth Museum, 1978.

**69**
*Power House*, 1936
Oil on canvas, 40 x 30 in.
Signed l.l.: "Niles Spencer"

*Provenance:*
the artist; Downtown Gallery; to present owner,
1956.

*Selected Bibliography:*
Davidson, Abraham H. *Early American Modernist
Painting 1910-1935*. N.Y., 1981.
*Memphis Commercial Appeal*, May 15, 1938
(illus.).
*Exhibitions:*
Whitney Museum, 1936; Brooks Art Gallery,
1938; California Palace, 1945; Amherst College,
1956; WHLF, Worcester Art Museum, 1957;
WHLF, Slater Mem. Museum, 1957; Univ. of
Iowa, 1958; WHLF, Mt. Holyoke, 1959; Univ. of
Kentucky and tour, 1965-66; WHLF, Univ. of
Conn., 1975; WHLF, Utica, 1979; WHLF, Bow-
doin, 1980; WHLF, De Cordova Museum, 1981.

**70**
*Near New London*, 1940
Oil on canvas, 25 x 36 in.
Signed l.r.: "Niles Spencer"
Inscribed on reverse: "near New London    N.
Spencer 1940"

*Provenance:*
the artist; Downtown Gallery; to present owner,
1954.

*Exhibitions:*
Whitney Museum, 1940; Corcoran Gallery,
1941; Virginia Museum, 1942; Albright-Knox
Gallery, 1943; Howard Univ., 1943; California
Palace, 1945; Cornell Univ., 1946; Downtown
Gallery, "Spencer," 1947; Boris Mirski Gallery,
1947; Univ. of Iowa, 1948; Brooklyn Museum,
1948; Walker Art Center, "Fantasy," 1954;
WHLF, Slater Mem. Museum, 1954; WHLF, De
Cordova Museum, 1954-55; WHLF, Wellesley,
1955; WHLF, Mt. Holyoke, 1956; WHLF,
Worcester Art Museum, 1957; WHLF, Slater
Mem. Museum, 1957; WHLF, Univ. of Vermont,
1958-59; Univ. of Kentucky and tour, 1965-66;
WHLF, Amherst, 1973; WHLF, Andover,
1973-74; WHLF, Danforth Museum, 1978;
WHLF, Utica, 1979; WHLF, Bowdoin, 1980;
WHLF, De Cordova Museum, 1981.

**71**
*The Cement Mixer*, 1949
Oil on canvas, 16⅛ x 20¼ in.
Signed l.l.: "Niles Spencer"
Inscribed on reverse: "The cement mixer Niles
Spencer 49"

*Provenance:*
the artist; Downtown Gallery; to present owner,
1958.

*Exhibitions:*
Long Island Art Festival, 1949; Boris Mirski
Gallery, group show, 1949; Downtown Gallery,
Christmas show, 1949; Texas Christian Univ.,
1951; Downtown Gallery, "Mr. and Mrs.," 1952;
Downtown Gallery, "Spencer," 1952; Cincinnati
Art Society, 1953; WHLF, Currier Gallery, 1958;
WHLF, Fitchburg Art Museum, 1959; WHLF,
Slater Mem. Museum, 1960; WHLF, Univ. of
New Hampshire, 1963; WHLF, De Cordova
Museum, 1963; WHLF, Springfield, 1964; Univ.
of Kentucky and tour, 1965-66; Univ. of Conn.,
1968.

**72**
*Above the Excavation*, 1950
Oil on canvas, 50 x 34 in.
Signed l.r.: "Niles Spencer"

*Provenance:*
the artist; Downtown Gallery; to present owner,
1953.
*Selected Bibliography:*
*Art Digest*, Aug. 1, 1951.
Porter, Fairfield. "Reviews and Previews: Niles
Spencer." *Art News* 51 (November 1952; p. 46).
*Exhibitions:*
Downtown Gallery, "1950," 1950; Carnegie Inst.,
1950; Penn. Academy, 1951; Downtown Gallery,

**SPENCER** (cont.)

"MCMLIII," 1953; WHLF, Andover, 1953; WHLF, Fitchburg Art Museum, 1953-54; MOMA tour, 1954; WHLF, De Cordova Museum, 1954-55; Univ. of Iowa, 1955; Des Moines Art Center, 1955; WHLF, Wellesley, 1955; Downtown Gallery, "Recurrent Image," 1956; Newark Museum, 1956; WHLF, Radcliffe, 1957; WHLF, Currier Gallery, 1958; WHLF, M.I.T., group show, 1959; "Precisionist View," 1960-61; Downtown Gallery, 1963; Whitney Museum, 1964; Univ. of Kentucky and tour, 1965-66; WHLF, Univ. of Conn., 1975; WHLF, Utica, 1979; WHLF, Bowdoin, 1980.

## YASUO KUNIYOSHI (1893-1953)

**73**

*Island of Happiness,* 1924
Oil on canvas, 24 × 30 in.
Unsigned

*Provenance:*
the artist; Mr. and Mrs. Arthur Schwab; Downtown Gallery; to present owner, 1954.

*Selected Bibliography:*
Frost, Rosamund. "Kuniyoshi, American of Two Decades." *Art News* 41 (May 15-31, 1942; p. 19; illus.).
*Yasuo Kuniyoshi.* American Artists Group Monograph. N.Y., 1945.
*Look* magazine, Nov. 23, 1948.
Goodrich, Lloyd. *Yasuo Kuniyoshi.* N.Y., 1948 (pp. 18-19, 44; illus. p. 11).
Pearson, Ralph M. *The Modern Renaissance in American Art.* N.Y., 1954 (p. 88; pl. 43).
Baur, John, ed. *New Art in America.* N.Y., 1957 (illus. p. 156).

*Exhibitions:*
Downtown Gallery, 1942; Whitney Museum, "Kuniyoshi," 1948; Japanese tour, 1954; WHLF, De Cordova Museum, 1954-55; WHLF, Worcester Art Museum, 1957; Ogunquit, 1958; WHLF, Currier Gallery, 1958; WHLF, Mt. Holyoke, 1959; Boston Univ., 1961; WHLF, Univ. of New Hampshire, 1963; Corcoran Gallery, 1963; WHLF, De Cordova Museum, 1963; WHLF, Univ. of Vermont, 1966; WHLF, Amherst College, 1973; WHLF, Univ. of Conn., 1975; WHLF, Utica, 1979; WHLF, Bowdoin, 1980; WHLF, De Cordova Museum, 1981.

## STUART DAVIS (1894-1964)

**74**

*Portrait of a Man,* 1911
Watercolor on paper, 15 × 11 in.
Signed l.l.: "Stuart Davis 1911"

*Provenance:*
the artist; Downtown Gallery; to present owner, 1954.

*Selected Bibliography:*
Goossen, E.C. *Stuart Davis.* N.Y., 1959 (pl. 1).
London, Jack. *Martin Eden.* N.Y., 1967 (cover illus.).
Cognil, Michèl-Louis. *Stuart Davis - Information et Documents* (Mar. 1, 1966).

*Exhibitions:*
WHLF, Slater Mem. Museum, 1954; WHLF, Wellesley, 1955; Dallas Museum, 1957; WHLF, De Cordova Museum, 1963; Smithsonian tour, "Davis," 1965; U.S.I.A. tour, 1966; WHLF, Univ. of Conn., 1979.

**75**

*Gloucester Street,* 1916
Oil on canvas, 24 × 30 in.
Signed l.r.: "Stuart Davis 1916"

*Provenance:*
the artist; to present owner, 1957.

*Selected Bibliography:*
Wolf, Ben. "Stuart Davis: 30 Years of Evolution." *Art Digest* 20 (Nov. 1, 1945; pp. 10, 34; illus.).
*Stuart Davis.* American Artists Group Monograph. N.Y., 1945.
Goossen, E.C. *Stuart Davis.* N.Y., 1959 (pl. 2).
Blesh, Rudi. *Stuart Davis.* N.Y., 1960.
O'Doherty, Brian. *American Masters — Voice and Myth.* N.Y., 1973 (p. 50).

*Exhibitions:*
MOMA, 1945; WHLF, Currier Gallery, 1958; WHLF, Fitchburg, 1959; WHLF, Mt. Holyoke, 1959; WHLF, Slater Mem. Museum, 1960; WHLF, Univ. of New Hampshire, 1963; WHLF, De Cordova Museum, 1963; Penn. Academy, 1964; WHLF, Amherst, 1973; WHLF, Andover, 1974; WHLF, Univ. of Conn., 1975; WHLF, Utica, 1979; WHLF, Bowdoin, 1980.

**76**

*Rurales No. 2, Cuba,* 1919
Watercolor on paper, 18 × 23½ in.
Signed l.r.: "Stuart Davis"

*Provenance:*
the artist; Downtown Gallery; to present owner, 1953.

*Exhibitions:*
WHLF, Andover, 1953; WHLF, Fitchburg, 1954; WHLF, Vassar, 1954; WHLF, Slater Mem. Museum, 1954; WHLF, De Cordova Museum, 1954-55; WHLF, Wellesley, 1955.

**77**

*ITLKSEZ,* 1921

Watercolor and collage on paper, 22 × 16 in.
Signed l.r.: "Stuart Davis"

*Provenance:*
the artist; Downtown Gallery; to present owner, 1954.

*Selected Bibliography:*
Goossen, E.C. *Stuart Davis.* N.Y., 1959 (p. 17; pl. 7).
Kelder, Diane, ed. *Stuart Davis.* N.Y., 1971 (fig. 8).
Lane, John R. "Stuart Davis: Art Theory" (Ph.D. thesis, Harvard, 1976; vol. 1, p. 9; illus. in vol. 2).
Davidson, Abraham H. *Early American Modernist Painting 1910-1935.* N.Y., 1981.

*Exhibitions:*
Downtown Gallery, "Davis," 1946; WHLF, De Cordova Museum, 1954-55; Downtown Gallery, "Abstract Painting," 1962; Univ. of Iowa, 1962; Smithsonian tour, "Davis," 1965; U.S.I.A. tour, 1966; Delaware Art Museum, 1975; Brooklyn and Fogg Museums, 1978; WHLF, Univ. of Conn., 1979; Whitney Museum, 1979.

**78**

*Apples and Jug,* 1923
Oil on composition board, 21¾ × 17¾ in.
Signed u.l.: "Stuart Davis 1923"

*Provenance:*
the artist; Downtown Gallery; to present owner, 1953.

*Selected Bibliography:*
Goossen, E.C. *Stuart Davis.* N.Y., 1959 (p. 19; pl. 9).
Lane, John R. "Stuart Davis: Art Theory" (Ph.D. thesis, Harvard, 1976; vol. 1, pp. 9-10; illus. in vol. 2).

*Exhibitions:*
MOMA, 1945; Frost Bros., 1951; WHLF, Andover, 1953; WHLF, Fitchburg, 1954; WHLF, Vassar, 1954; WHLF, Slater Mem. Museum, 1954; WHLF, De Cordova Museum, 1954-55; WHLF, Wellesley, 1955; WHLF, Mt. Holyoke, 1956; WHLF, Worcester, 1957; WHLF, Slater Mem. Museum, 1957; WHLF, Mt. Holyoke, 1959; Downtown Gallery, "Davis," 1962; Brooklyn and Fogg Museums, 1978.

**79**

*Adit, No. 2,* 1928
Oil on canvas, 29 × 24 in.
Signed l.r.: "Stuart Davis"

*Provenance:*
the artist; Downtown Gallery; to present owner, 1954.

*Selected Bibliography:*
*Christian Science Monitor,* Aug. 27, 1957.

Goossen, E.C. *Stuart Davis*. N.Y., 1959 (p. 23; pl. 19).

*Exhibitions:*
Downtown Gallery, 1930; Detroit Institute, 1931; WHLF, De Cordova Museum, 1954-55; WHLF, Smith, 1955; WHLF, Wellesley, 1955; WHLF, Mt. Holyoke, 1956; WHLF, Worcester, 1957; WHLF, Slater Mem. Museum, 1957; WHLF, Currier Gallery, 1958; WHLF, Univ. of Vermont, 1959; WHLF, Fitchburg Art Museum, 1959; WHLF, Mt. Holyoke, 1959; WHLF, Slater Mem. Museum, 1960; WHLF, M.I.T., 1961; WHLF, Radcliffe, 1962; WHLF, Springfield, 1964.

**80**
*Egg Beater No. 3*, 1927-1928
Oil on canvas, 25 × 39 in.
Signed l.r.: "Stuart Davis"

*Provenance:*
the artist; Downtown Gallery; to present owner, 1953.

*Selected Bibliography:*
Jewell, E.A. "Art: On the Abstract Trail." *N.Y. Times*, Feb. 17, 1935 (illus.).
*Stuart Davis.* American Artists Group Monograph. N.Y., 1939 (illus.).
Greenberg, Clement. "Review of Stuart Davis at MOMA." *Nation*, Nov. 17, 1945.
Davis, Stuart. *Stuart Davis*. N.Y., 1945.
"The Age of Experiment." *Time* magazine, Feb. 13, 1956 (illus.).
Eliot, Alexander E. *300 Years of American Painting*. N.Y., 1957.
Goossen, E.C. *Stuart Davis*. N.Y., 1957 (p. 21; pl. 16).
Blesh, Rudi. *Stuart Davis*. N.Y., 1960.
Kuh, Katherine. *The Artist's Voice*. N.Y., 1962 (pp. 65-66; pl. 62).
O'Doherty, Brian. *American Masters — Voice and Myth*. N.Y., 1973 (p. 56).
Lane, John R. "Stuart Davis: Art Theory" (Ph.D. thesis, Harvard, 1976; vol. 1, pp. 11-12, 21, illus.; diagram and study drawing in vol. 2).

*Exhibitions:*
Whitney Museum, 1935; MOMA, 1945; Downtown Gallery, "Davis," 1946; Minnesota State Fair, 1947; Cincinnati Museum, 1951; Brooklyn Museum, 1951; Downtown Gallery, "Mr. and Mrs.," 1952; WHLF, Andover, 1953; WHLF, Fitchburg Art Museum, 1954; WHLF, Vassar, 1954; WHLF, Slater Mem. Museum, 1954; WHLF, De Cordova Museum, 1954-55; WHLF, Smith, 1955; WHLF, Wellesley, 1955; WHLF, Mt. Holyoke, 1956; Downtown Gallery, "Recurrent Image," 1956; Brandeis Univ., 1957; WHLF,

Worcester, 1957; WHLF, Mt. Holyoke, 1959; "Precisionist View," 1960-61; WHLF, Univ. of New Hampshire, 1963; Corcoran Gallery, 1963; Penn. Academy, 1964; WHLF, Univ. of Vermont, 1966; "Cubism," 1967; WHLF, Amherst, 1973; WHLF, Andover, 1973-74; WHLF, Univ. of Conn., 1975; Brooklyn and Fogg Museums, 1978; WHLF, Utica, 1979; WHLF, Bowdoin, 1980.

**81**
*Interior*, 1930
Oil on canvas, 24 × 20 in.
Signed (twice) u.l. and l.r.: "Stuart Davis"

*Provenance:*
the artist; Mr. and Mrs. Michael Watter; George Fitch, N.Y.; Downtown Gallery; to present owner, 1961.

*Selected Bibliography:*
Goossen, E.C. *Stuart Davis*. N.Y., 1959 (pl. 30).

*Exhibitions:*
Downtown Gallery, 1931; Crillon Gallery, 1931; MOMA, 1945; Downtown Gallery, "Davis," 1946; Minnesota State Fair, 1947; Fairweather-Hardin Gallery, 1948; Stephens, 1949; Downtown Gallery, 1961; WHLF, Fitchburg Art Museum, 1965; WHLF, Univ. of Conn., 1975; WHLF, Danforth Museum, 1978; WHLF, Bowdoin, 1980.

**82**
*Hot Still-Scape for Six Colors — 7th Avenue Style*, 1940
Oil on canvas, 36 × 45 in.
Signed u.r.: "Stuart Davis"

*Provenance:*
the artist; Downtown Gallery; Mr. and Mrs. Jan deGraaff, Portland, Oregon; Edith Gregor Halpert, New York; Sotheby Parke Bernet Galleries, New York, Sale No. 3484, March 14-15, 1973, Lot No. 41; Mr. and Mrs. Meyer Steinberg, Hewlett Bay Park, New York; with A.C.A. Gallery, New York; Museum of Fine Arts, Boston, and the William H. Lane Foundation, 1983.

*Selected Bibliography:*
Johnson, Rhodes. "In Defense of Abstract Art." *Parnassus* 12 (December 1940; illus. p. 6).
Kootz, Samuel. *New Frontiers in American Painting*. New York, 1943.
Pearson, Ralph M. *Experiencing American Pictures*. New York, 1943, p. 37, illus. p. 38, fig. 25.
*Stuart Davis.* New York: American Artists Group, 1945 (n.p., illus.).
Riley, Maude Kemper. "Stuart Davis Retrospective." *Limited Edition: News and Comment on People and Events in Art* 50, no. 4 (November 1945), p. 2.

*Bulletin of the California Palace of the Legion of Honor* 5, no. 8 (December 1947).
Bear, Donald. "Davis Work at Museum Evaluated." *Santa Barbara News Press*, August 7, 1949.
Bankhead, Tallulah. "An Appreciation of Louis Armstrong." *New York Flair*, November 1950 (illus.).
"What Abstract Art Means to Me, Statements by Six American Artists." *Museum of Modern Art Bulletin* 18, no. 3, 1951.
"From the Recent Venice Biennale - Artists Progress." *New York Times*, December 14, 1952.
Fitzsimmons, James. "Painting for the 1952 Venice Biennale Being Shown by the Downtown Gallery." *Art Digest* 27 (December 15, 1952), pp. 16-17, no. 6.
Frankenstein, Alfred. "A Davis Retrospective and the Dutch Moderns." *San Francisco Chronicle: This World Magazine*, August 18, 1957, p. 23.
Lucas, John. "The Fine Art Jive of Stuart Davis." *Arts* 31, no. 10 (September 1957), pp. 34-35.
Goossen, E.C. *Stuart Davis*. New York, 1959 (illus. p. 44).
Kramer, Hilton. "Critics of American Painting: The First Six Volumes of the Great American Artists Series Underscore the Problems of Contemporary Art Criticism." *Arts* 34, no. 1 (October 1959), pp. 26-31.
Weller, Allen. "Stuart Davis by E.C. Goossen." *Art Journal* 20, no. 1 (fall 1960), p. 54.
Haverstock, Mary Sayre. "Stuart Davis as Prophet of Pop Art." *Washington Post*, September 8, 1961 (illus. in color).
"200 Years of American Paintings." *City Art Museum of Saint Louis Bulletin* 48 (April 1964), nos. 1 and 2.
Haverstock, Mary Sayre. "Stuart Davis, Artist, Is Dead." *Washington Post*, June 27, 1964.
Getlein, Frank. "Art and Artists / Exhibit Honors Stuart Davis." *Washington Sunday Star*, May 30, 1965, p. D-5.
Goodrich, Lloyd. "Rebirth of a National Collection." *Art in America* 53, no. 3 (June 1965), p. 87 (illus.).
Rose, Barbara. *American Art Since 1900: A Critical History*. New York, 1968, pp. 119, 295-296 (illus. nos. 5-29).
"Pop Art Pops up at the Metropolitan Museum of Art Birthday Celebration." *Famous Artists Magazine* 18, no. 1, 1970 (illus. in color frontispiece, also p. 7).
*Art News* 72 (February 1973), p. 9, no. 2 (illus. in color).

*Exhibitions:*
Corcoran Gallery, 1941; Santa Barbara Museum of Art, 1941; Cincinnati Modern Art Society,

**DAVIS** (cont.)

1941; Helena Rubinstein's New Art Center, 1942; Downtown Gallery, 1943; MOMA, 1945; Tate Gallery, 1946; California Palace of Legion of Honor, 1947; Santa Barbara Museum of Art, 1949; Venice Biennale, 1952; Downtown Gallery, "Davis and Kuniyoshi," 1952; MOMA, 1953; Brandeis Univ., 1957; Whitney Museum, 1958; Corcoran Gallery, 1959; St. Louis, 1964; Smithsonian tour, "Davis," 1965; Metropolitan Museum, 1969; Bell Gallery, 1977; Brooklyn and Fogg Museums, 1978; ACA Galleries, 1978; Museen der Stadt, Cologne, 1981.

**83**

*Eye Level,* 1951-1954
Oil on canvas, 17 × 12 in.
Signed u.l.: "Stuart Davis"
Inscribed on back (on stretcher): "Eye level   Stuart Davis 1951-1954"

*Provenance:*
the artist; Downtown Gallery; to present owner, 1954.

*Selected Bibliography:*
*N.Y. Herald Tribune,* May 30, 1954 (sec. 4, p. 8; illus.).
Goossen, E.C. *Stuart Davis.* N.Y., 1959 (pl. 61).
O'Doherty, Brian. *American Masters — Voice and Myth.* N.Y., 1973 (p. 74).

*Exhibitions:*
Downtown Gallery, "Davis," 1954; Downtown Gallery, "Summer," 1954; WHLF, Slater Mem. Museum, 1954; WHLF, De Cordova Museum, 1954-55; WHLF, Smith, 1955; WHLF, Wellesley, 1955; Penn. Academy, 1956; WHLF, Mt. Holyoke, 1956; Walker Art Center, Minneapolis (not on tour), 1957; WHLF, Worcester Art Museum, 1957; WHLF, Currier Gallery, 1958; WHLF, Univ. of Vermont, 1958-59; WHLF, M.I.T., group show, 1959; Smithsonian tour, "Davis," 1965; WHLF, Univ. of Vermont, 1966; WHLF, Amherst, 1973; WHLF, Andover, 1973-74; WHLF, Univ. of Conn., 1975; Brooklyn and Fogg Museums, 1978; WHLF, Utica, 1979.

**84**

*Medium Still Life,* 1953
Oil on canvas, 45 × 36 in.
Signed u.r.: "Stuart Davis"

*Provenance:*
the artist; Mr. and Mrs. Daniel Saidenburg, N.Y.; Downtown Gallery; to present owner, 1961.

*Selected Bibliography:*
Genauer, Emily. "Art & Artists." *N.Y. Herald Tribune,* Mar. 7, 1954 (illus.).
De Kooning, Elaine. "Stuart Davis: True to Life."

*Art News* 56 (April 1957; pp. 40-42, 54-55).
Goossen, E.C. *Stuart Davis.* N.Y., 1959 (pl. 59).
Blesh, Rudi. *Stuart Davis.* N.Y., 1960.
*Art in America* 4, 1965.
O'Doherty, Brian. *American Masters — Voice and Myth.* N.Y., 1973 (pp. 56, 74).

*Exhibitions:*
Whitney Museum, 1953; Downtown Gallery, "Davis," 1954; Detroit Institute Annual, 1954; Contemporary Arts Museum, Houston, 1954; Univ. of Nebraska, 1955; Univ. of Iowa, 1955; Downtown Gallery, "Recurrent Image," 1956; Parrish Museum, N.Y., 1956; Fed. of Jewish Philanthropies, 1957; Walker Art Center tour, 1957; Downtown Gallery, "Group Show," 1962; WHLF, Univ. of New Hampshire, 1963; Downtown Gallery, 1963; WHLF, Springfield, 1964; Smithsonian tour, "Davis," 1965; U.S.I.A. tour, 1966; WHLF, Univ. of Conn., 1975; WHLF, Utica, 1979; WHLF, Bowdoin, 1980; WHLF, De Cordova Museum, 1981.

**85**

*Unfinished Business,* 1962
Oil on canvas, 36 × 45 in.
Signed l.l.: "Stuart Davis"

*Provenance:*
the artist; Downtown Gallery; to present owner, 1962.

*Selected Bibliography:*
Judd, Donald. "In the Galleries." *Arts* (September 1962).
O'Doherty, Brian. *American Masters — Voice and Myth.* N.Y., 1973 (p. 46: photograph of Stuart Davis working on *Unfinished Business*).
Kramer, Hilton. "Stuart Davis — Modernist and Thinker." *N.Y. Times,* Jan. 29, 1978 (illus.).

*Exhibitions:*
Downtown Gallery, "Davis," 1962; "Irish Exhibition," 1963; WHLF, De Cordova Museum, 1963; Provincetown, 1964; Smithsonian tour, "Davis," 1965; U.S.I.A. tour, 1966; Univ. of Conn., 1968; Brooklyn and Fogg Museums, 1978; WHLF, Utica, 1979.

**ARSHILE GORKY** (1904-1948)

**86**

*Good Hope Road,* 1945
Oil on canvas, 34 × 44 in.
Signed l.l.: "A. Gorky 45"

*Provenance:*
the artist; Julien Levy Gallery; Kate Nichols; to present owner, 1954.

*Exhibitions:*
Julien Levy Gallery, 1946; Julien Levy Gallery,

1948; WHLF, Slater Mem. Museum, 1954; WHLF, De Cordova Museum, 1954-55; WHLF, Wellesley, 1955; WHLF, Worcester Art Museum, 1957; WHLF, Radcliffe, 1957; Univ. of Montreal (McGill), 1958; De Cordova Museum, 1958; WHLF, Currier Gallery, 1958; Boston Univ., 1960; WHLF, Univ. of New Hampshire, 1963; WHLF, De Cordova Museum, 1963; WHLF, Univ. of Vermont, 1966; WHLF, Univ. of Conn., 1975; WHLF, Utica, 1979.

**ABRAHAM RATTNER** (1895-1978)

**87**

*The Last Judgment,* 1955
Watercolor on paper, 40 × 29½ in.
Signed l.l.: "Rattner 55"

*Provenance:*
the artist; Boris Mirski Gallery, Boston; to present owner, 1958.

*Exhibitions:*
WHLF, Currier Gallery, 1958; WHLF, Slater Mem. Museum, 1960; WHLF, De Cordova Museum, 1963; WHLF, Springfield, 1964; WHLF, Univ. of Conn., 1975; WHLF, Univ. of Conn., 1979; WHLF, De Cordova Museum, 1981.

**BEN SHAHN** (1898-1969)

**88**

*Confrontation,* 1964
Watercolor on rice paper, mounted on artist's board, 24 × 32 in.
Signed l.r.: "Ben Shahn"

*Provenance:*
the artist; Downtown Gallery; to present owner, 1966.

*Exhibitions:*
WHLF, Fitchburg Art Museum, 1968-69; WHLF, Amherst, 1973; WHLF, Andover, 1973-74; WHLF, Univ. of Conn., 1975; WHLF, Danforth Museum, 1978; WHLF, Univ. of Conn., 1979.

**GEORGE L.K. MORRIS** (1905-1975)

° **89**

*Composition with Birch Bark,* 1939
Oil with birch bark and nails on canvas, 27½ × 25¼ in.
Signed l.r.: "Morris 39"

*Provenance:*
the artist; Downtown Gallery; to present owner, 1966.

*Exhibitions:*
Berkshire Museum, 1966; WHLF, Univ. of Conn., 1975; WHLF, Bowdoin, 1980; WHLF, De Cordova Museum, 1981.

**RALSTON CRAWFORD** (1906-1978)

**90**

*Maitland Bridge No. 2,* 1938
Oil on canvas, 40 × 32 in.
Signed l.r.: "Ralston Crawford"

*Provenance:*
the artist; Grace Borgenicht Gallery; to present owner, 1957.

*Selected Bibliography:*
Freeman, Richard B. *Ralston Crawford.* University, Ala., 1953 (illus. p. 16).

*Exhibitions:*
Downtown Gallery, 1944; Crosby Gallery, 1945; Louisiana State Univ., 1950; WHLF, Worcester, 1957; WHLF, Radcliffe, 1957; Milwaukee Inst., 1958; WHLF, Currier Gallery, 1958; WHLF, M.I.T., group show, 1959; WHLF, Slater Mem. Museum, 1960; WHLF, Univ. of Vermont, 1966; Whitney Museum, 1968; WHLF, Andover, 1974; WHLF, Univ. of Conn., 1975; WHLF, Utica, 1979; WHLF, Bowdoin, 1980.

**91**

*New Orleans No. 3,* 1953
Oil on canvas, 28 × 45 in.
Unsigned

*Provenance:*
the artist; the Grace Borgenicht Gallery; to present owner, 1954.

*Exhibitions:*
Borgenicht Gallery, 1954; De Cordova Museum, 1954; WHLF, De Cordova Museum, 1954-55; WHLF, Worcester, 1957; WHLF, Radcliffe, 1957; Milwaukee Inst., 1958; WHLF, Univ. of New Hampshire, 1963; Univ. of Illinois, 1966; WHLF, Utica, 1979; WHLF, Bowdoin, 1980; WHLF, De Cordova Museum, 1981.

**92**

*New Orleans No. 7,* 1954-1956
Oil on canvas, 40 × 28 in.
Signed l.r.: "Ralston Crawford"

*Provenance:*
the artist; Grace Borgenicht Gallery; to present owner, 1956.

*Exhibitions:*
Borgenicht Gallery, 1956; WHLF, Slater Mem. Museum, 1957; Milwaukee Inst., 1958; WHLF, Mt. Holyoke, 1959; "Precisionist View," 1960-61; WHLF, De Cordova Museum, 1963; WHLF, Springfield, 1964; Univ. of Illinois, 1966; WHLF, Univ. of Conn., 1975; WHLF, Utica, 1979; WHLF, Bowdoin, 1980; WHLF, De Cordova Museum, 1981.

**MORRIS GRAVES** (1910-)

**93**

*Spirit Bird,* 1956
Tempera on paper, 32 × 24 in.
Signed l.r.: "Graves 56"

*Provenance:*
the artist; Willard Gallery; to present owner, 1957.

*Exhibitions:*
Ogunquit, 1957; Whitney Museum, 1957; WHLF, Currier Gallery, 1958; WHLF, Fitchburg Art Museum, 1959; WHLF, Mt. Holyoke, 1959; WHLF, Slater Mem. Museum, 1960; WHLF, M.I.T., 1961; MOMA tour, 1963-64; WHLF, Amherst College, 1973; WHLF, Andover, 1973-74; WHLF, Univ. of Conn., 1975; WHLF, Danforth Museum, 1978; WHLF, Univ. of Conn., 1979; WHLF, Utica, 1979.

**FRANZ KLINE** (1910-1962)

° **94**

*Gray Abstraction,* 1949
Oil on beaverboard, 31½ × 41⅞ in.
Signed on reverse: "Franz Kline / 49"

*Provenance:*
the artist; to present owner, 1953.

*Exhibitions:*
WHLF, Andover, 1953; WHLF, Fitchburg Art Museum, 1953-54; WHLF, Slater Mem. Museum, 1954; WHLF, Slater Mem. Museum, 1960.

**95**

*Yellow Abstraction,* 1949
Oil on canvas, 42 × 35 in.
Signed on reverse: "Franz Kline 49"

*Provenance:*
the artist; to present owner, 1953.

*Exhibitions:*
WHLF, Vassar, 1954.

**96**

*Purple Abstraction,* 1949
Oil on canvas, 38 × 32 in.
Signed on reverse: "Franz Kline 49"

*Provenance:*
the artist; to present owner, 1953.

**97**

*Black and Red, Green and Yellow,* 1948
Oil on canvas, 40 × 32 in.
Unsigned

*Provenance:*
the artist; William H. Lane; Museum of Fine Arts, Boston, 1974 (gift of William H. and Saundra Lane).

*Exhibitions:*
WHLF, De Cordova Museum, 1963.

**98**

*Square,* 1953
Oil on canvas, 36 × 30 in.
Signed on reverse: "Franz Kline 53"

*Provenance:*
the artist; to present owner, 1953.

*Exhibitions:*
WHLF, Andover, 1953; WHLF, Fitchburg Art Museum, 1953-54; De Cordova Museum, 1954-55; WHLF, Slater Mem. Museum, 1954.

**JACOB LAWRENCE** (1917-)

**99**

*Café Comedian,* 1957
Casein on paper, 23 × 29 in.
Signed l.r.: "Jacob Lawrence 57"

*Provenance:*
the artist; Alan Gallery; to present owner, 1958.

Exhibitions:
Whitney Museum, 1957; Des Moines Art Center, 1958; WHLF, Currier Gallery, 1958; WHLF, Fitchburg Art Museum, 1959; WHLF, Mt. Holyoke, 1959; AFA tour, 1960-62; WHLF, Univ. of New Hampshire, 1963; WHLF, De Cordova Museum, 1963; WHLF, Radcliffe, 1964; WHLF, Springfield, 1964; UCLA tour, 1966-67; WHLF, Amherst, 1973; WHLF, Andover, 1973-74; WHLF, Univ. of Conn., 1975; WHLF, Danforth Museum, 1978; WHLF, Univ. of Conn., 1979.

**HYMAN BLOOM** (1913-)

**100**

*Female Corpse, Back View,* 1947
Oil on canvas, 68 × 36 in.
Unsigned

*Provenance:*
the artist; Durlacher Bros.; to present owner, 1958.

*Selected Bibliography:*
Freedberg, Sydney. "This Month in New England." *Art News* 47 (February 1949; p. 52).
Baur, John, ed. *New Art in America.* N.Y., 1957 (illus. p. 271).

*Exhibitions:*
Durlacher Bros., 1948; Boris Mirski Gallery, "Bloom," 1949; Virginia Museum, 1950; Univ. of Michigan, 1950; Saõ Paulo, 1953; ICA, Boston, and tour, 1954-55; Alan Gallery, 1957; Wellesley and MFA, Boston, 1959; WHLF, De Cordova Museum, 1963; ICA, Boston, 1979.

# LIST OF EXHIBITIONS

**1913**

The Armory Show, "International Exhibition of Modern Art": 69th Infantry Regiment Armory, N.Y., Feb. 15-Mar. 15; Art Institute of Chicago, Mar. 24-Apr. 16; Copley Society of Boston, Copley Hall, Apr. 28-May 19.

**1916**

Anderson Galleries, N.Y., "Forum Exhibition of Modern American Painters," Mar. 13-25.

**1917**

Ogunquit School of Painting and Sculpture, Ogunquit, Maine, Aug.-Sept. 10.

Der Sturm, Berlin, "Fünfundfünfzigste Ausstellung Lyonel Feininger Gemälde und Aquarelle Zeichnungen," Sept.

**1919**

Galerie Emil Richter, Dresden, "Lyonel Feininger Sonder-Ausstellung seiner Gemälde, Aquarelle, Zeichnungen, Holzschnitte," Sept.

**1923**

Anderson Galleries, N.Y., Jan.-Feb.

**1927**

Intimate Gallery, N.Y., "Arthur G. Dove: Paintings 1927," Dec. 12-Jan. 11 [1928].

Whitney Studio Club, N.Y., "The Whitney Studio Club Traveling Show," Dec.-May [1928].

**1928**

Intimate Gallery, N.Y., "Marin Exhibition," Nov.-Dec.

**1929**

Intimate Gallery, N.Y., "Georgia O'Keeffe: Paintings 1928," Feb. 4-Mar. 17.

National Alliance of Art and Industry, Arts Council of New York, Grand Central Palace, N.Y., "100 Important Paintings by Living American Artists," Apr. 15-27.

Intimate Gallery, N.Y., "Charles Demuth - Five Paintings," Apr. 29-May 18.

**1930**

Downtown Gallery, N.Y., "Stuart Davis: Hotels and Cafés," Jan. 21-Feb. 10.

**1931**

Downtown Gallery, N.Y., "Stuart Davis," Mar. 31-Apr. 9.

Detroit Institute of Arts, "17th Annual Exhibition of American Art," Apr. 14-May 17.

Crillon Gallery, Philadelphia, Dec.

**1932**

An American Place, N.Y., "Arthur G. Dove: New Paintings 1931-1932," Mar. 14-Apr. 9.

Downtown Gallery, N.Y., Oct. 4-22.

**1933**

Carnegie Institute, Pittsburgh, "Thirty-First International Exhibition of Paintings," Oct. 19-Dec. 10.

**1934**

Art Institute of Chicago, "A Century of Progress: Exhibition of Paintings and Sculpture," June 1-Nov. 1.

**1935**

Whitney Museum of American Art, N.Y., "Abstract Painting in America," Feb. 12-Mar. 22.

Corcoran Gallery of Art, Washington, D.C, "Fourteenth Biennial Exhibition of Contemporary American Oil Paintings," March-May.

An American Place, N.Y., "Arthur G. Dove: Exhibition of Paintings, 1934-1935," Apr. 21-May 22.

M.H. de Young Memorial Museum, San Francisco, May.

**1936**

An American Place, N.Y., "New Paintings by Arthur G. Dove," Apr. 20-May 20.

Whitney Museum of American Art, N.Y., "Third Biennial Exhibition of Contemporary American Paintings," Nov. 10-Dec. 10.

**1937**

An American Place, N.Y., "Georgia O'Keeffe: New Paintings," Feb. 5-Mar. 17.
MacDowell Club, N.Y., Feb.-Mar.

An American Place, N.Y., "Arthur G. Dove: New Oils and Water Colors," Mar. 23-Apr. 16.

Whitney Museum of American Art, N.Y., "Charles Demuth Memorial Exhibition," Dec. 15-Jan. 16 [1938].

**1938**

Worcester Art Museum [Mass.], "Third Biennial," Jan. 19-Feb. 27.

An American Place, N.Y., "Arthur G. Dove: Exhibition of Recent Paintings 1938," Mar. 29-May 10.

Brooks Memorial Art Gallery, Memphis, May.

Louisiana State University, Baton Rouge.

**1939**

Pennsylvania Academy of the Fine Arts, Philadelphia, "134th Annual Exhibition of Contemporary American Painting," Feb.-Mar.

Museum of Modern Art, N.Y., "Charles Sheeler: Paintings, Drawings, Photographs."

**1940**

An American Place, N.Y., "Arthur G. Dove: Exhibition of New Oils and Water Colors," Mar. 30-May 14.

Palace of Fine Arts, San Francisco, "Golden Gate International Exposition: Art," May 10-Oct. 16.

Whitney Museum of American Art, N.Y., "1940-41 Annual Exhibition of Contemporary American Paintings," Nov. 27-Jan. 8 [1941].

**1941**

New Britain Museum of American Art [Conn.], "17 Important Paintings from the Permanent Collection of the Whitney Museum," Jan. 15-28.

Corcoran Gallery of Art, Washington, D.C., "The Seventeenth Biennial Exhibition of Contemporary American Paintings," Mar. 23-May 4.

An American Place, N.Y., "Exhibition of New Arthur G. Dove Paintings," Mar. 27-May 17.

Amherst tour, Amherst College [Mass.], April-June.

Santa Barbara Museum of Art [Calif.], "Painting Today and Yesterday in the United States," June 5-Sept. 1.

An American Place, N.Y., "Exhibition: Arthur G. Dove, John Marin, Georgia O'Keeffe, Pablo Picasso, Alfred Stieglitz," Oct. 17-Nov. 27.

Cincinnati Modern Art Society, "Marsden Hartley, Stuart Davis," Oct. 24-Nov. 24.

**1942**

Virginia Museum of Fine Arts, Richmond, "Third Biennial Exhibition of Contemporary American Paintings," Mar. 4-Apr. 14.

Phillips Memorial Gallery, Washington, D.C., "American Paintings and Water Colors," Mar. 15-31.

Helena Rubinstein's New Art Center, N.Y., "Masters of Abstract Art: An Exhibition for the Benefit of the Red Cross," Apr. 1-May 15.

An American Place, N.Y., "Arthur G. Dove: Exhibition of Recent Paintings 1941-1942," Apr. 14-May 27.

Downtown Gallery, N.Y., "Yasuo Kuniyoshi Retrospective Loan Exhibition — 1921-1941," May 5-29.

**1943**

Downtown Gallery, N.Y., "Stuart Davis: Selected Paintings," Feb. 2-27.

Albright-Knox Art Gallery, Buffalo, "18 American Painters," Feb. 25-Mar. 23.

Howard University, Washington, D.C., Apr.

**1944**

Downtown Gallery, N.Y., "Ralston Crawford in Peace and in War," Jan. 4-29.

An American Place, N.Y., "Arthur G. Dove: Paintings 1944," Mar. 21-May 21.

Philadelphia Museum of Art, "History of an American — Alfred Stieglitz: '291' and After," July 1-Nov. 1.

Buchholz Gallery, N.Y., "The Blue Four," Oct. 31-Nov. 25.

Museum of Modern Art, N.Y., "Lyonel Feininger and Marsden Hartley," Oct. 24-Jan. 14 [1945].

**1945**

Stuart Art Gallery, Boston, and Plotkin Brothers, Boston, "Art Panorama Presented by United Modern Art in Boston," Jan. 22-Feb. 25.

Caresse Crosby Gallery, Washington, D.C., "Ralston Crawford," Apr. 10-30.

An American Place, N.Y., "Arthur G. Dove: Paintings 1922-1944," May 3-June 15.

Palace of the Legion of Honor, San Francisco, "Contemporary American Painting," May 17-June 17.

Museum of Modern Art, N.Y., "Stuart Davis," Oct. 17-Feb. 3 [1946].

College of Wooster, Ohio.

## 1946

Downtown Gallery, N.Y., "Stuart Davis Retrospective Exhibition: Gouaches, Watercolors, and Drawings 1912-1914," Jan. 29-Feb. 16.

Downtown Gallery, N.Y., "Exhibition of Recent Paintings by Charles Sheeler," Mar. 5-23.

Whitney Museum of American Art, N.Y., "Pioneers of Modern Art in America," Apr. 9-May 19.

Julien Levy Gallery, N.Y., "Arshile Gorky: Paintings 1946," Apr. 16-May 4.

Cornell University, Ithaca, N.Y., April.

Museum of Modern Art, N.Y., "Georgia O'Keeffe," May 14-Aug. 25.

Cornell University, Ithaca, N.Y., "Second Festival of Contemporary American Arts," May 26-June 2.

Tate Gallery, London, "American Painting from the Eighteenth Century to the Present Day," June-July.

Pennsylvania Academy of the Fine Arts, Philadelphia, Oct.

Whitney Museum of American Art, N.Y., "1946 Annual Exhibition of Contemporary American Painting," Dec. 10-Jan. 16 [1947].

## 1947

Betty Parsons Gallery, N.Y., "Hans Hofmann."

Downtown Gallery, N.Y., "Dove Retrospective Exhibition: Paintings 1914-1946," Jan. 7-25.

New Jersey State Museum, Trenton, "Modern Paintings," Jan.-Mar.

California Tour, "Paintings by Arthur Dove": Vanbark Studios, Studio City, Feb. 17-Mar. 15; Santa Barbara Museum of Art, Apr. 1-18; San Francisco Museum of Art, Apr. 22-May 19.

Grand Central Art Galleries, N.Y., Feb.

An American Place, N.Y., "John Marin," Apr. 1-May 2.

Boris Mirski Gallery, Boston (through Downtown Gallery, N.Y.), "First Exchange Exhibition," Apr. 29-May 17.

Minnesota State Fair, "37th Annual Fine Arts Exhibition," Aug.-Sept.

Downtown Gallery, N.Y., "22nd Annual Exhibition," Sept. 23-Oct. 18.

Coleman Art Gallery, Philadelphia, "5 Prodigal Sons," Oct. 4-30.

Pennsylvania Academy of the Fine Arts, Philadelphia, Oct.

Downtown Gallery, N.Y., "Niles Spencer - One-Man Show," Nov.

California Palace of Legion of Honor, San Francisco, "Second Annual Exhibition of Painting," Nov.-Jan. [1948].

University of North Carolina, Nov.

Whitney Museum of American Art, N.Y., "1947 Annual Exhibition of Contemporary American Painting," Dec. 6-Jan. 25 [1948].

Munson-Williams-Proctor Institute, Utica, N.Y., "Paintings by Arthur G. Dove, 1880-1946," Dec. 7-29.

## 1948

Addison Gallery of American Art, Phillips Academy, Andover, Mass., "Hans Hofmann," Jan. 2-Feb. 9.

University of Illinois, Urbana, "Competitive Exhibition of Contemporary American Painting," Feb. 29-Mar. 28.

Whitney Museum of American Art, N.Y., "Yasuo Kuniyoshi Retrospective Exhibition," Mar. 27-May 9.

Durlacher Brothers, N.Y., "Hyman Bloom," Mar. 30-Apr. 24.

Dartmouth College, Hanover, N.H., Apr.

Whitney tour, "1948 — An Exhibition of Contemporary American Painting": Joslyn Art Museum, Omaha, April; Walker Art Center, Minneapolis, June; Whitney Museum of American Art, N.Y., Nov. 13-Jan. 2 [1949].

University of Iowa, Iowa City, "Fourth Summer Exhibition of Contemporary Art," June-July.

Art Institute of Chicago, Aug.

Carnegie Institute, Pittsburgh, "Painting in the United States - 1948," Oct. 14-Dec. 12.

Fairweather-Hardin Gallery, Chicago, "Paintings from The Downtown Gallery," Oct. 24-Nov.

Julien Levy Gallery, N.Y., "Arshile Gorky, 1905-1948," Nov. 16-Dec. '4.

Brooklyn Museum, "The Coast and the Sea," Nov. 19-Jan. 16 [1949].

New York Board of Education, Nov.

Contemporary Arts Museum, Houston.

## 1949

Downtown Gallery, N.Y., "Charles Sheeler," Jan. 25-Feb. 12.

"Max Weber Retrospective Exhibition": Whitney Museum of American Art, N.Y., Feb. 5-Mar. 27; Walker Art Center, Minneapolis, Apr. 17-May 29.

Boris Mirski Gallery, Boston (in cooperation with Durlacher Bros., N.Y.), "Hyman Bloom," Feb.-Mar.

Stephens College Art Gallery, Columbia, Mo., Feb.

Corcoran Gallery of Art, Washington, D.C., "The Twenty-First Biennial Exhibition of Contemporary American Oil Paintings," Mar.-May.

Santa Barbara Museum of Art Tour, Santa Barbara, "Stuart Davis, Yasuo Kuniyoshi, Franklin Watkins: Thirty Paintings," July-Nov. 20.

New York Board of Education, Oct.

Boris Mirski Gallery, Boston, Oct.

Art Gallery of Toronto, Canada, "Contemporary Paintings from Great Britain, the United States and France with Sculpture from the United States," Nov.-Dec.

Texas Christian University, Fort Worth, Nov.

Downtown Gallery, N.Y., "Christmas Show," Dec.

Perls Gallery, N.Y., Dec.

Long Island Art Festival, N.Y.

## 1950

Colorado Springs Fine Art Center, "Twelfth Annual Exhibition of Artists West of the Mississippi," Feb. 7-Mar. 26.

Louisiana State University Art Gallery, Baton Rouge, "Ralston Crawford," Feb. 24-Mar. 17.

Virginia Museum of Fine Arts, Richmond, "American Painting 1950," Apr. 22-June 4.

Downtown Gallery, N.Y., "In 1950 . . .," Apr. 25-May 13.

Munson-Williams-Proctor Institute, Utica, N.Y., "Selected American Paintings, 1900-1950," Apr. 30-May 21.

Downtown Gallery, N.Y., "Charles Demuth, Paintings in Oil and Watercolor, Dated from 1912-1933," July 6-28.

University of Michigan, Ann Arbor, "Post-War American Painting," Summer.

An American Place, N.Y., "Georgia O'Keeffe: Paintings 1946-1950," Oct. 16-Nov. 25.

Carnegie Institute, Pittsburgh, "Pittsburgh International Exhibition of Paintings," Oct. 19-Dec. 21.

Virginia State College, Oct.

Delaware Art Center, Wilmington, Oct.

Museum of Modern Art, N.Y., "Charles Demuth."

## 1951

Akron Art Institute [Ohio] [Sheeler].

Contemporary Arts Museum, Houston, "Arthur G. Dove / Charles Sheeler," Jan. 7-23.

Pennsylvania Academy of the Fine Arts, Philadelphia, "The One Hundred and Forty-Sixth Annual Exhibition of Paintings and Sculpture," Jan. 21-Feb. 25.

Florida State University, Tallahassee, Jan.

University of Illinois, Urbana, "Exhibition of Contemporary American Painting," Mar. 4-Apr. 15.

Texas Christian University, Fort Worth, March.

N.Y. Assoc. for the Blind, "Lighthouse Exhibition," Apr.

Cincinnati Museum Association [Ohio], Apr.

Des Moines Art Center [Iowa], June.

Frost Brothers Gallery, San Antonio, Summer.

Ball State College, Muncie, Ind., Sept.

Brooklyn Museum, N.Y., "Revolution and Tradition: An Exhibition of the Chief Movements in American Painting from 1900 to the Present," Sept.-Nov.

## 1952

American Federation of Arts tour, High Museum of Art, Atlanta, "Painting Today," Jan. 6-27.

Downtown Gallery, N.Y., "O'Keeffe: Paintings in Pastel," Feb. 19-Mar. 8.

Des Moines Art Center [Iowa], "The Artist's Vision," Feb. 27-Mar. 23.

Society of the Four Arts, Palm Beach, Fla., "Thirteenth Annual Exhibition of Contemporary American Painting," Feb.

Downtown Gallery, N.Y., "Arthur G. Dove (1880-1946) Paintings," Apr. 22-May 10.

University of Chicago Art Gallery, Apr.

Downtown Gallery, N.Y., "Mr. and Mrs.," June.

Venice Biennale, June 14-Oct. 19.

Des Moines Art Center [Iowa], "Forecast and Review," Oct. 27-Nov. 30.

Downtown Gallery, N.Y., "Niles Spencer Memorial Exhibition," Oct.

Washington University, St. Louis, Missouri, Dec.

Downtown Gallery, N.Y., "The Retrospective Exhibition of Paintings by Stuart Davis and Yasuo Kuniyoshi being shown directly upon their arrival from the 1952 Biennale in Venice," Dec. 9-27.

**1953**

Mayo Hill Gallery, West Palm Beach [Fla.] [O'Keeffe].

Art Association of Indianapolis, Jan.-Feb.

Dallas Museum of Fine Arts, "An Exhibition of Paintings by Georgia O'Keeffe," Feb. 1-22.

Downtown Gallery, N.Y., "MDCLIII-MCMLIII," Feb. 17-Mar. 7.

Rose Fried Gallery, N.Y., "10 American Abstract Painters 1912-1952," Mar. 24-Apr. 11.

Norfolk Museum [Va.], "Significant American Moderns," Mar.

European tour, Museum of Modern Art, New York, "Twelve Modern American Painters and Sculptors," Apr. 23-Mar. 7 [1954].

Whitney Museum of American Art, N.Y., "1953 Annual Exhibition of Contemporary American Painting," Oct. 15-Dec. 6.

Cincinnati Modern Art Society, "Selection: American Painters," Oct.

Munson-Williams-Proctor Institute, Utica, N.Y., "Formal Organization in Modern Painting," Nov. 1-29.

Kootz Gallery, N.Y., "Hans Hofmann," Nov. 16-Dec. 12.

Downtown Gallery, N.Y., "Christmas Show," Dec.

Museu de Arte Moderna de São Paulo, Brazil, "II Bienal" [into 1954].

**1954**

Walker Art Center, Minneapolis, "Paintings and Watercolors by Arthur G. Dove," Jan. 10-Feb. 20.

Pennsylvania Academy of the Fine Arts, Philadelphia, "The One Hundred and Forty-Ninth Annual Exhibition of Painting and Sculpture," Jan. 24-Feb. 28.

Museum of Modern Art tour, "Niles Spencer: A Retrospective Exhibition": Akron Art Institute [Ohio], Feb. 1-21; Cincinnati Art Museum [Ohio], Mar. 1-29; Currier Gallery, Manchester, N.H., May 11-June 2; Museum of Modern Art, N.Y., June 22-Aug. 15; Walker Art Center, Minneapolis, Sept. 1-Oct. 1.

Massachusetts Institute of Technology, Cambridge, "John Marin: Etchings, Oils, Watercolors," Feb. 8-27.

University Galleries, University of Nebraska, Lincoln, "Nebraska Art Association Sixty-Fourth Annual Exhibition," Feb. 28-Mar. 28.

Downtown Gallery, N.Y., "Stuart Davis Exhibition of Recent Paintings," Mar. 2-27.

Detroit Institute of Arts, "Work in Progress: Ben Shahn, Charles Sheeler, Joe Jones," Mar. 9-Apr. 11.

De Cordova Museum, Lincoln [Mass.], "Paintings to Live With — A Collector's Show," Mar. 21-Apr. 16.

Detroit Institute of Arts, "Annual Exhibition for Friends of Modern Art," Apr. 20-May 16.

"Hyman Bloom": Institute of Contemporary Art, Boston; Albright-Knox Art Gallery, Buffalo; Lowe Gallery, Coral Gables [Fla.]; M.H. de Young Memorial Museum, San Francisco; Whitney Museum of American Art, N.Y., April-April [1955].

Walker Art Center, Minneapolis, "Reality and Fantasy 1900-1954," May 23-July 2.

Downtown Gallery, N.Y., "Summer 1954," May 25-June 25.

Tokyo, Osaka, Nagoya, Japan. "Kuniyoshi," (Spring-Summer; organized by the National Museum of Modern Art, Tokyo).

Contemporary Arts Museum, Houston, Sept.

Downtown Gallery, N.Y., "29th Annual Exhibition," Oct. 5-30.

UCLA tour, "Charles Sheeler: A Retrospective Exhibition": University of California at Los Angeles, Wight Gallery, Oct. 11-Nov. 7; M.H. de Young Memorial Museum, San Francisco, Nov. 18-Jan. 2 [1955]; San Diego Fine Arts Gallery, Jan. 14-Feb. 11 [1955]; Fort Worth Art Center, Feb. 24-Mar. 24 [1955]; Pennsylvania Academy of the Fine Arts, Philadelphia, Apr. 17-30 [1955]; Munson-Williams-Proctor Institute, Utica, N.Y., May 8-June 15 [1955].

Grace Borgenicht Gallery, N.Y., "Ralston Crawford," Nov. 8-Dec. 4.

Andrew Dickson White Museum of Art, Cornell University, Ithaca, N.Y., "Arthur G. Dove (1880-1946): A Retrospective Exhibition," Nov.

Randolph Macon Woman's College, Lynchburg, Va.

**1955**

Institute of Contemporary Art, Boston, "Pleasures of Collecting 1955," Jan. 11-Feb. 13.

Whitney Museum of American Art, N.Y., "Annual Exhibition," Jan. 12-Feb. 20.

Berne, Paris, London, Jan.-June.

Worcester Art Museum [Mass.], "Five Painters of America," Feb. 17-Apr. 3.

Dennis Hotel, Atlantic City, N.J., Feb.-Mar.

University Galleries, University of Nebraska, Lincoln, "Nebraska Art Association Sixty-Fifth Annual Exhibition," Feb.-Mar.

UCLA tour, "John Marin Memorial Exhibition": Museum of Fine Arts, Boston, Mar. 1-Apr. 17; Phillips Gallery, Washington, D.C., May 11-June 29; San Francisco Museum of Art, July 30-Sept. 11; Art Galleries, University of California, Los Angeles, Sept. 28-Nov. 9; Cleveland Museum of Art, Dec. 1-Jan. 17 [1956]; Minneapolis Institute of Arts, Feb. 3-Mar. 20 [1956]; Society of the Four Arts, Palm Beach [Fla.], April [1956]; University of Georgia, Athens, May [1956]; Whitney Museum of American Art, N.Y., June 12-July 31 [1956]; Tate Gallery, London, Sept. [1956].

Downtown Gallery, N.Y., "Georgia O'Keeffe: New Paintings," Mar. 29-Apr. 23.

University of Iowa Museum of Art, Iowa City, "17th Annual Fine Arts Festival — Contemporary American Painting," June 14-Aug. 10.

Museum of Art of Ogunquit, Maine, "Third Annual Exhibition," July 1-Sept. 11.

Des Moines Art Center [Iowa], Aug.

Milwaukee Art Museum, "55 Americans '55'," Sept. 9-Oct. 23

Downtown Gallery, N.Y., "30th Annual Exhibition," Oct. 4-29.

De Cordova Museum, Lincoln, Mass., "American Painters: 1955," Oct. 9-Nov. 4.

Downtown Gallery, N.Y., "Collages: Dove," Nov. 1-26.

**1956**

Pennsylvania Academy of the Fine Arts, Philadelphia, "One Hundred and Fifty-First Annual Exhibition of Oil Paintings and Sculpture," Jan. 22-Feb. 26.

Downtown Gallery, N.Y., "The Recurrent Image," Jan. 31-Feb. 25.

Downtown Gallery, N.Y., "Special Exhibition of Paintings by Dove," Feb. 28-Mar. 24.

Newark Museum [N.J.], "Abstract Art: 1910 to Today," Apr. 27-June 10.

Paul Kantor Gallery, Los Angeles, "Arthur Dove," May 7-June 1.

Museum of Art of Ogunquit, Maine, "Fourth Annual Exhibition," July 1-Sept. 10.

Parrish Art Museum, Southampton, N.Y., "What Americans are Painting," July 2-21.

Arts Council of Great Britain, London, "John Marin: Paintings, Watercolors, Drawings and Etchings," Sept. 22-Oct. 20.

Downtown Gallery, N.Y., "Stuart Davis: Exhibition of Recent Paintings — 1954-56," Nov. 6-Dec. 1.

Grace Borgenicht Gallery, N.Y., "Ralston Crawford," Nov. 19-Dec. 8.

**1957**

Institute of Contemporary Art, Boston, "Twentieth Anniversary Exhibition," Jan. 9-Feb. 10.

"Twenty-Fifth Biennial Exhibition of Contemporary American Oil Paintings": Corcoran Gallery of Art, Washington, D.C., Jan. 13-Mar. 10; Toledo Museum of Art [Ohio], Apr. 1-30.

Federation of Jewish Philanthropies of New York, Jan.

Downtown Gallery, N.Y., "New Mexico: As Painted by Stuart Davis, Marsden Hartley, Yasuo Kuniyoshi, John Marin, Georgia O'Keeffe, John Sloan," Mar. 2-30.

UCLA tour, "Hans Hofmann Retrospective Exhibition": Whitney Museum of American Art, N.Y., Mar. 24-June 16; Des Moines Art Center [Iowa], July 4-Aug. 4; San Francisco Museum of Art, Aug. 21-Sept. 22; Art Galleries, University of California, Los Angeles, Oct. 6-Nov. 11; Seattle Art Museum, Dec. 11-Jan. 12 [1958]; Walker Art Center, Minneapolis, Feb. 7-Mar. 11 [1958]; Munson-Williams-Proctor Institute, Utica, N.Y., Mar. 28-Apr. 30 [1958]; Baltimore Museum of Art, May 16-June 17 [1958].

Walker Art Center tour, "Paintings by Stuart Davis": Walker Art Center, Minneapolis, Mar. 30-May 19; Des Moines Art Center [Iowa], June 9-30; San Francisco Museum of Art, Aug. 6-Sept. 8; Whitney Museum of American Art, N.Y., Sept. 25-Nov. 17.

Landau Gallery, Los Angeles, Apr.

Brandeis University, Waltham, Mass., Festival of the Creative Arts-"Art on the Campus," June 1-20.

Museum of Art of Ogunquit, Maine, "Fifth Annual Exhibition," June 29-Sept. 9.

Downtown Gallery, N.Y., "New Art in America," Oct. 7-Nov. 2.

Dallas Museum for Contemporary Art, "Abstract by Choice," Nov. 19-Dec. 31.

Whitney Museum of American Art, "1957 Annual Exhibition — Sculpture, Paintings, and Watercolors," Nov. 20-Jan. 12 [1958].

Alan Gallery, N.Y.

### 1958

McGill Art Center, University of Montreal, Jan. 7-26.

Whitney tour, "Nature in Abstraction": Whitney Museum of American Art, N.Y., Jan. 14-Feb. 8; Phillips Memorial Gallery, Washington, D.C., Apr. 2-May 4; Fort Worth Art Center, June 2-29; Los Angeles County Museum, July 16-Aug. 24; San Francisco Museum of Art, Sept. 10-Oct. 12; Walker Art Center, Minneapolis, Oct. 29-Dec. 14; City Art Museum of St. Louis, Jan. 7-Feb. 8 [1959].

Des Moines Art Center [Iowa], "Art To-day," Feb. 2-Mar. 2.

Milwaukee Art Institute, "Ralston Crawford," Feb. 6-Mar. 9.

Downtown Gallery, N.Y., "O'Keeffe Exhibition: Watercolors 1916-17," Feb. 25-Mar. 22.

Downtown Gallery, N.Y., "Sheeler," Mar. 25-Apr. 19.

De Cordova Museum and Dana Park, Lincoln, Mass., "A Decade in Review," Apr. 27-June 1.

Whitney Museum of American Art, N.Y., "The Museum and its Friends: A Loan Exhibition," Apr. 30-June 15.

University of Iowa, Iowa City, "20th Annual Festival of Fine Arts — Contemporary American Painting," June 18-Aug. 13.

Museum of Art of Ogunquit, Maine, "Sixth Annual Exhibition," June 28-Sept. 8.

UCLA tour, "Arthur Dove": Whitney Museum of American Art, N.Y., Sept. 30-Nov. 16; Phillips Memorial Gallery, Washington, D.C., Dec. 1-Jan. 5 [1959]; Museum of Fine Arts, Boston, Jan. 24-Mar. 1 [1959]; Marion Koogler McNay Art Institute, San Antonio, Mar. 18-Apr. 18 [1959]; Art Galleries, University of California at Los Angeles, May 9-June 15 [1959]; Art Center in La Jolla, Calif., June 20-July 30 [1959]; San Francisco Museum of Art, Aug. 15-Sept. 30 [1959].

Pomona College Gallery, Claremont, Calif., Oct. 10-Nov. 15.

Tweed Gallery, University of Minnesota, Duluth, Oct. 15-Nov. 30.

Downtown Gallery, N.Y., "Max Weber: The Figure in Retrospect — 1906-1958," Nov. 11-Dec. 6.

### 1959

Corcoran Gallery of Art, Washington, D.C., "The 26th Biennial Exhibition of Contemporary American Painting," Jan. 17-Mar. 8.

Whitney Museum of American Art, N.Y., "The Museum and its Friends: Second Loan Exhibition," Mar. 5-Apr. 12.

Dallas Museum for Contemporary Art, Texas, "Flowers and Gardens," Mar. 19-Apr. 19.

"4 Boston Masters": Jewett Arts Center, Wellesley College [Mass.], Apr. 10-May 11; Museum of Fine Arts, Boston, May 19-June 26.

United States Information Agency Tour, "Modern American Painting, 1930-1958": City Art Museum of St. Louis, June 1-Sept.; Palazzo Reale, Naples, Nov.; Galleria d'Arte Moderna, Rome, Dec.-Jan. [1960]; Florence, Feb. [1960]; Milan, March; Palermo, Apr. [1960].

Museum of Art of Ogunquit, Maine, "Seventh Annual Exhibition," June 27-Sept. 10.

United States Information Agency Tour, "American National Exhibit in Moscow": Moscow, July 25-Sept. 5; Whitney Museum of American Art, N.Y., Oct. 28-Nov. 15.

Newark Museum, N.J., "Max Weber Retrospective Exhibition," Oct. 1-Nov. 15.

American Federation of Arts Tour, "A Rationale for Modern Art," Oct.-Oct. [1960].

American Federation of Arts and Whitney Museum of American Art Tour to Israel, "18 American Artists": Bezalel Museum, Jerusalem; Tel Aviv Museum, Tel Aviv; Museum of Modern Art, Haifa.

University of Illinois, Urbana, "Contemporary American Painting."

### 1960

Boston University Art Gallery, "Works from Private Collections," Apr. 23-May 14.

Worcester Art Museum [Mass.], "An Exhibition by Georgia O'Keeffe," Oct. 4-Dec. 4.

"The Precisionist View in American Art": Walker Art Center, Minneapolis, Nov. 13-Dec. 25; Whitney Museum of American Art, N.Y. [1961]; Detroit Institute of Arts [1961]; Los Angeles County Museum [1961]; San Francisco Museum of Art [1961].

American Federation of Arts tour, "Jacob Lawrence Retrospective": Brooklyn Museum and 16 other institutions, Nov.-Nov. [1962].

### 1961

Boston University Art Gallery, "Yasuo Kuniyoshi Retrospective Exhibition," Feb. 24-Mar. 18.

Boston YWCA, "Artists in Search of Freedom," Mar.

Downtown Gallery, N.Y., "New Acquisitions," Sept.

"An Exhibition of Painting by Mark Tobey": Willard Gallery, N.Y.; Musée des Arts Décoratifs, Paris; Tate Gallery, London; Palais des Beaux-Arts, Brussels; Oct.-Apr. [1962].

Allentown Art Museum [Penn.], "Charles Sheeler — A Retrospective Exhibition," Nov. 17-Dec. 31.

### 1962

"Max Weber — 1881-1961 — Memorial Exhibition": American Academy of Arts and Letters, N.Y., Jan. 19-Feb. 18; Boston University Art Gallery, Mar. 10-31.

Downtown Gallery, N.Y., "Gallery Artists - A Group Show," Feb.

"John Marin in Retrospect": Corcoran Gallery of Art, Washington, D.C., Mar. 2-Apr. 15; Currier Gallery, Manchester, N.H., May 9-June 24.

Downtown Gallery, N.Y., "Abstract Painting in America: 1903-1923," Mar. 27-Apr. 21.

Dwight Art Memorial, Mt. Holyoke College, South Hadley, Mass., "Women Artists in America Today," Apr. 10-30.

Downtown Gallery, N.Y., "Stuart Davis Exhibition of Recent Paintings," Apr. 24-May 15.

American Academy of Arts and Letters, New York, "Exhibition of Work by Newly Elected Members and Recipients of Honors and Awards," May 24-June 17.

University of Iowa Museum of Art, Iowa City, "Vintage Moderns: American Pioneer Artists - 1903-1932," May 24-Aug. 2.

United States Information Agency Tour, "John Marin 1870-1953": Amerika Haus, Berlin; Italy, July-Dec.

Currier Gallery, Manchester, N.H.; Keene State College [N.H.].

### 1963

Museum of Modern Art tour, "The U.S. Government Art Projects: Some Distinguished Alumni": Oberlin College, Ohio, and nine other institutions, Feb. 11-Feb. 28 [1964].

Whitney tour, "The Decade of the Armory Show": Whitney Museum of American Art, N.Y., Feb. 27-Apr. 14; City Art Museum of St. Louis, June 1-July 14; Cleveland Museum of Art, Aug. 6-Sept. 15; Pennsylvania Academy of the Fine Arts, Philadelphia, Sept. 30-Oct. 30; Art Institute of Chicago, Nov. 15-Dec. 29; Albright-Knox Art Gallery, Buffalo, N.Y., Jan. 20-Feb. 23 [1964].

University of Iowa Art Galleries, Iowa City, "The Quest of Charles Sheeler," Mar. 17-Apr. 4.

Corcoran Gallery of Art, Washington, D.C., "The New Tradition: Modern Americans Before 1940," Apr. 26-June 2.

"Maine and its Role in American Art — 1740-1963": Bixler Art and Music Center, Colby College, Waterville, Maine, May 4-Aug. 31; Museum of Fine Arts, Boston, Dec. 12-Jan. 12 [1964]; Whitney Museum of American Art, N.Y., Feb. 14-Mar. 4 [1964].

The National College of Art, Dublin, Ireland, "Irish Exhibition of Living Art - 1963," Aug. 15-Sept. 14.

Downtown Gallery, N.Y., "28th Annual Exhibition," Sept. 22-Oct. 17.

Poses Institute of Fine Arts, Brandeis University, Waltham, Mass., "American Modernism: The First Wave," Oct. 4-Nov. 10.

**1964**

The St. Louis Art Museum, St. Louis, "200 Years of American Painting," Apr. 1-May 31.

Whitney Museum of American Art, N.Y., "Between the Fairs: 25 Years of American Art — 1939-1964," June 24-Sept. 30.

Colby College Art Museum, Waterville, Maine, "Maine — 100 Artists of the 20th Century," June 25-Sept. 30.

Pennsylvania Academy of the Fine Arts, Philadelphia, "The Work of Stuart Davis," Sept. 30-Nov. 8.

Baltimore Museum of Art, "1914" (Golden Anniversary Exhibition), Oct. 6-Nov. 15.

"The Painter and the Photograph": Rose Art Museum, Brandeis University, Waltham, Mass.; Museum of Art, Indiana University, Bloomington; State University of Iowa Art Gallery, Iowa City; Isaac Delgado Museum of Art, New Orleans; University of New Mexico Art Gallery, Albuquerque; Santa Barbara Museum of Art [Calif.], Oct.-July [1965].

Provincetown Art Association [Mass.], Golden Anniversary Exhibition.

**1965**

"Stuart Davis Memorial Exhibition": National Collection of Fine Arts, Smithsonian Institution, Washington, D.C., May 28-Aug. 29; Art Institute of Chicago, July 30-Aug. 29; Whitney Museum of American Art, N.Y., Sept. 14-Oct. 17; Art Galleries, University of California, Los Angeles, Oct. 31-Nov. 28.

Smithsonian Institution, Washington, D.C., "Roots of Abstract Art in America — 1910-1930," Oct. 1-Jan. 9 [1966].

"Niles Spencer": University of Kentucky, Lexington, Oct. 10-Nov. 7; Munson-Williams-Proctor Institute, Utica, N.Y., Nov. 21-Dec. 19; Portland Museum of Art [Maine], Jan. 6-30 [1966]; Whitney Museum of American Art, N.Y., Feb. 8-Mar. 6 [1966]; Allentown Art Museum [Penn.], Mar. 15-Apr. 8 [1966]; Currier Gallery, Manchester, N.H., Apr. 15-May 8 [1966]; Museum of Art, Rhode Island School of Design, Providence, May 20-June 12 [1966].

M. Knoedler & Co., N.Y., "Synchromism and American Color Principles in American Painting - 1910-1930," Oct. 12-Nov. 6.

**1966**

Krannert Art Museum, University of Illinois, Champaign, "Ralston Crawford," Feb. 6-27.

United States Information Agency tour, "Stuart Davis: 1894-1964": Musée d'Art Moderne, Paris, Feb. 15-Mar. 14; Amerika Haus, Berlin, Apr. 22-May 21; American Embassy Gallery, London Chancery Building, June 7-24.

Public Education Association, N.Y., "Seven Decades - 1895-1965," Apr. 26-May 21.

"Lyonel Feininger": Pasadena Art Museum, Calif., Apr.

26-May 29; Milwaukee Art Center, July 10-Aug. 11; Baltimore Museum of Art, Sept. 7-Oct. 23.

Berkshire Museum, Pittsfield, Mass., "A Retrospective of George L.K. Morris," Aug. 2-31.

UCLA tour, "The Negro in American Art": Art Galleries, University of California, Los Angeles, Sept. 11-Oct. 16; University of California, Davis, Nov. 1-Dec. 15; Fine Arts Gallery of San Diego, Jan. 6-Feb. 12 [1967]; Oakland Art Museum, Feb. 24-Mar. 19 [1967].

William Penn Memorial Museum, Harrisburg, "Charles Demuth of Lancaster," Sept. 24-Nov. 6.

**1967**

Museum of Modern Art tour, "Synchromism and Related American Color Painting, 1910-1930": State University at Oswego, N.Y.; Santa Barbara Museum of Art [Calif.]; California Institute of Arts, Los Angeles; Allen Memorial Gallery, Oberlin, Ohio; Rose Art Museum, Brandeis University, Waltham, Mass.; Museum of Art, Rhode Island School of Design, Providence; Goucher College, Towson, Maryland; Cummer Gallery of Art, Jacksonville, Fla.; San Francisco Museum of Art; Feb. 4-June 17 [1968].

"Cubism: Its Impact on the United States": University Art Museum, University of New Mexico, Albuquerque; Marion Koogler McNay Art Institute, San Antonio; Los Angeles Municipal Art Gallery; San Francisco Museum of Art; Feb. 10-Aug. 31.

University of Maryland Art Gallery, College Park, "Arthur Dove: The Years of Collage," Mar. 13-Apr. 19.

Downtown Gallery, N.Y., "Arthur G. Dove," Mar. 15-Apr. 8.

Cedar Rapids Art Center [Iowa], "Charles Sheeler - A Retrospective Exhibition," Oct. 25-Nov. 26.

**1968**

Benton Museum, University of Connecticut, Storrs, "Edith Halpert and The Downtown Gallery," May 25-Sept. 1.

Smithsonian tour, "Charles Sheeler": National Collection of Fine Arts, Smithsonian Institution, Washington, D.C., Oct. 10-Nov. 24; Philadelphia Museum of Art, Jan. 10-Feb. 16 [1969]; Whitney Museum of American Art, N.Y., Mar. 11-Apr. 27 [1969].

Whitney Museum of American Art, N.Y., "The 1930s: Painting and Sculpture in America," Oct. 15-Dec. 1.

Kresge Art Center, Michigan State University, East Lansing, "Arthur Dove — 1880-1946," Nov. 3-24.

**1969**

The Metropolitan Museum of Art, N.Y., "New York Painting and Sculpture: 1940 - 1970," Oct.-Feb. [1970].

**1970**

"Georgia O'Keeffe": Whitney Museum of American Art, N.Y., Oct. 8-Nov. 29; Art Institute of Chicago, Jan. 6-Feb. 7 [1971]; San Francisco Museum of Art, Mar. 15-Apr. 30 [1971].

Terry Dintenfass Gallery, N.Y., "Arthur G. Dove: Collages," Dec. 22-Jan. 23 [1971].

**1971**

UCSB tour, "Charles Demuth: The Mechanical Encrusted on the Living": Art Galleries, University of California, Santa Barbara, Oct. 5-Nov. 14; University Art Museum, University of California, Berkeley, Nov. 22-Jan. 3 [1972]; Phillips Collection, Washington, D.C., Jan. 19-Feb. 29 [1972]; Munson-Williams-Proctor Institute, Utica, N.Y., Mar. 19-Apr. 16 [1972].

**1973**

"MacDowell Medalists Exhibition": Currier Gallery of Art, Manchester, N.H., June 30-July 29; Keene State College [N.H.], Aug. 18-Sept. 15.

**1974**

Washburn Gallery, N.Y., "Seven Americans," Feb. 6-Mar. 2.

"Charles Sheeler — The Works on Paper": Museum of Art, Pennsylvania State University, University Park, Feb. 10-Mar. 24; Terry Dintenfass Gallery, N.Y., Apr. 2-20.

"Arthur Dove": San Francisco Museum of Art, Nov. 21-Jan. 5 [1975]; Albright-Knox Art Gallery, Buffalo, N.Y., Jan. 27-Mar. 2 [1975]; St. Louis Museum of Art, Apr. 3-May 25 [1975]; Art Institute of Chicago, July 12-Aug. 31 [1975]; Des Moines Art Center [Iowa], Sept. 22-Nov. 2 [1975]; Whitney Museum of American Art, N.Y., Nov. 24-Jan. 18 [1976].

**1975**

Delaware Art Museum, Wilmington, "Avant Garde: Painting and Sculpture in America 1910-1925," Apr. 4-May 18.

**1976**

Department of State, Washington, D.C., Loan to Ambassador's Residence, London, England, May-May [1977].

Baltimore Museum of Art (U.S. State Department tour), "Two Hundred Years of American Painting": Rheinisches Landesmuseum, Bonn; Museum of Modern Art, Belgrade; Galleria d'Arte Moderne, Rome; National Museum of Poland, Warsaw; June 6-Jan. 15 [1977].

De Cordova Museum, Lincoln [Mass.], "Homer to Hopper: Sixty Years of American Watercolors," Dec. 12-Feb. 6 [1977].

**1977**

Bell Gallery, Brown Univ., Providence, "Graham, Gorky, Smith and Davis in the Thirties," Apr. 30-May 22.

Musée National d'Art Moderne, Centre Georges Pompidou, Paris, "Paris-New York," June 1-Sept. 19.

"Perceptions of the Spirit in 20th Century American Art": Indianapolis Museum of Art; University Art Museum, University of California, Berkeley [into 1978].

**1978**

"Stuart Davis: Art and Art Theory": Brooklyn Museum, Jan. 21-Mar. 19; Fogg Art Museum, Cambridge [Mass.], Apr. 15-May 28.

"Synchromism and American Color Abstraction 1910-1925": Whitney Museum of American Art, N.Y.,

Jan. 24-Mar. 26; Museum of Fine Arts, Houston, Apr. 20-June 18; Des Moines Art Center [Iowa], July 6-Sept. 3; San Francisco Museum of Modern Art, Sept. 22-Nov. 19; Everson Museum of Art, Syracuse, N.Y., Dec. 15-Jan. 28 [1979]; Columbus Gallery of Fine Arts [Ohio], Feb. 15-Mar. 24 [1979].

Detroit Institute of Arts, "The Rouge: The Image of Industry in the Art of Charles Sheeler and Diego Rivera," Aug. 1-Sept. 24.

ACA Galleries, N.Y., "19th and 20th Century Masterpieces in New York Private Collections," Sept. 26-Oct. 14.

Washburn Gallery, N.Y., "From the Intimate Gallery: Room 303," Oct. 4-28.

Worcester Art Museum, Mass., "Emotional Dimensions of Art," Dec. 5-Feb. 15 [1979].

## 1979

Institute of Contemporary Art, Boston, "Boston Expressionism," Jan. 9-Feb. 28.

Whitney Museum of American Art, N.Y., "Dada and New York," May 30-July 6.

"Patrick Henry Bruce: American Modernist": Museum of Fine Arts, Houston, May 31-June 29; Museum of Modern Art, N.Y., Aug. 22-Oct. 21; Virginia Museum of Fine Arts, Richmond, Nov. 26-Jan. 6 [1980].

## 1980

Terry Dintenfass Gallery, N.Y., "Arthur G. Dove: Singular Works," Jan. 8-Feb. 15.

"Marsden Hartley": Whitney Museum of American Art, N.Y., Mar. 4-May 25; Art Institute of Chicago, June 10-Aug. 3; Amon Carter Museum, Fort Worth, Sept. 5-Oct. 26; University Art Museum, University of California,Berkeley, Nov. 12-Jan. 4 [1981].

Terry Dintenfass Gallery, N.Y., "Charles Sheeler - Classic Themes," May 10-30.

"Georgia O'Keeffe and Her Circle": McKissick Museum, University of South Carolina, Columbia, Aug. 20-Sept. 26; Gibbes Art Gallery, Charleston, S.C., Oct.-Nov. 9.

## 1981

American Antiquarian Society, Worcester, Mass., "Lincoln's Birthday Exhibition," Feb. 11-12.

Museen der Stadt, Cologne, "West Kunst Zeitgenössisch Kunst Seit 1939," May 30-Sept. 16.

# William H. Lane Foundation Exhibitions

Addison Gallery of American Art, Phillips Academy, Andover, Mass.
"Paintings from the William H. Lane Foundation"
Nov. 20 – Dec. 14, 1953
40 works

Fitchburg Art Museum, Fitchburg, Mass.
"Contemporary American Paintings from the Collection of the William H. Lane Foundation"
Dec. 12, 1953 – Jan. 20, 1954
52 works

Vassar College Art Gallery, Poughkeepsie, N.Y.
"Twentieth Century American Paintings Lent by the William H. Lane Foundation"
Mar. 3 – 26, 1954
29 works

Slater Memorial Museum, Norwich Free Academy, Norwich, Conn.
"Collection of Paintings Loaned by the William H. Lane Foundation"
Oct. 10 – 31, 1954
60 works

De Cordova Museum, Lincoln, Mass.
"American Paintings from the William H. Lane Foundation"
Nov. 14, 1954 – Jan. 13, 1955
62 works

Smith College Museum of Art, Northampton, Mass.
"Twentieth Century Americans from the William H. Lane Foundation"
Apr. 15 – May 15, 1955
23 works

Wellesley College Museum, Wellesley, Mass.
"American Paintings from the William H. Lane Foundation"
Oct. – Nov. 1955
45 works

Hilson Gallery, Deerfield Academy, Deerfield, Mass.
"Arthur G. Dove, Charles Sheeler from the William H. Lane Foundation"
Feb. 12 – Mar. 11, 1956
22 works (10 Dove, 12 Sheeler)

Downtown Gallery, N.Y.
"Charles Sheeler Exhibition from the William H. Lane Foundation"
Apr. 3 – 28, 1956
29 works

Mount Holyoke College Art Museum, South Hadley, Mass.
"Contemporary American Painters from the William H. Lane Foundation"
May 9 – June 3, 1956
38 works; checklist

Worcester Art Museum, Worcester, Mass.
"American Painting since the Armory Show from the William H. Lane Foundation"
July 1 – Sept. 10, 1957
75 works; checklist

Slater Memorial Museum, Norwich Free Academy, Norwich, Conn.
"Notable American Contemporaries Loaned by the William H. Lane Foundation"
Oct. 1 – 31, 1957
40 works

Radcliffe College Graduate Center, Cambridge, Mass.
"Exhibitions of Contemporary Paintings from the William H. Lane Foundation"
Oct. 1 – 31, 1957
20 works; checklist

Currier Gallery of Art, Manchester, N.H.
"American Art from the William H. Lane Foundation"
Nov. 1 – Dec. 14, 1958
44 works

Robert Hull Fleming Museum, University of Vermont, Burlington
"American Paintings from the William H. Lane Foundation"
Dec. 22, 1958 – Jan. 24, 1959
22 works; checklist

Massachusetts Institute of Technology, Hayden Gallery, Cambridge
"Charles Sheeler: A Retrospective Exhibition from the William H. Lane Foundation"
Jan. 5 – Feb. 22, 1959
40 works; catalogue

Fitchburg Art Museum, Fitchburg, Mass.
"American Art from the William H. Lane Foundation"
Feb. 20 – Apr. 1, 1959
20 works

Massachusetts Institute of Technology, Cambridge, President's House
"Loan of Paintings from the William H. Lane Foundation"
Sept. 9 – Nov. 9, 1959
8 works

Mount Holyoke Art Museum, South Hadley, Mass.
"American Paintings Lent by the William H. Lane Foundation"
Oct. 10 – Nov. 2, 1959
34 works; checklist

Katonah Art Gallery, Katonah, N.Y.
"Charles Sheeler Exhibition Lent by the William H. Lane Foundation"
Apr. 24 – May 24, 1960
19 works; catalogue

Slater Memorial Museum, Norwich Free Academy, Norwich, Conn.
"William H. Lane Foundation Exhibition"
Nov. 2 – 22, 1960
39 works; checklist

Massachusetts Institute of Technology, Cambridge,
President's House
"Loan of Paintings from the William H. Lane
Foundation"
Spring 1961
6 works

Worcester Art Museum, Worcester, Mass.
"Paintings and Watercolors by Arthur G. Dove from
the William H. Lane Foundation"
July 27 – Sept. 17, 1961
43 works; catalogue

Radcliffe College Graduate Center, Cambridge, Mass.
"Paintings from the William H. Lane Foundation"
Oct. 17 – Nov. 17, 1962
10 works

University Art Galleries, University of New Hampshire,
Durham
"An Exhibition of Paintings from the William H. Lane
Foundation"
Feb. 13 – Mar. 15, 1963
30 works

De Cordova Museum, Lincoln, Mass.
"Paintings from the William H. Lane Foundation"
Nov. 23 – Dec. 29, 1963
64 works

Radcliffe College Graduate Center, Cambridge, Mass.
"Paintings from the William H. Lane Foundation"
Feb. 26 – Mar. 26, 1964
11 works

George Walter Vincent Smith Art Museum, Springfield,
Mass.
"Twentieth Century American Paintings Lent by the
William H. Lane Foundation"
Nov. 8 – Dec. 6, 1964
35 works

Fitchburg Art Museum, Fitchburg, Mass.
"William H. Lane Foundation: Twentieth Century
American Art"
Apr. 4 – May 1, 1965
22 works; checklist

Robert Hull Fleming Museum, University of Vermont,
Burlington
"Twentieth Century American Painting from the Wil-
liam H. Lane Foundation"
July 8 – Aug. 7, 1966
20 works; checklist

Massachusetts Institute of Technology, Cambridge,
President's House
"Loan of Paintings from the William H. Lane
Foundation"
Oct. 18, 1966 – June 30, 1967
6 works

Massachusetts Institute of Technology, Cambridge,
President's House
"Loan of Paintings from the William H. Lane
Foundation"
Sept. 1, 1967 – June 30, 1968
4 works

Fitchburg Art Museum, Fitchburg, Mass.
"William H. Lane Foundation - Contemporary Ameri-
can Art"
Nov. 24, 1968 – Jan. 11, 1969
25 works; catalogue

Fitchburg Art Museum, Fitchburg, Mass.
"William H. Lane Foundation - Charles Sheeler
Photographer"
Sept. 20 – Nov. 28, 1969
35 works

Currier Gallery of Art, Manchester, N.H.
"Selections of Paintings by Arthur G. Dove and Charles
Sheeler from the William H. Lane Foundation"
Apr. 7 – 20, 1972
65 works (33 Dove, 32 Sheeler); checklist

Amherst College Art Museum, Amherst, Mass.
"Twentieth Century American Art from the William H.
Lane Foundation"
Oct. 10 – Nov. 11, 1973
35 works; checklist

Addison Gallery of American Art, Phillips Academy,
Andover, Mass.
"William H. Lane Foundation Exhibition"
Nov. 20, 1973 – Jan. 24, 1974
33 works

William Benton Museum of Art, University of Con-
necticut, Storrs
"Selections from the William H. Lane Foundation"
Mar. 17 – May 24, 1975
80 works; catalogue

Danforth Museum, Framingham, Mass.
"American Art: Selections from the William H. Lane
Foundation"
Mar. 21 – June 4, 1978
32 works; checklist

William Benton Museum of Art, University of Con-
necticut, Storrs
"Selections from the William H. Lane Foundation: Part
II"
Jan. 22 – Mar. 11, 1979
100 works; catalogue (with bibliography)

Munson-Williams-Proctor Institute, Utica, N.Y.
"Paintings from the William H. Lane Foundation"
Apr. 8 – May 27, 1979
47 works; illustrated catalogue

Bowdoin College Museum of Art, Brunswick, Maine
"Paintings from the William H. Lane Foundation:
Modern American Masters"
Oct. 10 – Nov. 23, 1980
40 works; checklist

De Cordova Museum, Lincoln, Mass.
"Modern American Masterworks from the William H.
Lane Foundation"
Mar. 1 – Apr. 26, 1981
41 works

# INDEX OF ARTISTS